SELL & RE-SELL
YOUR PHOTOS
Learn how to sell your pictures worldwide

Rohn Engh

FIFTH EDITION! Completely Revised and Updated

W

WRITER'S DIGEST BOOKS
CINCINNATI, OHIO
www.writersdigestbooks.com

Visit our Web site at www.writersdigest.com for information on more resources for writers.

To receive a free weekly e-mail newsletter delivering tips and updates about writing and about Writer's Digest products, register directly at our Web site at http://newsletters.fwpublications .com.

11 10 09 08 07 8 7 6 5 4

Library of Congress Cataloging-in-Publication Data

Engh, Rohn
 Sell & resell your photos: learn how to sell your pictures worldwide / by Rohn Engh.
 p. cm.
 Includes index.
 ISBN-13: 978-1-58297-176-6 (pbk.: alk. paper)
 ISBN-10: 1-58297-176-5 (pbk.: alk. paper)
 1. Photography—Marketing. 2. Photography—Business methods. 3. Stock photography.
 I. Title.
TR690.E53 2003
770'.68'8—dc21 2003000249
 CIP

Edited by Donna Poehner and Jerry Jackson Jr.
Designed by Sandy Conopeotis Kent
Cover by Wendy Dunning
Production coordinated by Michelle Ruberg

Cover Photos
Bottom left: Robin Orans
Bottom right: Lee Snider
All others: H.T. White

DEDICATION

I'd like to dedicate this book to my wife, Jeri,
for the common sense, good humor and love that
has kept our family on a straight course.

Acknowledgments

I want to acknowledge Jeri's wonderful help with this edition. Not only did she bring her professional writing expertise to the project, she also is my severest critic and my best friend.

Sincere thanks also go to Mikael Karlsson for his untiring work in tailoring this edition to the new era of digital photography, to Bill Hopkins for his essential contributions to the computer and online references throughout this edition, to Julian Block for his expertise on the taxes section, and to Rick Smolan, Mitch Kezar, Lou Jacobs Jr., Joe Farace, Owen Swerkstrom, and the late Galen Rowell for their encouragement and support in my publishing efforts.

I'm indebted to the help I received in the background from my researchers and staff for their sound help: Bruce Swenson, Jeff Klawiter, Deb Koehler, Angela Dober, Neil Kaul, Phil Kalata, Annie Swerkstron, Shelby Peterson, Bonnie Cook, and Hope Church.

Likewise, I would like to thank Robin Orans and Lee Snider for their contributions to the cover of this book.

There are many others whose influence or example through the years has helped make this book possible. The best way I can express my appreciation is to pass what I have learned on to you.

Table *of* **Contents**

INTRODUCTION
Exciting Opportunities at Your Doorstep, 1

1 The Wide World of Possibilities

2 What Photos Sell and Re-Sell?

3 Finding Your Corner of the Market

Introduction

Exciting Opportunities at Your Doorstep

Will a Rolls-Royce be sitting in your driveway if you follow the principles set forth in this book? Maybe not. But then again, maybe two of them will. Or maybe a moped will. In other words, you'll reach whatever goals you set for yourself. Success or failure in publishing your pictures is not determined by the wave of some mysterious wand out in the marketplace. If you've got the know-how, *you* determine how far and how fast you go. This book will give you that know-how.

In more than forty years of selling photographs, I've refined a marketing system that works for me today better than ever. It also works for scores of other stock photographers who have learned the system in my seminars and through my market newsletters.

The components of the system are simple—but the process isn't easy. It takes effort, energy, and perhaps some unlearning of initial misconceptions. That's all that's required, and there are compensations.

LIVE ANYWHERE. No need to live in the canyons of Manhattan or downtown Chicago to be close to the markets. They're as close as your mailbox or your computer. You can work entirely by mail, entirely at home, and still score in the wide world of markets open to you.

PICK YOUR HOURS. You can arrange your own schedule and enjoy the flexibility of being independent. You can work at your stock photography full time or part time.

BE YOUR OWN BOSS. Photobuyers don't care whether you're an amateur or a professional, a homemaker or a parachutist. They're concerned about the quality of your picture and whether it meets their current needs.

TAKE PAID VACATIONS. You can pay for your trips through assignments you initiate or by judicious picture-taking and picture-placing, all described in my system.

EARN MORE MONEY. You will sell the same photo over and over again. You'll choose from hundreds of good-paying markets you never knew existed, and you'll enjoy working with them because they're in your interest areas.

SEE YOUR PICTURES IN PRINT. You'll be seeing your photographs in national circulation. Sometimes your picture will make a tangible social contribution, sometimes it'll be business as usual. Regardless, it will all be deeply satisfying.

THE SYSTEM: EIGHT ELEMENTS

There are eight elements in my marketing system that I'll explore with you in detail in the course of this book.

1. You market your photos by mail, and in some cases, by computer. No need to pound the pavement with a portfolio.

2. You distinguish between *service* photography and *stock* photography (photo illustration). The service photographer markets his *services*—on schedules that meet the time requirements of ad agencies, businesses, wedding parties, and portrait clients. The stock photographer takes and markets his *pictures*—on his own timetable, selling primarily to books, magazines, and publishing companies of all kinds all over the country. My marketing system addresses the stock photographer.

3. You distinguish between *good* pictures and good *marketable* pictures. The former are the excellent scenics, wildflowers, sunsets, silhouettes of birds in flight, scenic shots of the lake, and pet pictures. These are A-1 pictures, but in spite of the fact that we see them everywhere in the marketplace (on greeting cards, record covers, posters, travel brochures, magazine ads), they're terribly difficult (they can cost you money) to market yourself. I'll tell you why later in the book. You learn how to place these pictures in the right stock photo agencies, who *can* market them for you, for now-and-then supplementary income. For regular income

you sell good *marketable* pictures: photo illustrations. You continue to take pictures in your interest areas, but you learn how to turn a picture into a highly marketable shot, for sale to book and magazine publishers.

4. You look like a professional with photo-identification methods, stationery, labels, packaging, cover and query letters, and your product.

5. You determine your PS/A—your Photographic Strength/Areas—and specialize. Knowing how to do this will give you invaluable insight and irresistible momentum. To my knowledge, it is treated nowhere else in the photographic literature.

6. You focus on only a slice of the market pie. You specialize.

7. You determine *your* Market List, coordinated with your PS/A. You don't sell your pictures before you understand how to market them. Selling happens naturally, after you do your marketing homework. Once you develop a solid Market List, you cultivate the long-term "net worth" of each photo editor on your Market List.

8. You find the market first, then create for that market, not the reverse.

I have tried to present an honest overview. I am a working editorial stock photographer, and I also publish three photomarketing newsletters; my business deals with dozens of photo editors daily. As changes in online publishing and digital photography occur, I'm among the first to know.

My goal in this book is to give you the tools to be able to sell consistently to markets you enjoy working with. This book will help you tap these markets, and you'll discover the real excitement, the genuine exhilaration, of the venturesome process of producing your pictures and sharing them through publication.

ONWARD. With today's dramatic increase in the use of photography, and with the number of new markets and special-interest magazines, books, CD-ROMs, new media and Web sites, the challenges and satisfactions have never been greater. You can be part of them. The sky *is* the limit.

1

The Wide World of Possibilities

THE BUYERS ARE WAITING

You've probably turned to a photograph in a book or magazine and said, "I can take a better picture than that." You're probably right . . . and not only from the point of view of quality or subject matter. Often a photo you see published in a magazine or book doesn't really belong there. When the deadline arrived, the photo editor used it because it was there, not because it was the perfect, or best, photograph.

Photobuyers would gladly use your photographs if they knew you existed and if you'd supply them with the pictures they need, when they need them. The buyers literally are waiting for you, and there are thousands of them. This book will show you how to locate the markets that are, at this moment, looking to buy pictures from someone like you, with your special know-how and your camera talent. This book also will show you a no-risk method for determining what photo editors need; how you can avoid wasting shoe leather, postage, e-mail and Web site visits; plus

how you can avoid markets that don't offer any future for your kind of photography. You'll earn the price of this book in one week through the stationery, postage, and phone bills it will save you.

If you're a newcomer to the field of photomarketing, you'll be surprised to learn you can start at the top. I know many who have done so; I did myself. Many of my pictures have sold to *People, Redbook, Parents, U.S. News & World Report, Reader's Digest*, and *The Saturday Evening Post*. That said, I soon discovered that if I wanted to sell consistently to the top magazines, I would have to travel continually and make my headquarters in a place that was a good deal larger than Osceola, Wisconsin. That was not in my master plan. I wanted to make a life for my family in the country, so I started researching other possibilities.

I found there were at least 10,000 picture markets out there (many more exist today). I figured if I subtracted the top-paying newsstand magazines, numbering about 100, that left 9,900 for me to explore, to find several hundred that emphasized subject areas I liked to photograph. I learned that most of these markets were as close as my mailbox (today they're as close as my computer) and that many of them actually were eager for my photographs. Most important, I could sell to these markets on my own timetable and live wherever I wanted.

Trends in the Marketplace

In 1960 when I began marketing my pictures, few persons had the title "photo editor." The art director or an editor at a publishing house doubled as the person who selected pictures. The picture-selection process often was done at the last moment, whenever the book or magazine text was finalized. In those days, photos frequently served simply to fill white space or to support a subject with illustrative documentation.

During recent decades, our society has become increasingly visually oriented, to the point of a veritable explosion in the use of visuals. People today are more prone to be viewers than they are to be readers. Reading material is more and more capsulized. Witness the proliferation of condensed and "instant" books, and specialized newsletters; the success of

USA Today and its influence on the formats of many other newspapers; and magazines like *Time* and *Newsweek* designing their editorial as chunks of summarized information. People rely less on the printed word and more on pictorial images for entertainment and instruction. An automatic coffeemaker gives its instructions in illustrations, rather than text. Point-of-sale terminals at most restaurants provide clerks with pictures rather than words. Textbooks have more pictures and larger type. Illustrated seminars, Web sites, CD-ROMs, and instructional CD and video presentations are the preferred tools for education throughout the industry, and TV is conditioning all of us to visuals every day.

Words and printed messages aren't going out of style, but a look in any direction today shows us that photography is one of the most prominent means of interpreting and disseminating information.

New positions have been created in publishing houses—photo editor, photo researcher, photo acquisition director—positions that never existed in the past. Revolutionary technology is developing to handle and reproduce pictures. Publishers produce millions of dollars worth of books, periodicals, and audiovisual materials every year. The photographs used in these products often make the difference between a successful venture and a failure. An editor isn't kidding when she says, "I need your picture."

The breadth of the marketplace may come as a surprise. For example, some publishing houses spend as much as ten thousand to eighty thousand dollars *a month* on photography. Some of these thousands could regularly be yours, if you learn sound methods for marketing your pictures.

As I mentioned earlier, you can start at the top. It's not impossible, but making a full-time habit of selling to the top markets requires a specific lifestyle and work style. You need to examine your total goal plan and make some major decisions before you launch after the biggies. Only a handful of people break into that small group of professionals who enjoy regular assignments from the top markets. Moreover, most of those professionals pay their dues for years before they get to where their phones ring regularly.

Too often, the newcomer to any field believes the top is the only place

it's at. The actor or the musician rushes to Hollywood to make it big. We all know how the story ends. Out of thousands, only a few are chosen. We also know that they're not chosen on the basis of talent alone. Being at the right place at the right time is usually the key. The parallel holds true in photography. Good photographers are everywhere—just check the yellow pages or the Web. As with actors and musicians (or artists, dancers, writers, and so on), talent is only one of the prerequisites.

However, if you're serious about your photography and are willing to look beyond the top, you'll discover a wide world of possibilities. There are markets and markets—and yet more markets. You will get your pictures published, consistently, with excellent monetary return, and with the inner satisfaction that comes from putting your pictures out where others can enjoy them. You can accomplish this if you apply the principles I outline in this book. Your pictures will be at the right place at the right time, and your name will be on the checks sent regularly by the photobuyers and editors that you identify as your target markets.

Fifty Thousand Photographs a Day

As you read this, at least fifty thousand photographs are being bought per day for publication worldwide at fees of twenty-five to one hundred dollars for black and white, and often twice as much for color. I'm not talking about ad agencies or general newsstand-circulation magazines. These are closed markets, already tied up by staff photographers or established professionals.

I'm referring to the little-known wide-open markets that produce books, magazines, CD-ROMS, Web sites, and related printed products. Such publishing houses have proliferated all over the country in the last three decades. Opportunities for selling photographs to the expanding stock photo industry have never been greater. Some publishing companies are located in small towns, but that's no indicator of their photography budgets, which can range, I repeat, from ten thousand to eighty thousand dollars or higher per month.

A WIDE-OPEN DOOR

These publishers constantly need photographs. Many publishing companies produce three dozen different magazines or periodicals, plus related publications such as bulletins, books, curriculum materials, CD-ROM and DVD materials, brochures, video series, and reports. Staffs of the larger publishing houses have scores of projects in the works at one time, all of which need photographs. Before any company completes a publishing project, it's searching for photographs for the next project.

Textbook publishers fiercely compete with each other to nail down contracts with colleges and universities, technical institutes, school boards, and educational associations to produce millions of dollars of photo-illustrated educational materials. These materials range from printed manuals to CD-ROM and DVD discs.

Regional and special-interest magazines number in the thousands. While many general-interest magazines have been struggling or folding, regional and special-interest magazines (open markets for the stock photographer) have been on the rise. With the enormous amount of information available in any field or on any subject in today's world, our culture has become one of specialization. Increasingly, magazines and books reflect this emphasis, focusing on self-education and specific areas of interest, whether business, the professions, recreation, entertainment, or leisure. This translates into still more markets for the stock photographer.

Another major marketplace is found in the scores of denominational publishing houses that produce hundreds of magazines, books, periodicals, curriculum materials, posters, bulletins, video programs, CD-ROMs, and interactive media. Some of these companies employ twenty or more editors, who seek photos for all their publishing projects. Most of these photos focus on "the human condition" and are not what you might think of as specifically "religious." The companies' photography budgets are high because their sales volumes are high. Many have a photography budget of twenty-five thousand dollars per month.

As I mentioned earlier, nearly ten thousand markets are open to the stock photographer today. (That's apart from the about one hundred top

magazines, such as *National Geographic* and *Sports Illustrated*.) These ten thousand open markets are accessible to both the part-timer and the full-timer. Photobuyers in these markets continually revise, update, and put together new layouts, new issues, new editions, new publication projects, and new or updated CD-ROMs and Web sites.

If you compare the per-picture rate (modest) paid by these markets against that paid by the one hundred top magazines, or against what an advertising photographer receives for commercial use of his photo (five hundred dollars on average), there's a big difference. But that's misleading. Unless you number yourself among the handful of well-known veteran service photographers who sell to the top magazines (many have staff photographers in any case), gunning for those markets is sweepstakes marketing—chances are you won't win. The same goes for top commercial assignments. When you score, it's for a healthy dollar, but how frequently can you count on it? In addition, commercial accounts sometimes require all rights, including electronic rights to your photos, or they may ask you to sign a "work-for-hire" agreement. (Read more about work for hire in chapter fifteen on page 296.)

In contrast, as a stock photographer "renting" or "licensing" your photos for editorial use ("sold" on a "one-time use" basis), you can circulate hundreds of pictures to publishing houses for consideration, each picture making from twenty-five to two hundred dollars at every sale. You don't have to worry about the travel and deadline requirements of top magazine assignments or the stress of commercial assignments. Plus you can sell the same pictures over and over again.

You can do this from your own home, wherever you live. For the past thirty years, I've operated successfully out of a one-hundred-acre farm in rural Wisconsin. I can attest that more and more photographers are doing the same thing, from such diverse headquarters as a quiet side street in Kansas City, an A-frame in Boulder, or an apartment in Santa Rosa.

When you master the photomarketing system outlined in this book, you'll know how to select your markets from the vast numbers of possibilities and then tap them for consistent, dependable sales. If you're like

most of us, you'll find that your range of markets includes some that are good starting points (easy to break into but pay modestly); some that are good showcases for your work (prestigious publications in your special-interest area that may pay little but offer a good name to include in your list of credits, or good visibility to other photobuyers); many that will be regular customers for modest but steady return; and many that will be regular, well-paying customers.

Find the Market, Then Create

Many successful photographers say their careers surged when they realized that they were conducting the business side of their endeavors exactly backward. They had been creating first, then trying to find markets for the photos they created. That system can work to a certain extent (everyone gets lucky now and then), but it doesn't make for consistent, predictable sales. It's another form of sweepstakes marketing. The secret to guaranteed sales: *Find the market first.*

This isn't to say that you pick just any market and create for it. I mean search out the markets that appeal to you as a person and a photographer—markets that use the kinds of photographs that you like to take, markets you would love to deal with and create for: markets that wild horses couldn't pull you away from.

Finding your corner of the marketplace is going to be like prospecting (see chapter three for more details). It's going to take some digging, but the nuggets you discover will be worth the effort.

You, the Photo Illustrator

After you become familiar with the photomarketing system described in this book, you'll find that you can wear two hats in photography: One hat is that of the photo illustrator, or editorial stock photographer; the other is the hat of the service photographer. What's the difference?

Service photographers market their services on schedules that meet the time requirements of their clients: ad agencies, businesses, fashion and food assignments, wedding parties, portrait clients, public relations

firms, and audiovisual accounts. Service photographers usually find that they need several different kinds of cameras, lenses, lights and accessories, photo imaging and manipulation software, scanners, and frequently a well-equipped studio.

Stock photographers make and market their stock photographs (photo illustrations) on their own timetable, selling almost exclusively to publishers of books, magazines, and related digital media. They deliver their photos primarily through the U.S. mail, United Parcel Service (UPS), Federal Express (FedEx), or other overnight couriers; and electronically. They can operate with one camera and three lenses, though they're better off with two cameras. The extensive equipment and studio space (and resulting high overhead) of the service photographer aren't necessary.

A photographer can be either a service photographer or a stock photographer, or both. The marketing system in this book, however, addresses the stock photographer. As the demand for photo illustrations in the publishing world has increased, so have photography publishing budgets and the need for editorial stock photographers, who can supply on-target photo illustrations to these specialized publishing houses.

THE "THEME" MARKETS

The primary markets for photo illustration are the publishing companies located in every area of the country, and the magazines, books, and electronic media they produce. I've already touched on some major categories—educational, regional, special interest, and denominational. Now we'll look at each market in detail. Publishing houses specialize, and so should you. If you come across a magazine in one of your fields of interest, you'll often discover that the magazine's publishing house produces several additional magazines, usually related and focusing on the same "theme" or subject area. If your photomarketing strengths include that theme, you've discovered one of *your* top markets.

Prime Markets
1. Magazines
2. Books

Secondary Markets

1. Digital media
2. Stock photo agencies
3. Decor photography outlets

Third-Choice Markets

1. Paper product companies (calendars, greeting cards, posters, post-cards, personalized photo products, and so on)
2. Commercial accounts (ad agencies, public relations firms, record companies, audiovisual houses, desktop publishers, Web designers, graphic design studios, and so on)
3. Newspapers, government agencies, and art photography sales

You'll find a full discussion of third-choice and secondary markets later in this book, so I'll say just a word about them here. The third-choice markets range in marketing potential from "possible" to "not possible" for the stock photographer. In Appendix A, I outline what to expect at these markets and what the requisites are for selling to them.

The secondary markets—digital media, sales through stock photo agencies, and channels for decor photography—are discussed in detail in chapter twelve. Stock agencies aren't markets in the usual sense; they're middlemen who can market your photo illustrations for you. Decor photography (also called photo decor, wall decor, or fine art photography) involves selling large photos (from sixteen by twenty inches to wall-size) that can be used as wall art in homes, businesses, and public buildings.

Both the agency and decor areas offer sales opportunities to the stock photographer and can be important to your operation, but just how important may be different from what you initially assume. Photo agency sales can be successful when you place the right categories of pictures with the right agencies (not necessarily the most prestigious). This takes some homework. Likewise, the decor route has its assets and its liabilities. Chapter twelve gives you the know-how to approach agencies and decor photography with a chance for elation rather than frustration.

Now to the prime markets for the stock photographer: magazines and books (see Tables 1-1 and 1-2).

Magazines

You can determine how large a magazine's photo budget is by asking this question: "Whose dollars support the magazine?" If the magazine runs on advertising support, the photography budget usually is high. If a company underwrites a trade or industry, the photography budget also usually is high. The photo budget is in the middle range if an organization or association supports the magazine or if subscriptions alone support it. Many magazines operate with a combination of advertising and subscription revenue, making for healthy photo budgets. Magazines with no advertising, subscription, or industry/association support will have low photography budgets. In chapter three, I'll show you how to be selective in choosing your magazine markets.

Budget, of course, should not be the sole factor you use in determining what markets to work with. Often it's actually easier to sell ten pictures at $75 each to a medium-budget publication than it is to sell one picture at $750 to one of the higher-paying magazines. You can use the budget question to good advantage, though, in determining how healthy a magazine is and how stable a market it might be for you. Chapter eight will show you how to determine a market's photo budget and the prices you should ask for your photos.

Books

Approximately seventy-five thousand books are published in this country every year. Publishers, who orchestrate the complete package, produce books: They assign manuscripts, create graphics, edit, print, promote, and distribute. Before you deal with a book publisher, get the answers to these questions:

- How well known is the publishing company?
- How long have they been in business?
- How wide is the market appeal of the book in question?

Magazine Markets

Category	Description	How they use photographs	Examples
Special interest (avocation)	Focus on a specific subject area; aim at a specific target audience (e.g., travelers, skiers, runners, animal breeders, sailboaters, and so on) who are either activists or armchair enthusiasts. Sold at newsstands or by subscription or available free. Advertising supported. Good markets when they match your PS/A.[1] Pay can be excellent.	To illustrate articles, essays, poetry, how-to features, photo stories, covers, chapter heads.	*Organic Gardening; Ski Canada; Official Karate; Hot Rod Magazine; Photo Electronic Imaging; Horse and Horseman; Car & Driver; Popular Photography*
Trade (vocation)	Address a specific professional audience farmers, electricians, computer programmers, pilots, wholesalers. Not sold at newsstands. Advertising supported. If your PS/A includes technical knowledge, this will be a rewarding market. Pay is excellent.	To illustrate technical articles, how-to features, covers, photo essays, industry news.	*Studio Photography; The Ohio Farmer; Western Flyer; American Hunter; The Land; The National Utility Contractor; Wired*
Business	Industry-produced (internal and external) as a medium to reach both employees and the general public. Not sold at newsstands. Usually free. Editors expect solid knowledge in their field of interest. Pay is excellent.	To illustrate articles, covers, photo essays, industry trends; to establish a mood.	*Career Woman; Automotive News; Entrepreneur; Athletic Business*
Denominational	Scores of denominational publishing houses produce magazines, newspapers, bulletins, and curriculum materials specific to different age groups, couples, and families. Distributed by subscription or given away free to membership. Pay is medium to low, but volume purchasing is high.	To illustrate articles, essays, poetry, photo stories, news items, covers, chapter heads, video programs.	*Back to the Bible; Marriage; Christian Home and School; Response*
Associations, organizations	Published for members of organizations and clubs. News and events, plus general-interest articles. Not sold at newsstands. Sold by subscription. Supported sometimes by dues and by advertising. Audience usually is specialized. Pay is mediocre.	To illustrate articles, covers, news items, photo essays; to establish a mood.	*Kiwanis Magazine; National 4-H News; Scouting Magazine; The Rotarian; Canadian Journal of Botany*

Table 1-1.

Magazine Markets, continued			
Category	*Description*	*How they use photographs*	*Examples*
Local	Audience usually is a local metropolitan area. Feature stories, articles, and pictures of local interest. Advertising supported. Sold at newsstands and by subscription. Pay is low, but exposure is valuable.	To illustrate articles, covers, news items, photo stories; to establish a mood.	*Chicago*; *Michigan Living*; *Twin Cities Magazine*; *Los Angeles Magazine* Sunday newspaper magazine sections
State and regional	Audience is statewide or encompasses several states. Feature stories, articles, and pictures of regional interest. Sold at newsstands and by subscription. Pay is usually low, but volume makes up for it.	To illustrate articles, covers, news items, photo stories and essays; to establish a mood.	*New England Skier's Guide*; *Sandlapper Magazine*; *Pacific Northwest Magazine*; *Arizona Highways*; *Sunset Magazine*; *Wisconsin Trails*; *AAA Midwest Traveler*; *Outdoor Oklahoma*
News services	Timely features and news pictures produced by staff, stringers, and freelancers. They can use pictures of your area. Pay is low.	To illustrate articles, news items, covers; to establish a mood.	*Newsday*; American Media; Los Angeles Times Syndicate International
General newsstand	General, national interest, and large circulation (see Appendix A). These magazines are supported by advertising and subscription and appeal to a broad segment of the population (e.g., women, sports enthusiasts, and so on). These are third-choice markets for you because they assign most of their photo needs to staff photographers, well-known veteran stock photographers, or stock photo agencies.	To illustrate articles, news items, covers, essays, and feature stories.	*Redbook*; *Good Housekeeping*; *People*; *National Geographic*; *Sports Illustrated*; *Reader's Digest*; *Esquire*; *Cosmopolitan*

[1] PS/A = Photographic Strength/Areas. These areas are your specialties, your niche, what you photograph best. They can be anything from racehorses or kids to flowers or technology. See chapter three for more details.

The photography budget usually is high if the book has a broad potential audience and the publishing company is well established. Fledgling book publishers, small presses, and limited-audience publishers rarely pay high fees. Again, however, this is primarily to orient yourself—I'm not suggesting that your targets be only the high-paying markets. Selling a

Book Markets

Category	Description	How they use photographs	Examples. Ratings in terms of numbers of photo illustrations purchased
Encyclopedias and dictionaries	Multivolume and single volume. Some contain a broad range of information, others cover specific topics such as medicine or woodworking. Foreign-language editions. Children's editions.	To illustrate articles, section heads, updates, revisions, supplements, CD-ROMs.	*Britannica; Encarta; Handyman's; Van Nostrand's Scientific; Webster's New World Dictionary.* **Rating: C**
Textbooks	Textbooks range from brief paperbacks to multivolume hardcover series. Used in schools, associations, churches, businesses. All subjects (e.g., biology, math, history, special ed.). Foreign-language editions.	To illustrate chapter heads, covers, technical articles, revisions, supplements, CD-ROMs; to establish moods.	Ginn and Company; Scott Foresman; Addison Wesley; Silver Burdett; Houghton Mifflin; Pearson Education; McGraw-Hill Education. **Rating: A**
Church curriculum	Sunday school course books, Bible study materials, adult education, confirmation texts, family living and inspirational books.	To illustrate articles, chapter heads, updates, photo essays; to establish moods.	United Methodist Church; Augsburg Fortress; Church of the Nazarene. **Rating: B**
Consumer trade	Sold in bookstores, in supermarkets, by mail order, and through book clubs. Range from coffee-table books to best-sellers to vest pocket references. General and specialized hardcover and paperback. Specialized subject areas range from photographic to popular science to poetry.	To illustrate chapters, jackets, covers, chapter heads, section heads, how-to photo essays, updates.	Sierra Club Books; Fodor's Travel Guides; Bantam Books; *The Family Handyman; How to Travel Inexpensively;* American Booksellers Association. **Rating: D**

Table 1-2.

small publisher or a CD-ROM producer one hundred pictures at a bulk rate of twenty-five dollars each for one-time use makes good sense. In chapter three, I'll show you how to find your target book markets; chapters seven and eleven will tell you more about sales to book publishers.

A Hedge Against a Downturn in the Economy

When there's a downturn in the economy, photo editors turn to stock photography rather than hiring photographers to go on assignment. In the forty years I've been in stock photography, a recession (there have been five of them, so far) has always boosted my sales. Once the recession is over, some of those photo editors stay with me, having learned the economic advantages of buying direct stock from individual photographers. As stock agent Craig Aurness said in his International Stock Photography Report, "Stock is perceived as a recession-resistant industry, as downward trends force companies to look for alternatives to expensive assignment photography."

Good Pictures—Wrong Buyers

The prime markets pay stock photographers millions of dollars a year to get the photos they need. Sounds promising for the photographer, but wait—the key word is "need." Whether you plan on grossing fifty or fifty thousand dollars in sales each year with your photography, don't ever forget that photo editors purchase only pictures they need, not pictures they like. If you supply the right pictures to them, they'll buy. I've heard dozens of photographers over the years complain that their pictures weren't selling. When I examined their selling techniques, it was easy to see why: They were putting excellent photographs in front of the wrong buyers. A photobuyer may think your pictures are beautiful, but he won't purchase them unless they fit the publication's specific needs. A photo editor is like any other consumer: If she needs it, she'll buy it. Chapters two and three will show you how to determine what a photobuyer's needs are and how to fill them.

2

What Photos Sell and Re-Sell?

THE DIFFERENCE BETWEEN A GOOD PHOTO AND A GOOD MARKETABLE PHOTO

What kind of photo can you be sure will sell for you—consistently? And what kind of photo will disappoint you—consistently?

You may be surprised at the answer to these two questions. The heart of the matter is that one type is a good photo, and the other type is a good *marketable* photo. It's surprising because the good photos seem like they ought to be marketable; we see them everywhere, looking at us from billboards, magazine covers, brochures, advertisements, and greeting cards. These good pictures are lovely scenics, beautiful flower close-ups, sunsets and dramatic silhouettes—those excellent Kodak-ad shots and contest winners. These photos also could be called standard excellent pictures.

"But why do they consistently ring up no sale when I try to market them?" you ask. Because the ad agencies, graphic design studios, and top

magazines who use these standard excellent shots don't need them; 99 percent of the time their photobuyers have hundreds, indeed thousands, of these beauties at their fingertips—in inventory, at their favorite stock photo agencies, or from the list of stock photographers they've worked with and know are reliable. Ninety-nine percent of the "good" pictures you see published in major newsstand magazines or in calendars, brochures, or posters are obtained from one of those two sources: stock photo agencies or top established professionals.

The established professional usually has a better supply of standard excellent pictures than the average photographer or serious amateur, even though the latter may have been photographing for years. Professionals have work schedules and assignments that afford them hundreds of opportunities to supplement their stock files. The professionals can shoot more easily and less expensively because an assignment already has them in an out-of-the-way, timely, or exotic location, and they can piggyback stock-file photos with their original assignments. Getting the same shots could cost you a great deal in travel and operations expense. Moreover, when buyers of these photos want a good photo, they don't turn to a photographer with a limited—albeit excellent—stock file who's unknown to them and has a limited or nonexistent track record.

The best place for your standard excellent photos, then, is in a midsized stock agency. You may need to start in one or more small agencies, and work your way gradually into a major agency. This, too, is a form of sweepstakes marketing, but chances are that even amid the tough competition (by virtue of the sheer number of photos, you'll find that a sale now and then nicely complements the sales from your own direct marketing efforts. The key phrase here is "now and then." It's not a case of the checks just rolling in once you put your photos in an agency.

I realize there are a dozen books on the market that report that you can sell the standard excellent picture to buyers. There also are books that assert that you can write a blockbuster novel, write a top-forty hit song, and make a hit record that sells a million copies. I don't doubt that the authors of these books have hit the jackpot themselves or know

someone who has. However, you open yourself up to two disadvantages when you attempt to appeal to the common denominator of the public's taste.

1. First, the romance and appeal of commercial stock photography soon fades after you've snapped an angle of the Washington Monument or a sunset in Monterey Bay for the twentieth time; likewise with a standard symbol of power (ocean waves), hope (sunlight streaming through rolling dark clouds), and so on.

The original exhilaration of stock photography diminishes when you realize that you're following someone else's tracks, when you know the identical pictures are in other photographers' files. On the one hand, it can be money in the bank when you snap the standard shot of the Maroon Bells in Colorado, but it's disheartening to discover tripod marks or chewing gum wrappers in a spot where you had thought you were experiencing a moment of discovery. Eventually, you come back to your starting point and say, "There must be more to stock photography than this."

If you were to continue to snap these exquisite clichés as your standard stock in trade, what would you have after two or three decades? Would a publisher aggressively seek you out to publish an anthology of your work? Not if your photos were cookie-cutter versions of standard subject

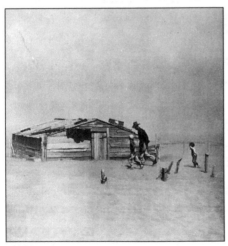

Illustration 2-1.

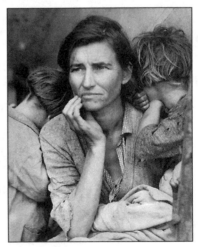

Illustration 2-2.

matter, making you indistinguishable from hordes of other commercial stock photographers.

2. The second disadvantage is economic. The law of supply and demand indicates that it's dangerous to count on consistent sales to the markets that buy the standard "excellents." The market is so flooded with these pictures—in commercial stock agency catalogs, CD-ROM "click art," and online digital portfolios—that the idea that your particular versions would hit every time, or most of the time, enters the realm of high optimism—admirable perhaps, but not too practical. No viable business can survive on the occasional sale, so even though it might be useful to take the odd cliché photo should the opportunity present itself, don't count on these kinds of images for your bread-and-butter sales.

I like to call these exquisite clichés "unbelievable." Although the elements of a marketable picture are there, they are missing one major element: believability.

Enduring Images

Look at the two editorial pictures on page 20 (Illustrations 2-1 and 2-2). Can you read into these pictures? Do they evoke a mood? When they were first made in the thirties, few photobuyers considered them blockbusters. Instead, photobuyers at the time probably were purchasing the standard decorative photos of the day. Today, the pictures endure and are included in anthologies. Are you aiming your stock photography activities at pictures that will endure and create long-term value?

If you've been spinning your wheels and getting frustrated in your photomarketing efforts, this chapter will be worth the price of this book many times over; it's a blueprint for the kinds of pictures you can start taking and selling—today.

Good Marketable Photos

What, then, are the good marketable photos that will be the mainstay of your photomarketing success and will supplement your retirement income, as well as be an asset to pass on to your heirs? These pictures

are the consistent marketing bets—the photos you can count on to be dependable sellers. These photos have buyers with ample purchasing budgets eager to purchase them, right away and over and over.

NO-RISK MARKETING

These good marketable pictures are the ones photobuyers need. Let the pictures in the magazines and informational books in your local library and on the Web sites of these publishers be your guide. These editorial (nonadvertising, or noncommercial) photos show ordinary people laughing, thinking, enjoying, crying, working, playing, sharing, helping each other, and building things or tearing them down. The world moves on and on, and our books, magazines, and online media provide us with a chronicle. About fifty thousand such photo illustrations are published every day. They are pictures of all the things people do at all ages, in all stations of life, and in all the countries of the world. These pictures are what editors need constantly. These are good, marketable stock photos— the best-sellers. They may not sell for $750 apiece, but if you plan your marketing system wisely, you can easily sell ten for $75 each.

To clarify the difference in your chances of selling these good marketable pictures compared with standard excellent pictures, consider the Los Angeles or Boston Marathon. Out of thousands of dedicated runners, there's only one winner. The trophy goes to the top professional who practices day in and day out, rain or shine, and who makes running a full-time occupation. Anyone can get lucky, so I can't deny that you might win the Boston Marathon—that is, you might score with one of your standard excellent pictures in a national magazine. However, for someone just starting out, the odds weigh heavily against you.

The first step, then, toward consistent success in marketing your photographs is to get out of the marathon and start running your own race.

I once asked a photobuyer, "Why do newcomers always submit standard excellent pictures, instead of on-target, marketable pictures?" His answer: "I think the photography industry itself is partly at fault. Their multimillion-dollar instructional materials, their ads, their video pro-

grams, are always aimed at how to take the 'good picture.' Photographers believe they have reached professional status if they can duplicate that kind of picture."

Well-meaning advice from commercial stock photographers sometimes adds to this misconception. In their books, seminars, and conversations, successful stock photographers sometimes forget how many years they spent paying their dues before they could sell standard "excellents" consistently. Successful people in any field—medicine, theater, professional sports, photography—often dispense advice based on the opportunities open to them at their current status. They fail to put themselves in the shoes of a newcomer who has yet to establish a track record.

In running your own race, you'll be up against competition, too, but it's manageable competition. As you'll discover in chapter three, you'll target your pictures to specific markets and take pictures built around your particular mix of interests, your expertise, and what you have access to.

THE ROHN ENGH PRINCIPLE FOR PRODUCING A MARKETABLE PHOTO EVERY TIME

You can discover the secret to producing good, marketable, editorial stock photos in the markets themselves—the books, magazines, periodicals, Web sites, CD-ROMs, brochures, ads, and other entities and materials that the publishing industry produces every day.

Use this test: Tear pages of photographs (editorial photos, not photos in advertisements) from magazines, periodicals, booklets, and so on, and spread them out on your living room floor. Now place copies of your own black-and-white or color prints[1] on the floor, or project your color slides. Do an honest self-critique. Do you see a disparity in content and appearance between the published photos and your own work? If so, how could you improve your pictures? If your pictures blend in, matching the

[1] Transparencies (slides) generally are used for publication in books, magazines, and electronic media. However, more publishers gradually are beginning to accept color prints and/or digital images, thanks to new advances in scanning techniques and the merger of the film and digital industries. This is discussed more thoroughly in chapter five.

quality of the published photos, you'll be leaps ahead of the competition. The key is to be fully honest with yourself. Compare your photos with the published photos, fair and square.

Next, give yourself a quick course in how to take marketable photos: Select any of the published photo illustrations, and then go out and take photos as similar to them as you can set up. Use a Polaroid or digital camera to give yourself fast, on-the-spot checks for how you can improve your picture quality.

Am I suggesting that you copy someone else's work? Yes, and if they will admit it, professionals will tell you that's how they originally learned many of the nuances of good photography. However, the word "copy" is a no-no in the creative world. (Unfortunately, purists place undue derogatory emphasis on the word. There is a significant difference between when you re-create an idea and when you just copy it. For instance, it's perfectly okay for you to re-create a photograph that you've seen in a magazine. If you scan the same photograph and claim that it's now your work, however, that's not okay.) If, because of conditioning, the word "copy" doesn't settle well with you, try "re-create." Remember, you're only copying (re-creating) to learn or improve a technique.

When you check the content and style of published photo illustrations, you'll find that they consistently feature a reasonably close-up view and a bold, posterlike design. Magazine covers are good examples of stock photography.

A stock photo is successful when the viewer can (1) read into it, and (2) sense a mood. To enable the viewer to see what's going on requires a close look. The viewer shouldn't have to work hard at studying the picture to perceive what it's trying to say, so a medium or close-up view works best. Bring the main subject or person in close. Most newcomers to stock photography improve their pictures 100 percent when they move toward their subjects for a tighter composition.

Like the background, the composition of your pictures should be simple and uncluttered. Strive for a clean and posterlike design, a picture that conveys in one glance its reason for being. Be careful not to allow

the background to "steal" attention from the main subject in the picture.

Try not to think of yourself as a "photographer," but instead as a graphic designer who happens to use photography as his medium. Try also to keep in mind that you "make" pictures rather than "take" pictures.

The Principle

This four-step principle is guaranteed to produce marketable photo illustrations every time:

$$P = B + P + S + I$$

PICTURE equals BACKGROUND plus PERSON(S)
plus SYMBOL plus INVOLVEMENT.

Most of the successful stock photos you come across in your research will contain these elements. There are always exceptions to the rule, and we'll go into some of those after we explore the formula in detail. Of course, as we learned in esthetics, all works of art have both form and content. You're able to learn how to produce the format of a painting, poem, or photograph, but producing the content, the spirit, is another matter. That talent is unique to you.

Step 1: Background. Choose it wisely. Too often a photographer doesn't fully notice the background until she sees her developed pictures. The background you choose often can make a difference between a sale and no sale. For example, if you are photographing a pilot, don't just snap a picture by a corner of a hangar that could be in any building. Search the airport area for a background that says "aviation." Similarly, an office shot could include a desk or computer to set the scene. A stock brokerage could show a wall screen with numbers in the background.

These background clues should be noticeable but not obtrusive, and the picture should not be cluttered with other objects. The background is crucial to how successfully your picture makes a single statement. Your illustration is more dramatic and more marketable if it expresses a single idea—and does it with economy. As you plan your stock photo, ask yourself, "What can I eliminate in this composition while still retaining my

central theme?" Simplicity and clarity are always better than hard-to-find clues and subtle suggestions about what an image is supposed to evoke or deliver.

EVOKE A MOOD

Your central theme doesn't always have to be describable in words; it can be a mood you wish to convey—a feeling that, if expressed with simplicity, actually lends itself to a variety of interpretations by different viewers. This is a marketing advantage to you because if the picture lends itself to, say, ten different moods or interpretations, you've increased its marketability ten times.

By eliminating unnecessary distractions, you guide the viewer to a strong response to your photograph. A clean, simple background usually is available to you. Remember, you have 360 degrees to work with. Maneuver your camera position until the background is uncluttered.

Employ your knowledge of design, color, and chiaroscuro (the play of darks against lights and vice versa). If the pilot is wearing a light uniform, shift your camera angle to include a dark mass behind him for contrast. If he's wearing a dark uniform, choose a light background. This technique will give your stock photos a three-dimensional quality.

Step 2: Person(s). Now that you have a suitable background, maneuver your models or yourself (in some cases, you'll have to do the maneuvering because the models won't or can't move for you) so that the background and models are in the most effective juxtaposition. The models themselves must be interesting looking and appealing. Choose them, when possible, with an eye to their photogenics.[2]

If your pictures will be used for commercial purposes, such as advertising, promotion, or endorsement, you will need your models to sign a model release (consent to be photographed). For pictures that will be

[2] A model is any person in your picture. Neighbors, relatives, celebrities, schoolteachers, lifeguards, police officers, groups of children at a playground, groups of adults at a town meeting—all are defined in our terms as models. I'm not talking about professional models.

used for editorial purposes, such as textbooks, magazines, encyclopedias, and newspapers, a model release in most cases is not necessary. (See chapters six and fifteen for more on models and model releases.)

Your photos are illustrations, not posed portraits, so the people you show must be engrossed in doing or observing something. We are all people watchers, and stock photos always are more interesting when the people in them are genuinely involved in some activity. An anthropologist once told me, "Watching other humans was probably the first form of entertainment for early man."

Remember: You are *making* a picture, not *taking* one. The only thing you should take is your time.

Step 3: Symbol. In stock photography, anything that brings a certain idea to mind is a symbol, sometimes referred to as an *icon*. Symbols are everywhere in our visually oriented world. They are used effectively as logos or trademarks in business, for example. In a stock photo, a symbol can be anything from a fishing pole to a tractor to a stethoscope. In the case of a pilot, the pilot's uniform and cap, an airplane, a propeller, a wind sock, are all symbols. Including an appropriate symbol will make your illustration more effective. Use your object symbols as you would a road sign—to tell your viewers where you are. However, be careful that your symbol is not so large or obvious that it overpowers the rest of your photo; symbols are most effective when they're used subtly. Avoid the temptation to use such mundane symbols as a pitchfork for a farmer, a sombrero for a Mexican musician, or a net for an Italian fisherman. The goal is to clue in your viewer to what is going on, but not to knock him over the head with it. Let him experience some discovery as he looks at your picture. Next time you're perusing pictures in a magazine or book, watch for the "road signs" and note how, and how often, symbols are used in stock photos.

Step 4: Involvement. The people in your photo should be the subject of the picture (showing enjoyment, unhappiness, fear, and so on); or they should be interacting, helping each other, working with something, playing with something, and so on; or they should be absorbed in watch-

ing or contemplating some object, scene, or activity. Marketable photo illustrations have an involvement, a dynamism, about them that's distinct from the portrait or scenic quality of standard excellent pictures.

Become a Monopoly

"A monopoly?" you ask. "Me, become a monopoly?" My Webster's tells me that a monopoly is a "commodity controlled by one party. . . . " Translated to our stock photography industry, that means if you have an extensive file on one single subject, you have a minimonopoly.

When photobuyers are facing a deadline and are up against a stone wall trying to locate a specific picture, you become a hero when you can supply them with that highly specific photo.

Monopolies already exist in stock photography. I have a friend, Flip Schulke, who has a near-monopoly of photos of Martin Luther King Jr. When photobuyers need photos of the civil rights leader, guess who they turn to?

You may already have an emerging monopoly of highly specialized photos: insects, daffodils, table tennis, giraffes, and so on.

In the world of commerce, marketing people say, "Find a need and fill it." In the creative world, we say, "Determine what I love to photograph, and find buyers who need that." In other words, if wild horses couldn't pull you away from your avid interest in some subject area, you've discovered where you can easily become a monopoly. Why? Because you don't have to worry about failing at it. You'll fail sometimes, but you won't quit. If you really love what you're doing, you won't mind failing until you get it right.

Begin now to ask yourself where your interest area(s) is (are). If it's animals, examine your collection. Do you lean toward certain animals? Domestic, wild, North American, European, African, Asian? Be specific. When photobuyers come calling, they'll be looking for a specific animal (Abyssinian cat, pileated woodpecker, dromedary camel, and so on), not animals in general. When photobuyers can target their search, they will avoid large, general stock photo agencies or Web sites that probably won't

have a deep selection for them anyway. They'll go to you with your highly specific file with its up-to-date depth of coverage and variety of choices. This approach results in you automatically developing an in-depth historical collection. Once you become an expert in your field, photobuyers will find that you can offer them what no big agency can offer: expert advice and topic-specific knowledge.

Because of space and storage considerations, most massive stock agencies throw away or delete outdated pictures. You have the capability to save the photos, let them mature, and feature them later as historical photos.

How do you know when you've achieved "monopoly" status? When you find your marketing posture has switched from an "us-to-them" mode to a "them-coming-to-us" mode.

You may find that you have three or four "monopolies." You can build your files in those areas. Caution: If you develop too many specialties, you'll land back where you started, being a generalist.

Photos That You Can Read Into—Using the Principle

Illustrations 2-3 through 2-8 show the formula at work. In Illustration 2-3, the principle is used to suggest a story. When I took this photograph, I was driving a back road in West Virginia. The dilapidated shed, the

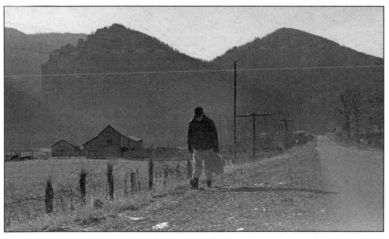

Illustration 2-3.

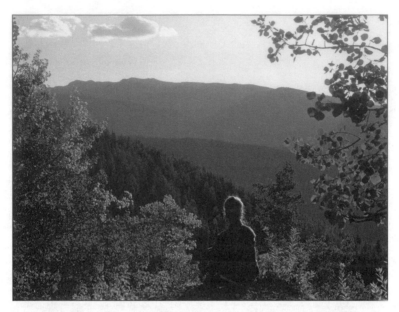

Illustration 2-4.

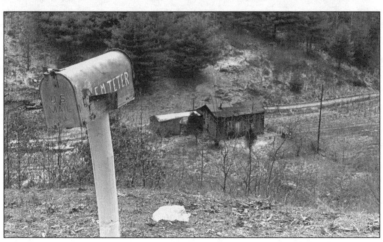

Illustration 2-5.

lighting on the Appalachian foothills, the shadows, and the lonely road all seemed to suggest rural poverty. I asked my traveling companion to walk along the road and hang his head down. For the symbol I gave him a suitcase. It introduces an element of involvement and spurs the viewer to think the man is leaving home or returning. Either interpretation gives rise to feelings about the photograph and its subject, with resultant interest. I made this picture in the sixties, and it's no longer in my contem-

Illustration 2-6.

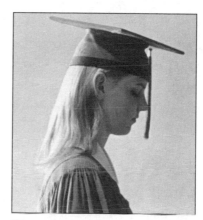

Illustration 2-7.

porary file, yet I've sold it twice in the last year from my historical file.

The principle can still work even if some of the elements are missing. In this mountain illustration scene (Illustration 2-4), symbol and involvement, per se, are lacking. The picture is still successful, though, because in this case, the background doubles as the symbol. The background is a panorama that the person is obviously involved with, enraptured by, as she sits quietly as part of the stillness of the scene. Without the person, the photo would have failed as a marketable picture. The photo moves from the standard-excellent scenic category to the good marketable category because of the predominant position and emphasis (with backlighting) on the person. The picture says "involvement" or "contemplation," in contrast to pictures that say "pretty scene" and have a person placed in the photo as a minor element for orientation.

Again, here is a variation on the principle that nevertheless works as a marketable stock photo (Illustration 2-5). In this case, the person is missing. Stock photos usually need people, but as shown in this instance, not always. The symbol here is the mailbox; involvement is with the modest cabin in the background, achieved by the juxtaposition of the two. The picture gives the desired feeling of poverty and isolation, which is heightened by the arduous climb to the mailbox, the link to the rest of society. As long as a picture without people implies people, as this one does, you come out with a marketable stock photo.

Rather than overstate, let simplicity transmit the mood you wish to convey. In Illustration 2-7, the contemplation of the soon-to-be graduate is captured in profile, almost cameo, against the smooth expanse of the wall in the school hallway. In this case, I chose a clean background to focus attention on the symbol—the graduation cap and tassel. The person is involved with the symbol by its effect on her demeanor, causing her to be in deep reflection.

Symbols can underscore what your photograph is attempting to portray. You will often find objects readily available at the location where you're photographing. Once you find a nondistracting background, position your model(s) for the best light, and so on, you can add dimension to your photograph with appropriate symbols. These children were practicing for their backyard theater (Illustration 2-8). I found a small filing box and had the three Magi pass it among themselves.

"Involvement" in your photo illustrations sometimes means your models conveying "serenity." Why is Illustration 2-9 so successful?

 B = Background is uncluttered and lends itself to story line.

 P = Person is included in story line.

 S = Symbol (church pews) highlights the mood of contemplation or prayer.

 I = Involvement is real.

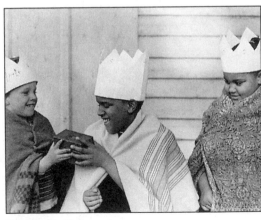

Illustration 2-8.

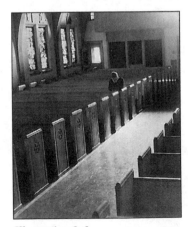

Illustration 2-9.

THE MISSING LINK

Meaningful pictures happen when you take an active hand in your composition. A snowy birdhouse hanging from a frosty limb on a December morning is picturesque, but when you add a young mother and her little boy (the people), a new dimension evolves. For Illustration 2-10, you may have supposed that the photographer snapped a picture of a young mother and son who happened upon the snow-covered birdhouse. The process was actually in reverse. I happened upon the birdhouse and then sought out my models as an interesting contrast to the stark frozen beauty. Try to think of your photography in these terms—in reverse. Find your symbol or background first, then the other elements: people, involvement, and either background or symbol. The resulting photo illustrations will be more marketable.

Illustrations 2-11 through 2-14 show how, with the elements in slightly different alignment, or with one or another of the principle elements

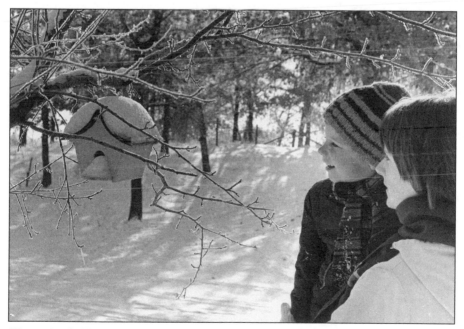

Illustration 2-10.

Illustration 2-11.

Illustration 2-12.

Illustration 2-13.

Illustration 2-14.

missing, Illustration 2-10 wouldn't make it as a good marketable picture.

1. Background distracting or inappropriate (Illustration 2-11).

2. People missing (Illustration 2-12).

3. Symbol missing (Illustration 2-13).

4. No involvement with symbol (Illustration 2-14).

STUDENTS: CLOSE, BUT NOT QUITE RIGHT

Illustrations 2-15 through 2-21 were taken by photography students. They are close to being good marketable pictures, and some are better than others, but they all need alterations to make the grade.

You Are an Important Resource to Photobuyers

This, then, is what marketable, editorial stock photography is all about. These are the kinds of good marketable pictures that allow you to run your own race.

To restate the problem with generic clichés: While you might hit a

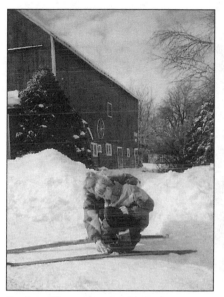

Student Illustration 2-15.
The background is clean and uncluttered; the involvement factor is high. Move in closer! We want to see more facial expression. A telephoto lens would have helped.

Student Illustration 2-16.
Successful stock photos follow the P = B + P + S + I principle. By moving the hood up, the background is clean and simple. The men are involved with the tools (symbol). As a general rule, avoid shooting in harsh sunlight: Objectional shadows ruined this picture. Of course there may be certain situations where the rule doesn't hold and where harsh shadows are appropriate, but not here.

calendar or magazine cover with one of these photos now and then, to depend on this type of shot for consistent sales is a mistake. Each buyer has hundreds of this kind of picture in inventory, or she gets buried in these shots if she puts out a request for them. *National Geographic*, for example, will not let us run a listing for them in our *PhotoDAILY* market letter asking for photos of a bald eagle. They know they would be deluged with bald eagles. The editors know they could find a CD-ROM filled with eagles or shout out the window and have fifty photographers respond with bald eagle photos. However, you will find plenty of *National Geo-*

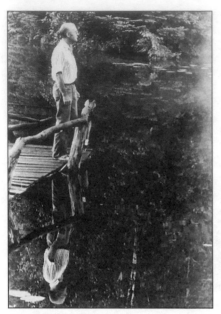

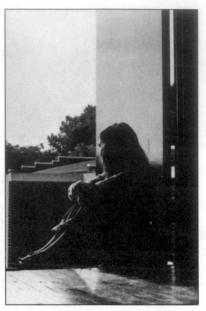

Student Illustration 2-17.
This stock photo expresses a mood or an emotion. It has the potential to be highly marketable because it lends itself to many themes treated in books and magazines. Expression and position of the model could be improved. The man's nervous hands are incongruous with his contemplative face. On these shots, you need to shoot a minimum of ten or twelve frames to capture that "just right" expression. Ask the model to continue to move slightly after each exposure. Then choose the right picture when you examine your prints or slides.

Student Illustration 2-18.
Editorial stock photography can leave much to the imagination. This picture is successful because the person's face is not in full view. Thus, it's not a portrait; it conveys a mood. The picture could be used many ways: articles on loneliness, meditation, boy-girl relationships, education. You'd be surprised at the uses photobuyers find for your pictures. The background is relatively uncluttered and nondistracting, which helps emphasize the center of interest. This photo gets eight points out of ten as a good marketable picture.

graphic listings for people interacting with the environment or for wildlife from specific parts of the world.

For every one of those "good pictures" that finally hits, you'll sell hundreds of good marketable pictures. One sunset at the beach might finally sell to an ad agency for a nice five hundred dollars, but you won't sell it again for three or five years. Meanwhile, one picture of a boy chasing a bubble will sell scores of times—and bring more return in the long run.

Student Illustration 2-19.
This is a typical amateur picture, "the character study." (We all have at least ten of these in our files.) This type of photograph is difficult to market—millions of them are available to photobuyers because everybody takes these pictures. It's a portrait with no involvement, no symbol, no dynamism, no action in the photograph. Get any of these into the photo, and it becomes a marketable picture.

Student Illustration 2-20.
A slice of life is what photobuyers like to see in your editorial stock photos. This particular photo could be a good nuts-and-bolts picture with marketing potential, but the photographer should move in closer to the girl and let us know her feelings. Is she tired, proud, enthusiastic? Would the photo have been more successful if the background were less distracting?

Student Illustration 2-21.
This picture is marketable, but it borders on being too clever, too cute. It's also old hat. Clichés are a fact of life in the stock photo business, but handle them with care and use them sparingly. On the other hand, don't go to the other extreme and be obscure.

The latter is a good, marketable stock photo. You'll have twenty, thirty, forty more of these, selling at the same pace, for every sunset in your inventory.

Don't rely on wishful thinking. A few stock photographers do get lucky, but by and large, those who are on top and stay there, are those who have recognized the overwhelming odds in the marathon route and have switched to what I call "Track B" (see the next chapter). There's competition in that race, too, but it's manageable enough to keep you healthily striving for excellence. You may win a blue ribbon for one of your sunsets, but the real judge of marketable photography is the photo-buyer who signs the check.

Whether you sell and re-sell your pictures is not up to the photobuyers, but to you, the stock photographer. You control whether you sell or don't sell—by controlling the content of your pictures.

When you're out on your next photographing excursion, keep two guidelines in mind:

1. Shoot discriminately. Treat each piece of film you expose as a finished product that will one day be on a photobuyer's desk.
2. As you prepare to take a shot, ask yourself, "Is it marketable?" (One photographer I know taped this question to the back of her camera.)

I'm not suggesting that you get involved in areas of photography that don't appeal to you. As I explain in the next chapter, you have assets, photographically, that are individual to you. In the course of this book, I'll show you how to match your photographic interests with the needs of buyers who are on the lookout for the kind of pictures you can easily supply.

For example, if you live in New Mexico, there's a lot of picture-taking and selling to be done that a person in Michigan can't do and vice versa. Your geographic location is only one advantage that you have over other photographers. You may be into sailing or raising hunting dogs. You may be an armchair geologist. Your hobbies and interests, and your knowledge and your career field, are assets. So, I say to persons new in the field of photomarketing, "You can position yourself where the competition is manageable." With your own PS/A (Photographic Strength/Areas),

which we'll learn to identify in the next chapter, you can be an important resource to buyers who are, right now, waiting for your pictures.

Your aim is to sell the greatest number of pictures with the least amount of lost motion (i.e., unsuccessful submissions). Why take unnecessary risks? Photomarketing is a business. Now that you know the difference between a good picture and a good marketable picture, your sales will start to soar.

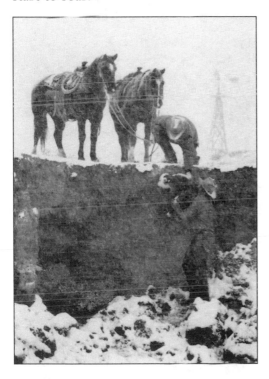

This photo has the four essential elements of the principle: a meaningful background, people, symbol, and involvement. Sometimes all four occur spontaneously; other times you have to plan them. "Rescue From a Washout," by western photographer Bill Ellzey of Crestone, Colorado, illustrates the latter, or "previsualization," as Ellzey calls it. He found one of the few remaining wooden windmills in his region, set up a tripod and coaxed his cowboy cousins into lifting a calf from the draw. Nature cooperated with a sudden snow flurry, and so did the horses by responding to one cousin's whistle (as directed by Ellzey). It took twenty-two shots to get a just-right picture. Back at the ranch, Ellzey and his cousins thawed out (and the calf returned to its mother). The picture continues to be a hot seller.

A GALLERY OF STOCK PHOTOS

Stock photos and stock photographers come from all walks of life. Here is a selection of pictures that have had repeat sales and a glimpse of the people who produced them.

I asked fellow stock photographers to send me samples of stock photos that produce continual revenue for them. All of these photographers zero in on their own PS/A and supply their own corner of the market.

"Our specialty is travel photography. We've flown over seven million miles and visited ninety-seven countries. Currently, our stock files contain over 670,000 images on a wide variety of subjects. We market these directly to advertising agencies, magazines, newspapers, textbooks, public relations firms, and picture agencies. We also market our pictures via electronic data bases with America Online and through Corbis."

Carl and Ann Purcell
Alexandria, Virginia www.photosourcebook.com/13 47, www.purcellteam.com

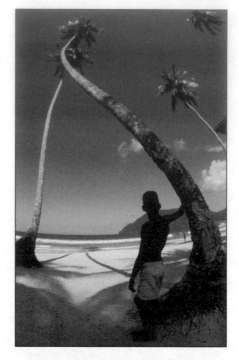

"I've always loved to travel and make photographs of the beautiful places and people along the way. Turning this love into a successful business has required taking care of business as though my photography were a product—not an art. It's one thing to make great photography; it's something else to sell it and administer those sales into profit. The simple formula for success is: Quality Product, Business Sense and Ability, Strong Marketing and Sales, and the Right Attitude."

Cliff Hollenbeck
Seattle, Washington www.photosourcebook.com/1091, www.hollenbeckproductions.com

"I've never been a fisherman, but I can imagine that making a special photograph is like catching the 'big one' that always 'got away.' I have been a photographer for more than twenty-five years, yet the thrill of seeing and capturing photographs that, I hope, have a lasting value is as exciting as it was when I was a pup."

Brent Jones, Chicago, Illinois

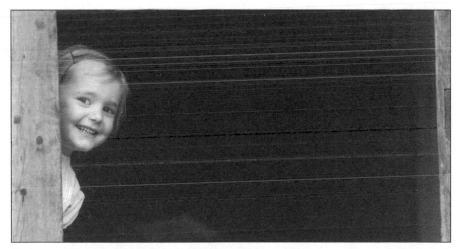

"I've been involved with photography for the past thirty-five years, mostly as a photojournalist working on assignment for national magazines. My strongest images are of people—a subject I never tire of. I find I'm able to sell and re-sell these photos to book publishers and magazines through my own mini stock photo agency. This photo is especially popular, as it combines the beautiful facial expression of the little girl with a large open area for publishers to use for type."

Rick Smolan, Sausalito, California www.photosourcebook.com/1330

"Having been a professional photographer for twenty-five years, I feel strongly that the secret to selling and re-selling is to maintain a strong stock file and to be professional and dedicated in one's marketing techniques. Follow up every lead, take advantage of the Internet, contact photobuyers when you see an opportunity, send out stock lists, and always be alert to any possibility that opens up new avenues for potential sales and income. Virtually all of my photography is travel-oriented these days, although I still do photojournalism and an occasional opera/theater shoot for various clients. Virtually all of my sales are now in color and I no longer do any black-and-white photography—never receive any calls for it. Market your work directly to photobuyers, and whenever possible create your own opportunities. Lastly, specialize—you cannot be everything to everybody."

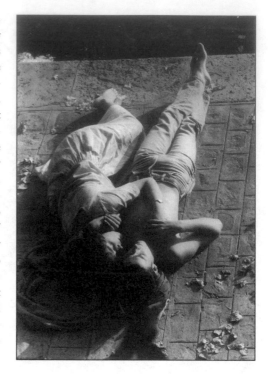

Lee Snider/Photo Images
New York, New York
www.photosourcebook.com/1016

"I began my freelance career while I was still a newspaper photographer in Tampa. Along with my national magazine and editorial work, I did advertising and corporate assignments. About nine years ago I began building a specialty niche of images: hunting and fishing. At trade shows for manufacturers in this area, I learned that with my knowledge of hunting and fishing, there's a market for my specialty. I now supply this market, not only with my own photos, but

those of forty-one other photographers, whom I now represent in my micro stock agency, *www.windigoimages.com*. Ninety percent of my sales are now delivered digitally."

Mitch Kezar, Delano, Minnesota www.photosourcebook.com/1736, www.kezarphoto.com

"Although my main income is derived from assignment photography, stock photography has always been a very important part of my total income. This 'Jumping Bass' shot is a good example of why. It's part of a series of six slightly different jumping bass shots, all done at the same time, which in the twenty years since they were taken have been an honest 'annuity fund'—selling and re-selling. The 'Jumping Bass' series has produced more than eighty-two thousand dollars in use fees to date."

Burton McNeely
Land O'Lakes, Florida

"I came to stock photography via the back door. I was a travel writer for eight years. I learned that pictures not only enhanced the impact of my articles, but also the sales. In the early stages of my career, I spent a lot of time contacting potential markets. Now I've discovered ways of getting them to contact me. I have built a solid market list. Periodically I send out 3,500 travel-photo postcards to my list. I keep in touch. Invariably the mailings result in assignments and also sales of the picture featured on the postcard. The mailing always pays for itself. The added promotional value is priceless. This picture has been used as the entire backdrop for a three-by-five-foot poster and has accompanied several of my own and other people's articles about the Grand Canyon."

W. Lynn Seldon Jr., Richmond, Virginia www.photosourcebook.com/1155, www.lynnseldon.com

"I used to do mostly assignments, but now I do mostly stock. By keeping informed through watching television, studying images in magazines and reading (yes, reading), you can keep abreast of trends and create appropriate images. You can't look at stock agency catalogs or go purely by published photos; if you do that all you're doing is reacting and you're already too late. You've got to seek out and perceive universal themes. Rarely is there such a thing as a lucky shot. Good images are not only of something, they are about something as well. Above all, you've got to do the work you like. You must shoot for yourself while keeping potential clients in mind as well. To be happy you must make the photos you'd make if nobody were paying you for it. After all, in stock photography, nobody is paying you for it until after the fact—sometimes way after the fact!"

Dale O'Dell, Dewey, Arizona www.photosourcebook.com/10 90, www.dalephoto.com

"I sold my first stock photo in 1971. It was a picture of a bear, which I sold to *Encyclopedia Britannica*. I operate my own stock photography business out of my home. I'm a one-man band—I don't hire any help, I keep it simple, and I've got my files of forty-five thousand photos down to a system that's easy to handle. I maintain two files, my 'star' file (where I log in my super-winners) and my regular file. I place my 'star' slides in four-by-five-inch black mounts, seal them, and store them in shoe boxes, according to subject matter. I don't need a computer search program: I know where everything is. I use The Cradoc CaptionWriter, the early version for the PC. It works great."

Larry Mulvehill, Sarasota, Florida

"When I first broke into stock photography, I photographed just about everything. Early on, I realized that I should pick out certain specialties and become proficient in them. My general specialty is travel photography, and I'm known in the industry for my expansive collection on China. I have visited there over twenty times."

Dennis Cox, ChinaStock Library
Ann Arbor, Michigan
www.decoxphoto.com, e-mail: decoxphoto@aol.com

"I was working for the Aspen Ski Corporation back in 1975 when I discovered I could turn my photography hobby into a profitable business. When ski magazines started buying my photos (one put one on the cover), I knew I could compete with the professionals. The magazine work led to assignments (one company sent me to Mount Kilimanjaro). Eventually we migrated to the East Coast where my western style of ski shooting was in demand. It was a challenge, though—no spectacular mountains, crisp blue skies, or mild, dry weather. My specialty is outdoor recreation in all seasons."

David Brownell, Andover, New Hampshire www.photosourc ebook.com/1190

"After many years in corporate America, I felt it was time to begin the greatest adventure of my life. I studied successful stock photographers until I learned to combine my business experience with my love of photography. I built a stock portfolio of thousands of images of children experiencing the many faces of family life in America. Learning your craft is much more than knowing which lenses, f-stop, or film to use. It's also the nature and soul of light, the art of seeing . . . not just composition and color, but seeing the story, the life force, and the way it touches us all. Then treating it like a 'business' five days a week—contacting photo editors and mailing images to prospective customers on your PS/A list, keeping up with the industry, staying organized and disciplined. Nothing has been harder— or filled me with more joy."

Kathleen Williams, Pensacola, Florida

"I've been taking pictures since I was a child. My specialty is family living with an emphasis on minorities and ethnic groups, with sales primarily to magazines and publishing companies. 'Grandpa and Grandson' won the *Parade Magazine* competition and has been used in over two hundred magazines, calendars, and greeting cards all over the world. I am also a professional trumpet player who has worked with Cab Calloway, Ray Charles, and Nina Simone, to name a few."

Oscar Williams, Kirkland, Washington

"I have been doing stock photography since 1972, and over two hundred different publishers have used my work, mostly as illustrations in books and magazines. Besides marketing stock photography through my mini-stock agency, I have written a stock-photography-management computer program for the Macintosh (MacStock Express), do custom programming, dabble in farming, etc. My photography covers the gamut of human-interest subjects. This photo, shot in Egypt, has sold thirty-eight times so far, illustrating Christmas, the Middle East, adventure, etc."

Robert Maust, Keezletown, Virginia www.photosourcebook.com/1995, www.PhotoAgora.com

"I've looked through my older files for black-and-white stock, to fit special needs. In the early years, magazine assignments yielded few reusable shots, but when I began taking pictures for my children's books and how-to photography books (I've written about twenty), I was encouraged to build a stock file that I add to frequently. I sell through four different agencies and avoid conflicting submissions. This photo of author Jackie Collins when she was a twenty-one-year-old potential starlet has appeared in several of my books. As I travel I try to envision possible markets for whatever I shoot."

Lou Jacobs Jr., Cathedral City, California

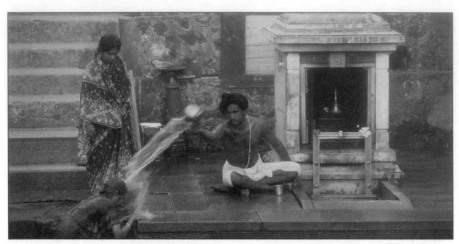

"I frequently work with freelance writers on picture stories. The material can often be rewritten and reslanted for extra mileage. I've been freelancing full time since 1972. I wear many hats as a freelancer. My work has ranged from portraiture and service photography to editorial, illustrative, and gallery prints. I have made a concerted effort to establish myself in this latter area. My archival black-and-white art prints have been selling well lately."

Bill Ellzey, Crestone, Colorado

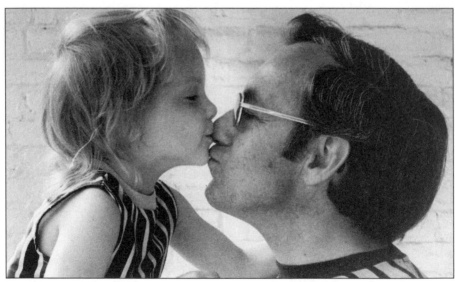

"After twenty years as a service photographer/reporter for a newspaper, I became a full-time freelance stock photographer twenty years ago. I enjoy the freedom from assignments. I offer thousands of good stock photos to magazine and book publishers; my specialty is the human-interest people picture, in basic contexts of home, school, and church."

David S. Strickler, Newville, Pennsylvania

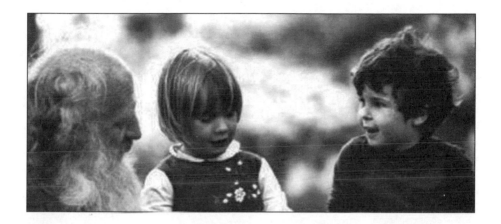

3

Finding Your Corner of the Market

FIRST, FIND YOURSELF

Who are you? Photographers who are successful in selling their pictures have learned this marketing secret: Know thyself. That is, know your photographic strengths and weaknesses before you begin marketing your pictures.

You want to find your corner of the market. First, though, you must find out who you are, photographically. You can do that by completing the following simple exercise.

Photographically . . . Who Am I?

Save a Sunday afternoon to fill out this section—it will help you avoid spinning your wheels, which you'd be doing if you jumped into photo-marketing without having the information in this chapter. If you're reading this book a second time because your stock photography enterprise is sputtering and coughing and you're wondering what went wrong, read

this chapter carefully. Many photographers fail to do so and then fail. As the saying goes, "When all else fails, read the directions."

Take a sheet of paper and make two columns like the ones in Figure 3-1. Head the column on the left, Track A; the column on the right, Track B. The columns can extend the length of the page, or pages, if necessary.

Next, fill in the Track B column with one-line answers (in no special order) to these questions:

1. What is the general subject matter of each of the periodicals you subscribe to, or would like to subscribe to (or receive free)? (For example, if you subscribe to *Today's Pilot*, you would write "aviation.") Write something for each magazine. Do you welcome catalogs in the mail? What are the subject matters? Write them down.

2. What is your occupation? (If you've had several, list each one.) Also include careers you'd *like* to pursue or are studying for or working toward.

3. When you're on a photo-taking excursion, what subjects do you enjoy taking the most (e.g., rustic buildings, football, celebrities,

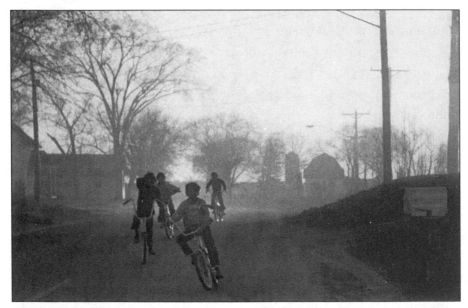

Will your models cooperate with you? The boys in the picture were happy to drive their bikes in a figure eight between two telephone poles I designated.

sunrises, roses, waterfalls, butterflies, fall foliage, children, puppies, Siamese cats, hawks, social statements, girls)? Use as many blanks as you wish. The order is unimportant.

4. List your hobbies and pastimes (other than photography).

5. If you were to examine all of your slides, prints, and digital files, would you find threads of continuity running through the images? (For example, you might discover that you often photograph horses, train stations, rock formations, physical fitness buffs, minority groups, and so on.)

6. What are your favorite armchair interests? (For example, if an interest is solar energy, astronomy, or ancient warfare, write it down.)

7. What is the city nearest you with a population of more than 500,000?

8. What state or province do you live in?

9. List any nearby (within a half-day's drive) geographical features (e.g., ocean, mountains, rivers) and human-made interests (e.g., iron or coal mine, hot-air-balloon factory, dog-training school).

10. What specialized subject areas do you have ready access to? (For example, if your neighbor is a bridge builder or a ballerina, a relative is a sky diver, or your friend is an oil-rig worker, list the person's subject area.)

Now, if the list in Track B includes any of the following, draw a line through them: *landscapes, birds, scenics, insects, plants, wildflowers, major pro sports, silhouettes, experimental photography, artistic subjects (such as the "art" photography in photography magazines), abstracts (such as those seen in photo-art magazines and salons), popular travel spots, monuments, landmarks, historic sites, cute animals.*

Transfer all of the subjects that you just drew a line through to Track A.

You'll find your best picture sales possibilities in Track B. Track A is a high-risk marketing area for you. Most photographers have spent a great deal of their time photographing in the Track A area, and because it's so popular, photobuyers can find these pictures easily in stock agencies, on CD-ROMs, and online.

When you get off Track A and onto Track B, you'll stop wasting time, film, postage, and materials. You'll get published, receive recognition for your specialization's in photography, and deposit checks. Let's examine the Track B and Track A of one hypothetical photographer, John, whose interests are listed in Figure 3-1.

John's Track List

Track A	Track B
Scenics	Gardening
Flowers	Electronics
Fountains	Grocer
Insects	Teacher
Sunsets	Scenics
Historic sites	Flowers
	Fountains
	Insects
	Sunsets
	Historic sites
	Antique automobiles
	Snowmobiling
	Old barns
	Old movies
	Minneapolis
	Wisconsin
	Mississippi River
	St. Croix River
	Interstate Park
	TV cameraman
	Dentist

Figure 3-1.

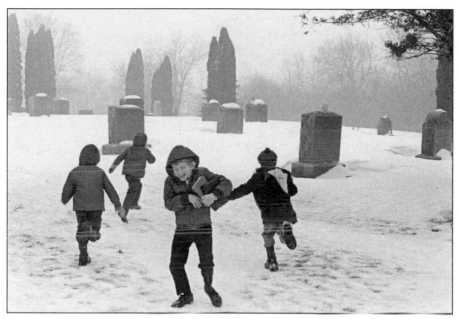

The Family of Children featured this picture. I started with two scenes: children playing a game and a cemetery in winter. Put the two together, and you have a new picture.

1. John subscribes to magazines dealing with gardening, electronics, and antique automobiles. Not only do these reflect John's interests, but the combined total of fees paid for photographs purchased by magazines and books in these three areas can exceed $150,000 per month. Yet John has put most of his picture-taking energy and dollars into Track A pictures, which have limited marketing potential for him because of the law of supply and demand.

2. John's occupation is grocery store manager. The trade magazines in this area spend about twenty thousand dollars per month for photography. John could easily cover expenses to the national conventions each year, plus add an extra vacation week at the convention site, with income generated by his camera.

John is a former teacher and retains his interest in education. His experience gives him the insight and know-how to capture natural photographs of classroom situations. Such photos are big sellers to the education field, denominational press, and textbook industry. A conservative industry esti-

mate of the dollars expended each month for education-oriented pictures is $800,000.

3. In his picture-taking excursions, John usually concentrates on scenics, flowers, fountains, insects, sunsets, and historic sites. These all have limited marketability with the big agencies and top magazines for the independent freelancer without a track record. However, John could place some of these Track A pictures in stock agencies for periodic supplementary sales. A stock agency that specializes in insects, for example, would be interested in seeing the quality of John's pictures. Some of John's other Track A pictures belong in different stock agencies. (Chapter twelve tells how to research which agencies are right for which pictures on your Track A list.)

4. John's favorite hobby is antique cars. He can easily pay for trips to meetings and conventions through judicious study of the market needs for photography involving antique cars. John also lists snowmobiling as a hobby. Publications dealing with winter fun in season spend more than eighty thousand dollars a month on photography.

5. John finds that he photographs picturesque old barns every chance he gets. The market is limited (Track A). One day he may produce a book or exhibit of barn pictures, but it will be a labor of love.

6. His armchair interest is old movies, which has no marketing potential unless placed in a specialized photo agency.

7, 8. Nearest city: Minneapolis. State: Minnesota. (Chapter eleven will explain how to capitalize on your travel pictures.)

9. The Mississippi and St. Croix rivers are nearby, plus several state parks (see chapter eleven).

10. John's neighbor is a TV cameraman. John could get specialized access to TV operations and be an important source to photobuyers who need location pictures dealing with the TV industry. John has access to the field of dentistry through his brother, a dentist. Publications in each of these areas easily spend a combined twenty thousand dollars per month for pictures.

Your PS/A (Photographic Strength/Areas)

Let's take a closer look at Tracks A and B.

TRACK A: THE PROGNOSIS IS GUARDED

These are the areas of formidable competition. Track A pictures are used in the marketplace all right, but it's a closed market. Photobuyers have tons of these photos in inventory, they locate them easily from their favorite top pros, they click one from a clip-art disk or an online service, or they contact a stock agency that has thousands upon thousands of these photos to select from. If you want to concentrate your efforts in the Track A area of photography, I suggest you stop reading right here, because you'll need to invest every minute of your time into making a go of it. Only a handful of freelancers in this country—most of them full-time professionals—successfully make

Photo illustrations are successful when they capture a mood that lends itself to book or magazine-article themes and topics. This picture has served many books and articles.

regular sales of Track A photos, and the majority must still supplement their incomes with writing, consulting, speaking, or teaching.

If you're not planning to concentrate on Track A pictures, but you still want to take them, one solution is to put your Track A shots into a stock photo agency and then not worry about how often they sell for you. Every once in a while, you may get a nice surprise check. (Chapter twelve shows you how to determine which agencies are for you.) A second solution is to turn to producing decor photography (again, see chapter twelve). Keep in mind, though, that you can't expect either of these solutions to result in *regular* sales. Decor photography is a labor of love; the big moneymaker at a stock agency is the agency director. Practically speaking, your forte and solid opportunity for immediate and consistent sales—in other words, your strong marketability areas—remain on Track B.

TRACK B: THE OUTLOOK IS BRIGHT

Take time to completely fill out Track B, and you'll find that you've sketched a picture of who you are photographically. This list is your PS/A, your Photographic Strength/Areas. You have vital advantages in these areas. You offer a valuable resource to photobuyers in these specialized subjects. You have access and an informed approach to pictures in these areas that many photographers do not have. Your competition in marketing Track B pictures is manageable. Throughout this book, I'll constantly refer to your PS/A, your Track B list. You are already something of an expert in many of these Track B areas, and the subject matter appeals to you. Not all of your interests, of course, lend themselves 100 percent to photography, but you will be surprised how many do. For example, chess has spawned few periodicals that require pictures. However, pictures of people playing chess have varied applications—concentration, thinking, competition—good illustration possibilities for textbooks or for educational, sociological, or human-interest magazines.

Photobuyers in the Track B markets will encourage you to submit pictures, by purchasing more and more of your stock photos. Gradually you'll receive higher fees—and eventually assignments. Pretty soon,

How to Find Your PS/A

There's a target market for every photographer. Take the time to fill out the lists on the next few pages. They are designed to fine-tune your photo-marketing. What follows is a tested timesaving system for finding an exclusive Market List tailored to *your* photographic strengths/areas.

1. Using the columns below, break down your photo-marketing potential into two areas—Track A and Track B, according to the instructions on pages 49-59.

TRACK A

(Weak Marketing Potential)

TRACK B

(Strong Marketing Potential)

Before turning the page, draw a big "X" over your Track A list.

2. Which entries on your Track B list don't appeal to you photographically? In other words, you wouldn't enjoy photographing in this area.

List here:

Eliminate that list from your PS/A. Write your *new* PS/A here:

3. Be realistic. Which areas on your PS/A list would it be impractical for you to photograph? For example, if you listed as an access a relative in Alaska who is a shrimp fisherman, it might be difficult to photograph this area (unless you're reading this in Alaska).

Figure 3-2.

Other considerations: Would any of the markets listed require a heavy investment in new photographic equipment? Does the magazine require model releases? Is it an uncopyrighted publication? Is it a low- or no-pay publication?

List here:

Eliminate the preceding list from your PS/A. Write your new PS/A here:

4. Which areas of your PS/A don't lend themselves widely to publishing? Few areas don't, but one or two of them might be on your list.

For example, there may be a very limited audience for pictures of antique clock repair, or there may be too few picture possibilities for an armchair interest in unidentified flying objects.

List here:

Rewrite your list below, leaving out the subjects that are unlikely to apply widely to publishing. You have now further refined your PS/A.

5. Decision! It's time to narrow down your PS/A to *four* major areas. If you aim your marketing strategy at a minimum of four strength areas, you'll be able to develop them to their fullest potential.

Here are seven factors that will aid you in your decision. (Make an educated guess on some of them, since you probably don't have access to current circulation and payment figures in all of these fields.)

High	*Medium*	*Low*	
☐	☐	☐	Your knowledge or expertise in this field.
☐	☐	☐	Your personal interest in this field.
☐	☐	☐	Your existing supply of pictures.
☐	☐	☐	The payment range for pictures in this field.
☐	☐	☐	The competition factor—is it high, medium, or low?
☐	☐	☐	Your access to the field or information about it.
☐	☐	☐	The size of the audience (number of readers).

Figure 3-2 continued.

Using any other criteria you can think of, narrow down your PS/A to four. Decide which one of the four offers the best marketing potential for you. Then list the second best, and so on. Note your four strongest areas below.

My PS/A
No. 1: _____
No. 2: _____
No. 3: _____
No. 4: _____

you'll consider graduating to higher paying markets in your specialization area(s). Your efforts and sales in the nuts-and-bolts areas of Track B may one day even justify the time you still may wish to give to Track A photos, which actually *cost* you money to try to market.

Throughout this book, when I refer to *you*, the photographer, I mean for you to adapt what I'm saying to your particular photographic strengths and approaches. Refer again to the photographic picture of yourself that you've outlined on Track B. When I say *you*, I won't mean *me*, or any other reader of this book. Another photographer would fill out this chart differently. She also would be an important resource to certain editors, but rarely would the two of you compete for the attention of the same photobuyers. Your task will be to find your own mix of markets, based on the areas you like and know best, and then hit those markets with pictures they *need*.

This approach eliminates the drudgery associated with the admonition we often read in books and hear at lectures: "Study the markets!"

When I first began marketing my photographs, I also heard "Study the markets!" I've always associated the word *study* with tedium. I found it unnecessary to study the markets. The only studying I needed was to study *myself*—and then develop my personal photographic marketing strengths. If I listed the market in my PS/A, I was already a mini-expert on the subject. If it wasn't in my PS/A, I had no business either studying it or photographing it.

The Majors and the Minors

Do you know any successful photographers? *Success* eludes concrete definition. We all know that it's irrelevant to judge people's success by their net worth, where they live, or the fame they have attained. When I refer to *success* in this book, interpret it not in terms of some stereotypical level of achievement, but in terms of the goals that are meaningful to *you*.

The major markets for your stock photos may not necessarily be the major markets for the stock photographer next door. Your neighbor's major markets may be your minor markets.

Will you have to change your lifestyle or your photography to apply the marketing principles in this book? Not at all. Moreover, breaking in won't put a dent in your pocketbook. Your major markets need not be in New York: They might be in your backyard.

The length of your Track B list will give you a good idea of the breadth of the market potential for your photography. Some stock photographers thrive in a very limited marketplace. Others find it necessary, because of the nature of their photographic interests, to seek out many markets. In my own case, I have seven file drawers filled with correspondence with over one thousand publishing houses or photobuying contacts that I've developed over the past forty years. The files, like the personnel in the publishing world, stay in a state of flux. New photo editors come and go, but the theme of the publishing house generally remains the same. As long as your collection of photos matches that theme, you have a lifelong market contact with that publishing house.

How to Use the Reference Guides,
Directories, and the Internet

Once you know your photographic strengths, you'll find your corner of the market more easily. Several excellent market guides exist that will point you in the right direction. Keep in mind that, because of publishing lead time, directories, even telephone directories, are up to one year older than the date on the cover. Use your directories to give you a general idea of potential markets for your photographic strengths. For specific

names, titles, updated addresses, and phone numbers, keep your directories current by making personnel changes whenever you learn of them through your correspondence, phone calls, newsletters, or online resources like PhotoSource International's free e-mailed news sheet, *PhotoAimLite www.photosource.com.*

Treat your directories like tools, not fragile glassware. Keep them handy, scribble in them, paste in them, add pages, or tear pages out. Your directories are a critical resource for moving forward in your photomarketing. If you're computerized, begin to maintain a photobuyer database. (See chapter seventeen for ideas on how software can help you organize your Market List.)

You can find outdated directories at your local library's "spring book sale." Usually the cost of a seventy-five-dollar directory is fifty cents to a dollar. However, don't automatically assume that addresses, names of photo editors, phone numbers, fax numbers, and so on are still accurate. Consult an up-to-date directory for that information. Outdated directories can be useful for checking to see how long a business has been around.

Table 3-1 lists the names and addresses of published directories. You'll find most of these at any large metropolitan library, and your local public library or a college library in your area will stock many of them.

Which directories are best for you? You'll find out by matching the subject categories in your Track B list with the market categories covered by the different directories. The most popular directory among newcomers to stock photography is *Photographer's Market* (published by Writer's Digest Books), an annual directory that lists two thousand up-to-date markets, including magazine and book publishers. This directory not only tracks down personnel changes in the industry, but it also lists the fees photobuyers are willing to pay for stock photos and, in some cases, assignments.

Using Your Local Interlibrary Loan Service

Some directories may be too expensive for you. They also may be too expensive for your community or branch library. Ask the librarian to

Directories

Advertising Red Book
West Telemarketing Corp., 9910 Maple St., Omaha, NE 68134

American Book Trade Directory
R.R. Bowker Co., 630 Central Ave., New Providence, NJ 07974
www.bowker.com

American Hospital Association Directory
One North Franklin, Chicago, IL 60606 *www.aha.org*

ArtNetwork Yellow Pages
P.O. Box 1360, Nevada City, CA 95959 *www.artmarketing.com*

ASMP Stock Photography Handbook
150 N. Second St., Philadelphia, PA 19106 *www.asmp.org*

Association for Education and Communications Technology
1025 Vermont Ave. NW, Suite 820, Washington, DC 20005

Audio Visual Market Place
R.R. Bowker Co., 630 Central Ave., New Providence, NJ 07974
www.bowker.com

Bacon's Publicity Checker
Bacon's Publishing Company, 332 S. Michigan Ave., Chicago, IL 60604
www.bacons.com

The Bowker Annual of Library and Book Trade Information
R.R. Bowker Co., 630 Central Ave., New Providence, NJ 07974
www.bowker.com

Broadcast Interview Source
2233 Wisconsin Ave. NW, Washington, DC 20007

Canadian Almanac
Micromedia, 20 Victoria St., Toronto, Ontario, M5C 2N8, Canada
www.mmltd.com

Cassell's Directory of Publishing
Villiers House 41/47, Strand, London WC2N 5JE England

Contact Book for the Entertainment Industry
Celebrity Service International
1780 Broadway, Suite 300, New York, NY 10019

Decor Services Annual
Commerce Publishing Co., 330 N. Fourth St., St. Louis, MO 63102

Directory of Post-Secondary Institutions, 1990
Superintendent of Documents
U.S. Government Printing Office, Washington, DC 20402

Table 3-1.

Editor and Publisher
International Yearbook, 770 Broadway, New York, NY 10003-9595

Encyclopedia of Associations
Gale Group
27500 Drake Road, Farmington Hills, MI 48331 *www.galegroup.com*

Gebbie Press All-In-One Directory
P.O. Box 1000, New Paltz, NY 12561 *www.gebbieinc.com*

Gift and Decorative Accessory Buyer's Directory
Geyer McAllister Publications
51 Madison Ave., New York, NY 10010, (212) 689-4411

Horse Industry Directory
American Horse Council
1700 K St. NW, Suite 300, Washington, DC 20006 *www.ahc.org*

IMS Directory of Publications
Gale Group, 27500 Drake Road, Farmington Hills, MI 48331
www.galegroup.com

Information USA Directory
Viking Penguin Books, 375 Hudson St., New York, NY 10014

Internal Publications Directory
Reed Elsevier Publishing, P.O. Box 31, New Providence, NJ 07974

The International Buyer's Guide of the Music-Tape Industry
Billboard Publications, 1515 Broadway, New York, NY 10036

Literary Market Place
R.R. Bowker Co., 630 Central Ave., New Providence, NJ 07974
www.bowker.com

Madison Avenue Handbook
The Image Makers Source, Peter Glenn Publications, Ltd.
49 Riverside Ave., Westport, CT 06880 *www.pgpdirect.com*

The Mail-Order Business Directory
Catalog Division, B. Klein Publications
P.O. Box 8503, Coral Springs, FL 33065

National Directory of Magazines
Oxbridge Communications, 150 Fifth Ave., New York, NY 10011
www.mediafinders.com

Newsletter National Directory
Gale Group, 27500 Drake Road, Farmington Hills, MI 48331
www.galegroup.com

O'Dwyer's Directory of Corporate Communications
J.R. O'Dwyer Co., 271 Madison Ave., New York, NY 10016 *www.odwyerpr.com*

O'Dwyer's Directory of Relations Firms
J.R. O'Dwyer Co., 271 Madison Ave., New York, NY 10016 *www.odwyerpr.com*

Patterson's American Education
Educational Directories Inc., P.O. Box 199, Mount Prospect, IL 60056-0199

Photographer's Market
Writer's Digest Books
4700 E. Galbraith Road, Cincinnati, OH 45236 *www.writersdigest.com*

Reader's Digest Almanac and Yearbook
Pleasantville, NY 10570

Register of the Public
The Public Relations Society of America, 33 Irving Place, New York, NY 10003
www.prsa.org

Society of American Travel Writers Directory
1500 Sunday Dr., Suite 102, Raleigh, NC 27607 *www.satw.org*

Standard Periodical Directory
Oxbridge Communications
150 Fifth Ave., Suite 301, New York, NY 10011 *www.mediafinder.com*

Talk Show Guest Directory
Broadcast Interview Source, 2233 Wisconsin Ave. N., #540, Washington, DC 20007

Traveler's Guide to Info
U.S. Department of Commerce
U.S. Travel Service, Visitor Services Division, Washington, DC 20230

Travel Writer's Markets Directory
Winterbourne Press, 7301 Burnet Rd., #102-279, Austin, TX 78757

Ulrich's Periodicals Directory
R.R. Bowker Co., 630 Central Ave., New Providence, NJ 07974 *www.bowker.com*

Working Press of the Nation
Reed Elsevier Publishing, P.O. Box 31, New Providence, NJ 07974

The World Almanac
United Media, 200 Madison Ave., Fourth Floor, New York, NY 10016-3903

World Aviation Directory
News American Publishing Inc., 210 South St., New York, NY 10002

World Travel Directory
Ziff-Davis Publishing Co., 1 Park Ave., Room 1011, New York, NY 10016

Writer's Guide to San Francisco/Bay Area Publishers and Editors
Zikawuna Books, P.O. Box 703, Palo Alto, CA 94302

Writer's Market
Writer's Digest Books
4700 E. Galbraith Road, Cincinnati, OH 45236 *www.writersdigest.com*

Table 3-1 continued.

borrow such a directory through the interlibrary loan service (or its equivalent in your area). If the book isn't available at a regional library, the service will locate it at the state level. It generally takes two weeks to get a book. Since the books you order will be reference manuals, your library will probably ask that you use them in the library. However, you can photocopy the pages you'll need, thanks to the *fair use* doctrine of the U.S. Copyright Act (revised 1978). (See chapter fifteen for more on copyright.)

Using the Internet

Internet search engines such as Google *www.google.com*, Alltheweb *www.al ltheweb.com*, AltaVista *www.altlavista.com*, Lycos *www.lycos.com*, Ask Jeeves *www.askjeeves.com*, Yahoo *www.yahoo.com*, and Dogpile *www.dogpile.com* can be invaluable when it comes to building your Market List. If you key "gardening magazines" into Google, for instance, chances are you'll be amazed at the results. If you don't have access to the Internet, you can use computers with Internet access at your local college or library.

Chart Your Course . . . Build a Personalized Market List

Now that you've defined your photographic strengths and focused in on accessible subject areas, you're ready to chart your market course.

Successful businesspeople in any endeavor aim to reduce the possibility of failure by reducing or eliminating no-sale situations. Why attempt to sell your pictures to a market where the no-sale risk is high? By using the procedure that follows, you will build a *no-risk* Market List and begin to see your photo credit line in national circulation.

Consult all of the directories available to you, and build a list of potential markets for *your* material by combing through the categories that match your photographic strengths. This might take several evenings of effort, but the investment of time is worth it.

Here at PhotoSource International, we offer specialized lists of photobuyers, which are computerized printouts of names and addresses of contact persons or photobuyers in every imaginable area. Your homework

will result in several similar lists (the number of lists depends on the length of your Track B column).

If you're not yet into computers, type the data for each market on a separate 3″ × 5″ file card, or Rolodex® card. Include on your lists information about the photobuyers you deal with at each market—title: nickname, phone, fax, e-mail address, former position or title, plus a note or two about their photobuying procedures, fee range, preferences, dislikes, and assignment possibilities. Leave room for code designations of your promotional mailings to them (see chapter ten) and space for changes of address, title, or personnel.

Chances are that you'll need more space rather than less space in your database, so choose systems wisely. Be it index cards or software, pick a system that's easily upgradeable when you need the extra space or additional capabilities. Your system should allow you to delete, repair (e.g., make changes of address or spelling corrections), or alphabetically add names, easily.

You can start your personal Market List from the directories, but you can discover additional markets for your pictures at newsstands, doctors' waiting rooms, reception rooms, and business counters.

Your list is now tailored to your exact areas of interest. If you have several areas of interest, should you make several lists? My advice would be to keep one master list. Color-code the categories, or type them on different-colored file cards, or use the capabilities of your database software. Then, when you repair or replace a listing, you need do it only once. (For more on record keeping, see chapter thirteen.)

THE SPECIALIZATION STRATEGY

Now that you have charted your course to sail straight for your corner of the market, you're bypassing the hordes of photographers on Track A, and you're moving along Track B, where the competition is manageable.

As you work with this system, you will discover that you can define

Narrowing Down Your Market List

1. Now that you've found your top photographic strength/areas (PS/A), you're ready to find the *markets* that are looking for pictures in your PS/A. Your library, depending on its size, can provide you with many of the directories and reference guides listed in Table 3-1. Your Market List is your gold mine; you will want to refine it in the same manner as your PS/A. In the two columns below, list magazines, publishing houses, and electronic markets that are potential markets for your PS/A No. 1. Do your research thoroughly.

My Initial Market List for PS/A No. 1:

_____ _____

_____ _____

_____ _____

2. To tailor your list, ask the following questions of each potential market on your list (you're going to do some shuffling).

 a. **What is the supply/demand factor?** (Remember that supply in this case means the photobuyer's supply, not your supply.)
- High supply, no demand = move to lower third of list.
- High supply, high demand = move to upper half of list.
- No supply, high demand = move to top of list.
- No supply, no demand = move to lower third of list.

 b. **What is the competition factor?**
- No competition = move to top of list.
- Moderate competition = move to upper half of list.
- Fierce competition = move to lower third of list.

 c. **Miscellaneous considerations**
- The magazine or house demands model releases = move to lower half of list.
- The magazine or house has no track record (has been in business less than three years) = move to lower half of list.
- Foreign market = move to lower half of list.

Figure 3-3.

- Slow or no payment reported = move to lower half or remove entirely.
- Poor reliability factor reported (e.g., photobuyers reported as unco-operative, disrespectful, poor administrators, or inefficient in handling photographers' pictures) = move to lower half or remove entirely.

d. **What is the publisher's purchasing power?**

Rather than trying to determine a single magazine's circulation, research the entire publishing house's purchasing power. Most publishers concentrate on a specialized subject or theme. Often, if your pictures don't score with one editor, they are circulated among other editors within the house. (Some publishing houses have as many as twenty to thirty editors.) The best way to determine the buying power of a publishing house is to tally the number of periodicals and/or books they publish annually. If that figure is not available, you can get an idea of the house's purchasing power by looking at their circulation figures, number of pictures purchased per year, or number of editors employed. Use Table 3-2 to rate and list your markets in order of purchasing priority.

(Note: In this chart, publishing house means book or magazine publisher.)

e. **What is the probability factor?**

In the final analysis, you will determine your probability of scoring with a given magazine. Pictures in magazines can be broken down into two categories: advertising and editorial. As a stock photographer, your main concern is the *editorial market*.

These pictures are supplied by staff photographers, assignment free-lancers, service photographers, stock photo agencies, and stock photographers such as yourself on the magazine's available-photographers list.

Using the magazines on your Market List, analyze their use of both advertising and editorial photographs. The amount of advertising in the magazine will indicate the magazine's picture budget. While you're at it, analyze the use of Track A pictures: This should convince you of the futility of trying to market Track A pictures yourself. (See chapter twelve for methods to sell these.)

Figure 3-3 continued.

Rate the magazines: 30 to 150 editorial pictures—place on top of list; 10 to 29 editorial pictures—place on top half of list; 1 to 9 editorial pictures—place on bottom half of list.

_____ _____

_____ _____

_____ _____

3. You have shuffled and refined your Market List for PS/A No. 1, and your strongest markets have come out on top. Go through the same process for your Photomarketing Strength Area.

Transfer your four Market Lists to three-by-five-inch file cards, a computer file, or a three-ring (expanding file) notebook (see chapter thirteen). Make additions, deletions, and address changes to each Market List as soon as they occur.

Some Market Lists are long because of the general nature of the subject. Others are short. Work closely with the top half of your list, but, because publishers' budgets change, continue to keep in contact with the lower half of your list as well. If in the future you acquire new knowledge or interest in another field, consider replacing one of your lists with a list for this new field.

your target markets even more specifically and improve the marketability of your pictures 1,000 percent through a strategy used by all photographers who are successful at marketing their pictures: the strategy of _specialization._

We live in an age of specialization. Once we leave school, whether it be high school or medical school, we are each destined to become a specialist in something. In today's world, with the immense breadth of knowledge, technology, and diversification, it's impossible for one person to be expert in all aspects of even a single chosen field. In our culture, buyers of a person's services prefer dealing with someone who knows a lot about a specific area, rather than with someone who spreads himself too thin.

The same holds true for photobuyers. They know the discerning readers of their specialty magazines expect pictures that reflect a solid knowledge of the subject areas. Understandably, then, buyers seek out photographers who not only take excellent pictures, but who also exhibit familiarity with and understanding of the subject matter of their publications.

Technical knowledge alone is not sufficient to operate successfully in today's highly specialized milieu. Marketing people have found that consumers often buy an image rather than a product. Their success at image-creating to sell cars, insurance, and beer attests to the power of images to move the buying public. Since most magazines (and, to a lesser extent, books) are extensions of their advertisers or supporting organizations, photo editors, directed by the publisher's editorial board, constantly seek out photographs and photographers who can capture the publication's image in pictures. The image projected in a yachting magazine will be subtly different than that projected in a tennis magazine. The image projected by a magazine called *Organic Fruit Growing* will be radically different from that projected by one called *Chemical Fertilizers Today*.

These nuances are important for you to be aware of. (In chapter nine, I'll discuss these nuances further and show you an effective query letter for reaching photo editors.) Go over the list of markets you've compiled for yourself. Familiarize yourself with the publications (write for copies or find them at the library) to educate yourself on their individual themes. Often, the book or magazine publisher will supply you with photo guidelines. If you can't get a handle on the image of some of the markets, put them at the bottom of your list. Keep the areas you're more sure of at the top. You have now fine-tuned your list; you can be more selective in your choices. The top of your list has your target markets, the ones that best reflect who *you* are *photographically*, the ones that fall within your personal photomarketing strengths. Editors have specific photo needs, and the sooner you match *your* subjects and interest areas with buyers who *need* them, the sooner you'll receive checks.

You'll also be building a reputation among the photobuyers who need your specialized photography. Photobuyers pass the word.

KEEPING ON TOP WITH NEWSLETTERS

Another way to discover additional markets for your list, and to keep abreast of current market trends, is to read the newsletters in the field. We produce a variety of newsletters here at PhotoSource International; for more information on any of them, visit our Web site at *www.photosourc e.com*, or send an e-mail to info@photosource.com.

You can find information about photo-oriented newsletters on the Web or at your local library. Sample copies usually are available for less than five dollars. For names and addresses of the best in the field, see the bibliography on page 363.

Guide to a Publisher's Buying Power			
Place in list:	*Top*	*Upper half*	*Lower half*
Number of editors at publishing house.	20 to 50	6 to 19	1 to 5
Number of periodicals at publishing house.	15 to 35	4 to 14	1 to 3
Number of books or magazines published per year by publishing house.	50 to 100	11 to 46	1 to 10
Number of photos purchased annually by publishing house.	400 to 3,000	51 to 399	1 to 50
Circulation figure (for single-magazine magazine publishers).	*250,000 to 500,000	75,001 to 250,000	20,000 to 75,000

Note: Magazines with circulations of more than 500,000 are closed markets to most part-time stock photographers. Large-circulation magazines acquire their photos from (1) their staff, (2) stock-photo agencies, or (3) established local (or sometimes national) service photographers. Once your stock-photo file grows to twenty thousand and more salable images, you'll be eligible for dealing regularly with top newsstand magazines.

Figure 3-4.

The Total Net Worth of a Customer

The effort it takes to locate your markets results in far more than a limited series of sales. You are in effect locating sources of long-term annuities. When you use the marketing methods outlined in this book, you're developing a potential long-term relationship with a portion of your markets or customers, whether they are corporations, public relations firms, or publishing houses. Publishing houses particularly lend themselves to a long-term affiliation because of the stability of their focus and emphasis. In my experience and in surveys of stock photographers (for an up-to-date list of surveys offered by PhotoSource International, check out *www.photosource.com/101*), ten years is a reasonable average length of time you can expect to stay with a publishing house. Sometimes it's much longer.

This idea of the long-term value to you of a customer can be stated as the *total net worth* of that customer to your business. To determine a customer's total net worth to your specific operation, average your total sales, also factoring in those markets you contact that you *don't* achieve sales with. For example, using a worst-case scenario: Taking only low-budget customers and figuring extremely conservatively that a customer may last only one year, you find you could spend up to one hundred dollars to acquire that one customer and still break even. (You'd break even because one hundred dollars is the net profit you could reasonably expect from one customer for one year at the low-budget level.) Since your promotional package to prospective photobuyers would cost about one dollar (an industry average), you could afford to contact one hundred potential customers (100 \times \$1 = \$100). If out of those one hundred that you contact you land two, three, or five steady customers, you're in the black. With experience gained through analyzing your data, you'll learn how many contacts you need to make, on the average, to land one consistent customer. Then you'll know the least amount you can afford to spend at the low-budget level to acquire a new customer.

Naturally, several contingencies are involved. For example: Does your prospect mailing list match your PS/A? Is your promotional package

professional looking? (Consult your mailing package checklist on page 150 in chapter nine.)

If you acquire just one consistent customer (just 1 percent) in your promotional campaign to one hundred prospects, you will break even. If you acquire ten (10 percent), you can make a potential (conservative) net profit of one thousand dollars for the year, and ultimately ten thousand dollars, based on the total net worth of each customer over a ten-year span.

Analyze your own Market List. How many markets have bought from you once, twice, five times, twenty times in one year? What is the average for one year? How many years have they stayed with you? What average net profit do you get from each sale? If you're just starting out, keep track of this information to refine your educated guesses until you gradually accumulate your averages.

Long-Term Value

I have presented this system conservatively. Actually, if you're aggressive and confident of the quality of your work and targeted value of your

Position Yourself

If you're interested in making money from your photographic talent, you will want to follow a basic business concept: positioning. If your collection of photos is strong in, say, education, position yourself so that you become a valuable resource to editors who are in continual need of education photos. I know photographers who have positioned themselves so well in their specialty area that they can call editors collect.

When you position yourself, you lock yourself into publishing houses that produce visual materials relating to *one* theme. This may be auto racing, gardening, hang gliding, medicine, and so on. When you submit your first selection of photos to such a publishing house, spark the photobuyer to say, "This photographer speaks my language." Once you sell your first photo to a theme publisher, you will find it much easier to make subsequent sales.

mailing list, you could lose money on your promotional campaigns and *still* come out ahead. The long-term income from your acquired customers would eventually eliminate the loss you initially experienced in acquiring them.

The total net worth principle presents you with a model of your business, a mathematical relationship as to how your business works and what works. Moreover, it provides you with a warning signal before you make a bad decision. Once you have done the tedious initial work of tracking and analyzing your customers, further analysis is easy and simple. A computer will help, and you can use most database and spreadsheet programs to process the information. This total net worth principle will help you guide your business ship with far more precision.

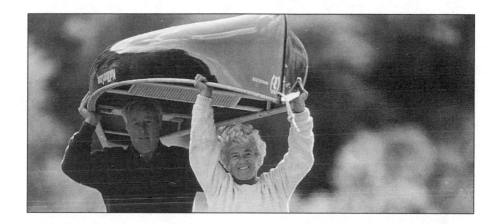

4

Getting Started

THE FOUR-WEEKEND ACTION PLAN

Most people have an aversion to starting things. Most of us procrastinate.

You don't have to wait any longer to fire up your photomarketing enterprise. Why not? Because the Four-Weekend Action Plan contains all the ingredients, all the tools, and all the know-how you need to propel yourself into the field of photo-marketing.

Your resolve will require some understanding on the part of your family and friends. Announce to your family that you are going to take the next four weekends to establish yourself in the business of marketing your photographs.

The photomarketing enterprise you're about to embark on is going to take endurance. You're going to experience setbacks. You will no doubt encounter some trying times of reassessment. If your desire is strong, none of this will faze you. Welcome to a magnificent obsession with this profession!

WEEKEND ONE: SET UP SHOP

Take action. Announce your plan to your family, relatives, colleagues, and friends. Enlist their help, but fly solo if they attempt to dissuade you from your plan.

Clear out a room, or a well-defined part of a room, and set up a desk, chair, lamp, computer, filing cabinet, telephone, and fax if possible. You can find bargains on used furniture through local thrift shops, surplus auctions held regularly by your state, and local companies that sell secondhand furniture and office equipment.

Name your work area. Tack a sign above the desk: "_____ Stock Photo."

Visit an office supply store and a photo equipment store in person or online and order the following supplies:

> Scanner
> Adobe Photoshop or similar photo-editing software
> Loupe for viewing slides
> Light box for viewing slides
> Personalized stationery
> Mailing envelopes
> Plastic sleeves for slides
> Labels (both for slides and for mailings)
> Business checks
> Simplified bookkeeping system
> Record-keeping system
> Subscriptions to business and photography periodicals such as
> *Photo District News*, *Shutterbug*, and *Outdoor Photographer*

WEEKEND TWO: ZERO IN ON YOUR PS/A

Determine your areas of strong marketing potential and your areas of poor marketing potential. Photomarketing is a *business*. Success comes when you eliminate the barriers and pitfalls that prevent you from succeeding. Discover your photomarketing strengths as described in chapter three.

Whether you have five hundred or five thousand:

> Catalog your slides.
> Catalog your prints.
> Build a photo database.
> Organize your computer disks and CDs.

Table 4-1.

Reread "First, Find Yourself" at the beginning of chapter three. Fine-tune your PS/A (see Figure 3-2 on page 57).

Reread chapter two, "What Photos Sell and Re-Sell?"

WEEKEND THREE: CAPTURE YOUR CORNER OF THE MARKET

Spend this weekend on the Web or in your local library, and compile your own Market List, a list of markets tailored to your photographic strengths. Refer to the directories list in chapter three.

Request photo guidelines from each of the markets that appeal to you.

Reread all of chapter three, "Finding Your Corner of the Market." Fine-tune your Market List (see Figure 3-3 on page 67).

WEEKEND FOUR: READY FOR BUSINESS!

All of your supplies are in. Your desk and work area are organized. Either in a notebook or on your computer, set up a simple record-keeping system to note what you send out, when, to whom, and what sells. Use search engines to find individual Web sites, and validate your Market List. Confirm spellings of names, make address corrections, and verify current contacts' names. Make your first submission, either online or by mail.

Read chapter fourteen, "Working Smart."

Read chapter sixteen, "Your Stock Photo Business: A Mini Tax Shelter."

From here on out, make it a habit to work in your new home office on a routine basis. Work for one hour or ten hours, whatever fits your work style, lifestyle, and income projections.

Read your business and marketing periodicals, and expand your knowledge a little each day. Learn what others are doing; attend specialized workshops and seminars. Listen to business and marketing cassette tapes during your downtime (driving to and from work, in your darkroom, and so on). Incorporate elements of such information as they apply to you.

You're now on your way. Depending on the size of your stock file, you'll have many published pictures (and deposited checks) to your credit by the time you're ready to celebrate your first anniversary.

5

Producing a
Marketable Photo

SOME BASIC QUESTIONS ANSWERED
Digital or Analog?

The reality of today's technology is that digital photography is the most cost-effective way to produce stock photographs. There's no film to contend with, no handling and storage concerns, the per-picture cost is less, the delivery is hassle-free, there's no liability on the part of the photobuyer, and best of all, your originals don't have to leave your premises.

There's only one problem: Most *editorial* photobuyers aren't ready for digital images—at least the majority of the buyers on your Market List. Digital technology hasn't advanced to a stage where editors at most publishing houses are ready to go completely digital. Their fellow editors at newspapers, and art directors at ad agencies, *have* migrated to all-digital. So why haven't your buyers?

The answer seems to lie in the nature of the publishing business. Pho-

tobuyers at book and magazine publishers depend on a wide variety of photographer talent and technology. They don't have the luxury that newspapers or corporations enjoy, dictating standards to a staff of photographers. Freelancers will submit to publishing houses every degree of quality of digital work; hence, the average editorial photobuyer holds to the tried-and-true mode developed over the past five decades: analog (film-based technology).

Until film cameras go out of style, you'll find that most buyers will request, in the end, your original transparency or a high quality scan from the transparency.

With this reality in mind, this chapter emphasizes film-based (analog) submissions.

For the time being, the best combination is to shoot color slides and to have, or have access to, a good quality slide scanner.

As in any other business, you'll need to stay connected and be knowledgeable of new technology, and you'll need to keep abreast of what the market prefers at any given time. Your photobuyers will certainly tell you what they prefer.

Until the industry develops a standard (format, size, type, resolution, and so on) for digital, you'll be better off shooting film.

Historically, the publishing industry is set up to accept transparencies, not color prints. Even though desktop publishing, the Web, scanners, and newspapers are putting a dent in this tradition and opening the door for a wider acceptance of prints and digital photos, for now you'll do best to work with color transparencies, not prints.

What Film Should I Use?

A huge number of choices are on the market today when it comes to slide film. Most brands have several variations of the same brand name, each with its unique characteristics. The only way to find out which films you like best is to test, and keep on testing, until you find the emulsions that fit your style and subject preference.

The vast majority of photobuyers will expect you to use 35mm, but a

few will request larger formats. (Most of the latter buyers are the lower-paying paper product markets.)

For some submissions, it can be a good idea to have 70mm reproduction-quality duplicates (dupes) made of your best slides. Why? Well, a 70mm dupe is larger than a 35mm slide, and it simply looks more impressive on the light table to the photobuyer.

Both fast and slow color film will be of value to you. For outdoor work, I use Fuji Velvia (daylight) ISO 50, Fuji Provia F100 and Kodak Ektachrome 100S. The lower the ASA (or ISO), the better the photo editors like the results; the lower ISO speeds produce a tighter-grained image, which means the photo editor can blow it up larger and still get good definition. (Frequently, a photobuyer will use only a portion of a picture and enlarge it to fit the layout.) Fuji Provia F100 is one of the sharpest films on the market right now. Photo editors often prefer one brand to another, but check with your buyers. Let them guide you.

If you can get away with it, it's generally a good idea to use the same type of film (brand and speed) indoors as you use outdoors. This depends on how fast your lenses are and how much available light you have. Of course, issues of color correction and light temperature can occur when you use daylight film indoors. You can master these situations, though, by using a flash and/or filters, or a combination of both.

BLACK AND WHITE—IS IT STILL VIABLE?

Black-and-white films are no longer as useful as they once were when it comes to editorial stock photography. It used to be that color conversions were both expensive and costly, but this is no longer the case. Color can quite easily be converted to black and white (though many editors prefer not to take those extra steps when black and white is required). The process doesn't work well in reverse, however.

Because of this, you will be far better off shooting color than you will shooting black and white.

Many photographers prefer to shoot exclusively in color. Service photography market areas—ad agencies, graphic design studios, corpora-

tions, commercial assignments, and stock photo agencies—often require a heavy concentration on color. Trends in the magazine and book industry also indicate an aggressive move toward more color. A good example is textbooks, which show a marked increase in the use of color over black and white in the last two decades.

Is it cheaper to shoot in black and white or color transparencies? At first glance, black and white would appear to be less expensive. However, if you take into consideration your developing/printing time and costs, color is actually less expensive.

SHOULD I RELY ON COLOR TO BLACK-AND-WHITE CONVERSION?

Some of your markets *will* require black-and-white prints and/or slides.

Despite the profusion of color used in the publishing industry, black and white is still used 10 to 15 percent of the time; however, almost all those cases are conversions from color. I'm not saying that shooting black and white is totally obsolete, but you will significantly lower the marketing potential of any image by having it available in black and white only.

With a good quality scan from a color slide or print, the conversion process is fairly easy and can be handled in any professional imaging software such as Photoshop. Photoshop *www.adobe.com* is by far the most widely used imaging software in the industry.

Photobuyers will let you know if they want you to submit in black and white or if they are willing to convert from color themselves. Time is always of the essence for photobuyers, though, so you can place yourself ahead of the competition by simply asking, prior to sending any submissions, if they want color or black and white. Better still, your market research will have identified their usual preference. By sending on-target images of the subject matter they need now, in the desired format, you've demonstrated your knowledge of the photobuyers' requirements, and thus that you're a valuable resource to them.

To make your own conversions from color to black and white, the easiest way is to scan your image and do the conversion digitally. For this you'll need a scanner, or you can have a service bureau scan the image

for you. You'll also need imaging software and some computer skills.

If you're going to have a service bureau or your local professional lab do the scanning for you, they will be able to do the conversion to black and white. More often than not, this is done free of charge.

Scanning: Should I Do It Myself?

Depending on your PS/A, you may want to invest some time in learning about scanning your images (digitizing them into pixels that can be manipulated, sharpened, color corrected, and stored).

Many other photobuyers will say to you, "Just send me the picture; we'll scan it here." What they're saying is because there are so many levels of proficiency and so much variety in equipment needed to transfer your film to pixels, they've found it more effective to work with their own service bureau.

Of course, if you are a *commercial* stock photographer, you're more in a position to consider investing in a scanner, such as Nikon's CoolScan, and do the work yourself. This area is much like working in a darkroom. Some photographers don't want to trust their finished products to other people. In the long run, if you're just starting out in *editorial* stock photography, your best bet to convert your film to digital is to farm your scanning out to a competent service bureau such as Kodak's PhotoCD and PictureCD. For the greatest control over the finished product, combine this with getting the software such as Photoshop so you can do your own sharpening, color correcting, manipulation, and so on.

Like anything else, learning to make good scans will take time and effort. There are a number of great books on the market for those interested in learning Photoshop, scanning, digital darkroom work, and so on. Your local camera club or community college might offer workshops in digital imaging as well. It doesn't really matter how you learn scanning and digital imaging, as long as you do. We often hear photobuyers talk about how often they come across scans that are simply not good enough for use in print. Make sure your scans are good enough to be used in print.

Digital Previews and Submissions

Even though most editorial buyers aren't positioned yet to accept digital images for publication, they can utilize handy digital "previews" for the selection process. Digital previews—sending a small, low-resolution, digitized image via e-mail to photobuyers—are quickly becoming popular. With digital previews, the photobuyer can have a quick look at an image risk-free. Without having to handle the original slide or a high-resolution image on CD, and risk damage or loss, the photobuyer can decide whether she wants to use the image. She can then have the photographer send the original, or a high-resolution scan.

Digital previews are typically scanned at 72 or 96 dpi (two by three inches) for viewing on-screen. The most common format for digital previews is JPEG (Joint Photographic Experts Group), a lossy compression algorithm that saves considerable disk space (and e-mail time) without much loss in image quality.

Should you send unsolicited digital previews to a photobuyer? Yes, if you're positive that your image collection matches the specific interest area of the buyer. However, if you send a general-interest selection of images, you'll probably get on the photobuyer's list—i.e., the blacklist. It's so easy to send off electronic pictures, but don't fall for it. It can be a trap, if misused.

Digital submissions, however, are handy in many ways. There are no original slides floating around and the photographer can easily make five or two hundred dupes of a digital image. Moreover, if a CD with a digital image gets lost, while that's not good, it's not nearly the catastrophe the loss of an original slide would be.

Format, resolution, and file size are perhaps the most important details to keep in mind when pondering digital submissions. If the photobuyer wants a digital image, the format can vary from photobuyer to photobuyer but most common are JPEGs and TIFFs (Tagged Image File Format). The resolution can vary with the usage of the image, but a good rule of thumb is to scan at a minimum of 2,800 dpi. This will give you an image roughly eight by twelve inches at 300 dpi output. As with everything else,

whatever the photobuyers say, goes. Listen, learn, and submit only what they want, exactly how they want it.

The Most Commonly Asked Questions About Color

Why do I recommend the low ISO Fuji and Kodak films? As I mentioned earlier, an editor may wish to use only part of your picture or use all of it for a cover or a poster; in either case, the image would require enlargement. If a higher ISO film was used, grain clumping might preclude using the picture.

Should I indicate to the buyer which film I used?

Some editorial stock photographers indicate on their slide mounts the film and film speed that were used. This isn't necessary. Keep your slide mounts looking clean, crisp, and professional without unnecessary clutter. If you need to keep track of film speed, brand, and other details, do so in a separate binder.

Should I shoot vertical or horizontal format?

Photo editors continually lament that they do not have enough vertical shots to augment their layouts. "Printed matter is usually a vertical format," one editor told me. "Yet photographers persist in sending me horizontal pictures. I could use many more verticals than what I get."

One photographer friend told me that when she was starting out she pasted a label on her camera that read, "Is it a vertical?"

Do photo editors accept color *prints*?

Few photo editors accept color prints. When they do, they expect a quality eight-by-ten rather than smaller "drugstore" prints. Do not send your color negatives. Keep them home, safe, and on file.

The industry as a whole would certainly fare better if color prints, rather than color transparencies, could be accepted across the board. At last, the industry (except for newspapers and some major printing houses)

is in the process of making the costly conversion to digital photo technology, which *will* accept color prints.

Although color negatives are more logical and convenient and have a greater exposure latitude than transparencies, for now you're stuck with shooting transparencies.

How can I get around the color print barrier?

If you have a lifelong history of working only with color negatives and are not willing to work with transparencies, read on. Some stock photographers have attempted to circumvent the color negative-vs.-transparency situation via these two methods.

1. Make your photographs in color negative, select the most marketable, and have reproduction-quality transparencies made from the selected negatives. (This approach, however, can be costly.) Fuji NPH 160 and Kodak Portra 160 film provide high resolution and fine grain. Also, Fujicolor Press 400 and 800 and Kodacolor Professional 400 and 800 films provide excellent quality images for indoor situations. For mixed lighting situations, both Fuji Press emulsions work great. A custom lab will charge between ten and twenty-five dollars per transparency.

2. Some photo editors on your Market List may be capable of accepting digital formats on disk, CD-ROM, or online. If you haven't mastered scanning technology, check your local yellow pages or search the Web for a service bureau that will digitize your pictures for you. One popular format is the Kodak PhotoCD or PictureCD.

Select your service bureau carefully. Like any photo lab, there are great variations in the quality of the finished CD product. Some photo retail stores provide a kiosk for do-it-yourself scanning and digitizing. As with any outsourcing, there's good quality and there's mediocre. Ask around your photography community for the optimum in digital services.

I don't want the previous suggestions to give you the impression that the color negative system is the answer. In most cases, it's not, and for this reason: A photo editor wants a picture now. Any extra steps, such as

waiting for a service bureau to digitize your photo or for a transparency to be made, will often make the difference between a sale and no sale.

Making Duplicates of Slides

Newcomers to the field of photomarketing have a well-founded hesitation about sending their original transparencies to some unknown entity. A seemingly popular answer is to make dupes of your originals. Before I launch into the pros and cons, here's the most convenient way to make dupes: Make them *in-camera* during the original shooting of your subject matter.

Since you know what pictures will sell to your Market List, you aren't gambling away film dollars by making several extra exposures of an especially marketable scene or situation.

Of course, depending on the scene or situation, your "originals" won't be exactly the same. Some you might want to discard. Those that remain will share equally strong marketing potential. With several "originals," you won't worry about losing, misplacing, or damaging "the original."

But what if you do have only one original? I wish I could say that an inexpensive, quick, and high quality method of duplication is available to you. However, there is none—not for reproduction purposes.

Let me explain: The photobuyer is midway between you and the printer (the pressman, platemaker, etcher, and so on), who demands the best quality image in order to satisfy the tastes of the publishers, advertisers, and subscribers, not to mention his own. The printer has a bag of tricks that can perform some limited miracles, but in the end, nothing can substitute for a good original image.

This then rules out everything you've heard about making your own dupes or having them made professionally by a duping company at a dollar apiece. The products at these levels are dupes, yes, but usually not dupes that a quality printer can accept for reproduction.

However, all is not lost. Higher quality reproduction dupes *can* be made, and the cost is usually comparable to lunch at a good restaurant.

Here's how the pros make their dupes. Select an original image that has the potential for wide sales. Contact a reputable color lab, and have

your original made into a 70mm transparency. In many cases, your original can actually be improved by adjusting the color balance in the dupe. Slides that are too dark, but with adequate shadow and highlight detail, can be lightened either for a more pleasing effect or to bring their density into line with other slides in your presentation.

Overexposed slides can be darkened. Composition can be corrected, or emphasis can be given to just a portion of the slide by cropping and copying a certain area. Color rendition can be changed by means of filters, for either correction or creative deviation from the normal.

The price quoted earlier (five dollars) is for a reproduction-quality dupe. At about half this fee, you can get a lesser quality *display grade* dupe.

Incidentally, many stock photo agencies (see chapter twelve) will make 70mm reproduction-quality dupes of your 35mm slides. The reason? The improvement in color balance, plus the added size, improves sales. The agencies often have sales reps here and abroad who carry these dupes with them on CDs or in their display cases. They sell the dupes directly from the CD or display collection as top-quality reproductions.

To find a good-quality lab, talk to other professional photographers in your area, search on the Web, or visit the PhotoSource International Q&A Board, Kracker Barrel, at the PSI Web site *www.photosource.com/ board/* and ask fellow stock photographers for recommendations.

Can I submit digital scans of my transparencies? Yes. If you're computerized, you can import recent photos into your cover letter to a buyer. Another technique: Feature the photos on a light table (on a Web page), and invite interested viewers for a visit. Or you can include samples of your photos on a "sell sheet," and run them off on your color printer. One word of warning, though: You will want only the highest quality, and if your printer isn't capable of this, farm the work out to your local professional lab or service bureau.

Instant-print shops, banks, and libraries often feature copying services. Consult the yellow pages for a Quick-Print or Xerox Center in your area.

If you have the equipment and feel up to the task, you also can burn

a specialty catalog on CD and distribute the CDs to a select a group of photobuyers.

From Film to Pixels

As I've mentioned, digital imagery has not yet reached a point where most editorial photobuyers will be willing to take a serious look at digitized photos for publication. More and more photobuyers do want to see digital *previews* (the small, low-resolution images) sent to them by e-mail before they commit to looking at actual slides. The vast majority of all publishers still prefer to scan the images themselves or use a service bureau that they've worked with previously. Digital gradually is becoming more acceptable, however. An excellent how-to book for digital beginners is *Beginner's Guide to Digital Imaging for Photographers and Other Creative Types* by Rob Sheppard, editor of *PCPhoto* magazine.

Unless your photobuyer is hooked up to a broadband Internet connection, sending a high-resolution image to a buyer is not recommended. Large image files can take a long time to upload and download. To understand how frustrating this might be, imagine if you had to wait forty-five minutes for one e-mail to download and then it turned out to be something that wasn't of any interest to you. Lesson: Before sending any large file to a photobuyer, get his okay, first.

Using Specialized Films

Be wary of using most specialized films such as 35mm movie film in your stock photography. For example, even though Infrared can produce stunning images, it's not suitable for every situation nor should every picture be made using this film.

Generally speaking, photobuyers tend to be—for good reasons—traditionalists when it comes to film. They prefer images taken with the brands and emulsions that have been proven again and again.

Various online forums sponsored by the film manufacturers mentioned in this chapter can be found on the Internet and at their Web sites. At a search engine on the Web, type the company name and select the product you'd like to know more about.

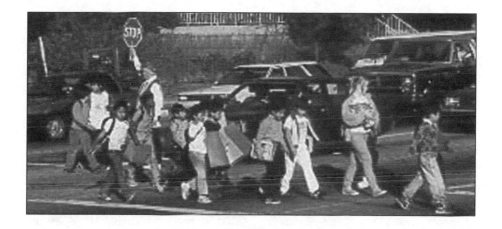

6

Taking and Making Editorial Stock Photos

Do You Take or Make Them?

Throughout this book, when I refer to stock photos, I'm referring to the Track B editorial stock photo—the marketable picture. The stock photo as we know it today has evolved from a documentary snapshot to a subtle and sophisticated art form. This evolution can be traced in magazines such as *National Geographic* that have existed for one hundred years. Following the progression in bound *National Geographic* volumes at the library can be entertaining as well as informative.

As we learn in zoology class, ontogeny recapitulates phylogeny (the stages in the development of the individual mirror those of the species). A photographer entering the field undergoes the same sort of progression. She begins by taking simplistic photographs, similar to the early photo illustrations, gradually incorporates new ideas and technical knowledge that enable her to produce better and more interesting pictures, until, if she endures, she eventually turns out fine photo illustrations—

editorial stock photos. This evolution is a valuable learning experience for the photographer, but it can be accelerated. Here's how.

Many photographers are conditioned to take photographs that reflect the world, somewhat as a mirror does. A documentary photographer *takes* a picture: He simply records things the way they were at that moment.

However, to limit photography to mirrorlike documentation is to restrict knowledge and understanding.

Stock photography opens up a vast new field of interpretive endeavor. The fact that stock photos are in large measure workaday pictures doesn't preclude innovative and creative treatment of them. Photo illustration allows a photographer to *make* photographs. The stock photographer creates a situation as it could be, or as it should be, or distills the essence of a scene or event. As we all know, painters rarely paint their landscapes true to nature. To limit their illustrations to exact duplications of nature would be to confine their creativity and their viewers' enjoyment. They rearrange the elements in their paintings to achieve a composition of wholeness and meaning that didn't exist earlier. Similarly, jazz musicians improvise on the melody and rhythm of a familiar tune not because they wish to seem clever or self-consciously different, but because they wish to discover, for themselves and their listeners, new meaning in the music. Photographs, like other expressive media, can offer fresh insights and deeper understanding. A photograph can become a microscope or a telescope for the viewer to see into or beyond what is being photographed.

All of this, of course, does not apply to photojournalism or documentary photography. It would be dishonest and unethical to alter or shape a news photograph to misrepresent a scene or subject. The line between photo illustration (stock photography) and photojournalism can be thin. Photojournalist W. Eugene Smith was criticized for moving the bed away from the wall for a better camera angle in some of his photographs of a midwife for *Life Magazine*.

Stock photographers often confront ethical questions when it comes to such improvisation. For example, if you photograph a teenager whose

blemishes are here today but gone tomorrow, do you leave them in the picture or retouch them out? Which is the truer interpretation? Are the blemishes inappropriate if you're illustrating the winners in a student government activity or a science fair? Should they remain if you're illustrating nutritional deficiencies or youth gangs? Or should the blemishes remain no matter what the context?

The answers are ultimately left to you, the stock photographer. It might appear to photography purists that allowing free rein to interpretive photography could lead to a lack of respect for the truth. However, before the arrival of the photograph and the photographer, pictorial illustrations came in the form of etchings, cartoons, drawings, and paintings. We accepted the artists' interpretations and managed to survive.

In photo illustration work, then, you are frequently and legitimately *making* a picture, not *taking* it. For example, you see something happen, you feel it was significant, and you would like to photograph it. You have two alternatives.

1. You can hope it happens again in your lifetime.
2. While you're still on the scene, you can attempt to re-create it, "improving" it (stripping it of distracting elements) as you do your $P = B + P + S + I$ principle.

In stock photography, you can also create scenes that never happened, but could happen. On an assignment to photograph a child's visit to a toy factory, for example, I realized my little model wasn't at all intrigued

THE WAY THE PROS DO IT

Trends are an important factor for some of your editorial stock photo clients. Here are two clues on how to keep up. Check out the new book categories at popular stores like Barnes and Noble. They've already done the market research for you by bringing out books that will match current trends. Secondly, attend trendy events like film festivals and observe what's currently hip in the way of clothing styles.

by the assembly-line production. The bits and pieces didn't look like toys yet, the pounding and banging of the machinery was hurting his ears, the paint smell was disagreeable—yet I needed to illustrate a small boy's excitement at seeing toys being manufactured. In desperation, I wadded a piece of bubble gum (when working with kids, always have a supply of goodies handy) and stuck it on one of the panels of a toy truck as it moved toward the next assembly stage. I stood on a ladder above the moving belt and asked my model to point out the bubble gum as it came into view. He did so with enthusiasm, and I snapped a picture of a delighted youngster pointing at a toy truck on an assembly line. In stock photography, it is true, you may bring elements together that never happened. You are, in effect, contriving. However, you can keep your illustrations authentic by selecting situations that could happen and then reenacting them in a way that appears unposed.

Danger Ahead: Trite Pictures

There's a trap waiting for the photographer who is new to stock photography. Although I continually remind you in this book that workaday pictures are the most marketable, that kind of subject matter can fall into the trite category—if you let it. Corny pictures are easy to produce. Beware of the temptation to take pictures that are trite, cute, or clichéd.

"There's nothing new!" you're probably saying.

Stop. Think about the pictures in your portfolio, print notebook, or recent slide show. If you were to eliminate (1) dramatic silhouettes, (2) sunset scenes, (3) postcard scenes of mountains and clouds, (4) portraits of old men, (5) the father lovingly holding his daughter, and (6) experimental abstract shots, how many pictures would you have left?

I don't want to imply that the previous subjects are always trite. We have all seen these subjects treated with compassion, depth, and a sense of beauty. Many of them can qualify as standard excellent pictures. However, the more photographs we see of these familiar subjects, the less charity we have available for them in our appreciation bank.

The tendency to take trite pictures is almost a disease among

photographers—even veterans. Because we see trite pictures every day in local, regional, and national publications, we become conditioned to the status quo. Photographers find an easy way to take a school portrait, a commercial or architectural shot, or a standard stock photograph, and they gradually lock themselves into an effortless routine that stifles creativity.

Photography, especially photo illustration, has become a vibrant communication vehicle in our daily lives. The public expects not only to be entertained, but also to be informed by photos; people don't take well to stock photographs that, like old news or old jokes, are mere repeats. People want new insights and angles, and thought-provoking interpretations of everyday subjects. As Don Hewitt, famed producer of CBS-TV's *60 Minutes*, says, "Show me something I don't already know!"

HOW TO AVOID MAKING TRITE PHOTOS

Let's say a publisher has assigned you to produce a photo essay on "The Circus." Take a scratch pad and jot down ten picture situations that come to mind. Don't read further until you've jotted down at least ten. . . .

That was easy, wasn't it? Well, if it was, I'll bet you've listed ten trite ideas. Producing untrite pictures takes thought.

Before you rush out and snap away five rolls of 35mm film on a subject that every man, woman and child is familiar with, take at least a half hour to sketch out some picture possibilities. This brief exercise will save you hours of location and computer time spent on pictures that a publisher would probably reject. It will also eliminate those blinders we often inadvertently wear when we arrive at a picture-taking locale and become immersed in the scope and immediacy of the situation. Objectivity is easier to retain if you have a preplanned sketch of what you want to photograph before you get there. By the same token, don't go overboard and lock yourself into a plan that has no room for spontaneity and innovation sparked by on-the-scene elements. Always be ready to discover and adjust to new picture possibilities.

Let's take our circus example. These shots are not new to us: the clown in his dressing room; the elephant's trunk appearing through the window

of the circus moving van; the tightrope walker silhouetted by spotlight against the tent's ceiling; the roustabouts taking a well-earned coffee break; the trainer at work with his chimpanzees; the cleanup crew the day after. We've all seen these pictures over and over again. Maybe the documentary photographer can be satisfied with such pictures, but not the stock photographer or the photobuyer who strives to provide fresh insights, even on such a familiar subject as the circus.

What do we want to see in your essay on the circus? The answer will take thought, timing, and preparation on your part. Imagination, luck, and persistence will be important, too. You've got to zig when other photographers zag. You've got to anticipate. Most importantly, you've got to show us the circus as we never imagined it could be. (Don't interpret this as license to shoot obscure, experimental, weird-angle pictures in an effort to be different. That would be equally trite.)

What nontrite pictures, then, will you shoot at the circus? For starters, let's see an extreme close-up of one of the acrobats straining at push-ups, showing the effort and dedication it takes behind the scenes to produce a quality performance come showtime. How about a mother with toddler in arms happily finding a seat ringside? Or a stocky father lifting his three-year-old up to touch the bar of the trapeze? How about a backstage shot of a roustabout pumping air into the tire of the goofy mobile while the chimpanzee driver waits nearby? As a stock photographer, you must remember that readers of publications are people and that people love to watch and learn about other people. You will record how spectators at the circus relate to the performers (with admiration?); to the animals (with amazement, fear, or pity?); to the atmosphere generated by the circus (with awe?); to each other (with friendship?). You will include symbols of the circus in your pictures—a trapeze, a cage, a tent—but you'll keep these low-key, to serve only as incidental elements to establish the circus atmosphere.

In most cases, you will want to apply the principle of making a picture rather than taking one. You can reenact or improve picture possibilities by asking the cooperation of spectators or performers. To a clown: "Would you mind taking a bite of that cotton candy again?" To a teen-

ager: "Could I ask you to do that again—over here by the zebras?"

To see a refreshing photographic insight into the circus, look up an archive copy of the January 1986 issue of *American Photographer* (now *American Photo*) at your library, and turn to the feature by Susan Felter on page 58.

Photography is visual, and you can escape the plague of triteness by constantly visualizing picture-taking possibilities. Most successful photographers use this secret, so why not try it out yourself? In free moments, even days before you actually perform your assignment (circus, annual report, political convention, and so on), visualize the hundreds of picture-taking possibilities that will probably come up. Eliminate the trite, the corny, and the too cute. Concentrate on innovative possibilities that are practical and realistic. (This process will save you on-the-scene time, too.) If you visualize, you'll arrive at your assignment well prepared. Most important, you will have worked all of the tempting trite pictures out of your system, and you'll be able to concentrate on a fresh approach to your subject matter.

Are trite pictures salable? Like trite paintings, songs, and handicrafts, they are. There also are directories, Web sites, catalogs, and CD-ROMs devoted to displaying trite stock photos, and books devoted to making trite photographs—*but not this one*. If, after reading this admonition against trite pictures, you find some culprits in your stock photo file, send them to a stock photo agency (see chapter twelve). Veteran photographers are familiar with stock agencies' need to provide standard trites to their (mostly commercial) clientele. One photographer friend says, "I market my best pictures myself, and I dump my clichés on my agency, which can use all I can send." While agency cliché sales do come in, for any one photographer the checks are "every now and then." You don't want to depend on them to pay the rent.

How to Manage Models

Marketable stock photos are very often pictures of people doing things. How well the people in your pictures perform can determine the success of your photos. The commercial service photographer usually has the

convenience of working with professional models. In contrast, most of your models in stock photography will be regular folks rather than professionals, and it's up to you to make sure they feel comfortable and are cooperative.

You will encounter many of your models spontaneously in the course of your routine shooting. For the most part, children, teenagers, and adults will willingly cooperate with you for the fun or novelty of being photographed or being involved in the action. People often are intrigued that their picture might be published.

Before you begin photographing your on-the-spot models, let them know who you are and why you want to photograph them. Take the time to make them feel at ease.

Often their first question will be, "What's this photograph going to be used for?" Give your models a direct answer: "For a book. If this photo is selected for publication, you'll appear in a school textbook." Or "For a magazine [name]." Or "For my photograph files. I'm a stock photographer and have a library of pictures that I sell to magazines and books." Give some examples of where the picture might be used.

CONTROL THE CONVERSATION

If it seems appropriate, explain the mood you're trying to capture in your pictures. Control the conversation throughout the whole picture-taking session to trigger naturally the kind of expressions you're aiming for. Don't let the conversation slip into a subject that is contrary to the mood you are trying to create. For example, if your picture calls for a happy mood, steer the conversation away from war, taxes, or the fire that took so many lives last week or the twenty-car pileup on the freeway this morning. However, if your picture calls for somberness, guide the conversation to something difficult or puzzling (not necessarily sad—serious expressions can be interpreted as sad).

HOW TO GET THE MOST FROM YOUR MODELS

Sometimes, to elicit the right kind of expressions from a nonprofessional model, you'll need to go a few steps further and become an actor—

occasionally to the point of giving an award-winning performance as a clown, demagogue, or saint.

After a while, you'll find that in working with people for your pictures, you've developed a technique of gentle persuasion. You become adept at moving the conversation along the lines you want it to go.

Be as selective as the situation allows in your choice of models. Don't choose the model because she is a neighbor, relative, or friend. You'll make your task easier if you choose a model whose natural style or demeanor comes close to the expression you're aiming for—a serious thinker for sadness or weary expressions, a clear-eyed, upbeat individual for happy shots, and so on.

Here are some tips on how this works in practice.

HAPPINESS. Don't ask for a smile. Instead, maneuver the conversation to some magic questions that always get smiles.

SENIORS: "Do you have any grandchildren?"

ADULTS: "How's your golf [bowling, tennis] game?" Or "Been anywhere fun on vacation lately?"

TEENAGERS: Teenagers usually won't allow themselves to be categorized. I've found it best to learn the teenager's interests first (sports, music, movies, and so on), and then ask questions in those areas. Don't attempt to speak their language. They'll only become more suspicious of you.

PRETEENS: "Who's your boy- [or girl-] friend?"

SMALL CHILDREN: "What's your dog's [cat's, horse's] name?"

BABIES: If you make strange noises, you'll usually be rewarded with a smile (from everyone!).

SORROW. Some people (Abraham Lincoln, for example) look sad naturally. You can induce a sad-looking expression by asking a model to look tired. Another method is to catch him "between expressions," which can appear pensive and sad-looking.

INTIMACY. Shoot from a three-quarter view with a long lens. This

will bring two people closer. Ask your models to look at each other's eyebrows. Unless they are pros, models who do not know each other will feel self-conscious, and your resulting pictures will look stilted. For your intimate pictures, choose models who know each other.

OVERCOMING SHYNESS. Use a long lens when your model is shy

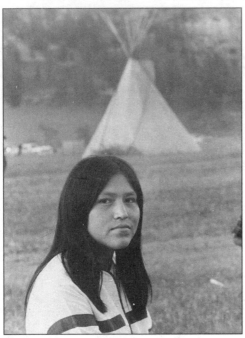

about being photographed. Teenagers are often self-conscious when asked to be photographed. If you need a single shot, ask the shy teen to be photographed with a friend. Then use a telephoto lens to capture a single portrait of the person. In Illustration 6-1, the long lens also brought the tee-pee (see chapter two for more on symbols) closer. "Don't take my picture!" shy people will often say. To accomplish your mission, try taking a picture of what they are doing, as in Illustration 6-2. If people truly do

Illustration 6-1.

not want their photograph taken, you should respect this.

Children are good models and can be diverted in ways that will enhance picture content. They tend to participate more fully than teenagers or adults. A good technique is to get your kid models involved in guessing games with you (the type of games we offer our children on long, boring car rides). Kids become animated when they like what they're doing. Children, like pets, are fast, though, and when photographing these subjects, you have to be alert and on your toes.

Pictures of people sell. Photo editors know that we're human, that nothing touches us more than a picture of someone feeling something we identify with—be it anger, humor, pensiveness, bewilderment, or

Illustration 6-2.

delight. Thus, when you aim your camera at your models with photo illustration in mind, you've got to adjust your thinking from the cosmetic approach usually employed when taking pictures of people. Your customer is not the portrait client or the bride or Aunt Harriet, but a photobuyer. Photo editors are not interested in how pretty or handsome you have made your subject appear, but in what emotion, what spontaneity, what insight into the human condition you have captured.

Should You Pay Your Models?

If you're shooting on speculation for inventory for your stock photo file, many of your on-the-spot models will be satisfied with a copy of the published picture (tearsheet) if and when it is published. Other nonprofessional models are willing to cooperate just for fun or for the experience, especially if you're a beginner yourself. Still others are happy to have copies of the photographs. Give them your card, and have them write to

you for the pictures. If you do promise photographs, and they contact you for them, follow through. You'll find, though, that the majority of people don't get around to writing for the pictures.

Monetary payment is in order for nonprofessional models when you're shooting a commercial assignment as a service photographer. A good rule of thumb is to budget a minimum of 5 percent and a maximum of 10 percent of the fee you're receiving for the picture to pay your model(s). Seal the transaction with a signed model release. I've included a sample model release that you can use. (See Figure 15-2.)

Other Model Sources

A good source of models is your local community theater. Amateur actors always need portraits for their portfolios. You can trade them some portrait shots for their posing (in natural settings, of course) for your people-picture needs (e.g., people talking, engaged in some activity, expressing fear, sadness, loneliness, joy, and so on).

You can try to find models at the drama departments at your local university, community college, and high school.

Check also with local families and neighbors in need of family portraits. I will often sketch out photo illustration ideas (using my principle $P = B + P + S + I$—see chapter two) and have the members of the family act out the photo illustration situations. In return for their modeling services (about an hour's work), I supply them with a family portrait.

When Is a Model Release Necessary?

It is the *usage*, not the picture, that determines whether or not a model release is needed.

If the photograph you take might be used commercially (basically for advertising), you will need a model release (you may also need a property release). If the photograph will only be used editorially, you will not need a model release in ninety-nine out of one hundred situations.

Generally speaking, commercial usage is when a photograph is used in an advertisement and/or to endorse a product or service. Editorial

usage is when a photograph is used to illustrate an article in a magazine, newspaper, or book.

If you don't want the intrusion or the administration of releases for each photo, a general rule many stock photographers (and some service photographers) follow is to use photogenic neighbors, friends, and relatives as models. If you need a model release for a particular photo later, you know where to find the models to obtain it.

Occasionally I get a model release request for a picture I took a decade ago. I consult my model file-card box and usually find that I received a blanket model release for an entire family when I originally took the picture. To obtain a blanket release, I had both parents fill out and sign the release and asked them to list their (minor) children.

What if I don't have a release? Because the model was usually a neighbor, friend, or relative, I often can track them down for the release.

In the early stages of my stock photography career, I obtained model releases on every occasion. I have since turned this completely around and now almost never get one. Experience has shown me that this administrative disruption of the mood or atmosphere of my picture-taking session isn't necessary. Model releases are not required when a picture is used for educational or informational purposes. Since my personal Market List consists of magazine and book publishers, I rarely get a release request from an editor. However, since your PS/A and Market List are different from mine, you will know how extensive you'll want your model release system to be. (See chapter fifteen for a full discussion on model releases.)

Dealing With Officials

The scene: You've arrived at an important high school football game to get pictures of the kickoff for an assignment and for your stock file. You'll leave as soon as you get the kickoff pictures, so you see no reason to pay admission. You enter by a side gate and are met by an attendant with an officious "Where do you think you're going?" expression.

You're not going to let this fellow steal your precious minutes, so you try to ignore him. You walk right past him. "Wait a minute!" he says,

insulted that you have not recognized his importance. He has the right to detain you, and he does—long enough for you to miss the kickoff shots.

Sound familiar? It will, unless you keep in mind the stock photographer motto: "Officials: Handle With Care."

As stock photographers, we frequently can't get our pictures without first having to get permission from someone. Security is getting tighter in many sectors, which is understandable because past abuses—or the sheer numbers of people—have made it necessary to screen who takes pictures of what. You'll encounter officials in many forms: gatekeepers, receptionists, police, bureaucrats, teachers, secretaries, and security guards. You'll even encounter unofficial officials: janitors, ticket takers, and relatives of officials. No matter who presents himself as an official barrier to your picture taking, handle the person with care, allowing for the amount of time you sense will satisfy his need to detain you. For example, a gatekeeper with sparse traffic might have the luxury of detaining you longer than one who is dealing with hordes of people.

One of the easiest official-eliminators is the "I need your help" routine. In the case of the football gate attendant, you say, "I need your help. I'd like to get a dramatic picture of the kickoff (look at your watch). Could you tell me the quickest way to the fifty-yard line?"

If an official wants to know something about you—why you're here, what the pictures will be used for—here's the answer: "I represent the John Doe Stock Photo Agency, and I'm John Doe. These pictures go into my files of over five thousand stock photos. They're used in magazines, textbooks, calendars, anything that would be in the public interest—you name it! (Smile.)"

Try to cultivate officials who could have access to information relevant to your assignment. Ask questions such as: "When will he be back?" "How many players are on this team?" "What time does the gate close?"

When you encounter an official who isn't cooperative, try offering a copy of the picture you're going to take. Don't take his name on a piece of paper; such papers either get lost or add to your office work. Instead,

offer him your card and say, "Here's my address. Write me in about two weeks. The picture will be processed by then." (Experience predicts that you have a one-in-a-thousand chance of hearing from him.)

Should you carry a press card? For large, important events, written permission from headquarters is your best introduction to on-site officials (headquarters usually issues its own press cards, stickers, and/or passes). For the 999 other events you'll attend, officials don't ask for a press card. If you're carrying two or more cameras around your neck (even if they're borrowed from a friend), that's official enough for them.

If you've found officials to be a constant thorn in your side, try the handle-with-care approach. However, there's an exception. If you stand to lose too much time by acquiescing to an official's demands ("Wait over there"; "Fill out this form"; "Stand in line"; "I'll put you on hold"; "I have to check with my boss first"), then take a different tack: Try a different official. In the case of the football gate attendant, if he is uncooperative, walk away and find another gate. In the case of an uncooperative receptionist, wait until she goes on a coffee break or to lunch. The replacement might be more agreeable (or you might think of a better approach).

In cases in which no officials appear, don't go out of your way to find someone to ask permission from. That someone may have no authority (a waiter in a restaurant, an attendant at a conference); he'll only pass the buck, detain you, and cause delays. Rather than take no pictures (because you didn't have permission), jump in and start clicking. An official will usually come forward. Before he gives you his routine, give him your "I need your help" routine.

Officials can delay or even prevent you from getting your picture. When all else fails, remember this: It's sometimes easier to apologize for jumping in and getting the photos than it is to get permission.

However, you owe it to yourself and to the rest of us in the field to carry out your projects in a professional way and in a manner that will earn the respect of the public. Keep courtesy a priority.

The Fine Art of Dealing With Photobuyers

GETTING TO KNOW THEM

Thousands of photobuyers exist in market areas ranging from the commercial (advertising, public relations firms, corporations, and so on) to the editorial (books, magazines, and publishing houses). In this book, when I refer to *photobuyers*, I will be referring almost exclusively to those (mainly editorial) photobuyers who deal with the stock photographer and not those (mainly commercial) photobuyers who deal with the service photographer.

Art director, photobuyer, picture editor, designer, photo researcher, graphics director, photo acquisition director, and photo editor are just a few of the titles bestowed on photobuyers at publishing houses and magazines. In this book, I refer most often to *photobuyers*. They usually work out of an office, are between twenty-five and forty-five years old, and approve between two thousand and twenty thousand dollars a month in photo purchases; probably half are female, and all are busy people.

You'll find that photobuyers are interested in photographs, not photography. You'll find, too, that setting up business with a photobuyer is quite easy. It takes just a handshake—in a letter (e-mail or postal), over the phone, or in person. You'll seldom find the contracts or lengthy legal documents (unless you request them) that you often encounter in commercial stock photography.

Photobuyers tend to mellow with age. Younger editors, new to the job, sometimes exercise their newfound decision-making power by exhibiting impatience or intolerance. Handle them with care.

Veteran photobuyers usually have survived the rigors of the publishing world with enough aplomb to be able to take the time to admire a photograph now and then. They've also honed their viewing skills to the point where they can speedily select the image they need out of a large pile, as if by magic. This brings to mind: Always send a photobuyer more pictures than you believe to be adequate, provided the pictures are appropriate. You'll often be surprised at the pictures the editor chooses. Don't edit your selection (except to delete off-target pictures). Let the editor do the editing. Beware, though, that some buyers want only *exactly* what they have requested.

A visit to a photobuyer's office will bring home to you my adage about picture editors buying pictures they need, not pictures they like. The walls of an editor's office are plastered with lovely Track A pictures: prints clipped from calendars or signed originals from friends. Track B pictures, the kind the editor authorizes a check for, are rarely on the wall. What editors need and what they like are different. Marketing is understanding that difference.

Your pictures may have won contests or received awards, but the real judge of a marketable picture is the photobuyer who signs the checks.

The Reliability Factor

Always remember that it can take months to build a good reputation for yourself but only seconds to destroy it.

One paradox in the story of creativity in the commercial world is that those who succeed are not necessarily the most talented. In all creative

fields—theater, music, art, dance—talented people abound. However, the world of commerce is a machine, and a machine operates well only if all parts are moving smoothly together.

The people who sign the checks will readily admit that talent doesn't head the list when it comes to selecting a new person for a part, an assignment, or a position. History has taught them that "the show must go on," that *reliable* people make commercial productions a reality. Someone with passable talent who is dependable will probably be selected before the unpredictable genius.

Thus, an unwritten law in the world of commercial creativity is the reliability factor. How well would you stack up if a photobuyer were to ask, "Are you available when I want to contact you? Are you honest? Prompt? Fair? Dependable? Neat? Accurate? Courteous? Experienced? Sharp? Articulate? Talented?"

I placed "talented" at the bottom of the list because that's where most photobuyers will place it. They assume you are talented. Their basic question is, "Can you deliver the goods when I need them?"

Because you're talented in photography, you purchased this book. You know your work can easily compete with the pictures you've seen published, but talent will not be your key to success in marketing pictures. You will succeed in direct proportion to the attention you pay to developing and strengthening your reliability factor.

There are exceptions to everything, of course. Even with a low reliability factor, some creative people succeed. (Witness the temperamental screen idol or the eccentric painter.) Usually, though, they are coasting on previously established fame, or they exhibit a unique ability. As a newcomer to the field of photomarketing, your greatest asset will be your ability to establish a solid reliability factor with the markets (photo editors) you begin to deal with.

The Photobuyer Connection

You will connect with photobuyers in person, by phone, by fax, by e-mail, and in writing. As an editorial stock photographer who conducts business

via e-mail and the mailbox, it's important to express yourself well in your communications with photobuyers.

From my ongoing overview of photographer/photobuyer relations at PhotoSource International *www.photosource.com*, I have noted that if a breakdown occurs, it's usually because the photographer didn't express himself clearly, whether in text, in person, or by phone.

Many photobuyers reached their picture-editor post after serving as a text editor—and many continue to do both. They're often journalism or English majors initially attracted to editing and writing because of their communication skills.

In dealing with photobuyers, if you experience a misunderstanding or mix-up in regard to purchase, payment, assignment, or whatever, here's how to handle it.

1. Give the photobuyer the benefit of the doubt. Despite the harangues we hear from some of our fellow photographers, rarely will you encounter an intentional hustle on the part of a photobuyer. If you're in a dispute with a photobuyer and you're positive the fault is his, rest assured that it was probably an honest mistake. We're all allowed some of those.

2. Be firm but not offensive. Consider the buyer's self-esteem, too.

3. If you're emotionally upset over a transaction between yourself and a photobuyer, wait a day (twenty-four hours) before you react.

4. Photobuyers are continually up against deadlines and will be short with you. Some will offer you a fuse to ignite; don't be tempted. For a one-page report, "How to Turn a Recalcitrant Photobuyer Into a Kitten," check out *www.photosource.com/101* and click on "Free Reports."

Remember this: The photobuyer is dealing with you probably because she considers your work valuable, even essential. Don't let a harsh word or irresponsible statement slip out and get in the way of future opportunities to publish your work (and deposit checks).

The newcomer to the field of photomarketing often is amazed, and

sometimes insulted, by the casual approach many photobuyers take in their handling of photographers and the photographers' work. To a photographer, a photograph can be like a child, an extension of the soul, a piece of poetry or music. Photobuyers don't have the same reverence for your work that you do; they can't. You may consider your photograph a work of art; to them it's another piece of work to process. This is not to say they don't admire talent or good photography. They do—most of them. However, to survive in their field, they have to learn to separate their emotional appreciation from their career demands.

If you take the same approach with your stock photography—that is, separate and compartmentalize your photography into marketable pictures that will feed your family and not-so-marketable pictures that will feed your soul—you will be able to suffer the jolts and inconveniences of photobuyers without feeling they are callous or insensitive. They usually aren't. They're just doing a job, and they're usually doing it well.

Should You Visit a Photobuyer?

If you tailor your marketing plan correctly, your specialized markets will be scattered throughout the nation, even the world. Unlike the service photographer who can work effectively with commercial accounts within the confines of a single city, the editorial stock photographer deals with far-flung buyers—mostly through the postal mail (see chapter nine) and e-mail.

I have dealt with some photobuyers for a decade and have never met them. My reliability factor continues to score high with them. A personal visit would serve only to satisfy our mutual curiosity.

Yet while personal visits are not always necessary, they can be a real plus. Personal visits, if conducted smoothly, always help seal a relationship. If my itinerary and schedule permit, I drop in on photobuyers when I can, to say a personal hello. People do respond more actively to a face than to a letterhead. If you're trying to develop a new market, a personal visit to a key buyer could be your turning point. Or a personal visit might help solidify

your relationship with an editor you've already been dealing with successfully. However, you will not necessarily find photobuyers eager to set up an appointment with you, especially if they don't know you. Talent is plentiful. Besides, they have deadlines coming up tomorrow. If they need photographers, they'll consult their photographer files. They know that personal visits take time and aren't often immediately fruitful. Their needs are too specific for a general introductory visit to solve.

Don't make an appointment unless (1) you have sold a picture to the photobuyer in the past, or (2) you have something of value to give the photobuyer, such as information or photos targeted to what you have learned is a current need for him. Photobuyers are understaffed and underpaid. They'll have little reason to welcome an "I'm me and I have photos" visit from you. You'll end up creating a reaction opposite to what you're after and getting put on that buyer's blacklist. If you can make your visit worthwhile to the photobuyer, however, you'll be greeted warmly and your time will be well spent.

Realistically, a visit to a photobuyer can be extremely costly for you. In effect you are making a sales call, and in the corporate world, a salesperson's call costs just about the price of the suit he is wearing. As of this writing, the average cost of a sales visit is $357. If you live close to some markets, those visits need not cost that much. For your far-flung markets, though, the cost could be much more.

By working smart, you can cut such costs by diverting funds that would be spent for personal visits toward contacting buyers by e-mail or postal mail instead. Since photobuyers buy pictures not because they *like* them but because they *need* them, your tailored selection of twenty-five to a hundred images on a CD, or your tailored sales sheet mailed to a buyer, will serve the same purpose as a personal visit with your portfolio. Also, your selection will receive more attention from the photobuyer. Remember, as an editorial stock photographer, your separate photobuyers will not require you to be versatile; therefore, a portfolio that demonstrates your wide range of photographic abilities will not be necessary.

Photobuyer Requirements in the Digital Age

With the digital age upon us, the postal system is fading as the main method of contacting and submitting to photobuyers. Stock photographers have to learn new sets of contact and delivery protocols. The "mail order" part of our business still exists, but it's going, going, and soon to be gone.

Recent requirement of photobuyers who list their needs in the *PhotoLetter* and *PhotoDaily* market letters give insight into the "new ways" to conduct the operation of your business, especially the delivery option. Here are some sample quotes.

We prefer to view photos on a Web site or sample digital preview scans.
—Paula Heyer, product manager, Thayer Publishing

Request sample digital preview scans, or link to online samples of previous work.
—Gregory Matusky, Gregory Communications

Prefer sample digital preview scans, or a link to a light box.
—Laura Wyss, St. Martin's Press

View the "Submitting Photography" page at our Web site, and our photographer guidelines, before sending work.
—Liz West, art editor, *Florida Wildlife Magazine*

Should You Write?

Despite the convenience to you of e-mail, postal mail is by far the most effective way to contact and deal with photo editors. Chapter nine shows you how to write the standard cover letter (Figure 9-1) and how to graduate to the "magic" query letter (Figure 9-2) that captures a buyer's interest every time. You'll also learn that looking like a professional is key to the success of any correspondence you have with a photo editor.

Letter writing is probably the least expensive method of contacting photo editors, save e-mail (but e-mail has its own inherent problems—how do you like all that unsolicited e-mail you receive every day?). Never-

theless, the corporate world tells us that letter writing is not cheap: Each business letter costs about the price of breakfast at a restaurant. As of this writing, the cost is $8.75. The stock photographer's letter can be much less expensive, as I'll show in chapter nine. Because you have narrowed your list to a select group of markets, you'll find that you'll need only about a dozen basic letters.

By using the mail to contact photobuyers, you'll have the opportunity to include self-promotional literature ("sell sheets") that will serve as an effective reminder to your clients that you exist and that you can produce what the photo editor needs.

One excellent way of writing photobuyers is to use postcards. If you have your own postcards printed, you can display one—or more—of your images when writing a prospective client. MWM Dexter *www.mwmdexter .com* and Modern Postcard *www.modernpostcard.com* are two postcard printers that come highly recommended.

Should You Telephone?

Phoning can be a bit of a gamble and should be avoided unless absolutely necessary. The reason for this is simple. When you send a photobuyer a postcard or an e-mail, the photobuyer can read it and see it when time permits. A phone call has to be dealt with then and there, which might be an interruption for the photobuyer.

Above all, do not use the phone to find out basic information. If you need to find out the name of a photobuyer, check out the organization's Web site, or ask the receptionist answering the phone.

If you need to call the photobuyer, here's the secret: Before you make the call, study the buyer's needs backward and forward, get the company's editorial calendar (of upcoming features), and then make up a *give* list. Decide what you will give the photobuyer.

How do her needs match your PS/A, your Photographic Strength/ Areas? You won't be wasting her time when you can say: "I'm a bass fisherman, and I have some excellent pictures of bass fishing in Florida, which I understand you'll be covering in your magazine next August."

Once you've established contact with a photobuyer and perhaps sold a photograph or two to him, the following kind of call could be appropriate: "I regularly vacation in Maine, and I'd be available for assignment when you need to update your files of New England pictures."

This call is better avoided: "I notice you have continuing need for classroom pictures. My neighbor is a teacher. With a few guidelines from you, I could get the kind of pictures you want."

Instead, check the photobuyer's Web site for submission guidelines. If there are no guidelines on the Web site, write the photobuyer asking for a copy of the guidelines, and enclose an SASE (self-addressed, stamped envelope).

Generally, if the information you want the photobuyer to have can be communicated on a postcard, in a letter, or by e-mail, pick that option instead of calling.

Should You E-Mail?

You bet. However, there are a few things to keep in mind.

1. E-mails to info@, sales@, and similar "general" addresses are seldom successful unless you're requesting very general information. Often these are autoresponse mailboxes and will only send you a boilerplate response. Find out the name and the e-mail address of the person you need to get through to.

2. Spend some time browsing the publisher's Web site before you e-mail a question. Sometimes the answer is readily available on the company's Web site.

3. *Spam* is the word used to describe inappropriate, unsolicited "junk e-mail." If you have the need to send a large number of e-mails to photobuyers, always see to it that the option of being taken off your e-mail list is included in the missive.

4. Unless you're on a first-name basis with the photobuyer, avoid irony, sarcasm, and other things that could be misunderstood. In addition, rarely rely on the smiley face, :), to cover a dubious statement.

5. You've probably received e-mails sprinkled with misspellings, poor phrasing, and "cute" emoticons like :-), or Internet abbreviations such as *lol*, IOW, and so on. They didn't make a favorable impression, did they? Although this style might be acceptable to friends and family, it won't go over well with business associates.

6. Be persistent, but also be patient. If you plan to follow up with a prospective photobuyer, allow enough time for your e-mail to arrive and be read. Then consider a courteous follow-up phone call.

7. Attachments. Unless you've had ongoing correspondence with a photobuyer, it's not a good idea to send unsolicited attachments. With the proliferation of e-mail viruses, some companies have a policy of refusing e-mail containing any form of attachment. This "refusal" often is handled automatically by their e-mail gateway software before the message is passed to the intended recipient. You can work around this problem by uploading photos or text to your Web page and giving the URL address to your correspondent.

8. Cute jokes, chain letters, urban legends, hoaxes, and computer virus warnings that you've received from others don't have a place in your business correspondence.

Get on the Available-Photographers List

Your Track B list probably features several strong areas of special interest, ranging from gardening to sailing. You have contacted a number of potential photobuyers in each of these areas, all of whom would like to know more about you because your photographic interests match their needs. They each maintain an "available-photographers list" in the office. If your reliability factor looks high, you could be on several dozen photobuyers' lists. Here's how you get on a list.

Make a *categories* form letter similar to the one in Figure 7-1, and send it to photobuyers in your target market areas. Don't give in to the tendency to print only the few categories that match your Track B chart. Instead, write them all down, but check off only the ones that apply to your PS/A and the photobuyer's needs. This may be only five or six

YOUR LETTERHEAD

Dear Photo Editor:

Kindly include my name and my work on your photographers list. I have checked off several areas below that I have strong coverage in and where I could be of photographic service to you.

Format Available
- ☐ 35mm color transparency
- ☐ 2¼ color transparency
- ☐ 4×5 color transparency
- ☐ Digital delivery by e-mail
- ☐ Digital delivery on CD
- ☐ 8×10 black and white
- ☐ Other _____

Reproduction fee for one-time inside-editorial North American print rights. Other rights (e.g., electronic rights and cover rights) are available upon request.

Black and white: _____
Color: _____

Holding fee past two weeks:
- ☐ I charge no holding fee.
- ☐ My fee is: $ _____ Color/Week
 $ _____ Black and white/Week

Social
- ☐ Health
- ☐ Welfare
- ☐ Drug abuse
- ☐ Alcoholism
- ☐ Violence
- ☐ Sex education
- ☐ Rights movements
- ☐ Emergency
- ☐ Role reversals
- ☐ Juvenile delinquency
- ☐ Other _____

Nature
- ☐ Animals
- ☐ Scenic
- ☐ Seasons
- ☐ Other _____

Sports
- ☐ Basketball
- ☐ Football
- ☐ Baseball
- ☐ Track
- ☐ Other _____

Education
- ☐ Adult education
- ☐ Primary
- ☐ Elementary
- ☐ High school
- ☐ College
- ☐ Vocational
- ☐ Other _____

People

☐ Preschool
☐ Elementary
☐ Junior high
☐ Senior high
☐ College
☐ Adult
☐ Families
☐ Senior citizens
☐ Multiracial groups
☐ African Americans
☐ Native Americans
☐ Hispanics
☐ Asians
☐ Middle Easterners
☐ European Americans
☐ Other ethnic groups
☐ Customs
☐ Holidays

Other

☐ City life
☐ Rural life
☐ Environment/ecology
☐ Occupations
☐ _____

Religious

☐ Congregational worship
☐ Communion, baptism, bar mitzvah
☐ Adult education
☐ Missionaries
☐ Church school: age levels _____
☐ Family worship
☐ Religious holidays
☐ _____

Industrial/Technical

☐ Food
☐ Agriculture
☐ Industry
☐ Government
☐ Labor
☐ Manufacturing
☐ Mining
☐ Transportation
☐ Communications
☐ Fisheries
☐ Tourism
☐ Entertainment
☐ Medical
☐ _____

Travel

I have current pictures (within the last three years) of the following COUNTRIES:

I have current pictures (within the last three years) of the following STATES:

[Your Name]

Figure 7-1. Tailor this sample marketing categories form letter to the photo editor you are contacting. If you are a ''specialist,'' you'll find that the photo buyer will take an interest in you. ''Generalists'' who have not mastered at least one of the categories listed are of little interest to the buyer. Don't be tempted to check off dozens of categories.

checkmarks. Photo editors will gravitate to their own immediate spheres of interest, and when they find those specific areas checked off, they'll take notice of you. Since you checked few other areas, they'll know you aren't dissipating your photographic talents over territory that is of little concern to them, and concomitantly that you must have a lot of material in the areas you concentrate on, i.e., what they specialize in. This is one of the reasons I suggest you curb your picture-taking in Track A areas and accelerate your Track B areas (see chapter three). This form letter is another way of saying to photobuyers, "I'm the person for the job." The photobuyer will respond, "This photographer speaks my language."

The categories letter is appealing to photobuyers because it doesn't call for any action on their part. They can just file it for future needs. Moreover, it is concise and to the point.

Photobuyers will do one of four things when they receive your letter:

1. Throw it away.

2. File it to have on hand for reference.

3. Phone you because of an immediate photo need.

4. Put you on their available-photographers list.

Note: To repeat, resist the urge to appear versatile by checking off several categories. Photobuyers prefer dealing with specialists in their areas. If you do check off plenty of squares, they'll say, "No one is *that* good!" and they'll choose the photographers who definitely appear to have large stock files in their areas of interest.

The available-photographers list in the photo editor's office can take many forms: $3'' \times 5''$ file cards, a three-ring notebook, separate files, or a computerized database. Photo editors will add notes to your file, such as what they perceive to be your strong areas within their categories of interest. They may also add notes concerning conversations with you, assignments, and a running list of your pictures they have used to date or pictures they have scanned to include in their central art file for possible future use.

Once you're on the buyer's available-photographers list, you will peri-

odically be sent a "needs" or a "want" sheet, which delineates the current photo needs of that publishing house or magazine. Send pictures in for consideration whenever you receive a needs sheet. Depending on the arrangements you have with the photobuyer, you can submit either original transparencies or digital preview scans. Since the sheet describes the exact photos needed, you'll find yourself saving time and postage and earning points by not sending inappropriate pictures for consideration. The photobuyer will welcome your pictures because they are tailored to the publication's needs.

Since the publishing industry is forever in a state of change, mail or e-mail your categories form letter to each entry on your Market List at least once a year. Why? Because some things might change: (1) your priorities, (2) the photobuyer's priorities, (3) your address, (4) your Web site, (5) your stationery, (6) the photo editor's address, (7) the photo editor.

Whether or not any changes have occurred, this letter is a good reminder to the photo editor. New competition appears on the scene every day. Your letter will keep you and your work in the front of the photo editor's mind.

Selling the Same Photo to Multiple Buyers

Multiple submission is the phrase often used when photographers submit the same photographs to different publishers at the same time. Unethical? Not at all. The reason? You're submitting your Track B pictures to specialized markets targeted to different segments of the reading (viewing) public. There is no cross-readership conflict, especially if your markets are regional or local. In other words, the readers of magazine X never read magazine Y or Z. Feed those statistics into the ten thousand photo-buying markets that exist, and you can see why an editor is not too concerned if your photo has already appeared, or will appear, in magazine X.

What's the appeal of multiple submissions to photobuyers? Savings. Most editors don't have the budget to demand more than one-time rights.

They know they can get a picture much cheaper if they rent (lease) the picture from a photographer on a one-time basis.

The multiple-sales system also is healthy for you, the stock photographer. It will encourage you to research more picture-taking possibilities, as well as produce more photographs because you will be getting more mileage out of each photo through multiple sales.

Multiple submission, of course, does not always apply to major national publications, such as *People* or *Ladies' Home Journal*, who would prefer that you sell them *first rights* to your picture. Nor does it apply to commercial stock-photographer accounts where you often sign a work-for-hire agreement in which you transfer all your picture rights to your client. (This is a procedure I do not recommend to the editorial stock photographer—more about work for hire in chapter fifteen.)

However, you'll find that you can use the multiple-submission system with 95 percent of the photo editors you deal with. The exceptions will be, as mentioned, large-circulation newsstand magazines, most calendar and greeting card companies, ad agencies, public relations agencies (service photographer areas), and other commercial firms that require, because of their nature, an exclusive right to, or sometimes ownership of, your photograph. (Unless a photobuyer offers you a fee you can't refuse, don't sell anything but one-time rights.)

Many of my pictures have been worth more than one thousand dollars in total sales. With one picture, for example, an art director wanted to pay me five hundred dollars for all rights to the image. That picture has earned $6,500 so far. If I had sold it for five hundred dollars, I would be out six thousand dollars! The cash register keeps ringing. I'll also be able to pass the rights to the photo on to my heirs.

Scanning and Photocopying Your Photographs

A great boon to stock photographers has been the practice, on the part of photobuyers, of scanning or photocopying certain pictures (black and white or transparencies) when you send them in for consideration. The advantages:

1. Although photobuyers may not be able to immediately use a picture

you have submitted, they might anticipate its future use. A copy in their central art file will serve as your calling card. When the need arises for your picture, the photobuyer contacts you for the original.

2. Some buyers might hold copies of twenty to thirty of your photos in their central art libraries (see pages 120). Often as many as ten to forty other photo editors at the publishing house can have the opportunity to view the pictures.

3. Since your original is returned to you, you can send it elsewhere. Conceivably, photocopies or digital scans of the same picture can be working for you in a couple dozen central art libraries at the same time.

4. You incur no costs.

And the disadvantages? Unauthorized use of your photocopies for display layouts might occur. Copyright infringement? There isn't any. The photobuyers are using your picture for the purpose of research [Sections 113(c) and 107 of the Copyright Act (enacted 1978)]. They are required neither to ask your permission nor to compensate you for its temporary use. However, that's a small price to pay (and it happens only rarely) for the marketing potential your pictures enjoy while on file.

Digitizing of black-and-white and color photos is now refined to the point where it's difficult to tell the difference between your original picture and the resulting copy. Is this a disadvantage?

Not really. Photobuyers will sometimes make digital copies—more often than not low-resolution scans—of some of your images to keep on file. Should you allow photobuyers to do this?

Absolutely.

Does the possibility exist that one of your images might be used without your permission? Yes, it does, but it would be very rare.

In the last century, with the introduction of scanning and storing devices, photographers feared that publishing house art directors would capture a photographer's photos into the company's database. They would then use the photos without paying or crediting the photographer.

Except in a few rare cases where misunderstandings were to blame, this has not happened in the editorial stock photography field.

The Central Art File

Publishing houses usually start from a modest venture and then expand, sometimes over several generations. The main theme of the publisher usually remains the same. For example, automotive publishers expand with things automotive, and so on.

Large houses have large photography budgets; forty thousand to fifty thousand dollars per month is not uncommon for a large publishing house. If you've done your research well, part of that budget can be yours, because you can supply pictures that fill their needs.

As you research market possibilities geared to your Photographic Strength/Areas (PS/A), you'll plug into some large publishing houses with twenty to thirty or more editors, for as many periodicals and/or book specialties within the same firm. In marketing your pictures to such houses, you can save yourself time and expense if you send only one CD or one shipment of one set of prints or slides, rather than thirty sets to thirty separate photobuyers.

In most magazine or book publishing houses, you'll find a central art library (sometimes called the *photo library* or the *photo file*, and sometimes referred to as "the morgue"). Depending on the structure of the library, it will accept photos in various forms: originals, dupes, photocopies, and digital images. Incoming pictures are logged by a librarian and then distributed to the appropriate photo editors (or art editors or designers) for viewing. If your picture(s) is selected, the art librarian will make a delivery arrangement, put a purchase order into motion and, within a month or so, you will receive a check.

Original color transparencies are returned to you, but once your black-and-white or color print is used, it's tagged and placed in the central library's filing system, usually by subject, age bracket, or activity. Digital images are cross-referenced by author and subject matter and stored in a database.

"But isn't a used picture less salable?" you might ask. On the contrary. The fact that your picture sold once puts a stamp of approval on it. The next photobuyer who comes along and sees your picture in the file and notes its previous use will more likely want to use it since it has received prior approval from a colleague.

You'll receive, generally, 75 percent of your original fee when your picture is used again. However, if the repeat sale is for other than inside-editorial use, you should receive a higher fee (see Tables 8-2 on page 132 and 8-3 on page 138).

About once a year, the art librarian will conduct a spring-cleaning of the central art file and return outdated photos to photographers.

The PhotoSourceBANK and PhotoSourceFOLIO

Nothing is more important to photo editors than to have the pictures they need in hand, in front of them and ready to go.

As the demand for photography in publishing grows, the need outraces the supply, and immediate access becomes increasingly difficult for photo editors.

Editors with highly specialized needs cannot always find their pictures readily, since most stock photo agencies hold in inventory only generic pictures with the potential to sell over and over. Where does a photobuyer go for that picture taken within the last two years of Albuquerque after a winter snowfall? Or a picture of a carbonized piece of grain? Or a scene of the plains in Iowa as the Mormons might have seen it in their trek across the country in 1847?

Here at PhotoSource International we offer several ways for photographers and photobuyers to find each other. We offer listing services and a photographer's directory (PhotoSourceBOOK) free to photobuyers. For photographers we offer several market letters, where we list images that photobuyers are currently seeking, and the PhotoSourceBANK and PhotoSourceFOLIO services.

Both BANK and FOLIO are services for you as a photographer. Both make it a snap for a photobuyer to find you and find you fast. BANK

allows you to list your photographs on your own page on our Web site, and FOLIO allows you to display six (or more) of your photographs where photobuyers are sure to find them. You can find information about the PhotoSourceBANK by going to *www.photosourcebook.com/bank/photog rapher.php*, and information about PhotoSourceFOLIO by going to *www .photosourcefolio.com*.

The Permanent-File System

Large publishing houses, especially the denominational houses that employ thirty or more editors, are always in need of up-to-date photographs that reflect the society we live in. Their need is so great (they produce several dozen periodicals and as many book titles each year), that editors keep a permanent file of transparencies, black-and-white prints, and color photographs in their art libraries. Some publishers maintain a digital collection. These photographs are chosen because of their broad appeal to the particular readership reached by that publishing house. The editors welcome additions to this file to keep on hand for immediate use when needed.

Photobuyers are fond of saying, "Send me pictures that I can always find a place for in my layouts." Of course, it would take a mind reader to score every time, but if you've been successful in selling to a certain market several times, in all probability you have a keen understanding of the photographic needs of that publishing house. Ask all your photo editors if they have a permanent file; if they do, submit your pictures for consideration. Your photos can be included in the file, and each time a picture is used, you will receive a check. Most photo editors prefer original slides, and you may not wish to place your originals with a central art librarian. However, the system works well for black-and-white prints, color prints, and digital files. Some textbook publishers will accept display dupes as file copies.

Can you depend on publishing houses to be financially conscientious in their dealings in this kind of arrangement? In my experience of more than three decades, yes. The risk factor of a mix-up in use and payments

is low to nonexistent. When you balance an honest mistake every now and then against all those checks you would not have received if you had never placed your pictures with the permanent file, your choice becomes obvious. Your greatest risk actually will be investing in multiple color and black-and-white prints and then relying on your judgment as to which publishing houses would be likely to use them most frequently.

As publishing houses become more sophisticated in developing digital files, the problem of sending original prints and slides to photo editors will diminish. However, you will find that most editorial publishers are more interested in having a print or slide readily available, rather than the computerized version. Is this laziness? In some cases, yes. In reality, though, given the human tendency to resist change, most editorial photobuyers will defend the present way they are conducting business. As the new breed of photo editors comes on the scene, you can expect a shift to more use of digital files and research on the World Wide Web.

From time to time, you'll want to update your supply of work on file by sending a fresh batch of photos. From time to time, too, the art librarian will return pictures to you to make room for more recent submissions.

The Pirates

Some photographers new to photomarketing bring with them misconceptions about the ethics of photobuyers. From my conversations and correspondence with beginners, I'm always amazed at how many have visions of picture-buyer pirates lurking in their office coves, ready to seize some unsuspecting photographer's pictures and sell them on the black market.

Such infringers might exist in the field of commercial stock photography, where stakes for a single picture are known to reach impressive heights (such cases are reported in trade journals such as *Photo District News*); however, in thirty-five years, I have never run across a deliberate case of piracy in the editorial field. An occasional inexperienced photobuyer may make an error of omission or commission. Photographers have been known to do likewise. The lesson here is to be cautious when work-

ing with new publications that don't have a substantial track record, or a third-world publishing house which may be unaware of international copyright law, or publishing houses that have a history of hiring green-horns. I suggest that you deal with publishers who have been in business for a minimum of three years.

The Legal Side

If you're just starting out or starting over, don't be tempted to include the highly legalized transfer documents that are sometimes recommended by the American Society of Media Photographers (ASMP). These can be a definite turnoff to your would-be photo editor. In the early stages, expect to work on a handshake basis. Later, when you're on a first-name basis with photobuyers or they have invited you to call them collect, you can introduce ASMP-type forms with all their legalese and fine print. This doesn't mean that you shouldn't include *any* paperwork at all; include a simple delivery memo (sample forms are available on *www.photosou rce.com/101/answers.html#packagingqa*) and a cover letter.

All in all, you'll find photobuyers of stock photography reliable and interested in you as a person and as a photographer. If you operate with the same attributes, you'll find dealing with photobuyers to be an easy task.

8

Pricing Your Photos

Master Your Marketing System First

Chapters two and three showed you how to set yourself apart from the hordes of stock photographers trying to sell the standard excellent picture (Track A) to photo editors who already have hundreds or even thousands of such pictures readily available to them. Chapter three explained how to analyze your Photographic Strength/Areas (PS/A) and, in so doing, immediately become a valuable resource to specific photo editors.

Be sure, then, to get chapters two and three under your belt before moving to this chapter on pricing. In other words, set up your marketing strategy before you attempt to sell. It will save you time and money otherwise spent on postage and packaging that bring only "nice work, but . . . " letters from photo editors, if they respond at all. Figuring prices need not be a mystery. The system I outline will help you keep your prices professional and acceptable to photo editors.

Sell and Re-Sell

There is a myth I will ask you to unlearn at this point: Selling a picture means selling it once—you can't sell it again. This myth is perpetuated

because it can be true in the field of service photography. It doesn't apply to photo illustration stock photography.

You can sell your pictures over and over again, because in selling a photo illustration—a stock photograph—you are selling (or, to be more accurate, "licensing," which is like renting) one-time use of the picture, not the picture itself. Naturally, you must use common sense, and not simultaneously submit a picture to three sailing magazines that could have cross-readership. However, you can submit the same picture simultaneously to three diverse markets: a sailing magazine, an elementary school textbook publisher, and a denominational publishing house. Photo editors license a photo for one-time use, whether for cover or inside-editorial use, to obtain quality pictures at fees lower than they would have to pay to purchase the picture outright. They do not attempt to exercise any control over where else you might market the same picture. It's understood that you observe the ethics of the business by not sending the same pictures at the same time to competing publications.

Photo editors recognize that the risk of the same picture appearing simultaneously in another publication is minimal. It rarely happens. In the nearly four decades that I have been submitting pictures on a multiple basis, only one photo editor has been hesitant, and that was back in 1973 when the field was young and editors weren't always familiar with the benefits of one-time-use licensing.

The Price Range

Should you set a fee for your pictures and stick with it? If you're a service photographer, perhaps, yes. If you're selling stock photographs, you'll learn that the different photo editors on your Market List have different budgets. You generally go by the pay range of each different market. If you have three hundred potential markets on your list, you're going to find a wide range of fees paid for your photos.

A low-circulation magazine will not have the budget of one with a high circulation. A high-circulation publication sponsored by a nonprofit organization might not have the budget of a low-circulation magazine

sponsored by an oil company. Another consideration is advertising. Some trade magazines are heavily supported by advertising; other magazines with the same circulation figures have little or no advertising and are supported by subscriptions. You'll find the latter category on the lower end of the payment range. You, of course, have the option to choose which markets and which price ranges you want to deal with.

Base Camp: Inside-Editorial Use

As a newcomer to the stock photography field, you deal basically with photo editors, designers, and art buyers at publishing houses. Your pictures are usually bought (licensed) to illustrate the editorial content of periodicals or books. You'll find that 90 percent of your pictures go to inside-editorial use in magazines, periodicals, Web sites, encyclopedias, textbooks, and trade books. Payment for this type of use spreads across the seven basic fee ranges shown in Table 8-1.

To apply to publishers and publishing companies for one-time inside-editorial use.

Range No.	Black and White	Color
1	$175 to $250	$300 to $500
2	$150 to $175	$250 to $300
3	$135 to $150	$225 to $250
4	$125 to $135	$200 to $225
5	$120 to $125	$175 to $200
6	$115 to $120	$150 to $175
7	$50 to $115	$75 to $150

Table 8-1. Pricing Guide One. Note: A photobuyer will fall into one of these sectors depending on budget, circulation, uniqueness, and other factors.

The textbook market deserves special mention here. In general, you don't have many options when quoting prices to textbook publishers. Their budgets are set and usually are low when compared to the world of commercial stock photography. Most textbook photo editors buy in volume and expect to pay lower fees per photo as a result. For example, they'll often purchase ten or fifteen photos from the same photographer at one time and pay $75 or $125 for each, when the photos ordinarily would sell singly for $150 or $175. Payment ranges from $50 to between $150 and $250 for a quarter page. Fees depend on many factors: whether

the picture is to be used for a chapter head or cover, the size of the print run, the prospect for electronic use (such as a Web site or instructional CD), the number of languages the book is to be printed in, and so on.

In all fairness to textbook publishers, they often need hundreds of photos for illustration in a single book. If "reasonable" market prices were insisted on for each picture, some textbooks would never be printed.

Textbook publishers also are known to hang on to your pictures for months (up to one year is not uncommon). Despite all this, they're an excellent market for both the entry-level photographer and the seasoned professional. The publishers pay on time, they're dependable, and they have a voracious need for photos. If you establish a working relationship with them, they'll come to you again and again. (Review "The Total Net Worth of a Customer" in chapter three.)

The seven price categories in Table 8-1 reflect the circulations and budgets of the existing market areas, from local newspapers to major magazines, book publishers, and Web site markets. If a picture is to be used for a purpose other than inside-editorial use (for example, as a cover, a chapter head, or an informational brochure), you should charge a higher fee, and you can use the above standards to figure what that higher fee should be. (We'll cover how to do this in "Using the Pricing System: What to Charge" on page 129.)

Which Range for You?

Depending on your Track B list and your Market List, you'll probably deal primarily with photo editors in fee ranges 2 to 6. Why won't you deal with range 1? Although I've covered this question in chapter three, it bears repeating. Range 1 is a closed market. Getting excellent pictures is no problem for them. Neither is the question of cost. For example, most of the photographers who subscribe to our *PhotoDaily* listing-service deal in this area. The photo editors they are in contact with allow them to phone collect. The modus operandi of range 1 photobuyers is to deal with professionals who they've bought from before and who have established a track record with them. If you're listed in *PhotoSourceBOOK*,

Literary Market Place, *The Creative Black Book*, *The ASMP Directory*, or *The Blue Book* (see the bibliography), or if you subscribe to *PhotoDaily* or *PhotoLetter* (see the bibliography), you already have high visibility. This chapter may not apply to you.

Using the Pricing System: What to Charge

As I indicated earlier, the fee for a particular stock photograph will vary according to who is using it and how it is used. This presents the problem, "How do I determine which range to charge a particular market?"

There are three standard answers: (1) guess, (2) ask, (3) research it. All three are viable alternatives.

Guessing—educated guessing, that is—will become an important tool for you as you progress. You'll be able to judge a magazine by its cover (and its advertising and circulation). Once you know what comparable periodicals and books are paying, you'll find it easier to be on target with your pricing. Figure on using guessing later in the game, after you've racked up some experience.

Asking would be easy if buyers readily gave the information, but photo editors are sometimes hesitant to reveal such information to unknowns. Most photo editors, however, provide photographer's guidelines. Write to each photobuyer on your Market List, using professional stationery, and request a photo guideline sheet. (Be sure to include a business-sized no. 10 self-addressed, stamped envelope—SASE.) The photo guidelines often include price information. If you approach a photobuyer by phone or in person, phrase your question this way: "What is your payment range for color and for black and white?"

Since photo editors always work within a given range, you are saying two things to photobuyers: (1) You know something about pricing if you ask for a *range* rather than a set fee, and (2) you allow editors to save face and not have to commit themselves (which means you won't be coming back later with, "But you said such and such . . . "). Photo editors will usually cooperate when your question is worded in this manner. However, before you embark on your quest for price-range information, re-

view chapter seven for how to deal with photo editors by phone, by mail, by e-mail, and in person.

Researching your answer might be easiest for you. Turn to the marketing directories and reference guides listed in Table 3-1 on page 62. Turn also to publishing house Web sites. For example, Barnes and Noble Publishing often publishes the current pictures they are looking for and the prices they will pay. Remember that fees quoted on a Web site or in a national directory are probably going to be conservative; that is, they will be the lower figure (the minimum) on the pricing guide in Table 8-1.

As an example, let's say in your research you find that the published fee for a black-and-white print for *Golf Today* magazine is $140. You can assume that this magazine will pay in range 3 ($135 to $150 for black and white, $225 to $250 for color, for inside one-time use).

Many market directories also will give circulation figures, which are invaluable in determining the price ranges of similar publications. For example, if *Golf Today* pays in range 3 and its circulation is 800,000, we can assume that another magazine, *Teen Golf Digest*, with a circulation of 400,000 and with similar advertising accounts, might pay in range 4. If *National Golf Review* has a circulation of 1,000,000 and stronger advertising support than *Golf Today*, we can figure that they probably pay in range 2 ($250 to $300 per color, $150 to $175 per black and white, for inside one-time use.) These examples can give you a base from which to start. You often can find circulation figures on the publication's Web site. You'll probably find the circulation figures in the sections for advertisers.

Payment for Other Uses
Again, the fee ranges in Table 8-1 apply to inside-editorial use. As I mentioned, if the publisher uses your photograph for a different purpose as well, such as on a Web site, you should receive a higher fee.

Publications, of course, will be local, regional, or national in scope. You should be compensated accordingly. National use carries the most generous compensation, but keep in mind that sometimes a national magazine will be limited to a highly specialized audience and thus yield a

lower pay rate. For example, a skydiving magazine would be limited in its impact, even though it might have national circulation. So would a national magazine directed to nurses or model railroad enthusiasts.

Table 8-2 provides a system for arriving at a fair price to charge for other than inside use of your photos, no matter what level publishing market you're dealing with. Take the price you normally receive for one picture from that market, and multiply it by the factor that represents the purpose for which the photo will be used.

For example, if a photobuyer in range 7 (see Table 8-1), who normally pays $50 for a black and white (inside-editorial use), would like to use one of your photographs for local public relations use, multiply $50 by the factor 1.429 to come up with a round figure of $75 ($71.45). To figure the fee for the same black-and-white photograph to the same market for use in a national advertisement, multiply $50 by the factor 7.144 and you get $350 ($357.20). By the same token, if you're working with range 1 buyers and the one-time-use fee is $450, national advertisement use would be $2,850. This system is applicable to the publishing (books and magazines) industry. For service photography and commercial stock, check out three excellent pricing techniques by Michal Heron, Jim Pickerell, and Cradoc Bagshaw (see pages 139-140).

For the sake of completeness, Table 8-2 includes uses such as advertising, calendars, record covers, postcards, and CD-ROMs; these are all commercial areas that publishers sometimes delve into. (Table 8-2 applies to projects by publishers or publishing companies, not to commercial uses by ad agencies, calendar companies, and the like.) Most often, however, you will use Table 8-2 to calculate fees for book or magazine covers, catalog promotions of a periodical or book, chapter heads, informational brochures, and similar editorially connected uses.

Pricing your photographs for covers or other special uses is easy if you follow the pricing guidelines in Table 8-2. The key is to determine the photobuyer's *basic budget range*. Once you have that, all other prices will fall into line when you use this factor system, no matter which month or year you're reading this book. Considerations such as inflation or a drop or raise

To determine a ballpark fee for other than inside-editorial use of your picture, multiply these factors by the figures in Table 8-1.

****Advertising**
***National	7.144
Regional	3.155
Limited	2.867
Local	1.621

****Annual Reports**
Local	1.429
Regional	2.867
National	3.155
Cover	7.144

****Audiovisual Packages**
***National	1.621
Limited	1.429
Cover	5.859
Advertising	3.155

****Brochures**
Inside	
Limited	1.429
***National	4.867
Cover	
Limited	3.621
National	6.859

****Calendar**
Exclusive (limited three-year rights)	2.143
One time	1.429
World rights	50 percent additional
Advertising	3.155

****CD-ROM**
Limited	1.429
***National	1.621
Cover	5.859

(Note: Some CD-ROM companies may ask you to take part of the risk by receiving royalties only.)

****Coffee-Table Books** (see Table 8-1)
Chapter head	1.621
Cover	2.859
Advertising	3.155

Contests (Payment based on contest rules. Allow only limited rights to your winning entry, never all rights.)

****Curriculum**
Inside**	(see Table 8-1)
Chapter head	1.429
Cover	1.621
Advertising	2.143
Montage	Negotiable

****Decor Photography**

Sold by an agency
Framed prints	(Find out what royalties the competition is paying.)
Limited editions	Negotiate

Sold by yourself
Framed prints	(Sell to a distributor in volume at one-third his retail fee.)
Limited editions	Negotiate, but expect a wide range depending on client, use, and your "name."

****Electronic** (see Internet; Web)

****Encyclopedias**
Inside *** (see Table 8-1)	
Chapter head	1.621
Cover	2.143
Advertising	3.155

****Gift Wrap** 2.859

****Greeting Cards**
Exclusive (limited three-year rights)	2.143
One time	1.429
World rights	50 percent additional
Advertising	3.155

****Hardcover Books** (see also Paperback, Coffee-Table Books, Textbooks, Encyclopedias)

Table 8-2. Pricing Guide Two.

Inside (see Table 8-1)
Jacket or cover

Limited	2.621
National	3.859
Chapter head	1.429
World rights	50 percent additional
Advertising	3.155

****House Magazines**
Cover

Limited	2.429
National	3.143

****Internet**
(Electronic House
Magazines)

Limited	2.429
National	3.143
Cover (entry point)	3.555
Banner or design element	4.100

***Magazines**
Cover

Limited	3.429
Regional	5.621
***National	7.716

****Motion Pictures**

Nonprofit	1.255
Experimental	1.429
Test	1.621
Limited	1.429
Regional	1.621
***National	2.143
Promotion	5.621

***Newspapers, News Services**
Cover

Limited	1.429
Regional	1.621
National	2.143

Spectacular exceptions (disasters, etc.):
Consult your directories (or the library) to
determine competing national news
agencies or periodicals and then put the
picture up for bids on a limited-rights basis.
An agent might be your best bet.

****Nonprofit Organizations**

Regional	1.429
***National	2.143
Poster	3.155

****On-Demand Printing**
Short-run print runs usually will be local or
regional. Fees can range from 30 to 50
percent lower than a standard brochure
run.

****Paperback Books—Editorial** (see also
Hardcover Books)
Cover

***National	2.859
Limited	1.621
World rights	50 percent additional

****Place Mats**

Exclusive (limited three-year rights)	2.143
One time	1.429
World rights	50 percent additional
Advertising	3.155

****Playing Cards**

Exclusive (limited three-year rights)	2.143
One time	1.439
World rights	50 percent additional
Advertising	3.155

****Postcards**

Exclusive (limited three-year rights)	2.143
One time (national)	1.621
One time (regional)	1.429
One time (local)	1.077
Advertising	2.188
World rights	50 percent additional

****Posters**

Exclusive (limited three-year rights)	2.143

One time	1.429	Chapter head	1.429
World rights	50 percent additional	Cover	2.143
Advertising	3.155	Advertising	3.155

****Product Packages**

| Regional | 1.621 |
| ***National | 5.716 |

***Trade Publications**

Cover	
Limited	1.129
Regional	3.621
***National	5.155

****Public Relations**

Limited	1.429
Local	1.429
Regional	1.621
***National	3.155

****Video Commercial**

Nonprofit	1.621
Limited	2.444
***National	6.152

****Puzzles**

Exclusive (limited three-year rights)	2.143
One time	1.429
World rights	50 percent additional
Advertising	3.155

*****CD/DVD**

Educational	1.429
Industry	3.621
Advertising	5.155
Cover	5.859

****Music CD Covers**

Limited	1.621
***National	
Front	3.143
Back	2.521
Wraparound	5.211
Advertising	6.155
Promotion	5.429

***Television**

Editorial	
Local	1.429
Regional	2.859
***National	3.155
Advertising	
Local	3.155
Regional	5.333
***National	7.144

(Note: Expect to negotiate with major advertisers.)

***Textbooks** (see also Hardcover Books)
 ***Inside (see Table 8-1)

Web Usage

Fees for Web usage are most often negotiated separately from other usage fees. Typically, fees for Web usage range from 25 percent of the original fee and up, depending on usage.

*For inside-editorial use, see Table 8-1.
**Note: A general rule for photographs used in a publisher's advertising campaign: Charge 50 percent of the space rate that the publisher is paying. Space rates are available by phoning the organization (newspaper, magazine, and so on). Use Table 8-1 as a guide for Web sites.
***These fees are based on domestic rates. For world rights, charge 25 percent more for one language, 50 percent more for two languages; negotiate thereafter.

Table 8-2 continued.

in the photobuyer's fee structure will not be a problem. The factors still work, based on the buyer's basic fee paid for inside-editorial use.

One final word regarding the use of Table 8-2: Whether you multiply the appropriate factor by the lower or higher figure of a fee range or pick a figure in the middle depends solely on your own experience and/or judgment with regard to that particular market or photobuyer. If your reliability factor has been high with the client and you're confident of the quality of your pictures, aggressively market them. Aim for the *highest* fee practical (check out "Negotiating Your Fee" on page 208 in chapter eleven) that still keeps the door open for future assignments from the same people.

In the end, the buck stops with you. You will have to be the final judge in setting the price. As you gain experience, you will come to know each magazine or publishing house that you have a track record with; you will know their photo editors and the temper and tone of your relationships with them. All of these factors will help you fine-tune your pricing.

Within the Price Range, Should You Charge the High End or the Low End?

There's an adage in the business world, "You can always come down in your fee, but you can't go up." As a newcomer to the field of stock photography, however, initially you will want to charge the lower figure of the price range. Why? Because you are an unknown to the photobuyer. She has little to gain if you charge the maximum fee within the range. She already has a roster of high-priced but familiar photographers who would require less time to deal with. However, if your pictures are on target and your fee is at the lower end of the range, she can justify the time taken out from her busy day to instruct you in the submission procedures, holding requirements, electronic-use policy, payment policies, and so on, unique to her publishing house. Once you have made two or three sales to the photobuyer, test the waters by raising your fee on your next statement. Think in terms of long-range goals. By progressing patiently up the pay-

range scale, you'll gain experience and eventually become a top-notch contributor to each of the outlets on your Market List.

PRICE UNDERCUTTING

Price undercutting has always been a problem for photographers who produce the similar, generic type of stock photos used so frequently by the commercial stock photo industry. Whether going after a cookie-cutter royalty-free (RF) photo or attempting a clone of a rights-protected (RP) image from a high-end catalog, commercial photobuyers always are looking for discount stock photography. As RF practitioners continue to lower their fees, there will soon come a time when commercial stock photographers won't be able to stay in business on the proceeds of commercial stock. However, if you specialize, concentrate your stock photos in a special-interest area (desert flowers, motorcycles, paddlewheels, parachutes, rock climbing, musical instruments, and so on), and build up a deep selection for buyers to look at, you'll have no fear of competitors challenging you on price.

Unique Pictures—What Are They?

As antique dealers and baseball card traders know, the word *unique* has to do with the buyer, not the seller. With the arrival of CD-ROM "click art" and "royalty free," exquisite clichés began to lose their appeal with photo editors. It'll be a rare occasion when one of your Track A pictures is considered unique.

To make their publications unique, many photo editors will shy away from using clip art and will seek out unique pictures. Translated into real terms, that means editorial photobuyers will look for highly specialized pictures that match their editorial needs. A generic picture won't do. If your specialization (PS/A) matches the photo editor's theme or special interest, your pictures are unique to that photobuyer.

Second Use of Your Pictures

As an editorial stock photographer, you price your pictures on a one-time-use basis. In effect, you are renting your pictures to the photobuyer. What happens if the photobuyer wants to rent the same picture a second time? Should he use it free, at a discount, or at the same fee? Many publishing houses have set policies on photo reuse, but you can set policies, also. For a starting point, you can use the guide in Table 8-3.

Here is an exception to these reuse guidelines: If a publishing house has retained your picture in its central art library and reuses it in a new format, you should expect 75 percent and not 100 percent. The 25 percent in such a case is understood as a privilege fee for holding your

Joy! to the reader, and also to the photographer—me! This picture taught me how to market my pictures. I took it more than thirty years ago, sold it right away, and it has been selling over and over again ever since. Photobuyers use it for articles on children's games, summer recreation, health, playtime activities, camping—not to mention articles in textbooks on happiness, sorrow, depression, and exuberance. To date, it has earned more than $6,500.

	Percent of original fee
For use in same format as original use (e.g., in a revision, new printing)	75 percent
For use in an anthology	75 percent
For use in a new format (a new or different project)	100 percent
For use as a cover, in advertising, public relations, filmstrip, and so on	See Table 8-2

Table 8-3. Pricing guide for photo reuse.

pictures in the library; it goes toward the library's operating costs and services.

The fees discussed in this chapter are for domestic use of your picture. You may have the occasion to sell world rights to your photo. A generally accepted fee structure is to charge 25 percent per language. For two languages, charge 50 percent additional; for three or more languages, negotiate. If the photo editor asks, "What would you charge for world rights in all languages?" a generally accepted answer is 200 percent. By the way, if your picture appears in a Chinese book, be sure to find a way to get the book for display on your living room coffee table!

State Your Fee

Always state your fee when you submit pictures to a photobuyer (assuming you've done your homework and can quote a fee you know is within the photobuyer's range). This practice will increase your chances for sales. Why? Photo editors tell me that one of the main deterrents to purchasing a picture from a submission is that the photographer failed to state a fee in the cover letter.

When I first began submitting photographs, I fell into the "hesitancy trap." I hesitated to put down a fee. I believed that the photobuyer would want my picture so much that he would phone me, write and ask for the fee, or better still, tell me what he would pay.

It didn't work out that way. Yes, the photobuyer wanted my picture.

However, he would have to go through the busywork of getting in touch with me (and what if I were out of town), perhaps negotiate with me, and at minimum endure time-consuming back-and-forth communication with someone he wasn't even familiar with. And he had a deadline to meet. To avoid those problems, he chose a second-best picture that was available and had a price on it. (Have you ever wondered why some pictures that are not as good as yours are published? This is one reason.)

The fee you're charging is the most important element in your cover letter (except for spelling the photobuyer's name correctly). If you can't come up with a price that you know is within the buyer's range, make an educated guess based on your research. Even a guess too high or too low can result in a sale that you might not have made if you had not quoted a fee at all. When all else fails, simply state "for publication at your usual rates." By telling you this, however, I hope I haven't given you license not to do your homework.

Pricing the Service Photo

Six excellent guides exist for the person who sells photography in the following assignment areas: advertising illustration; architectural; general commercial (studio and/or location); photojournalism; photo reporting; public relations; and publicity.

These are the price guides:

ASMP Professional Business Practices in Photography and *ASMP Stock Photography Handbook*, 150 N. Second St., Philadelphia, PA 19106, *ww w.asmp.org*

FotoQuote With FotoBiz (software), Cradoc Bagshaw, Cradoc Corporation, P.O. Box 1310, Point Roberts, WA 98281, *www.cradoc.com*

Negotiating Stock Photo Prices, by Jim Pickerell and Cheryl Pickerell DiFrank, 110 E. Frederick Ave., Suite A-3, Rockville, MD 20850, *www .pickphoto.com/nspp.html*

Graphic Artists Guild Handbook: Pricing and Ethical Guidelines, Graphic

Artists Guild, 90 John St., #403, New York, NY 10038-3202, (212) 463-7730, *www.gag.org*

Pricing Photography: The Complete Guide to Assignment and Stock Prices, by Michal Heron and David MacTavish (contributor), 10 E. Twenty-third St., Suite 210, New York, NY, 10010, *www.allworth.com*

ASMP Professional Business Practices in Photography is a compilation of rate surveys made among the highest paid photographers in the country. If some of the markets on your Market List are over a quarter-million in circulation, this book could be worth the investment (around thirty-five dollars). The ASMP is an organization of more than three thousand media photographers. (I was a member in the 1960s but dropped my membership when I changed my focus from service photography to editorial photo illustration.)

Service photography, because of the complexities and the high fees often involved, requires extra attention to precision when you negotiate a picture sale or an assignment. The ASMP book will inform you about book-publishing contracts, settlement of disputes, trade definitions, photographer/agency relationships, copyright, commercial stock photo sales, online sales, and insurance. It also contains forms (which you can adapt to your own needs) for assignment confirmations, delivery memos, and model releases. Remember, though, that the mission of the ASMP book is to guide the photographer who operates in a city of at least one million population, or who deals with publications of 250,000 circulation or higher. If you employ the ASMP guidelines or forms with smaller publications outside those parameters, you and your photobuyers might find the experience less than satisfactory. Keep in mind that it is the photobuyer who approves the assignment, initials the proposal, or forwards a statement for reimbursement.

So use the ASMP book wisely. It was conceived and produced for top professionals in the big leagues of Madison Avenue and parts West. A book is always the extended shadow of its author; in this case, the book was written by a committee. Unless you have lucked into a top-paying, range 1 assignment, modify the ASMP guidelines accordingly. (Incidentally, the ASMP underscores that fees mentioned in the guide are only

guidelines, by stating in their introduction, "ASMP does not set rates.")

The ASMP is a group of hardworking photographers who devote their energy and time to setting and maintaining high standards for the industry. As a group, they are in a position to exert pressure for the betterment of working policies for service photographers.

Negotiating Stock Photo Prices is an excellent guide for the experienced commercial stock photographer. Although the suggested fees are not in the entry-level range where you might realistically enter the market (the range in the guide is number 1), this guide by photographers Jim Pickerell and Cheryl Pickerell DiFrank shows you the opportunities available if you choose to enter the field of commercial stock photography.

FotoQuote With FotoBiz software is another way to determine fees for just about any kind of stock photography usage—editorial, advertising, record covers, television, CD-ROM, or Web pages. The program takes your costs into consideration. When you input various information elements concerning the sale of the photo, it adjusts all factors and comes up with a suggested fee. There's even a special "coaching" section that suggests negotiating tactics for commercial stock photography.

If you don't wish to invest in any of these service-photography pricing guides, you can determine the going rate in your area by a somewhat roundabout route. It's sometimes difficult to get the information from other photographers or the photo editors themselves. (Unlike editorial stock photographers, who work in their own market and subject areas, and therefore don't compete with many other editorial stock photographers for the same dollar, service photographers often compete with each other for specific assignments and are not eager to give information to newcomers.) Do ask other photographers and photo editors, but do it long-distance; go to the Web or a large library and find the yellow pages of several cities around the country that are comparable in size to your own. Pick out several photographers and photo editors, and phone them to find out what they consider fair fees for service photographers. Be sure to establish early in the conversation that you are calling long-distance. The time and money spent in such research will save you hundreds of

dollars in either underpricing or accounts lost (assignments missed) because of overpricing. You could do the same via e-mail, but you'll probably get better results using a personal telephone call.

Royalty Free

Royalty-free (RF) use is something photographers either love or hate. There are those who say royalty free is just like work-for-hire but with lower fees, and those who say that royalty free is a great moneymaker.

Royalty free is often produced by a stock agency. The agency produces a CD with photographs from a selection of photographers, and the CD is sold outright to photobuyers and graphic artists. The photobuyers do not pay per image usage. Instead, the price they pay for the CD includes all usage fees. Some restrictions on the use of the photos often apply. The prices on RF CDs can range from twenty-five dollars up to one thousand dollars or more. Participating photographers agree to a set fee per CD that's sold, much like royalty payments of yesteryear.

Those who like RF say that it's often used by photobuyers who would never be able to afford standard licensing fees, thus opening up a brand-new market for photographers.

Those who do not like RF say that it's an enormous loss for photographers to put their images out as RF since it destroys all future sales for those images to higher-paying clients.

Can RF be good for you? If you're just starting out, chances are that RF isn't going to be your best bet. Why? RF is best suited for photographers who have a lot of generic—very generic—images that are difficult to market individually.

Since RF appeals to photobuyers outside the realm of editorial stock photography, be prepared to produce ironclad model releases (check out *www.editorialphotographers.com*) for situations where your RF image might be employed for a highly sensitive use.

If you feel tempted by RF, do your homework. Carefully research before you sign a contract. Check the specialized chat groups such as *www.stockphoto.com* or PhotoSource International's Kracker Barrel, *www.p*

hotosource.com/board, and ask veteran photographers their opinion about this emerging stock photo marketing area.

The Lowest Fee Possible: Nothing

I can't close this chapter without a word about zero-price marketing.

Some publishing houses have no budget for photography. They have budgets for carpenters, secretaries, printers, and the IRS, but they don't budget for you, the stock photographer.

If you discover some of these nonpaying markets on your Market List, chalk it up to the research and refinement inherent in hammering out a strong Market List. Delete these markets or let them sink to the bottom.

You may wish to let one or two no-pay markets stay in at the bottom because you feel they can serve as a showcase for your photography. As a newcomer, you want to build your published-pictures file as quickly as possible. Your credit line next to your pictures will establish your credibility and lead to other sales. Aside from the free advertising benefit you reap from such publications, you can request copies (tearsheets) of your published picture(s) as payment. The usual method is to request three copies after publication. If you're interested in several dozen copies, contact the photobuyer a month before publication and ask the publishing house to give you or sell you overrun pages. (They'll let the press run a little longer for your order, generally for slightly more than a dime a page.) Request a number of these copies, and use them as stuffers in your mailings to other prospective photobuyers (see "Credit Lines and Tearsheets—Part of the Sale" in chapter ten). There's also a chance that some no-pay markets may be ground-floor businesses with promise, i.e., markets that eventually will grow to healthy budgets for photography, and that will remember and appreciate you when they do, if you keep reminding them of your existence. (It's always up to you to keep the communications alive.)

Once you have attained whatever benefits you sought in allowing your pictures to be published free, begin working up toward the top of your Market List, where pricing is healthy and lucrative.

9

Managing Your Mail and Internet Marketing Operation

HOW DO I GET MY PICTURES FROM HERE TO THERE?

The ad in the photography magazine shows a distraught woman at the airline terminal being informed by an attendant that she has missed her plane. "Don't Let This Disaster Happen to You!" reads the caption. The full-page ad for a software company goes on to imply that if you don't keep up with digital technology (by buying their product), you will be left hopelessly behind.

Do you sometimes get a nightmarish vision of your competition flying light-years ahead of you, enjoying high-powered electronic sales and de-livery advantages with the photobuyers out there in cyberspace?

"Hey, I don't have the expertise or the budget to keep up the pace in the digital world. How can I compete?" you say.

It's true that fax, e-mail, and the Internet are opening up new worlds of instant-speak. But what channel of communication do photobuyers *really* prefer?

The good news: Here at PhotoSource International we are in touch with hundreds of editorial photobuyers every week. More than fourteen thousand photobuyers are in our database. The great majority of these buyers still prefer the U.S. mail or courier (such as FedEx or UPS), not only for delivery of photos, but also for sales introductions, promotion, and routine communication. Digital—both for photographs and promotions—is gaining ground, but it has not yet won the hearts and minds of the majority of editorial photobuyers. It's likely that in the future, digital will become the most common method for delivering images. However, we're not there yet. Right now, one doesn't rule out the other. Both the "good old ways" and digital can happily co-exist.

Delivery: As Close As Your Mailbox and Computer

Communication by computer enjoys big-time media attention, but as stated previously, the reality is that standard U.S. mail and courier service continue to be the communication methods overwhelmingly preferred by editorial photobuyers. Before you shut down your computer, however, check out chapter seventeen. You're going to find that the Internet offers an important and growing sales-and-delivery method that may one day rival the U.S. mail, and you can start getting your feet wet right now.

In 1981 I wrote in my newsletter *PhotoLetter* that within a decade, digital delivery of photo illustrations would be the norm. I was wrong. Even many commercial stock photographers are not convinced that digital photos will completely replace film-based photography.

Having your own Web site is perfect for delivering *information* about you and your photography. If you specialize and inform Web users of your specialty, they can look at your online specialized portfolio. A phone call or e-mail from the photobuyer will get the sales process moving. Again, for more information, see chapter seventeen.

In this chapter, however, we'll address the communication method that 90 percent of your buyers in the editorial field prefer.

Our Postal Service—A Bargain for the Stock Photographer

As an editorial stock photographer, you can market your pictures almost entirely by mail or courier. Photobuyers like working this way. It saves them time, and it's efficient. For you, marketing by mail is less expensive than costly personal visits. The risk? Minimal. Here at PhotoSource International, I've been engaged in a campaign to debunk the myth of photos missing in the mail.

We've all heard horror stories about the U.S. Postal Service, but I've found the vast majority of those "lost picture" stories to be untrue. For example, at my seminars I ask people to describe their experiences with photographs *lost* in the mail. When the facts are laid out, I've yet to discover one case that could be documented. Not that it isn't easy to have a photograph damaged or lost in the mail. Simply ship it in a flimsy envelope, and don't identify it as yours: The odds are you'll never see the image again.

When photos fail to arrive at their destination or fail to return home, it most frequently is the photographer's fault, not the fault of the postal service. Typical reasons are incorrect address, incorrect editor, no editor, no ZIP code, no return address, no e-mail address, no identification on prints or slides, or poor packaging.

We sometimes get a call from a photobuyer who asks, "Can you locate the address of Harrison Jones for us? We want to send him a check, but all we have is a slide with his name on it. No address. No phone."

Stock photo agencies and film processors must know something about the U.S. mail. They have shipped pictures across the nation and around the globe for years. Magazines use the postal service successfully, as do Light Impressions, Spiegel, and Calumet Photographic.

If there is a risk, it's in *not* sending your pictures through the mail. Pictures gathering dust in your files are hazardous to your financial health.

Preparing Your Stock Photos for Market

The first impression a photobuyer has of you comes from the way you package and present your material. Photobuyers assume that the care you've given to your packaging reflects the care you take in your picture-taking and your attentiveness to their needs. They believe they are paying you top dollar for your product. They expect you to deliver a top product. If you want *first-class treatment* from a photobuyer, give *her* first-class treatment.

SENDING TRANSPARENCIES

To best protect your transparencies, send them in vinyl sleeves. Use slides mounted in plastic or cardboard, or else unmounted. For mounted slides, use the popular vinyl pages that have twelve 2¼ inch or twenty 35mm-size pockets on one page. For unmounted transparencies, the vinyl pages also are useful. For prints, four 4 × 5s, two 5 × 7s, or one 8 × 10 can fit in one page. If you have only a few transparencies to submit, cut the page in half or quarters. Send your selection in a smaller envelope. Single acetate sleeves are another option for protecting transparencies. They're available at photo supply houses. In the past, there has been some concern as to whether the polyvinylchloride (PVC) in vinyl sleeves can damage a slide. Use this rule: *Ship* your slides in thick vinyl (or nonvinyl) sleeves, but *store* your slides in archival plastic pages. Don't use a thin plastic page to ship your slides because the slides fall out too easily.

When you submit transparencies, you might wish to keep not only a numerical record of your submission, but a visual record as well. Here are four ways: (1) Make a color photocopy (at a library, Xerox Center, bank, Kinko's, or a print shop); (2) make a 35mm black-and-white or color shot of your slides on your light box; (3) using a cheap digital camera, make a low-resolution picture of each image; (4) using your scanner, copy your submission and save it in a folder entitled, "Submissions sent." Keep the results on file until your slides are returned.

How can you caption unmounted transparencies? Fit your caption information on an adhesive label, and place the label at the bottom of the protective sleeve or vinyl page pocket where it won't cover the image.

Inexpensive protective vinyl (or similar plastic) transparency-holder pages are available from your regular camera equipment supplier and from mail-order companies. For an up-to-date listing of suppliers, check the ads in any photography magazine.

SENDING CD-ROMs

Label CD-ROMs with your name, e-mail, postal address, and contact information—just like anything else you send out. Your CD label should look neat and crisp and convey professionalism.

Send CD-ROMs packed in jewel or slim-line cases, along with a cover letter. Ship in white cardboard mailers that are clean and crisp. A great source for these cardboard mailers is Mailers Company, 575 Bennet Road, Elk Grove, IL 60007, (800) 872-6670, *www.mailersco.com*.

Make it clear in your cover letter that your specialized images are going to match the photobuyer's special-interest area. Indicate what format the images are saved in and any other details a photobuyer might need to be able to open your images. For example, is your CD-ROM cross-platform compatible? That is, will the CD-ROM work equally well in a Macintosh or an IBM-compatible personal computer?

If you've selected a photobuyer from your Market List to send the CD-ROM to, invite the photobuyer to download your selection of low-resolution images into his database. Depending on your history of publishing with the buyer, you might suggest that you can send a selection of high-resolution images also.

SENDING BLACK-AND-WHITE PRINTS

Some photobuyers still wish to see (paper) black-and-white prints. If your black-and-white prints are dog-eared or in need of trimming and spotting, they may miss the final cut. Often, excellent pictures never reach final layout boards because they make such a poor first impression. As the saying goes, "You never get a second chance at a first impression." Your stock photos make the rounds of many buyers, so check your prints

regularly to trim any edge splits or dog-ears. Before submitting black-and-white eight-by-tens, retouch any flecks.

Use plastic sleeves to protect your black and whites. These sleeves present a fresh, professional, and cared-for appearance, and they hold your prints in a convenient bundle for the editor. They come in 8½-by-11-inch (or larger) sizes. One sleeve can hold up to fifteen single-weight or ten double-weight prints. A company that sells 3 mil sleeves is: Sunland Manufacturing Company, 1658 Ninety-third Lane NE, Blaine, Minnesota 55449, (763) 785-2247.

Should you send negatives? If an editor wants your negatives, it's probably to make better prints than those you have submitted. Rather than run the risk of damage to your negatives, volunteer to reprint the pictures or to have a custom lab print them. Avoid sending negatives to photobuyers.

IDENTIFY YOUR PRINTS, THUMBNAILS, AND TRANSPARENCIES

Identify slides with labels (½" × 1¾" return address labels, such as Avery #8167, are good for this) that state your name, e-mail address, and phone number. Put the labels on the slide mount. You should use two labels for each slide mount, one for contact information and one for caption information. Caption information should also accompany your preview scans. Read more about captions in the next section.

Identify each of your black-and-white prints using a label (on the back) that includes a copyright notice and your name, address, e-mail address, and telephone number. Also include your picture identification number (see chapter thirteen).

Do not include a date code in your identification system. Photobuyers will recognize the date, and your picture will be "dated" before its time. If slides have a date printed on the side, cover it with a label imprinted with your identification details. If for some reason you do need a date, put it in Roman numerals or use an alphabetical code, for example, A = 1, B = 2, C = 3, and so on. The fifth month would be E, and the year 2003 would be MMIII. E/MMIII.

CAPTIONS

Accurate captions have become an important tool for photobuyers. Since you are specialized and photograph in a specialized field, you know a lot about your field of choice. The photobuyer will rely on you to help with important information about your images. On slides, use a separate label for captions. Mark the label with an identification number and captioning information.

Try to keep captions brief, yet complete. If you're captioning a photograph of a horse grazing in a pasture, don't caption it "horse in pasture" and leave it at that. The caption might read something like, "Thoroughbred grazing in Wyoming pasture in spring." You want to be informative, and you want to state the obvious, but also include the not so obvious.

Typically you can caption digital images in the photo editing software that you use (Photoshop, for instance). This is attached to each image as part of the digital file. Mention this in your cover letter.

Extensive captioning of your images can benefit your marketing efforts. How? Powerful search engines maintain "Web crawlers" that seek images for display on their Web sites. If a photobuyer is searching for an arcane word, location, or species, for example, and you have listed it in your captions, you might be more likely to get a hit and make a sale.

CHECKLIST

Before packing your photographs to send to a prospective buyer, give your images this checklist test.

☐ Selection.

 Do your images fall within the specialized interest area of the photobuyer?

☐ Style.

 Do your photographs follow the illustrative style the buyer is partial to?

☐ Quantity.

 Are you sending enough? Generally, you should submit a minimum of two dozen and a maximum of one hundred. (There are exceptions

to this, such as the single, truly spectacular shot that you might rush to an editor because of its timeliness.)

☐ Quality.

Can your photographs compete in aesthetic and technical quality with stock photos the buyer has previously used?

☐ Appearance.

Are your prints, digital scans, and transparencies neat and professionally presented?

If your photos don't conform to the suggestions I've given, then wait to submit them. Eagerness is a virtue, but as in any contest, you must match it with preparedness.

Packaging: The Key to Looking Like a Pro

Once you have your photos prepared, present them in a professional package. One editor told me that she receives about ten pounds of mail every morning. She separates it into two piles: one pile that she will tackle immediately, and a second that she will look at if and when time permits. I asked her how she determined which pile things belonged in, and she answered, "By the way they're packaged."

Your package will be competing with all those other pounds of freelance material when it arrives. The secret to marketing your pictures is to match your PS/A with the correct Market List. However, if the editor never sees your pictures because of faulty packaging, they won't get a chance.

Use an envelope that is trim and sturdy and that stands out. I recommend large white mailers made of stiff cardboard. They give an excellent appearance and have a slotted end flap that makes them easy and fast to open and close. Buyers can use the same mailer to return unused photographs. (Since you can't be sure the buyer will automatically reuse your envelope [or *mailing carton*, as it's called in the industry], have a rubber stamp or label made that reads: "Open Carefully for Reuse" or "Mailer Reusable." Stamp or put the label on the flap of the envelope.) The mailers can be recycled several times, since they are made of heavy material and hold up well. Place your new address label over the existing

label, and place white self-apply labels (available at stationery stores and through computer sales catalogs) over previous stamps and markings. Three distributors of white cardboard mailers are:

- Mailers Company, 575 Bennet Road, Elk Grove, IL 60007; (800) 872-6670, *www.mailersco.com*.
- Calumet Carton Company, 16765 Armstead St., Granada Hills, CA 91344-2702, (877) 404-7799, *www.calumetcarton.com*.
- PACK A LOPE, International Envelope Company, Number 11, Crozerville Road, Box 2156A, Dept. 52, Aston, PA 19014.

This type of mailer also saves you from having to pack your photographs between two pieces of cardboard, wrap rubber bands around them, and then stuff the result into a manila envelope. You can understand why, when editors have to unwrap this type of submission twenty times a day, they welcome a submission in a cardboard envelope, where pictures tucked in a plastic sleeve slide out and in easily.

Manila envelopes also have another disadvantage. Postal workers tend to identify the manila color as third class. Also, photobuyers might think of your photos as third class, and worse, you may think they are. Go first class, and mail in a *white envelope*. It will help your package receive the tender care and respect it deserves, both coming and going.

As long as we're judging the book by its cover, invest in some personalized, self-stick address labels. Your reliability factor will gain points if your logo on the labels is distinctive. Also use this opportunity to display your company's "unique slogan." Have return labels printed with your name and address, and include a label on the inside of your package, with return postage, which the editor can apply to your reusable mailing carton.

HOW TO SEND YOUR SUBMISSIONS

Assuming you use the U.S. Postal Service, you will find that Priority Mail treats your packages with respect and moves them quickly to their destinations for the least cost. Priority Mail is placed in the first-class bin. For added impact, you can place your white mailer (onto which you can affix your return address label and postage) inside the Priority Mail

Tyvek package. You can get this free at your local post office or have it delivered free through the Internet.

If you need to know that your package reached its destination, you can purchase Delivery Confirmation for your Priority Mail shipments. It costs forty cents (at this writing).

Courier systems such as FedEx and UPS are popular with stock photographers, especially if you're dealing with a buyer new to your Market List. The advantage of couriers is that your submission is tracked during its journey to the photobuyer, and the couriers usually hand deliver directly to the photobuyer and obtain a delivery signature.

You might want to consider insuring your U.S. mail package. (The best bargain is the one- to fifty-dollar coverage, for seventy-five cents. Postal rates change, so check the *www.usps.com* Web site for current information, or call your local post office.) Keep in mind that in the event of damage or loss, the U.S. Postal Service considers your pictures worth only the cost of replacement film. Your main reasons for getting insurance will be the extra care it guarantees your package and the receipt the delivery person collects from the recipient. The post office will have documentation that your package arrived, if you need to trace it. For less than a dollar more, you also can have a return receipt sent directly to you. This document can come in handy if the photobuyer ever says, "I didn't receive your shipment."

Shipping your photos by registered mail is good insurance, too, of course, but expensive. I'm aware that many photography books recommend sending your shipment via registered mail. I'm also aware that the authors of those books are not engaged in stock photography as their principal source of income.

Insuring or registering your photos for fifteen or fifteen hundred dollars will not ensure that you will receive that amount if they're lost or damaged. You will have a case only if you have receipts showing how much you have been paid for your pictures previously. Otherwise you'll receive only the replacement cost—about fifty cents for each slide or print. The best insurance is prevention. Use the packaging techniques I've described here, and you will have little or no grief.

If you're just starting out in stock photography, include return postage in your package. Most buyers not only expect it, they demand it. Some refuse to send photographs back if return postage is not included. Purchase a small postal scale at a stationery store, and you can easily figure your postage requirements at home.[1]

There are three acceptable ways to include return postage, described as follows.

1. If you use a manila-envelope packaging system (which is not recommended, as discussed earlier), affix the stamps to a manila envelope with your return address, fold, and include in your package.

2. Place loose stamps for the amount of the return postage in a small (transparent) coin envelope, available at hobby stores. Tape (don't staple) this envelope to your cover letter. The advantage of this method is that often the photobuyer will return the stamps to you unused. You can interpret this as a sign that the photobuyer is encouraging you to submit pictures again in the future.

3. Write a check from your business checking account for the amount of return postage. Make it out to the organization (publishing house, agency, and so on). Your reliability factor will zoom upward, and, nine times out of ten, you'll receive the check back, uncashed. Besides, the organization's bookkeeping department probably has no accounting system for such checks. Another advantage: By rare chance the client happens to lose or damage a print and reports to you that he has no record of receiving the pictures; if he cashed the check, you would have proof that he received your submission.

Writing the Cover Letter

Always include a cover letter in your package, but remember that photobuyers must sift through dozens of photo submissions weekly. They don't appreciate lengthy letters that ask questions or detail f-stops, shutter

[1]Readers outside the U.S.: Contact your local Postal Service, purchase International Reply Coupons and include them as equivalent return postage.

speeds, or other superfluous technicalities. Such data is valid for salon photography or the art photo magazines, but not for stock photography.

If you do feel compelled to ask a specific question (and sometimes it's necessary), write your question on a separate sheet of paper and enclose an SASE for easy reply. Better yet, send your question separately from your photo submission, and only send it after you've tried to find the answer to your question on the organization's Web site.

The shorter your cover letter, the better. Your personal history as a photographer, or where and when you captured the enclosed scenes, is of little interest to the photobuyer. All you need in the cover letter is confirmation of the number of photos enclosed, your fee, and the rights you're selling. Let your pictures speak for themselves. However, include extensive caption information for each image. As mentioned earlier, it can lead to sales.

Address your cover letter to a specific person, whose name you'll find by consulting your Market List or the agency's Web site, or by calling the agency's reception desk. A typical cover letter might read like the one in Figure 9-1.

This cover letter may not win any literary awards, but it's the kind photobuyers welcome. It tells them everything they want to know about your submission.

Photobuyers like to deal with photographers with a high reliability factor—photographers who can supply them with a steady stream of quality pictures in the photobuyers' specialized interest areas. They don't want to go through the time-consuming process of developing a working relationship with photographers who can supply only a picture or two every now and then. The right cover letter will signal to the photobuyer that you are not a once-in-a-while supplier.

If you have learned of a specific need that a photobuyer has (through a mailed photographer's memo, an announcement in a photo magazine, or a listing in a market service such as *PhotoLetter*, *PhotoDaily*, AGPpix, or Visual Support/Photonet), what kind of letter should you send? Again, keep your letter brief. Include many of the details listed in Figure 9-1.

However, also include the number or chapter of the book, brochure, or article for which the photos have been requested. Photobuyers often work on a dozen projects at a time. Knowing which project your pictures are targeted for, helps!

Use a form letter if I've convinced you; otherwise, send a neat word-processed letter.

FIRST-CLASS STATIONERY

To make a professional impression, design your cover letter as a form letter. Use your word processor, and have the letter printed at one of the fast-print services on twenty-four- or twenty-eight-pound off-color business stationery. Scan in your letterhead and logo for a first-class appearance. Leave the five blanks in your letter to fill in by hand for each submission (see Figure 9-1).

Photobuyers will not be offended by receiving a form letter, but rather will welcome it as the sign of a knowledgeable, working stock photographer. The message the letter telegraphs is that this is a working stock photographer. Someone who has gone to the expense of a printed form letter on quality stationery has more than a few photographs to market. If the pictures you submit are on target and you include an easy-to-read, concise form letter, you are on your way to establishing yourself as an important resource for the photobuyer.

Deadlines: A Necessary Evil

Because photography is only one cog in the diverse wheel of a publishing project, photos are necessarily regarded by layout people, production managers, printers, and promotion managers not as individual aesthetic works, but as elements of production value within the whole scope of the publishing venture. Book and magazine editors often tend to treat photography as something that should support the text, rather than the other way around. Hence, they load photo editors with tough deadlines. If your photographs are due on such and such a date, the photo editor is

Your Letterhead

[Date]

Dear _____:

Enclosed please find [number] [slides, images on CD-ROM(s), 8″ × 10″ black-and-white prints] for your consideration. They are available at $ _____ (color) and $ _____ (black and white)[2], for one-time publishing rights, inside-editorial use. Additional rights are available. Please include credit line and copyright notice as indicated.

You are welcome to scan or photocopy the enclosed picture(s) for your files for future reference. My name, address, and photo identification number are included on each picture.

I'd appreciate it if you would bring the enclosed pictures to the attention of others at [publishing house or company office] who may be interested in reviewing them.

You are welcome to hold this selection for two weeks (no holding fee). I have enclosed postage for their return.

Thank you for your attention.

Sincerely,
[Your name]

Figure 9-1. Sample cover letter to send with unsolicited submissions to photobuyers.

[2] It's essential that you state a fee (see table 8-1 on page 127 and table 8-2 on page 132).

not kidding. Being on time can earn you valuable points with a photobuyer, and it can mean the difference between a sale or no sale.

Develop the winning habit of meeting deadlines in advance. It will increase both your reliability factor and the number of checks you deposit each month.

Unsolicited Submissions

The word on the street is that photobuyers look upon unsolicited submissions with disdain. This is partly true. If you were an editor of an aviation

magazine and I sent you, unsolicited, a couple dozen of my best-quality horse pictures, you'd be righteously perturbed. However, if I sent a group of pictures, unsolicited, that were tailored to your needs, and showed a knowledge of aviation plus some talent with the camera, you'd be delighted, especially if I sent you an SASE for those you couldn't use.

"Most freelancers send me views of birds against the sun or close-ups of flowers, and maybe a kid with a model sailboat. Don't they even look at our magazine?" an editor of a sailing magazine asked me.

You can understand why some editors tend to lump freelancers and unsolicited pictures into the category of "undesirable."

If you've done the proper marketing research, photobuyers will welcome your unsolicited submission. On the other hand, if you haven't figured out the thrusts of the magazines or the needs of the publishing houses, don't waste your time or postage and earn their ire by submitting random photos. You won't last long as a stock photographer, no matter how good your pictures are. Ask yourself before you send a shipment: "Am I risking a *no-sale* on this one?" Choose a market whose needs you've pinpointed—one that you're sure of scoring with.

Digital delivery, on CD-ROM, is a great way to send unsolicited submissions to photobuyers; you can fit many high-resolution images on a CD-ROM, and it's cheaper to mail a CD-ROM than it is a selection of originals. It's also cheap to make extra copies of CD-ROMs. Make sure that your digital images are in a commonly accepted format such as JPEG or TIFF and that the photobuyer is willing to accept images on a CD-ROM. As I said earlier, the transition to digital is a slow process for the photobuyer community.

The Magic Query Letter

If you've advanced to a stage in your photomarketing operation in which you're prepared to contact multiple markets on your list, here is an introductory, or query, letter system that will prove helpful. This system is designed to hit the right buyer with the right photograph every time.

The age of the general-audience magazine ended with the weekly *Life*

Magazine, Look, and *The Saturday Evening Post.* They were replaced by the special-interest magazines, which contain subject matter ranging from hang gliding to geoscience to executive health. The diversification continues. Gardeners have their interests featured in magazines covering houseplants, ornamentals, backyard farming, organic gardening, flowers, and so on. Boat enthusiasts have special magazines that range from sailboats to submarines. Horse lovers have their own private reading: magazines on the Arabian, the quarter horse, and so on. Why venture into fields of little or no interest to you, when you're already a mini-expert in at least a half-dozen fields that could provide you with more than enough markets to choose from?

The key to the magic query method is an initial query letter to each prospective editor. What you say in this letter will move the editor to invite you to submit your photographs.

YOUR LETTERHEAD

[Date]

Dear: _____

 I am a stock photographer who specializes in _____ .[3] (Note: It's on these lines that you enter your magic phrase or sentence.)
 May I be of assistance to you? I'd like to send you a selection of my photographs for your consideration. They are available at $ _____[4] for one-time rights, inside-editorial use.
 I have enclosed an SASE for your convenience. I look forward to working with you.
 Thank you for your attention.

Yours sincerely,
[Your name]

Figure 9-2. The magic query letter.

[3]Or you could say, "I am a photographer who has a file of pictures that. . . . "
[4]Insert your fee (see chapter eight).

The query letter, to be effective, must be brief and simple, yet spur the editor to reply immediately and request your submissions for consideration. Here's how to plan your letter, individualized for each market.

Immediately hit the buyer where his heart is: In your first sentence, include a magic phrase that will grab his attention and rivet him to your letter. It will take some research on your part, but once you've worked out that magic phrase, not only will your letter be read, it also will be hearkened to and acted on. The query letter in Figure 9-2 provides a useful model for you to follow.

The majority of publications today are designed for specialized audiences. Imagine the structure of a special-interest magazine as a pyramid. At the base of the pyramid are the thousands of readers and viewers who are fans of this special area of interest. Next on the pyramid are the people with an economic interest in this specialized area: the advertisers. Farther up are the creative and production people who put the magazine together—the writers, designers, layout artists, printers, photographers, and so on. At the top of the pyramid is the publishing management. The pinnacle of our pyramid contains the concept, the idea, or theme upon which the magazine is based.

Now, here's the key to that magic phrase. Outside appearances would have you believe that the essence of, say, a magazine called *Super Model Railroading* would be model railroads. You're only one-eighth right. (This is where most suppliers—writers, graphic designers, and photographers—lose the trail when they initially contact prospective editors.) Here's the essence of *Super Model Railroading*: to allow adults the license to buy and play with expensive toys.

In the first sentence of your query letter to the editor of this magazine, you would use a magic phrase like, "I specialize in photographs of people enjoying their hobbies."

Let's look at another example. A magazine called *Today's Professional RN* appears to have professional nursing as its theme. Yes, that's the magazine's stated theme. But what is its unstated theme—the subject that touches the heart of its readers and therefore the publication's manage-

ment? The essence of *Today's Professional RN:* to remind nurses that they deserve the respect and esteem accorded to other community health-care professionals such as physicians, psychologists, and dentists.

In the first sentence of your query letter, you would use a magic phrase like, "I specialize in health-care photography and have in my stock file a large selection of pictures showing nurses playing a key role in our health-care system." The editors of specialized magazines are always looking out for their readers, advertisers, and bosses. If the first sentence in your query letter indicates that you can help in that mission, the editor will say to herself, "Now here's a person who speaks my language!"

Your job as a query-letter writer becomes one of separating illusion from reality in the publishing world. As you can see, it will take some study on your part, but the study becomes pleasurable if you direct your research to magazines you already enjoy reading. Make a game of distinguishing between a magazine's stated theme and its real theme. You'll be surprised how easily you learn this technique, especially for the magazines on your Market List.

What is the reaction of an editor who receives a query letter that shows no preparation on the part of the photographer? He feels insulted. He runs a tight ship. He has deadlines. He trashes the letter. He's not about to show any consideration to a photographer who has not shown him the courtesy of studying his magazine.

If you've done your job in your first sentence, and your first paragraph shows you are interested in both the magazine *and* the photo editor, you will have his attention. He will be alerted to your inventory of pictures, but beyond that, a couple more ideas will occur to him.

1. If you're an informed photographer (in his field), you are a mini-expert and therefore a valuable resource to him, and you could be available for assignments.

2. Although you've said you have certain photographs that you believe to be adaptable to his needs, you might have many more photographs that are adaptable to his needs. For example, perhaps his

publishing firm is starting a sister publication and is on the lookout for additional pictures in an allied area of interest.

The second paragraph of your query letter should confirm the attitude expressed in your first paragraph, namely, that you are aware of his photo needs.

How do you become aware of those needs? By studying the magazines you find in libraries, dentist offices, friends' homes, and business reception rooms. Web sites and photomarketing directories, such as *Photographer's Market* and those listed in Table 3-1 on page 62, describe thousands of magazines and list them by special-interest areas.

Before you send your query letter to an editor, request her photographer's guidelines. Most magazines provide a sheet of helpful hints to photographers, and if you contact the photobuyer on deluxe, professional stationery, complete with your logo, and you include an SASE, she'll send a sample issue of their publication as well.

You now are ready to write the magic query letter. Figure 9-2 is a sample of how your query letter should look.

You'll notice in the magic query letter that there is an abundance of *I*s. This may seem contrary to your writing style (or training), but those *I*s are there for a purpose: to give the editor the impression that this new recruit is dynamic, aggressive, and self-centered. (Note: Welcome to the world of business! If being dynamic, aggressive, and self-centered turns you off, you've got to reexamine and adjust your thinking. Timidity, modesty, and humility are nice attributes, but not if you want the world to see your pictures.)

In this letter, there is a good balance with the word *you*. (Most schools of persuasive writing teach that *you* is the most beautiful word in the language.) Your job as a letter writer is not really to inform an editor, but to move her to action, to make her want to see and buy your pictures. The magic query letter will put you leaps ahead of your competition, because editors will act.

Should You Deal With Markets Outside of the United States?

Once you're settled into dealing with domestic markets for your stock photography, you might want to investigate the thousands of international markets, some of which might be target markets for you. The easiest way to break in is to work with an established international stock photo agency. Digital possibilities make it even easier to show and sell your work internationally, by placing it on a Web site (your own or an agency's) and by participating in international stock directories.

Photographer's Market publishes an excellent listing of international stock agencies every year, including a number of Canadian agencies. If you'd prefer to sell by yourself, start by using the Internet search engines. Other great sources of information are foreign embassies in the United States. All embassies have a press or information department that will direct you to their Web site as well as help you with requests of information about publications in their country.

For a directory of international markets, ask at your library for *Ulrich's Periodicals Directory*, or look up the publisher, R.R. Bowker, on the Web *www.bowker.com*.

Another popular guide to overseas marketing of photos is Michael H. Sedge's *The Writer's and Photographer's Guide to Global Markets*, available through *www.photosourcefolio.com/bookstore* or Amazon books *www.amazon.com*.

Which Are the Heavy Purchasing Months?

Recently I sent a questionnaire to one hundred photobuyers asking which months of the year were their busiest in terms of picture-buying. Table 9-1 indicates that the thirty-five photobuyers who responded shared one of two prime purchasing periods: midwinter and midsummer. With more than four decades of experience as a stock photographer marketing by mail, I can confirm that these are heavy purchasing periods for a good proportion of the publishing industry.

Publishers are working on either a fiscal (July 31) or a calendar (De-

cember 31) year, which means cash flow is down in July or December and up again in August or January.

Knowing this can help you market more accurately. Your marketing strategy calls for periodic mailings of stock photos for consideration. Note in Table 9-1 that you can increase your chances of scoring if you aim at the midwinter and midsummer months.

Don't forget: When preparing seasonal pictures, find out the lead time (usually about six months) for your individual markets. In other words, be prepared to send springtime pictures in September. Photobuyers usually work that far in advance.

Before you decide that you have photomarketing down to a formula, though, don't forget that Table 9-1 represents only thirty-five publishing houses. Also, some of the photobuyers, such as Rodale Press and *Highlights for Children*, reported that "All months are equally busy."

If your Market List leans toward textbooks, you'll want to consider this: Many textbook companies work with two different printing dates during any given year—June, for the regular September delivery date on textbooks, and December, usually the month of kickoff sales meetings, when all new special books and textbooks are presented to the sales staff for the coming year's sales efforts. You can figure that picture selections for books and textbooks are made anywhere from two to four months before the printing date. This average, of course, is relative and subject

Table 9-1. Seasonal trends in photobuying in the book publishing industry.

to variations (both yours and the photobuyer's), so be sure to consider Table 9-1 only as an indication of what happens much of the time, in much of the market—and balance this against your PS/A, Market List, experience, and schedule.

How Long Do Photobuyers Hold Your Photos?

"The photobuyer is holding my pictures an unreasonably long time, don't you think?" a photographer recently asked me. He had sent his pictures six weeks previously.

"Not so," I said. "Especially if the photobuyer makes a purchase."

The buyer subsequently bought the pictures in question. Everyone was happy.

How long should a photobuyer hold your photos? Two weeks to two months is a safe answer, but it could be even longer. Magazine editors, for example, will hold your pictures about two weeks, sometimes four. However, if you've requested in your cover letter that the editor circulate your submission to others at the publishing house who might be interested in reviewing them, and the publishing house is large, you may not see your pictures again for six weeks.

If you've directed your pictures to a book or textbook publisher, they could remain there for as long as eight weeks (up to six months for a textbook publisher). Book production schedules often require more complex dovetailing and coordinating than magazine schedules.

Ad agencies and public relations firms are less likely to hold your pictures for an unreasonable length of time. The reason? They're usually working on tight deadlines. Their decisions must be quick.

You won't notice how "unreasonably" long photobuyers are holding your pictures if you multiply your marketing efforts: Make in-camera duplicates of your slides, copies of your CD-ROMs, and duplicates of your black and whites. Offer your images to noncompeting photobuyers on your Market List simultaneously. Establish a "light box" Web site where photobuyers can go to see your most recent portfolio.

Here are a few variables that can result in photobuyers holding your pictures for a while:

1. The deadline for the project (textbook, brochure, article) has been extended, giving the buyer more time to make a decision on your pictures.
2. The buyer likes your pictures and has set your package aside for further consideration.
3. The buyer likes your picture but wants to do a little more shopping, in case he can find something even more on target.
4. The photobuyer has forwarded your pictures to the author (of the textbook, book, and so on) for consideration. The author is holding up the decision.
5. The buyer's priorities have changed and your picture is now in the number two (or number six) priority stack.
6. The photobuyer is a downright sloppy housekeeper and your pictures won't surface until spring housecleaning time. (Fortunately, very few photobuyers are in this category.)

If a photobuyer keeps your pictures longer than four weeks (and you are certain the selection date has passed), drop her a courteous note. You can expect a form-letter reply letting you know of the disposition of your pictures. Textbook editors hold pictures longer, as mentioned earlier. Usually, if a picture lingers at a textbook publisher's, you'll be notified within three months that it's being held for final consideration.

However, when most editors (textbook editors included) look over photography (especially general submissions), they attempt to review pictures the same day they arrive. If none of the pictures are to be considered for publication, the editor will have them shipped back the following day. This makes good sense both for insurance purposes and for office organization. If one or more of your pictures is being considered for publication, the photo editor might hold your complete package until a decision is made.

Again, the best solution to the "unreasonable" length of time a photo-

buyer may hold your pictures is to follow the four suggestions mentioned previously. You'll be so preoccupied with sending your photos out and reaping the rewards that you won't have time to track down tardy photobuyers.

INSURANCE CONSIDERATIONS

What insurance coverage does a publishing house have, that, in case of fire or similar calamity, would cover your pictures being held? In some cases, your slides, prints, and digital images would be considered "valuable documents" and be replaced accordingly. Generally speaking, publishing houses have a blanket insurance policy on your photographs. This blanket policy also includes the company's office equipment, lighting fixtures, and other tools of the trade.

Nevertheless, publishing houses do not like to keep your pictures any longer than they have to, because as long as your pictures are in their possession, they are responsible. Between your place and theirs, the U.S. Postal Service, FedEx, or UPS has that responsibility—if you insure your package. (Note: FedEx, UPS, and other carriers will insure all your packages for free to a maximum of one hundred dollars, but they will reimburse for loss only to the amount of replacement. You can declare a higher value and pay a higher fee. However, unless you can prove the value of the prints, transparencies, or disks, you'll receive only the minimum fee unless you take your case to court, which can often cost more than you would receive in compensation.)

USING POSTCARDS TO RELIEVE THE AGONY

If not knowing the disposition of your photos is frustrating to you, take a tip from stock photographers who include a return postcard with their submissions. The stamped card is addressed to the photographer and says, in effect, that the photo shipment was received by so-and-so on such-and-such date.

Another effective contact with a photobuyer would be a memo on your

letterhead, with the message shown in Figure 9-3. The accompanying postcard reads as shown in Figure 9-4.

A HOLDING FEE—SHOULD YOU CHARGE ONE?

As mentioned before, some editors must of necessity hold your picture(s) for several months. This in effect takes your picture out of circulation. If it's a timely picture, such as a photograph of performers who will be in town in two weeks, or a photograph taken at the fair that ends this week, you could lose sales on it. By the time it's returned to you, it could be outdated and have lost its effectiveness. To compensate for this potential loss, the holding fee was born. (Happily, most of your stock photos are universal and timeless if you've applied the marketable-picture principles of this book.) Some photographers charge a holding fee for pictures held beyond two weeks. The holding fee ranges anywhere from one to five dollars per print per week for black and whites, to five to ten dollars per photo per week for color.

To make a potentially lengthy discussion short: Don't charge a holding fee unless you're a service photographer dependent on quick turnover of your images or you're an established stock photographer working exclusively with range 1 (see Table 8-1 on page 127).

TO:
FROM:
PROJECT:

On _____ I sent _____ [transparencies] [CD-ROMs]
[prints] to your office for consideration. Kindly let me know their disposition on the enclosed return-reply postcard.
Thank you for your interest in my work.

Yours sincerely,
[Your name]

Figure 9-3. Memo to inquire about pictures being held too long.

We have received your [transparencies] [CD-ROMs] [prints].

☐ Your pictures were returned to you on _____ .

☐ We are still holding your pictures for final selection. You should hear from us by _____.

☐ _____ of your pictures have been selected. You will receive payment on _____ .

☐ Enclosed are _____ of your pictures. We are still holding _____ pictures for final consideration.

Remarks:

Name Title

Firm

Figure 9-4. Postcard form for editor's reply about late pictures.

You may want to disagree with this advice. You'll have to be the judge for each situation. Generally speaking, editors will frown on an unreasonable holding fee, and on you, especially if you are a first-time contributor to them.

As I mentioned, here's the secret to overcoming the possibility of losing sales on your timely pictures: Make duplicates, and have several of them out working for you simultaneously. (For information on quality color-reproduction duplicates, see chapter five.)

Sales Tax—Do You Need to Charge It?

Not every state charges sales tax, but if you live in a state that does, contact your State Department of Revenue for details. If you make a sale within your state, you need to charge sales tax, unless the sale is to a state or federal government agency. (You can forgo charging your photobuyer the necessary sales tax and pay it yourself by sending the appropriate sales tax amount on an annual or semiannual form to your state's sales tax department.) If the sale is to an address outside your state, no sales tax is

required. Generally, most stock photographers deal long-distance and sell outside their own states.

In California, the State Board of Equalization addressed the question of "one-time" use of photographs with this ruling: "Photographers who license their photographs for publication should be aware that merely because the photographer owns the rights to the photographs and retains the negatives, does not mean that a sale has not taken place. The transfer of possession and use of a photograph for a consideration (license fee) is a sale and is subject to state sales tax. There is only one exemption to the above, which is for newspaper use—but not for magazines or any other commercial use—even if for 'one-time use only.' "

You'll need to check what your state's policy is and make sure you are in compliance.

When Can You Expect Payment?

Most photobuyers on your Market List will pay on acceptance rather than on publication. If they don't, drop them to the bottom of your Market List. After all, your PS/A matches only certain markets, but you bring to those markets an exclusive know-how that other photographers do not possess. You are an important resource to editors. Be proud of your talents. If some editors don't reward you with payment on acceptance, replace them.

Photobuyers usually send a check to you within two to four weeks after they've made their decision to purchase. However, each publishing house works differently: some pay more quickly, others take longer in their purchase-order and bookkeeping procedures. However, if a publishing house has a thirty-thousand-dollar-a-month photo budget—not a high figure in the photo-buying world—and is slow in paying, I'm sure you won't be too irate if the checks addressed to you customarily arrive a little late each month. Many publishing houses across the nation have thirty-thousand-dollar-a-month photo budgets or close to it, and they're seeking your pictures right now. If one publishing house is late with its payment, spend your energy sending the others more pictures, rather

than composing letters of complaint. (If you've built your Market List correctly, you'll find few deadbeats in it.)

How Safe Are Your Pictures in the Hands of a Photobuyer?

Contrary to popular opinion, photobuyers do not have machines that zap disks, split and crack eight-by-tens, scratch and crinkle transparencies, and sprinkle coffee over all three. Your submission will receive professional handling if you're careful to submit only to professionals. If you aren't sure whether a publishing company is new to the field, check a previous edition of *Photographer's Market* or a similar directory (one reason to keep back editions of such directories). If the house was listed three years ago, that's a factor in its favor.

Here at PhotoSource International, I receive occasional complaints from photographers about a photo editor's handling of their pictures. Invariably, mishandling of pictures can be traced to employees of a company new to the publishing business. It's rare that a publishing house with a good track record will mishandle your submissions. The reliability factor (RF) works both ways: Buyers expect you to be dependable, and you should be able to expect the same from them. If you find that a publishing house projects a low reliability factor, avoid it.

Don't spend sleepless nights fretting about your pictures. Instead, imagine your stock photography operation as a long tube. You put a submission in one end, and keep putting submissions in, moving down the tube. Instead of waiting by the mailbox, put in more time at your computer or in the darkroom, or snap more slides for your stock photo file. Keep the submissions moving down the tube. One day you'll hear a sound at the other end—the check arriving!

LOST, STOLEN, OR STRAYED?

You'll rarely hear of a stock photo stolen by an established publishing house. Online delivery of stock photos, plus improvements in scanning techniques, make it easy for just about anyone to "borrow" images. How-

ever, a stolen photo that's subsequently published increases the thief's chances of being discovered. As the Internet matures, new encryption methods and enforcement of copyright will meet this challenge.

Will your photos get lost? As I mentioned earlier, when a picture is lost, whether en route or at a photobuyer's office, the record reveals that it's most often the fault of the photographer.

Here are some common reasons:

1. No identification on the pictures, or identification that is blurred or unclear.
2. Missing, incomplete, or unclear return mailing information.
3. Erroneous address on the shipment.
4. Failure to include return postage (an SASE) when appropriate.

I have talked with many photobuyers who say they have packets of photographs and many single photographs gathering dust in their offices because the photographers didn't include an address on the pictures. Once pictures become separated from the original envelope, unless they include an identification label, the buyer has no way of knowing where to return them. Many orphan photographs hang temporarily on photo editors' walls—they're that good!

I've lost only one shipment in over thirty-five years of sending out stock photos. I should say temporarily lost, because after five years, the editor's replacement discovered my ten slides, kept in a "safe place"—in the back of a filing cabinet. My mistake: sending a shipment to a start-up publishing house.

Loss of your disks or transparencies is best avoided through prevention: Don't send original pictures to photobuyers or publishing houses that have no track record. Prevention is cheap, and it's a good habit to get into in photomarketing.

YOUR RECOURSE FOR LOST PHOTOS

This is not to say that a photobuyer can't commit an honest error. Let's say that some of your pictures are lost and the photobuyer appears to be

at fault. Your best policy is good old-fashioned courtesy. Otherwise, a good working relationship between you and the photobuyer can break down, sometimes irreparably. Don't be quick to point an accusing finger and perhaps lose a promising client. Consider the following:

1. Have you double-checked to see if the person you originally sent your pictures to is the same person you are dealing with now?
2. Have you waited ample time (four weeks for a magazine, eight weeks for a book publisher) before becoming concerned?
3. Have you asked if your pictures are being considered for the final cut?
4. Have you checked with the postal authorities or courier on initial delivery?

If you definitely establish that your submission arrived and is now lost, three options are open to you, depending on who lost your pictures— the photobuyer or you because of flawed labeling.

When I speak of lost pictures, I am referring now to one or more transparencies, a disk, or a group of prints. Photobuyers generally do not expect to engage in negotiations over a single print that they know can be reprinted at much less cost than the cumulative exchanges of correspondence over it between photographer and photobuyer. If a single print disappears, my suggestion is to accept the loss and tally it in the to-be-expected-downtime column.

Transparencies are another story. A transparency is an original. Photobuyers are prepared to talk seriously about even a single transparency— if it has been established that they did receive the image. One excellent way (mentioned earlier) to keep tabs on delivery of your shipments is to invest in a return receipt. The post office will provide you with documentation that someone signed for the package.

Another protection is a liability stipulation, which you include in your shipment, to the effect that if the buyer loses or otherwise damages your transparency, his company is liable to you for $1,500.

Does this latter course seem excessive? Many photobuyers think so, and you get on their blacklist if you try it. There's an old story about

Michael Jordan demanding a special jersey number, a special footlocker, and white basketball shoes. The coach just laughed at him. Michael was thirteen at the time. Even Stephen King had to settle for less than optimum contract agreements in the early stages of his career. So did Van Cliburn, Tom Cruise, and Julia Roberts.

When you're an unseasoned freelancer, you "takes what you gits." Initially, exposure and credit lines are your prime rewards. Only when you have proved to an art director or photobuyer that you can deliver the goods, and that she needs you, can you call the shots. Until you've proved yourself valuable to a photobuyer or publishing house, you're not in a position to talk liability stipulations.

In this age of malpractice suits, some publishers have become gun-shy because a small but significant number of photographers have pressed suit for loss of transparencies (rarely are prints or disks involved). Consequently, publishers shy away from dealing with new and untried stock photographers, or they take precautionary measures with them, such as having the photographer sign an indemnification waiver that in effect releases the publishing house from any and all liability.

That's why it's important to discern who's doing the talking when you hear seasoned professionals advise that "you ought to require photobuyers to sign liability agreements." When the professional advises you to get a liability release from the publisher, he just might be using one of the tricks of the trade (any trade) to eliminate competition. He knows that photobuyers will steer clear of you if you summarily present them with a liability requirement. Or it might be an ego trip for the pro to suggest that you get the release. Only the known and the best can make demands, as Michael Jordan eventually learned.

The commercial stock photographer and the editorial stock photographer may have different attitudes toward this liability problem. As an editorial stock photographer, your interest in photography as an expressive medium differs a lot from that of the commercial stock photographer who concentrates on photography as a graphic element in advertising, fashion, or public relations. The commercial stock photographers' rights

to sell their services and to protect their business with holding fees, liability terms and conditions, and so on should be honored. However, their business is not editorial stock, and their markets are not magazine and book publishers, when it comes to dealing with photo illustrations. Yes, of course, if you're dealing with a buyer in range 1 (see Table 8-1 on page 127), you'll probably arrive at some mutually reasonable liability agreement. If you deal with buyers in range 6, the subject may never come up.

How Much Recompense Should You Expect?

The compensation you should expect from a photobuyer for a lost picture is dependent on several factors: (1) the value of the picture to you and to the photobuyer, (2) the anticipated life of the picture itself, and (3) which price range (1 to 6) the photobuyer is in.

I have talked with photographers who have received compensation ranging from one hundred to fifteen hundred dollars for an original transparency. A good rule of thumb is to charge three times the fee you were originally asking. If the lost transparency is a dupe, in most cases only the cost of replacement would be in order. One final consideration: Some politics are involved here. Each photobuyer can be a continuing source of income for you. How you handle these negotiations will influence how much of that income continues to come your way.

LIABILITY: Submitting any film, print, slide, or negative to this firm for processing, printing, or other handling constitutes an AGREEMENT by you that any damage or loss by our company or subsidiary, even though by our negligence or other fault, will only entitle you to replacement with a like amount of unexposed film and processing. Except for such replacement, the acceptance by us of the film, print, slide, or negative is without other warranty or liability.

Customer's film is developed by _____ without warranty or liability of any kind, except to furnish the customer with replacement film at least equivalent in number of exposures to negatives lost or damaged in processing.

NOTE: Responsibility for damage or loss is limited to cost of film before exposure.

Figure 9-5. Liability notices.

If you're still not convinced that a liberal policy toward a photobuyer's liability is sound, consider this: Two other entities also handle your transparencies, the film processor and the delivery service (U.S. Postal Service, UPS, FedEx). Neither of these entities will accept liability for your transparencies (or prints) beyond the actual cost of replacement of film, disk, and/or paper, unless gross negligence can be proven. You've seen this in small print, but as a reminder, see Figure 9-5. (These notices are all from reputable film-processing companies.)

The U.S. Postal Service, UPS, and FedEx will not award you more than the *replacement cost* of the film or prints. If you've insured your package for the intrinsic value of your pictures, in the event of damage or loss, the carriers will want to see a receipt establishing that value. If you don't have one, they will pay you only what it would cost you to print the pictures again or have duplicates made. The insurance would not cover sending you back to France to retake the pictures.

If you were a commercial stock photographer and the loss was substantial, and evidence of gross negligence by the courier was involved, you might want to consider taking the courier to court.

Such harsh terms should encourage you to prevent the loss of your film or pictures by packaging them well.

If you have arrived at a point in your own stock photo career where you'd like to test the reaction of your photobuyers to a Terms and Conditions Agreement form, buy a current copy of *ASMP Professional Business Practices in Photography* ($29.50 at the time of writing). It includes the following sample forms (which you can photocopy or modify): Assignment Invoice, Stock Photo Submission Sheet, Stock Pictures Invoice, Model Release, and Terms of Submission and Leasing (which lists the compensation for damage or loss of a transparency at $1,500). You'll also find similar forms in a book on commercial stock photography by Michal Heron, entitled *How to Shoot Stock Photos That Sell* (see the bibliography).

If you'd like to know more about ensuring your rights when a transparency or shipment of black and whites is lost or damaged, here are four references: *A Guide to Travel Writing and Photography* by Ann and Carl

Purcell; *The Photographer's Business and Legal Handbook*, by Leonard D. DuBoff; *Photography: What's the Law?* by Robert Cavallo and Stuart Kahan; *ASMP Stock Photography Handbook*, by Michal Heron, editor.

Remember, the key to successful marketing of your pictures lies in effective communication with the people who approve payment for your pictures—the photobuyers. Your photos may have won ribbons in photo contests, but the real judge of a marketable picture is the photobuyer.

A Twenty-Six-Point Checklist to Success

Sending a submission to a photobuyer? Run your package through this quality control:

Packaging

- ☐ Clean, white, durable outside envelope with correct amount of postage.
- ☐ Professional-looking label with your correct (legible) return address and logo printed on it.
- ☐ SASE enclosed.
- ☐ All photos clearly identified: picture number, plus your name and address.
- ☐ Copyright notice.
- ☐ No date on your slides or prints (unless you use a code).
- ☐ Captions when appropriate.
- ☐ Transparencies in thick, see-through vinyl pages.
- ☐ Cover letter (printed form letter) that is brief and on clean, deluxe stationery.

Cohesiveness

- ☐ Solicited submission: Pictures are on target as per request of photobuyer.
- ☐ Unsolicited submission: Pictures follow style and subject of photobuyer's publication. They fit the buyer's graphic and photographic needs.
- ☐ Pictures are consistent in style.
- ☐ Pictures are consistent in quality.

Quality
Color

☐ Color balance is appropriate for subject and is suitable for reproduction.

☐ Dupes are reproduction quality (with proper filtering) or else identified as display dupes.

☐ Each slide has been checked with a magnifying glass or a loupe for sharpness. No fuzzy shots!

Digital

☐ Resolution matches the photobuyer's needs.

☐ Format is acceptable to photobuyer.

☐ Delivery method (e-mail, CD-ROM, and so on) acceptable to photobuyer.

Black and White

☐ Good gradation: stark whites; deep, rich blacks; appropriate gradations of grays.

☐ Spotted.

☐ Trimmed: Edges are crisp and straight; no tears or dog-ears.

Both Color and Black and White

☐ In focus, sharp, good resolution (no camera shake).

☐ Current (not outdated).

☐ Appropriate emphasis and natural (unposed) scenes.

☐ $P = B + P + S + I$. Pictures evoke a mood.

Readers outside the United States who are marketing to U.S.-based companies: Contact your local postal service, purchase International Reply Coupons and include them as equivalent return postage.

10

If You Don't Sell Yourself, Who Will?

PROMOTING YOUR PHOTOGRAPHY

The greatest hurdle in the area of self-promotion, it seems, is not *how* to advertise oneself (many clever and creative methods are open to you), but the reticence most of us have when it comes to self-advertising. We're uncomfortable talking about ourselves in glowing terms, afraid of seeming pushy or immodest.

Many a talent has gone undiscovered because he failed to act on this salient reality: If we're going to be discovered, it's our job to orchestrate it. The number of talented photographers in this country alone must run in the hundreds of thousands. Picture the Bronx telephone directory. Then imagine that all those names are modest, talented photographers, and your name is among them. It seems preposterous to think that the world of its own accord is going to come along and pick you out from

all those other fine talents, doesn't it? Sometimes it's actually immodest to be modest.

Society has ingrained in us the idea that unless we exhibit an acceptable degree of self-effacement, we won't be thought well of ("He's so conceited!" "She's stuck on herself!" "What an ego!").

However, the viewing public deserves to see and enjoy your pictures. You deserve to have your talent rewarded with that which allows us to survive in today's world: money. You must overcome the conditioning our culture lays on us, and accept the fact that if your stock photographs are going to be seen and enjoyed, you're going to have to blow your own horn.

With good judgment, you can accomplish this and come off looking not like an overbearing egomaniac, but like a talented businessperson who knows how to keep her product in the marketplace.

Talent Can Take You Just So Far

Here are four tips that should help you maintain your resolve to promote yourself—and to keep on promoting.

1. Many stock photographers, once they have achieved a name in their local area, lull themselves into supposing that the *world* is aware of their work. Not so. Think big. Don't just toot that horn; *blow* it.

2. If you want your stock photos to continue selling, you have to continue selling yourself. Horn blowing is an ongoing task. Don't think that photobuyers or potential clients are going to remember you next week because of your success with them last week or last month. Today's successes are history tomorrow.

3. Once you begin to promote yourself, you will be pleasantly surprised to find that the people you thought would be highly critical of your promotional efforts will actually be the first to compliment you.

4. Because part of your motivation as a photographer is to share your insights and your vision of the world with others, you will find that the rewards of promoting yourself (and therefore your stock photography) will far outweigh the personal discomfort you sometimes feel when writ-

ing and distributing press releases about yourself, or when enclosing tear-sheets of your triumphs in business correspondence. Without such promotion, you leave yourself at the mercy of chance. Sure, a few photographers are going to make it by sheer luck alone. Someone always wins the lottery or the one-million-dollar jackpot at Atlantic City. However, the majority of photographers who become successful have managed it by means of effective self-promotion.

Look Like a Pro Even If You Don't Feel Like One . . . Yet

This applies to everything from your stationery to your flyers. The adage in this business is: *Appearance communicates quality of performance.*

Your new contacts in the photomarketing field, since they rarely meet you in person at first, will rely heavily on the appearance you project via your communication materials. Your photography speaks for itself. Your promotional material speaks for you. It tells photobuyers how serious you are about your work—whether you're a good bet to be producing the same fine photography next month, or next year, at an address they can reach you at (your *reliability factor*). Photobuyers assume that your performance and dependability will match the quality of your presentation.

As publisher of the *PhotoDaily* market letter, I have the opportunity to see numerous creative methods of self-promotion. I've included some examples in the following sections. They will give you an idea of the possibilities open to you: producing brochures of photo samplings, making catalogs, enhancing your stationery with examples of your work, and designing a distinctive logo.

Your Personal Trademark or Logo

Your photography itself becomes your trademark once you get established. Before you reach that point, though, a specific trademark or a logo may be an important element contributing to your success. A distinctive logo or design can help your correspondence to start looking familiar to buyers—and your name to start being remembered.

When you design your symbol or logo, be aware of a common error: the temptation to use the obvious—a camera, a computer disk, a tripod, or a piece of 35mm film. You may, of course, want to choose from things photographic, but try for a combination or adaptation that's all your own. Make it simple and easy to remember. Recruit a graphics student, or a friend who's good at designing, drawing, or critiquing your work, to help in the decision, based on the pointers mentioned earlier. Flip through the yellow pages or a business directory to see how others have tackled the question of logos. Don't be too cute in your design—the novelty will soon wear off or even be offensive to some clients. Don't be obscure, either.

I consider the design of a stock photographer's stationery so important that I have prepared a small kit for our newsletter subscribers to help them select a letterhead and logo for their stationery. This kit is available on our Web site in the Stock Photography 101 section at *www.photosource .com/101.*

If your photographs are highly specialized in one area, be specific with your trademark or logo. If you're a nature photographer, you can choose a design that reflects your work—a silhouette of a fern or a close-up of a toad. Children photographer? Choose a classic shot of yours that lends itself to a simplified sketch or drawing. As your photomarketing enterprise grows, you'll be building equity in, and getting exposure and mileage from, your trademark or logo. Decide your specialty early, and produce a trademark that will cause editors to say, "Aha—he's a transportation photographer," or, "She's a tennis photographer." However, don't worry if you don't have a strong specialty yet. You can start with a neutral logo, or no logo, and work gradually toward becoming strong in one or two defined areas on your Photographic Strength/Areas (PS/A) list. Then you can alter your logo from a more general design to one tied into your specialty.

Your personal trademark or logo doesn't necessarily have to include a design or photograph. It can consist of the name you give to your stock photo business, with or without an identifying design. The name can be

your own name or a product of your imagination. Choosing your trade-mark is like naming a child: Once you make your final decision the result is here to stay, so do it carefully.

If you think you may register your trademark down the line, better check it out *now* to avoid disappointment in later years, when you find that someone else or another company has already registered the exact same mark you desire.

It's not absolutely necessary to formally register your trademark ($325, at this writing), but if you wish to explore the process to ensure that no one can legally copy your design, you can check information that's available on the Web at *www.uspto.gov* or write to Trademarks, Superintendent of Documents, U.S. Government Printing Office, Washington, DC 20402. You also can register your *mark of trade* with your state officials.

YOUR LETTERHEAD

Your stationery often is your first contact with a photobuyer. Put special care in designing your letterhead. For the lettering, you can experiment with the graphics or word-processing software that came with your computer. Often fifty or more fonts will be available to you. If you have a general mood running through your pictures, match it with a typeface that has the same feel to it. Consider incorporating a carefully chosen sample of your photographs in the design. Barter with a graphics student to conjure up some ideas for you to choose from. Outside help usually is more objective.

As I mention throughout this book, "You don't get a second chance at a first impression."

You are working long-distance with your buyers. The first impression they have of you is the piece of paper with which you contact them. When you initially write for photo guidelines, contact the photobuyer on *deluxe* stationery. If it costs a minimum of a dime a sheet, you're on the right track. At a quick-print shop, get only one hundred printed at a time. It's costly, but if you change your address or your mind, an investment in five thousand sheets isn't lost. Once you eventually decide on

your design and letterhead, then you can consider getting a larger order printed to your specifications.

ENVELOPES

Make your envelope a calling card. How do you decide which logo or photograph to use on your outside envelope? Use one that (1) commands attention and (2) reminds photobuyers and the public of your specialty. If your specialty is agriculture, and an extensive portion of your Market List includes publications in the area of farming, a strong agricultural photograph or logo will serve well. Keep in mind the purpose of your envelope promotion. You want your name to become synonymous with agriculture photography. When photobuyers in the farm-publications industry ask themselves, "Who has good agriculture pictures?" you want your name to come up.

What if you have two or three specialties? Print two or three different envelopes targeted to the different segments of your Market List.

BUSINESS CARDS

A distinctive business card will keep your name circulating. Business cards are inexpensive, and any printer can produce them. If you and your computer are up to the task, you also can create and print your own business cards on Avery business card stock *www.avery.com*. For a better, finished look, use scissors or a paper cutter to separate the cards rather than folding on the laser perforations. Don't fall into the trap of acquiring a couple thousand business cards that are cheap looking and indistinguishable from your competition. Make your next business card something people will remember: a photograph (see Figure 10-1). Consult the yellow pages for printers. A good source for photographic business cards is Herff Jones Inc., Suite 82, P.O. Box 100, Lewiston, Minnesota 55952, *www.herff-jones.com*.

Build a Mailing List

The core of your operation is your Market List—the list of your photobuyers, past, present, and future. Your promotional mailing list should

STOCK OPTION PHOTOS™

www.stockoptionphotos.com

RICK SCHAFER
PHOTOGRAPHER

T: 503.293.5377
F: 503.452.1232
E: rick@stockoptionphotos.com

Figure 10-1. Business cards.

start with your publication Market List. Begin to extend it to camera columnists, local galleries, photography schools, camera clubs, camera stores, radio and TV stations, and newspapers that will receive the press releases you'll periodically circulate.

Preferably, these names and addresses should be on one major database that separates them by code. Keeping one central list helps you avoid duplication in mailings and time-consuming tracking when an address changes.

Faithfully keep your list up-to-date. Print on all of your envelopes. The cost you pay the postal service for the correction is currently a few cents, but it's worth it. Whenever you make a mailing, code the mailing on your master list with a color, symbol, or date so that you'll have a means to measure how many mailing pieces certain markets or columnists are receiving. If your list is on a database, set up your program to antici-pate categories that may be useful in the future, such as number of sales per individual market, and type of sales (book, curriculum, or magazine). Clean your list often (i.e., weed out addresses that have changed or are no longer useful).

MAILERS—THEY PAY FOR THEMSELVES

Probably the most cost-effective means of self-promotion is the *mailer* (also called *sell sheet*, *flyer*, *insert*, or *stuffer*). These promotional pieces are similar to brochures (described later in this chapter), but are less elaborate (thus less costly), and you can make them yourself if you wish. They consist of a grouping of examples of your pictures, in whatever size you wish to make them.

Dennis Cox, a stock, corporate, and editorial photographer in Ann Arbor, Michigan, suggests a mailing every three to four months, mini-mum. His mailing list includes magazines, book publishers, design firms, corporate communications directors, and ad agencies. "Naturally, not every direct-mail piece is going to fit everyone on my list, so I target mailings to only those I think will respond favorably to the particular mailing." Though this is guesswork, Dennis advises keeping your guesses

Figure 10-2. Self-promotion mailers.

wide, not limiting. "Just when you think it may be time to remove a name because of lack of response, you'll get a call from them. My rule is: If you want to work for them, keep mailing to them."

In the fast lane of self-produced sell sheets is the digitally generated promo. Joe Farace *www.joefarace.com*, a stock photographer out of Brighton, Colorado, tailors short-run sell sheets to specific themes and then sends them to photobuyers who are looking for pictures within that theme area. Because he produces the sheets using his own computer and printer, Farace can print from one to one hundred, depending on his target market.

His method is to work with images created with digital cameras or film scanned on a flatbed scanner with a transparency unit. He uses the Layers function of Photoshop to create composites of several color and black-and-white images along with supporting text, on a single sheet of paper. He prints the results on an Epson Stylus Photo 1280 ink-jet printer using photo paper. Each 8½″ × 11″ sheet costs him less than two dollars.

A word of caution: If you decide to make, and print, your own sell sheets, pay close attention to detail, layout, and printing. It might take ten mailings

of an exceptionally good sell sheet to win a client, but it will take one mailing of a poor-quality sell sheet to lose the client forever. If you have a professional printing company print your sell sheets, you will pay about five hundred dollars for five thousand deluxe quality sheets in black and white; you will pay a minimum of three times as much for color.

Other types of mailers are 3″ × 5″ or Rolodex®-size cards (2¼″ × 4″), in various colors with promotional reminders on them. Dennis Cox sends Rolodex® cards printed on durable plastic. He says, "They attract attention and should be a long-term asset. I've also sent out a series of postcards with good results." Rolodex® cards are available through MWM Dexter Inc., 107 Washington Avenue, Aurora, Missouri 65605, (800) 354-9007, *www.mwmdexter.com*. A punch-out Rolodex® card is available through your local business printer or from specialized print shops in metropolitan areas.

POSTCARDS

Full-color postcards are an excellent marketing tool. There's no envelope that the recipient has to open, and its cheaper to send a postcard than it is to mail a letter. Promotional postcards are available from Modern Postcard, 1675 Faraday Avenue, Carlsbad, California 92008, (800) 959-8365, *www.modernpostcard.com*; and MWM Dexter Inc., 107 Washington Avenue, Aurora, Missouri 65605, (800) 354-9007, *www.mwmdexter.com*.

BROCHURES

Design and produce a professional-looking four-page brochure—that is, one large (8½″ × 9½″) sheet folded once. It will be a showcase for you, and it will pull in sales and assignments. Use as guides the brochures or pamphlets found in airline or travel offices. Such a brochure usually pays for itself, whether you invest two hundred or two thousand dollars. If you have the cash, courage, and marketable pictures available, bend your budget and produce a full-color brochure aimed at a specific market that has both the need for your PS/A and a pay rate that will make it worthwhile. Look at other brochures to see which ones appeal to you. When

you find one, adapt the design, using pictures that will appeal to your Market List.

Handsome, four-color brochures can cost as much as several dollars each depending on number of pages and size. A good place to find a wide selection of samples of these exquisite brochures is in the wastebasket of your local post office. Does this tell you something? Make sure your brochure reaches the right target.

How many brochures should you print and where? Take your mock-up to several four-color printers for quotes on one thousand, three thousand, and five thousand copies. The quantity depends on the size of your market. It's better to print more than you think you'll need. It's cheaper per unit; besides, you'll discover new uses for your brochures once you have them. Such brochures need little copy. Put your photographs into the space. About the only words you'll need are your name, address, phone number, e-mail address, and Web site address. For assistance on self-promotion, check out the Stock Photography 101 section on the PhotoSource International Web site at *www.photosource.com/101*. Also see *The Photographer's Guide to Marketing and Self-Promotion* by Maria Piscopo.

CATALOGS

Have a catalog printed displaying a selection of your stock photos based on your PS/A. Assign identifying numbers (as used in your filing system, see chapter thirteen) to each picture. Three-hole-punch the left side of each page, and send it to current and prospective editors (see Figure 10-2).

The cost for three thousand copies of an eight-page, 8½" × 11" black-and-white catalog runs from $1,200 to $2,000 or more. Stock photographer Robert Maust of Keezletown, Virginia, sent out such a catalog and says, "My costs were paid off by sales I made directly related to the catalog in only a few months."

Here's how to put together such a catalog: Place sixteen verticals or fifteen horizontals on one page. Using eight-by-tens, make a huge pasteup of each half of the page. The printer shoots it in halftone, reduces it, shoots the other half, tapes the upper and lower halves together, and prints it.

You also can scan your images, make a digital catalog, and have a printer print that for you. You'll need to coordinate with the printer ahead of time to ensure your scans are of high enough quality, of the proper format, that the program you've used to create the catalog is compatible with his equipment, and upon which medium to record your files (such as CD-ROM or ZIP cartridge). You should not print your own catalogs unless you have access to a professional-grade color laser printer.

CD-ROM CATALOGS

Should you produce one yourself? It's not as difficult as you might think, and it's not very costly. The question you should ask first is, "Will the photobuyers I send this to look at my CD-ROM catalog?" The reality is that most photobuyers stand over a wastebasket when they read their mail. Unless you have produced a first-class carton and mailing label for your digital catalog, photobuyers probably won't open it.

A good rule of thumb is to not send a CD-ROM catalog to a buyer you have never worked with before. Try to establish some sort of contact first, and then send the CD-ROM catalog once the photobuyer knows who you are.

There are a couple options for producing a CD-ROM catalog. You can farm it out to a company that specializes in it, or you can do it yourself with software such as Adobe Acrobat, any HTML editor, Microsoft FrontPage, or Macromedia Dreamweaver. New software products appear on the market constantly, so check around before you decide which one to use. Consider the fact that you want your catalog to be able to run on a PC and a Mac, and you want the photobuyers to be able to easily view it without having to buy or download special software.

THE PHONE

Telephone marketing is an effective way to sell yourself. Each phone call is actually a self-promotional opportunity. Be sure to prepare for it with a *give* list. If you call a prospective photobuyer with nothing to give,

your intended promotion may end up a bust. (For more on dealing with photobuyers by phone, see chapter seven.)

Your local telephone company will have promotional aids available to you, ranging from voice mail, toll-free numbers, and Internet connections, to literature on how to overcome "phonephobia." Practice your promotional calls using a tape recorder. If your voice sounds too high, too low, or unenthusiastic, keep trying until you get it right. Then practice with a few trial calls. You'll know by the response if the phone is for you.

Credit Lines and Tearsheets—Part of the Sale

Credit lines and tearsheets of your published stock photos are significant self-promotional tools. How do you get them? Request them when you're notified that your picture has been accepted for publication. Even better, you can include a courteous statement in your original cover letter to an editor that the terms of sale include use of your credit line and provision of a tearsheet upon publication.

Major markets ordinarily print credit lines as a matter of course; however, they expect you to purchase the publication and get your own tearsheets. Textbook editors also will expect you to make your own photocopies of your published pictures. Photo editors of regional, local, or specialized limited-circulation publications work with smaller budgets and will usually supplement the dollars with a credit-line guarantee and forward tearsheets to you. Some of your markets will have the provision of tearsheets built into their standard operating procedures. They automatically send them to all contributors to a given issue, to confirm for their own records that the photographer (or writer) has been correctly credited and paid. (To help ensure a correct credit line for your photographs, use the identification system described in chapter thirteen.)

You can use tearsheets for self-promotion in a variety of ways. Make photocopies of them to tuck into your business correspondence. This will show prospective clients how other publishers are using your stock photographs and will remind past photobuyers of your existence. Inexpensive and immediate, such promotions often pay for themselves

through orders of the actual stock photos pictured in the photocopy. You also can use groups of tearsheets (originals or photocopies) to send to a prospective photobuyer to illustrate the depth of work you have available on a given subject.

When you accumulate a number of tearsheets, file and cross-reference them to locate subject matter you've previously photographed.

Credit lines, besides the good advertising they provide for you, can be instruments for additional sales. Art directors and photo editors are always on the lookout for promising new stock photographers. When your credit line appears next to your photo illustration or in the credits section of a publication, it's available for all to see and make note of. If you're doing your self-promotion job correctly, your credit line will be popping up often, and photobuyers will become familiar with your name. In some cases, photobuyers will want to reuse a published photo that catches their eye, and they will seek out the photographer to make arrangements. Without a credit line, this would be a complex detective task that the buyer wouldn't have time for.

What if a photobuyer doesn't give you a credit line? Beyond an approach of courteous insistence, your hands are tied. The use of credit lines, in the majority of cases, is left up to the editor or art director of the publishing project. You're fighting city hall when you vent righteous indignation at the lack of a credit line. However, have faith. As in city hall, administration changes occur in the publishing world, and the next art director you deal with at a particular publishing house may have the "right" attitude toward including credit lines. An examination of magazine and book layouts over the last decade shows that the trend is decidedly moving toward the use of credits. Meanwhile, it's up to you to politely but firmly continue to press for the use of your credit line next to your published photograph.

Show Yourself Off

Your promotional tools are working to make sales of your pictures for you. Now you want to begin getting some promotional exposure for *you* as a photographer.

TRADE SHOWS

Publishing trade shows, book fairs, and magazine workshops always attract publishers and photobuyers. Invest in trade shows with either an exhibit booth or a ticket to the event to personally meet publishers and photobuyers who represent potential markets and/or new members for your promotional mailing list.

To learn which trade shows would be most productive for you, ask buyers on your Market List which ones they personally attend. Since these people are your target markets, you can be sure the events they deem worthwhile will pay off for you in opportunities to become aware of new, similar market areas.

Carry your business cards and CDs with you to pass out, with each CD representing a separate area of your PS/A. I went to my first trade fair with a general portfolio. Photobuyers weren't interested in seeing my generic, pretty pictures. The next year, I built three packets, each with twenty-five 8″ × 10″ black and whites and two vinyl pages of color slides (forty dupe 35mm) enclosed in a plastic folder. Each aimed at a specific market: education, gardening, and teens. I talked only with photobuyers in each of those three specific interest areas and showed only the photographs they were interested in seeing. My visit more than paid for itself in subsequent sales.

WEB SITE

The Web might be one of the easiest, most efficient, and cheapest tools you can use to get photobuyers to see your photographs. At the same time, it might also be the most difficult, inefficient, and expensive tools you have ever used. Sound strange? Allow me to elaborate.

Building a Web site doesn't have to be all that difficult. You can build one yourself with basic knowledge of HTML or with off-the-shelf software, or you can hire a Web designer to design and build your site. Publish the address of your Web site on your business card, envelopes, stationery, sell sheets, even your business checks.

If you're considering signing up with a Web photo gallery, check out

their traffic numbers by looking them up on a ranking site such as Google.com. Alexa.com also is a free service owned by Amazon.com. The more traffic a photo gallery has, the more exposure for you. As an example, check out PhotoSourceBANK and PhotoSourceFOLIO, where you will be able to showcase your photography, and make the buyers aware that you exist.

Avoid "freebie" sites that require you to allow advertising space along with your photos. Be cautious with companies that purport to allow you use of "your own domain name," but which often bury your name after a long and hard-to-remember URL.

For further Internet tips, my book *sellphotos.com* covers the topic of Web sites more extensively than I have room for here.

SPEAKING ENGAGEMENTS

Here's a simple way to promote yourself, and it doesn't cost you anything. If you communicate effectively with your camera, you may have the potential to communicate effectively as a speaker. Take to the platform!

In the trusty yellow pages, you'll find a listing of community and photographic organizations, clubs, and associations. Most have a regular need for interesting program speakers. Let the program chairpersons of several groups know that you are available. In most cases, they'll be happy to book you.

How do you get started? What should you talk about? As a stock photographer, you have a wealth of subject material available to you—and since 90 percent of your listeners fancy themselves photographers, too, you'll have a receptive audience. Build your talk around a how-to subject, for example, "How to Take Pictures of Your Family," "How to Take Indoor Natural-Light Pictures," "How a Digital Camera Works," or "How to Make a Photo Illustration." You are welcome to use any of the ideas in this book.

Give your speech title this test: "Am I speaking about something that applies directly to my audience?" Your listeners don't want a lecture, or they'd register at the local adult education center. Be entertaining. In-

clude anecdotes, personal experiences, and humor. Use charts, slides, or blackboards. You'll get audience response, and this will aid you in refining your speech. Eventually, program chairpersons will seek you out.

At first, charge nothing, except perhaps a fee to cover your out-of-pocket expenses such as baby-sitting, gas, and the meal. As you progress, start charging a modest fee. Increase the fee as demand for your services increases. As your good track record grows, so will your fee.

You'll discover some surprising spin-offs from your public appearances. Local publishers will hear of your talents. Assignments will be directed your way. Photobuyers will contact you. Your name as a stock photographer will be catapulted ahead of equally talented but less visible photographers.

For good advice and direction on speaking engagements, there's a newsletter that could be helpful to your speaking career: *Sharing Ideas*, Dottie Walters, Royal Publishing, P.O. Box 1120, Glendora, California 91740. Walters also is the author of *Speak and Grow Rich*. If you branch out into seminars, you can list them free in the *Shaw Guides*, *www.shawguides.com*, and in *Photographer's Market*, 4700 East Galbraith Road, Cincinnati, Ohio 45236.

RADIO AND TV INTERVIEWS

Make yourself available to community radio talk-show hosts. They usually are interested in interviewing people engaged in out-of-the-ordinary pursuits, and you qualify. Photography is an ever-popular subject, as listeners are always eager to learn how they can improve their picture-taking. Add some local or farther-afield radio-show hosts to your promotional mailing list. Some radio hosts will phone across the nation for an on-the-air phone interview if they believe that their listeners would be interested in what you have to say.

A good source to locate radio stations and the addresses of hosts of talk shows is *All-In-One Directory*, Gebbie Press, P.O. Box 1000, New Paltz, New York 12561. The same organization can give you the names and addresses of TV-show hosts. Television interviews are possible if you

can present your story in a five- to nine-minute segment. Since photography can easily hold viewer attention, your chances are better than average for making a TV appearance, particularly in a nearby city. For a fee, you can get yourself listed in a talk show guest directory called the *Directory of Experts, Authorities, and Spokespersons*, Broadcast Interview Source, 2233 Wisconsin Avenue, NW, Washington, DC 20007, (202) 333-4904. A helpful book is *DIY PR: The Small Business Guide to "Free" Publicity*, by Penny Haywood. For New York radio and TV contacts, refer to *New York Publicity Outlets*; for California, refer to *Metro California Media*.

Contact the producer of a local talk show (by letter, by e-mail, by phone, in person—or all four). You could offer to serve as the resident critic for photography submitted by viewers. Build your format around a how-to theme. Tailor your critiques so that the average snapshooter will understand them and will be able to improve the family's scrapbook photographs.

PRESS RELEASES

If you've been making speeches, giving talks, making appearances at vocational, technical, graphics or design classes, or giving interviews on radio or TV, someone's going to be mentioning you in your community news media. However, whether or not you've been engaged in these activities, you can write your *own* press releases: They are an excellent form of promotion for your stock photo business. Newspapers and magazines are willing to accept news about you and your photography; so are the specialized newsletters and trade magazines that reach photobuyers and publishers. *You* must contact *them*, and send them your press release. About one-third of the media channels you contact will print your release.

When you consider that the average advertising rate is fifty dollars per inch, when your press release is used you receive a sizable amount of advertising space free. What's more, your release is read as editorial, human-interest material rather than as advertising.

When can you send a news release about your photography or your-

self? Depending on whether the item would be of interest on a local, regional, or national level and whether your target is a trade publication or a general-interest one, your press release can center on a recent trip; your photo exhibit at the local library; an award you received; your move from farm to city or city to farm; your donation of photo illustrations to a nonprofit publication or auction; your publication of a photo in a national magazine or book; or a recent speech or interview.

Press releases follow a basic format: double-spaced on a half page or a full page. Write your release as if the editor (or radio commentator) were writing it. Remember: It is not an ad. This is not the place to speak in glowing terms about yourself or your photography.

A good handbook on this subject is *Bulletproof News Releases: Help at Last for the Publicity Deficient*, by Kay Borden. See also *The Successful Promoter: 100 Surefire Ideas for Selling Yourself, Your Product, Your Organization*, by Ted Schwarz. A newsletter that broadcasts the current press needs of authors, columnists, and editors is *PartyLine*, 35 Sutton Place, New York, New York 10022, (212) 755-3487, fax: (212) 755-4859, *www.partylin epublishing.com*.

You don't need to include a cover letter, but do enclose a black-and-white photograph (a five-by-seven is acceptable) when appropriate and practical. (Don't expect its return.)

Your best teachers for learning your way around press releases are news items you discover in the press. If you find yourself saying, "That could be me!" rewrite the item to reflect your own information, and send it to similar media channels.

Occasionally you will learn that an upcoming issue of a trade magazine in one of your fields of interest will be devoted to a certain subject. If you or your stock photographs can comment on that subject matter, volunteer to contribute (for free). The resulting exposure of your name and your stock photos in both the publication itself and the subsequent press release you write about it will more than compensate for your effort and expense.

Once a press release is used, capitalize on the published article by

making copies and sending the news item along in all your business correspondence and/or in a mailing to your market and promotional list.

PROMOTIONAL NEWS FEATURES

Local, regional, or trade publications often welcome articles or short features (250 to 500 words) on somebody who's doing something interesting—you. Don't wait until a publication contacts you. Write your own material.

Photographer Bill Owens of Livermore, California, gets more mileage out of free advertising by turning a news feature about himself into a productive promotion mailer.

FREE PROMOTION

It costs nothing but a little time to make sure you're included in a number of directories that photobuyers use. Many of the market directories listed in chapter three include a section entitled "Freelance Photographers" or "Stock Photography." *Literary Market Place* and *Working Press of the Nation* list individual photographers free of charge. Apply to be listed in the photographer sections of their next editions.

ADVERTISING

Straight advertising is a direct method of self-promotion, but here you'll have to experiment—and it's usually expensive. Ordinarily, ads will not be the most cost-effective route for you as an editorial stock photographer, unless you have strong depth in an unusual specialty with a known target market.

Only one publication will help you reach editorial photobuyers almost exclusively—*PhotoSourceBOOK*. Published annually by PhotoSource International, this desktop photographer directory for photobuyers is the way to go when the size of your stock photo files reaches approximately five thousand high-grade photographs. For more information, see *www.photosourcebook.com*.

The following publications can be useful advertising vehicles, as some photobuyers cull photo contacts from them. (Most of the ads are run

by stock photo agencies and commercial stock photographers who have extensive coverage of specific, select subjects.) *Adweek Creative Services Directory*, *www.elance.com*; *American Showcase*, *www.americanshowcase.com*; *American Society of Picture Professionals Newsletter*, *www.aspp.com*; *The Creative Black Book*, *www.blackbook.com*; *KLIK showcase photography*, *www.americanshowcase.com*; *Direct Stock*, *www.directstock.com*; *Photo District News*, *www.pdnonline.com*; *The Stock Workbook*, *www.workbook.com*.

Although you may not wish to invest in a costly display ad in any of these publications, you could test for response with a classified ad. A typical example, which appeared in *Folio* magazine listed under "Photography, Stock," reads: "Emphasis on the Southwest. 150,000 images. Color and black and white. Write for free catalog [name, address, phone, e-mail, Web address]."

Ask which trade publications the photobuyers on your Market List read. Assume that other publishers with a similar editorial thrust read the same publications, and start your ad experiments there. Following are some of the questions you should ask yourself when you're thinking of buying an ad:

"Who are the readers of the publication?"

"Is it a desktop directory, e.g., Green Book, PhotoSourceBOOK?"

"Do they buy photography?"

"Will my ad get effective placement in the magazine or directory?"

"What do I expect to achieve from this ad?"

"What is the cost?"

Whenever you advertise, key your ad with its own code number (for example, add "Dept. 12" to your address). You'll be able to tally the replies and check how well each ad or directory listing works for you.

To measure the response rate to your ad, divide the number of queries you receive by the circulation of the magazine. Expect a response of between 0.1 and 1 percent (.001 and .01). Compare the response from each ad with those from the rest of the ads in your advertising program to weed out ads that are ineffective or reaching the wrong audience.

Another type of advertising tool, which you can use year-round, is a

handy calendar of a size that you can include in your correspondence. Obtain more information from companies like MWM Dexter *www.mwm dexter.com.*

Or you can engineer this kind of arrangement: When I was starting out in the business, I cooperated with a Midwest printing firm in a wall-calendar project. In return for the use of twelve of my photos, they paid me with a prominent credit line and five hundred calendars, which I distributed as promotional pieces.

The optimum ad is one in which a manufacturer, supplier, or photography magazine highlights (promotes) you and your photography. Nikon, for example, featured different photographers and their work in a series of full-color, full-page ads that appeared in national photography magazines. In my own case, features and photographs of mine have appeared in *Time, Money, Changing Times, USA Today,* many newspaper photo columns, computer magazines, and most of the photography magazines. Was this luck? No. I applied the principles outlined in this chapter.

Again, *don't wait* for things like this to land in your lap. Do something interesting (or different), and then let the industry and the media know about it. Keep alert for openings, and *go for them.*

Reassess Your Promotional Effectiveness

Periodically monitor the effectiveness of your promotional efforts. Chart the percentage of your releases that are used, document the response to them and any ads you place by including a code, match numbers of mailings to specific markets with numbers of sales, and analyze feedback from your photobuyers. Continue to test new ideas, drop those that show no promise, and produce more of those that have been effective.

What about promotion tools such as the portfolio or the exhibition? For the everyday photographer, they appear to be good sales tools and exposure opportunities. For the *stock* photographer, however, these elements either don't help at all or do little to increase sales. Let's examine them.

PORTFOLIOS

A portfolio is an excellent tool for a *commercial stock* photographer because of the varied markets that he or she works for. A portfolio exhibits the breadth of a photographer's talent, skill, and experience to a potential client who may wish to contract for her *services*. Legwork and personal visits are part of establishing credibility when one is selling *oneself*.

On the other hand, a portfolio and personal visits are not necessary for the *editorial stock* photographer. You work primarily electronically and by postal mail, and your photobuyers are not interested in looking at portfolios—they want to see pictures geared to their current layout needs. Your pictures, if they're content specific and on target, sell themselves.

A photo researcher or an editorial photobuyer isn't interested in your versatility. In fact, he wishes you weren't so versatile. He'd prefer you to concentrate more thoroughly on one subject—the one he needs, the sub-ject of his magazine or book project. It stands to reason that a stock photographer who sends apple-orchard pictures in response to a photo request from the editor of an agriculture magazine is going to make a lot more points with that editor than a stock photographer who takes up time showing him a portfolio of underwater, aerial, and architectural photography.

EXHIBITIONS

Exhibitions are monumental time-consumers and have limited influence on sales, but they don't hurt and they're good public relations, especially when you attain national prominence. Your exhibit area can range from your local library, bank, restaurant, insurance office, or church to a city gallery or an art museum. For the latter, a theme exhibit, rather than a general across-the-board show, will get more response from a gallery director. Once you have pinpointed your PS/A, your thematic material should build rapidly. Later, these same photo illustrations can lend them-selves to books—another advantage for you as you build your career with marketing precision. (See chapter seventeen for examination of the use of online photo galleries.) Capitalize on the exhibit through news releases

and posters, plus radio, TV, and speaking appearances. A helpful book is *The Photographer's Guide to Getting and Having a Successful Exhibition*, by Robert S. Persky, *www.photosourefolio.com/bookstore*.

SALONS

Salons, usually sponsored by local and national photography organizations such as camera clubs, offer you little promotional value. Salons, in fact, perpetuate many of the myths that stock photographers must unlearn in order to understand what is a marketable picture and what is not. Salon photographs usually are the standard excellent pictures—exquisite clichés.

CONTESTS

Contests are somewhat different from salons in that they can offer national publicity plus cash awards to the winners. Contest sponsors tend to judge pictures on their photo-illustrative merit rather than outmoded classical-composition rules that limit a photographer's creativity and expressiveness. If you win a prestigious photo contest, let the photobuyers on your Market List know about it through a press release or photocopy of the news announcement. A book on the subject is *Winning Photo Contests*, by Jeanne Stallman, *www.photosourefolio.com/bookstore*.

However, enter photo contests with caution. Read the rules carefully. Many times it's the sponsor of the contest who is the *real* winner. Sponsors sometimes require the photographer to give up *all* rights to the picture. In other words, you transfer your copyright, including electronic rights, over to the sponsor—who can then use your picture in whatever way they wish, forever.

If you come across any contests that require you to give up the rights to your photo, remind the sponsors that you, the stock photographer, own your own creation. Write them postcards that say, "If my picture is good enough to win a national contest, it is good enough to earn me many dollars over its lifetime. This is how I earn my living and provide for my family. I choose not to relinquish my copyright."

DECOR PHOTOGRAPHY

Producing artful Track A prints for decor use in commercial buildings or residences can result in excellent showcases for your talents. As you'll read in chapter twelve, *decor photography* will take special administrative (as well as photographic) talent on your part. One approach is to become associated with an existing decor-photography business that has already solved the administrative problems. Place your Track A pictures with them, much as you would with a stock agency, and receive a percentage.

GREETING CARDS, CALENDARS, AND POSTERS

Greeting card, calendar, and poster companies offer you other showcase opportunities but have drawbacks of their own (see Appendix A).

From time to time you may decide it's worth your while to barter for the printing of greeting cards, calendars, or posters in return for licensing ("renting") some of your pictures at no charge. Depending on where you stand on the ladder of your business development, such an arrangement may be of self-promotional value to you.

Some Final Self-Promotion Suggestions

1. Keep several current photographs of yourself on file for promotional use. Often, stock photographers have to make a quick digital photo or Polaroid of themselves to meet a deadline. Have a press kit handy—one that includes a couple of color or black-and-white prints of you plus a photographic biography of you that includes your accomplishments.

2. Don't do it all yourself. *Get help*. Promotion is always more effective if you can get someone else to write it for you or at least read it and suggest corrections.

3. You can't measure promotion such as news releases, interviews, and exhibitions as effectively as you can direct-response advertising, such as with a coupon or a return postcard. However, if your business grows, you can assume that your promotional efforts are on the right track and are having an effect.

4. Be helpful. If a writer requests information or an interviewer wants

answers, cooperate. *Any* kind of publicity is good. As Governor Huey Long once said, "Say what you want about me, just spell my name right."

5. Share the news with others. If an article about you appears in a magazine or newspaper, share it with the photobuyers on your Market List. Place it on the Internet, on a Web page, along with photos if they are available. Buyers will be interested in it for the confirmation that they chose correctly in adding you to their available-photographers list.

6. Here today, gone tomorrow. Promotion—like fitness—is short-lived and can't be stored. Your smashing success today will be history tomorrow. Photobuyers forget. Oh, do they forget! Keep reminders flowing their way every three to four months.

7. Your promotional tools—stationery, brochures, catalogs, labels, business cards, envelopes—can speak as eloquently as your photographs.

8. Don't expect overnight results. Expect to move mountains, yes, but only stone by stone. Promotion works slowly, but it works.

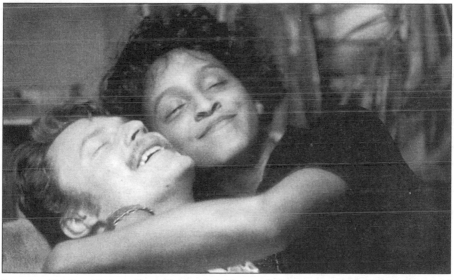

Is grain objectionable in a photo illustration? Photo editors are more artist than engineer. If the pictures fit their needs, they tend to excuse what a photography purist might call technical imperfection, such as the grain in this picture.

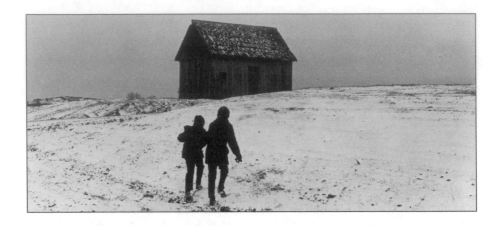

11

Assignments

An Extra Dimension for the Photo Illustrator

Buzz Soard of Littleton, Colorado, was taking a family vacation trip to New Zealand, and he decided to query editors on his Market List before he left. The result was a four-page article on New Zealand's flora and fauna for the former *Adventure Travel Magazine*.

Gene Spencer of Payette, Idaho, queried his Market List before he left for the Northwest and learned that one photobuyer needed a picture of the Olympia brewery in Washington state. "I did several other assignments, too," Gene said, "but that one picture nearly paid for all my gas!"

William Neumann received an assignment after a conversation with an art director on an AOL chat room. Jock Fistick sold a photo from his Web site and also established inroads to assignments for the *Los Angeles Times*.

Assignments can be fun, lucrative, and fascinating, and you can generate them yourself, as well as experience those happy times when the phone rings unexpectedly. One of the biggest rewards, even for those workaday situations ("We need a shot of the National Balloon Race winners"), is the satisfaction—and the glow—that come from the professional recogni-

tion of your competence that's implicit in any assignment.

As a stock photographer, you can nail plenty of assignments, many of them by mail (postal and electronic). Once you've sold several pictures to a photobuyer, you become a valuable resource for her. Most photobuyers keep a list of "available photographers," and this is the first resource they consult when looking for a photographer who has special talent or who is located in a particular part of the country. Make sure you work to get on that list. Once you've made a couple of sales to a buyer you are generally considered an "available photographer." If you don't receive periodic "want lists" from the photobuyer, ask to be put on his mailing list. The situation can arise where the buyer needs a particular picture in a particular part of the country. The photobuyer consults his list of available photographers (in much the same way as you consult your Market List) and finds that you live near the area. He contacts you and offers you the assignment.

It also works the other way. You're planning a trip, and you tell this to several of the photobuyers on your Market List, as Buzz and Gene did. One buyer might respond with a two-day assignment, another might tell you that she needs one picture dependent on the weather ("The sky must have clouds"). A third might imply that he needs three different pictures if you'd like to take them on speculation. Assignments come in all varieties and will be limited only by the focus of the markets on your personal Market List.

Are assignments in your future? It all depends on your own personal interest in being mobile in your photomarketing operation. Some editorial stock photographers thrive on travel; others like to work from their homes. If you opt for assignments, you'll find it rewarding to apply the principles in this chapter.

Because of the proliferation of generic photos on CD-ROMs and in online galleries, assignments take on a special meaning for photobuyers who hire you to get a specific picture or series of pictures. Your assignment pictures will be unique and content-specific. Photobuyers are willing to pay high fees for assignment photography.

Negotiating Your Fee

How much should you charge when you get an assignment? I could give a quick answer to this question by referring you to *ASMP Professional Business Practices in Photography*, by the American Society of Media Photographers (ASMP). However, this guide doesn't have all the answers since it reflects top-dollar fees from top-drawer markets commanded by top professionals. Moreover, it pertains primarily to the world of service photography, where fees range from $650 per day for corporate photography to $5,500 per day for national ads (note that ASMP "does not set prices").

The other guides for pricing assignments are the software FotoBiz with FotoQuote, by Cradoc Bagshaw *www.cradoc.com*; *Negotiating Stock Photo Prices*, by Jim Pickerell and Cheryl Pickerell DiFrank *www.pickphoto. com*; and *Pricing Photography: The Complete Guide to Assignment and Stock Prices*, by Michal Heron and David MacTavish (contributor) *www.photosou rcefolio.com/bookstore*. All three are excellent sources of information.

As in any business, until you have an impressive track record and your name is known, it's unrealistic to expect top dollar. Perhaps the most basic point to keep in mind is this: Many of the markets you deal with as a stock photographer are publishing markets that consistently pay you respectable fees for your photos—but they can't match New York day rates. Your fees will depend entirely on your own mix of markets. Some of the photobuyers on your Market List may indeed have healthy budgets for photography assignments, but feel them out. Don't price yourself beyond what they can bear.

Essentially you're left on your own to judge the particular market and your track record with it, and to negotiate accordingly. Effective negotia-

TRAVEL ASSIGNMENT OR VACATION?

Sky Auction and eBay have teamed together to provide an auction-type travel service to destinations ranging from Morocco to Canada, South Africa to Paris. For a reduced fare, look into this site at *www.skyauction.com*.

tions will make the difference between making or missing an assignment.

Now that I've delivered a caution to not overprice yourself, I want to emphasize, on the other hand, not to *undervalue* your services. Many creative people tend to put too low a price tag on their talents. A good formula to follow is to take whatever you decide to quote to the photobuyer as your day rate—and quote half again as much. You will be surprised how many will accept your higher fee.

In other words, say you have a chance at a plum assignment from an oil company's regional trade magazine. Taking into consideration that you've already sold two pictures to this magazine and that this is your first assignment opportunity, you arrive at a six-hundred-dollar-a-day rate for such a market. Instead, quote nine hundred dollars. You're probably worth it—and the photobuyer probably agrees—but you won't know until you start negotiating. In a situation like this, think big. With assignment work, while you have to walk a fine line and not charge beyond the range for the particular market, if you quote too low a figure, you lose not only the photobuyer's dollars, but also her respect for you as a professional.

When you get an assignment with the higher-paying trade magazines, you probably will be invited to the photobuyer's office, provided you're in the same town, rather than having to negotiate by phone or mail. Being there in person is an advantage in this case, because you can watch the photobuyer's expression and body language when you quote your fee. He'll let you know if you're on target.

If your figure is high for his budget, you'll get some resistance. However, he invited *you* to the office; thus, you know he thinks that:

1. You're an established photographer.
2. You bring specialized knowledge and talent to the assignment.
3. You have access to a certain profession and/or geographical area in relation to the assignment.

HE WHO SPEAKS FIRST . . .

Keep in mind that the photobuyer could have invited a dozen other photographers to his office. It may seem like a disadvantage to have all that

competition, but it's actually a plus in this case. By inviting *you*, he has established in his own mind that he has chosen the *right* person. If you quote a low fee, it might lower his estimation of you.

Remember, the photobuyer must report to his superiors. A high fee tends to justify his choice of photographer.

How you state your fee should go like this:

When the photobuyer inquires as to your rate, state your prepared answer confidently—and then remain quiet. Don't say another word. This is a well-established principle of negotiating. The person who speaks next is at a disadvantage in the bargaining process.

Let the buyer do the talking. When he speaks, it'll probably be to commit himself to your fee or to indicate his budget. He'll probably indirectly answer some questions that are important to you.

1. How badly is the picture needed?

2. What is the competition charging?

3. How easily can he get the picture from some other source?

If the photobuyer seems genuinely resistant to your fee, determine the basis for his resistance and you'll be able to figure the direction you should take in the negotiations. There are a lot of tactics you can consider. Here are some possible scenarios, with suggestions about how to handle them.

1. He'll probably come back to you quoting a lower figure (you've tossed the ball to him—now he's tossing it back). Don't immediately accept it. Why? He's probably testing you with a figure lower than what he actually could pay. He'll make some concessions if you press him.

2. Don't concede anything if you can help it, or at least don't be the first to concede ("Okay, I'll complete the assignment in two days instead of three . . ."). If you concede first, the picture buyer has the upper hand.

3. If you have to concede something (the buyer tells you he can't cover the cost of developing your film, for example), ask him for a concession, too ("I must have double mileage for this trip. There are a lot of dirt roads out there in West Texas!").

4. If you must match concessions with the picture buyer, remind him that these concessions are valid only if you and he are able to reach a final overall agreement on a contract or a fee for the assignment.

5. Decide beforehand what you want: a minimum and a maximum. (Make sure these figures are realistic.) Keep mental score as you negotiate.

6. If you come out smelling like roses, don't feel guilty about it. Remember: You don't always win in such negotiations. Enjoy the glow while it lasts. Next time you may not come out so well.

7. What if the photobuyer says, "This is the fee we can pay. You can take it or leave it!"? You can either say, "Thanks, but no thanks," or explore with him the possibility of retracing your steps to either narrow or broaden the scope of the assignment. Offer more or fewer pictures, discuss travel expenses or change the length of the assignment; these are areas where you can concede wisely. Don't agree, however, to give up your negatives or to grant the buyer ownership (all rights) to your pictures.

Even in these areas, though, it isn't a case of "never"; you may get in situations where the fee for all rights is sky-high or where you are eager to get that particular assignment at all costs. (See the discussion of work for hire in chapter fifteen.)

An excellent book on how a stock photographer should negotiate a fee is *Negotiating Stock Photo Prices*, now in its fifth edition, by Jim Pickerell and Cheryl Pickerell DiFrank, 110 Frederick Avenue, Suite A, Rockville, Maryland 20850, (301) 251-0720, fax: (301) 309-0941, *www.pickphoto.com*.

Negotiating can be challenging—even fun. Practice makes perfect. Try variations of your routine with your spouse or a friend playing the part of photobuyer. If you'll be negotiating by phone, practice on extension phones or in a couple of phone booths. You'll find that just running through your script is a tremendous catalyst for new thoughts and new ways to phrase your points.

In the long run, a photobuyer will appreciate your efforts to get the best fee for your pictures. Even if you come away with six hundred dollars

a day instead of the nine hundred dollars you asked for, remember, that's the fee you were willing to settle for originally.

Do you own the pictures you take on assignment? It depends on what type of contract, if any, you have signed, or what rights agreement you and your client have arranged (see chapter fifteen).

Expenses

The day-rate quote you give to a photobuyer does not include your expenses. These are over and above the day rate you receive, and they depend on a number of variables.

When negotiations reach the point where you address expenses, your reliability factor will be strengthened if you hand the photobuyer a copy of your *expenses form.*

Have a personalized business form typeset and printed that lists expenses involved on assignment work. When I first started out, I had my own form printed on $4\frac{1}{2}'' \times 9\frac{1}{2}''$ paper in three different colors—white, blue, and pink—then collated and gum-sealed the forms into a pad using NCR (no carbon required) paper. I sent the first two copies to my client and kept the third for my records. The pad paid for itself on my first assignment.

In a corner of the pad, in small print, is this message: "This sale or assignment is in accord with the code of practices as set forth by ASMP."

You may not be an ASMP member, and your client may not be able to afford ASMP rates, but your expenses are a fixed cost, and you should expect reimbursement accordingly. Your expense form should be similar to the one in Figure 11-1.

An equally effective approach, if you're computerized, is to present to the photobuyer a printout that includes not only your expense estimates, but other points you agreed upon during the negotiation.

You also can make your own expense form on your computer. Any word processing and/or desktop publishing software should work for this. A specialized software product called IMSI Form Tool will let you create your own forms. Find more information about this product online at *www.imsisoft.com.*

```
┌─────────────────────────────────────────────────────────────────┐
```

YOUR LETTERHEAD
Expenses

From: (Your Name) To:
Your Reference #: Date:
Subject: Project:
Title:

Travel
Taxi .. $ _____
Auto (_____ ¢ per mile) .. $ _____
*Plane, train, bus ... $ _____
*Car rental ... $ _____
*Tips .. $ _____
^Meals ... $ _____
*Lodging ... $ _____

Photographic
Processing
Color: _____ Rolls @ $ _____ $ _____
Black and White: _____ Rolls @ $ _____ $ _____
CD-ROM: _____ CDs @ $ _____ $ _____
^Rental of special equipment .. $ _____
Scanning .. $ _____
Digital transfer .. $ _____
Digital manipulation ... $ _____
Other: .. $ _____

Props ... $ _____
(Construction of or rentals)

Model Fees ... $ _____
(Hired or nonprofessional releases)

Location Charges .. $ _____

Mailing, UPS, FedEx, Trucking $ _____

Incidentals
Long-distance phone calls .. $ _____
Liability insurance .. $ _____

Special Services
Casting .. $ _____
Styling ... $ _____
Catering .. $ _____
Costumes, clothing .. $ _____
Location scouting .. $ _____

Other ... $ _____

Total Expenses: $ _____

*Receipts attached This sale or assignment is in accord with the code
 of practices as set forth by ASMP.

Figure 11-1. A sample expense form.

Extra Mileage From Assignments

Your assignments will take you to locations you might not ordinarily visit. Carry an extra camera and shoot some stock photos for other photobuyers on your Market List. These are called "sister" shots.

This will not be as easy as it sounds. Full concentration on your assignment is essential to producing quality results, which is also the way you maintain a strong reliability factor with your client. Anything less than 100 percent attention to your assignment will give you mediocre, or at least ordinary, results. When you shoot "side" pictures while on assignment, then, plan to shoot them on your time and at your expense.

Many assignments call for only specific pictures. This situation allows you to add the sister shots to your stock file. Some stock photographers arrive early on the scene or stay late on an assignment. As long as the client has paid the transportation expense, you can capitalize on the (sometimes exotic) locale and shoot for your stock file. Some photographers shoot to add to their collection of pictures on special themes. Simon Nathan of New York, for example, snaps pictures of clothes hanging on clotheslines all over the world. "One day I'll have an exhibit—or publish them in book form," says Simon.

Industry-Sponsored Assignments

Funding is available for your trips. Since the article or book you produce as a result of a major self-assignment (which I'll explain in this chapter) will be read by thousands, even millions, you're in a good position to get sponsorship from manufacturers, governments, TV networks, and cable companies. Media coverage would normally cost them hundreds of thousands of dollars. You're providing it free. You can order a 1,500-word report on this subject, *6 Steps to Gain Financial Support for Your Travel Adventure*, from PhotoSource International, *www.photosource.com/101*.

The Stringer

Another assignment channel is open to the photographer who is on tap for picture-taking services for a trade magazine, news service, newsstand

magazine, or industry account. The photographer in this situation is usually called a *stringer*. You are, in effect, a part-time freelancer who sometimes works on a retainer basis—that is, for a regular monthly fee. In most cases, however, you work on a per-assignment basis. You get paid only when you produce.

Being a stringer falls primarily into the area of service photography and news photography, but stringer opportunities also are there for the stock photographer. By working out flexible contracts with trade publications, you can arrange to regularly supply them with single pictures relating to their subject theme.

For example, if one of your PS/A areas is purebred dogs and you travel often to dog shows, you would be a valuable resource to editors of various dog magazines, which have audiences ranging from breed associations to veterinarians. (We're talking about good working shots of dogs in action or breed portraits. Remember, if you emphasize cute-puppy pictures, that's crossing into Track A—pictures that you'll want to place in a photo agency. See chapter twelve.)

If you travel often, you could tie in your mobility with other photobuyers on your Market List (for example, recreational pictures for outdoor magazines, horse shows for horse magazines, or equipment in use for heavy-equipment magazines).

Your contract need not be more formal than a letter of agreement stating that you will supply them with X pictures a month (week or year) for Y dollars. The fee won't be monumental, but if you have several contracts, the sum will more than cover your expenses to those dog shows.

Competing magazines, of course, would not appreciate your supplying the same photographs simultaneously across the market. By researching the specific needs of the photobuyers on your Market List, you can guard against inappropriate multiple submissions, yet set up an operation to receive checks with regularity.

As a stringer, you are not "working for hire." Avoid any agreements with your clients that would allow them to own all rights to your photos.

Self-Assignments—Where Do You Start?

If assignments aren't coming your way yet, give them to yourself. Such self-assignments will reward you with new insights into lighting, working with models, using the $P = B + P + S + I$ principle (see chapter two), and using varied lens lengths for effect, as well as pulling elements together to make a cohesive and interesting feature.

You can start right away and give yourself a course on producing the picture story, if you're not afraid to copy. Through the ages, creative people have learned from each other through imitation. As the Bible says, "There's nothing new under the sun!" A simple, effective technique based on this principle is *the switch*. Here's how it works.

Let's say you come across a one-page, three-photo picture story in one of the magazines on your Market List. It's about a young man from Philadelphia who's spending his summer in the West, earning money for college by working as a wrangler at a dude ranch in Wyoming. The copy block contains about three hundred words. The pictures are one close-up of the young man and two middle-view shots, one a vertical and the other a horizontal.

You will use this story as a *blueprint*. It shows you what the requirements are for a similar picture story (not the same story, but one that's similar). In your case, you know of a young Japanese girl down the block who is in the United States for a year as a high school exchange student. To improve her English and to earn spending money, she is working as a baby-sitter for your neighbors.

The city-boy-turned-cowboy story showed the young man with a ten-gallon hat. You will picture the Japanese girl in a kimono. The blueprint story showed the boy helping in the early morning roundup of the horses. You will picture your subject showing the neighborhood children how a Japanese-style kite is made. The blueprint story showed the boy at breakfast with companions, downing heaps of flapjacks. You will picture the Japanese girl cheering with friends at the local high school basketball game.

The original article is also a blueprint for the writing. Tailor your

writing to match the content and style of your blueprint. Insert quotes and anecdotes in much the same proportion as your model. If your writing skills are weak, team up with a friend who writes well. Or simply amass the details (who, what, where, when, how), and submit them to the editor with your pictures. The editor will find a writer.

Where should you market your picture story? Start with the local metropolitan Sunday paper. The editors always are interested in seeing this slice-of-life kind of story. Then, e-mail the feature editor at a couple of Japanese-American newspapers and magazines, and query to find out whether they're interested in the story (often they are). Also send it to noncompeting magazines on your Market List (those that have no cross-readership with each other) that accept brief photo stories.

Expand certain aspects of your story to fit other markets. The kimono, emphasized correctly, would appeal to trade magazines in the teen-fashion industry. Periodicals in the educational field would like to see emphasis on the Japanese girl's learning experience in this country. Cultural and children's magazines may like more insight into Japanese kites and their popularity and importance to children in Japan.

Submit at least a half-dozen pictures to give the photobuyer a choice for his layout. Again, tailor your story line to your original blueprint, and you will earn not only the price of this book, but possibly the price you paid for the camera that took the pictures.

The key is to locate your blueprint example in the magazines on your Market List. This way you know you're on target with subject matter and treatment that are coordinated with *your* PS/A.

While you're learning the ropes with such self-assignments, remember: If your first tries don't prove immediately marketable as picture packages, certain photographs may become individual stock photo winners.

SPECULATION

On self-assignments, you're working on speculation. Is this a "no-no" in stock photography? Not if you've used some savvy and done some

homework to identify your PS/A and become familiar with the kind of pictures needed by those on your individual Market List.

This way, if your stock photo doesn't sell the first time around, it's a valuable addition to your files and stands a good chance of earning its keep over the long haul.

You also can take pictures on speculation in response to a specific photo request by a photobuyer (this is not a no-no either). In fact, this is especially helpful to the newcomer to the field. When you speculate by following the guidelines of a photobuyer, you are, in effect, receiving free instruction in what makes a good, marketable stock photo. The photobuyer's specifics will tell you what to include and what not to include. Subscribers to our *PhotoLetter* and *PhotoDaily*, which lists the current needs of photo editors, often will use a current photo-need listing as a guide, take the picture, and submit it to the photobuyer, if the deadline is within reason.

There are times, however, when you shouldn't speculate. For example, a timely picture will quickly lose its marketability. A highly specific picture will probably not be marketable to many targets. Going after a picture that entails a good deal of expense (in time, travel, or special arrangements) is questionable. The president's visit to Ohio might attract so much freelance and staff-photographer competition that it would not be cost-effective for you to become involved. Finally, a picture that's outside your PS/A might reflect your lack of expertise, and that would certainly limit its marketability.

TAKE A FREE VACATION

One type of self-assignment you can give yourself with assurance, over and over again, is the travel assignment—but with a switch: If you're planning a vacation or a business trip, plan to profit on your trip through your photography. Because your travel can be a business expense when it involves getting pictures to add to your stock photo files, your travel expenses can be a tax write-off, another way your trip pays for itself. (Chapter sixteen details the tax benefits of making a business out of your

photography expertise.) However, rather than aiming your camera at standard tourist attractions (Track A pictures with limited marketability), concentrate on pictures where the supply is short and demand is great.

Another free vacation is one that's offered to established stock photographers and writers by public relations firms representing ship lines, ski resorts, hotel chains, spas, and so on. Invitations are issued regularly in the *PhotoDaily www.photosource.com* and *Travelwriter Marketletter www.tra velwriterml.com* by firms that will provide lodging, meals, and often airfare to writers and photographers who have firm assignments.

Who buys travel pictures? Travel editors, of course, but they are *so* deluged with travel pictures (exquisite clichés) from freelancers, government agencies, stock photo agencies, public relations people, and authors of travel stories, that this market takes time to break into. At first, you represent more *work* for the travel editor, as someone new that she has to deal with, communicate with, and explain her picture needs to—all of which she wants to avoid, since she already has established picture sources that supply her needs. Instead of aiming at travel editors at first, direct your marketing efforts toward the publicity offices of airline, bus, train, ship, and hotel organizations; city, state, and national tourist offices; public relations agencies; CD-ROM companies; video production companies; ad agencies (who represent a country or state); plus encyclopedia and other reference-book publishers who are continually updating their publications. Also, it's helpful in some cases to contact photo agencies. (See Figures 11-2 and 11-3.)

Standard travel pictures are difficult to market because of the competition. Do not submit spectacular (in your estimation) pictures of standard tourist sites. The publicity officer or photobuyer has already rejected hundreds of them. You can, however, include pictures of *new* travel attractions or *changes* in existing attractions.

What does the travel photobuyer really need? Current pictures in their locales of these areas of interest: agriculture, mining, transportation, cuisine, contemporary architecture, celebrities, communications, recreation, education, industry, labor, sports, business, and special events.

Your travel pictures, then, are not really *travel* pictures at all; they are pictures of factories, airports, new sports facilities, freeways, festivals, open-pit mines, housing, people, and skylines.

To know what to take and where to find the subject matter, write to the Department of Economic Development and/or Department of Tourism (or Consulate/Embassy, if foreign) of the area you will be visiting. They will supply you with several pounds of literature—all of which needs updating. Travel agencies can supply similar literature. Consult the encyclopedias at your library, as well as other reference books, maps, CD-ROMs, Web sites, videos, and pamphlets that feature your areas of interest. All of this material will serve as a blueprint for the kind of pictures that photobuyers need. Make photocopies of pertinent leads, pictures, and details (these will aid you in your query letter).

The agencies you will be working with are actually *public relations* and *promotion agencies*. They want to put their client's best foot forward. In these times, the profile of a city, tourist attraction, national park, or monument changes rapidly. *Updated* quality pictures are always of interest to travel-picture buyers. (Note: Remind the photobuyer that your pictures are an update.)

Certain stock agencies are interested in seeing specific quality travel pictures (see chapter twelve). If they like your selection, they'll probably ask to see more from other areas of the country or the world that you could take or may have in your files. If your travel pictures are large format (120-size, four-by-fives or eight-by-tens), you may have a better chance of scoring at an agency than if the pictures are 35mm. Yet some stock agencies deal strictly in 35mm. Others are beginning to show preference for high-resolution digital images.

However, scoring with an agency depends on factors other than size. One of the most important is *content*. If the photos cover a relatively untraveled area of the world, or places currently in the news, they will probably interest an agency more than if they were taken in, say, the Grand Canyon or Paris.

Here's another type of buyer for your kind of travel pictures: publish-

ers. New books, CD-ROMs, photo products, and Web sites focusing on the area you just photographed come out all the time. Why not have your pictures appear in them? The tourism departments and economic development offices mentioned earlier are often aware of projects in progress. They will steer you in the right direction (since their job is public relations) if you mention in your letter to them that you would welcome information on forthcoming features on their area. Photo agencies, too, are aware of new projects in progress because photo researchers are knocking on their doors, looking for a picture from such and such a place. While you're checking at the photo agencies, tell them you have fresh, updated pictures of the places you've visited. Frequently, photo agencies miss a sale because their locale images are outdated.

Public relations agencies will be interested in placing your photos if your pictures match their client's area of interest. Let's say, for example, you just returned from a trip to Venezuela, where you took forty marketable pictures of birds. Using the Society of American Travel Writers directory (see 62), find out which public relations agencies represent Venezuela. For example, XYZ Agency will have an in-house writer prepare an article on "Birds of Venezuela." Using your photos, the agency will sell the article to several nature magazines in several countries. You will receive payment for your photos, as well as recognition.

What about postcards? Postcard companies (see Appendix A) rarely are good markets for your travel pictures. They pay low fees, your picture is fighting hundreds or thousands of others for selection, and the companies usually want all rights. The commercial stock photography competition is stiff in the photo products, postcard/gift area, and the fees are generally low. Unless you have a special reason for marketing in these areas, avoid them.

Making the Contact

When possible, contact picture buyers *before* you go on your trip rather than after you return. Photobuyers, editors, and agencies can inform you of their current needs and suggest side trips to collect pictures (on specu-

lation or assignment) to supplement or update their files. Independent photographers do sometimes shoot first and ask questions later (the *shot-gun method*). However, most veterans inquire first, with a letter like the one shown in Figure 11-2, and then shoot (the *rifle method*). Following are some letter-writing guidelines.

1. This is a form letter you will send to a number of promotion directors or editors, so type an original that includes your address, phone/fax, and e-mail address (and Web site address, if you have one) on your professional letterhead, and then photocopy or instant-print it. Leave a blank in the salutation to fill in the name, with space above for each

YOUR LETTERHEAD

[Date]

Dear _____:

On August 15 through August 20, [year], I will be traveling in the state of Minnesota. My itinerary will include Duluth, the Iron Range, Charles Lindbergh's home, a visit to The Mall of America in Minneapolis, and stopping points in between.

May I help you update your files with pictures from these areas? I shoot color slides, in both 35mm and 2¼″ formats.

If you have any particular photo needs along this itinerary, I would be interested in learning about them. Perhaps we could work out an assignment that is mutually beneficial. I would submit my pictures to you, of course, on a satisfaction-guaranteed basis.

My pictures, including the several thousand I have in stock, are available on a one-time basis for publication at your usual rates.

Thank you for your attention, and I look forward to hearing from you. If you prefer to reply by U.S. mail rather than by e-mail, I have enclosed an SASE for your convenience.

Yours sincerely,
[Your Name]

Figure 11-2. A typical assignment query letter.

different address. (You can write to "Editor," "Photo Researcher," "Photo Editor," or "Art Director," but if you can find out the name of the individual, this is preferred.) The form-letter format is an asset here because it tells the picture buyer two reliability factors about you: (1) you deal with many photobuyers who are interested in your pictures—and the photobuyer believes that if he acts quickly, he can be first to review them; and (2) you do business in *volume*, so you must be competent and familiar with the marketing process—you're someone he could develop as a consistent source of pictures. Photobuyers usually aren't interested in dealing with one-shot, now-and-then photographers.

2. In your first paragraph, let the photobuyer know *when* you're going, for *how long*, what your *itinerary* is (only the routes that will relate to his area of interest), and how you'll be traveling (car, plane, train, or bus).

3. Never ask if he'd like to see your pictures of *standard* tourist attractions—national monuments, parks, and so on. (You should know that he already has these covered.) Instead, ask if he would like his files of these pictures *updated*. Recognizing his need to constantly update his files puts you in a professional light.

4. Explain whether you will shoot film or digital, and tell him the size of the film format(s) you'll be shooting. If you're able to offer digital delivery from the location, this can be an important point worth mentioning.

5. Suggest that if he has some upcoming photo needs, you can save him time and expense by shooting them for him—if it's not too much out of the way for you. Assure him that you are not locking him into any definite contractual arrangement. (It's easy to say no to those.) Let him know your pictures will be taken with no obligation or precommitment on his part. Mention in the next paragraph your stock file of several thousand images. The editor will interpret this to mean that it will be no loss to you if he doesn't accept your pictures—that you're an established stock photographer with a high reliability factor and plenty of available markets. Let him know you are licensing these pictures, not selling them outright. Try to find out the going rate for his publication or publishing

house before you contact him; if you can't, tell him your pictures are available for publication at his usual rates.

Figure 11-2 is a typical assignment query letter. Notice that it's brief. No photobuyer wants a history of you or your photography. If your photos fit her needs, she'll buy. If they don't, she won't.

Let's say you didn't contact anyone before your trip, and you've just returned from Germany with many fine pictures. What do you do now? Contact all promotion bureaus, offices, and agencies that represent Germany. These will include government agencies, as well as private German and American agencies such as airlines, ship lines, and hotel chains. Your list might also include American ad and public relations agencies that handle these accounts. Design a form letter that informs these agencies of your pictures of Germany. Do not send actual pictures or a Germany portfolio until an agency expresses interest to you. Visit the agency in person, if possible, with a portfolio of pictures tailored specifically to the agency's interest. Or upload them to your Web site, and inform potential buyers of your Web site's URL. Use the tips in chapter seven on how to contact photobuyers by e-mail, by phone/fax, by mail, and in person. It's on these visits that you might receive referrals for your pictures ("No, we can't use them, but I know Mike Sarfaty is preparing a book on Southern Germany").

Here's how to develop an after-the-trip query letter (see Figure 11-3).

1. See number 1 of the instructions for writing a letter of inquiry (on page 222).

2. In your first paragraph, let the editor or art director know who you are, where you're from (your letterhead will help), and when you were in her state or area. If your pictures are fresh updates, she is going to be interested. Mention specific areas that you have photographed.

3. Ask if you may send a selection of photos for her consideration. (Don't send photos with this first letter.) If you know what she pays, mention this fee in your letter. This will save both of you an extra exchange of negotiating correspondence. If you don't know her fee range, apply some of the pricing tactics outlined in chapter eight.

YOUR LETTERHEAD

[Date]

Dear: _____

My name is [your name], and I recently updated my stock photo files of several thousand transparencies, high-resolution digital images, and black-and-white prints when I traveled through [state/country] in [month]. My files now include substantial coverage of these points of interest*:

I would be happy to send you a selection of transparencies for your consideration. They are available for $ _____ on a one-time rights basis. If you prefer digital previews, kindly let me know and I will send you those by e-mail or on a CD ROM. Request to review these pictures does not obligate you to any purchase.
Which pictures would you like to receive for consideration?
I have enclosed an SASE for your convenience.

Yours sincerely,
[Your name]
*P.S. I also have strong coverage in my stock file of these areas:

Figure 11-3. Sample shotgun (after-the-trip) query letter.

4. Being an unknown photographer puts you at a disadvantage: Editors sometimes ignore introductory letters such as this. They prefer to stay with their own cadre of familiar and reliable photographers rather than do the extra work of establishing contact with a new one. It's a good idea, therefore, to insert a line in your letter to this effect: "Requesting review of these pictures does not obligate you to any purchase."

5. Ask outright which pictures (of those you've listed) the photobuyer would like to review.

6. Copywriters tell us that the section of your letter that gets read first (if your letter gets read at all) is the *postscript*. You can attract a photobuyer's attention by listing some of the places you have previously (or recently) photographed in her city, state, or country. Since these names will be familiar to her, this will help personalize your letter to her.

If your contact person *does* ask to see your pictures, you should enclose a cover letter when you submit them for consideration. Again, a form letter is useful both to you (for your own records) and the editor. Your pictures, of course, will sell themselves, but as consumers, we all know that we're unlikely to buy a new product (in this case, *you* are the new product) if service and support aren't available. In other words, if the editor suspects you are a fly-by-night, that you have no reliability factor, or that your telephone number or business address might change next week (I know it's tempting, but try to avoid using a P.O. Box or Box number), she is not likely to give your submission much attention.

Photobuyers recognize the professional touch in submissions accompanied by a form cover letter. Again, it must be brief. Editors must sift through hundreds of photo submissions weekly. They don't appreciate lengthy letters that ask questions or relate irrelevant details about the enclosed submission. If you do feel compelled to ask a specific question (and sometimes it *is* necessary), write it on a separate sheet of paper and enclose an SASE for easy reply.

If your form letter is neatly typed or computer-generated (don't handwrite queries to editors unless you're on a first-name basis with them), the editor will greatly appreciate your professionalism. Better yet, have a fast-print service print it (ask for seventy-pound, off-white stationery stock), leaving blanks to fill in specific details for each different situation. The editor will then recognize you not as a one-shot photographer, but as someone with a good supply of pictures and, therefore, as an important resource for handling future stock-photo needs and assignments. (The

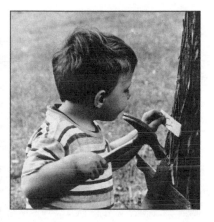

The Photo Essay

Want to make your picture stories come alive? Learn from the pros. A movie-maker in Africa taught me this trick, which you can apply to your photo stories, "Every story has a beginning, a middle, and an end," he said. "Whenever I get spectacular footage, say of a successful rescue in a river or one of my African crew fending off an attack by an animal, I consider that the climax footage. I then go back and film footage that will lead up to my climax footage. This subsequent footage I then use as my beginning and middle shots." In the case of the little boy at left, I shot the third picture on Saturday, and the first two on Sunday.

thinking here is that no one would go to the expense of a printed form letter if he had only a few photographs to market.)

A typical form letter to accompany your submissions could be the standard cover letter in chapter nine (Figure 9-1 on page 164). (If your submission is solicited, you can begin the letter with, "Thank you for your request to see my coverage of") Be sure to mention in this letter that "captions are included."

Ordinarily, stock photos do not require identifying captions (unless

the photos are meant for technical or scientific use), but travel and location pictures generally do. In your captions, identify the location and the action/situation in the picture.

As a photo illustrator just starting out, your reliability factor can increase several notches if a selection of your photos can be found on the World Wide Web. Another approach: on-demand printing, which allows you to print a short run of sell sheets at a low cost. Marv Dembinsky Jr. captures a half-dozen images from a recent trip onto a single sheet using his scanner, Photoshop software, and a good-quality color printer. He then mails or hand delivers the results to his photobuyers.

A Sampling of "Hot Sellers"

Each of your prime travel markets (e.g., mining, transportation, education) will present varied opportunities for stock photos. The pictures by freelancer Mitch Kezar (see chapter two, "A Gallery of Stock Photos") are a good indication of the style and type of pictures sought by textbook publishers, encyclopedias, TV stations, tourism bureaus, and the education industry. Instead of aiming your camera at tourist attractions when you travel, use his pictures as a blueprint to follow. In these examples, he captures the spirit of outdoor recreation. His pictures have enjoyed many repeat sales.

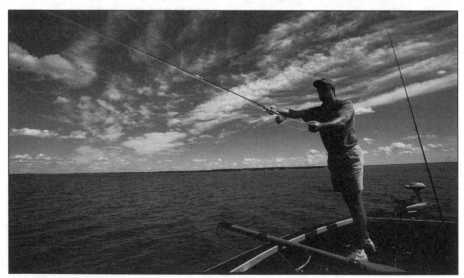

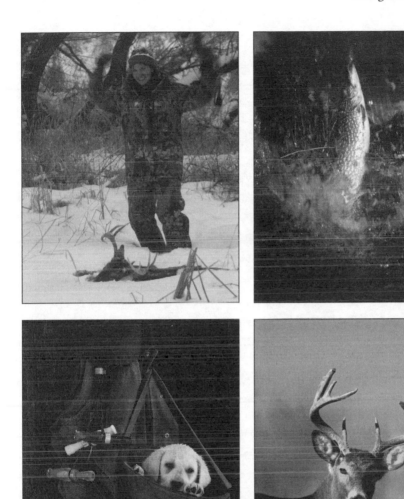

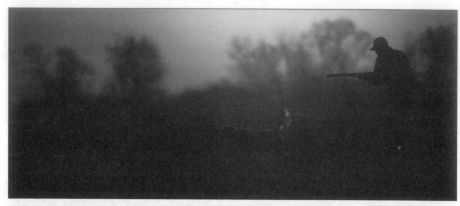

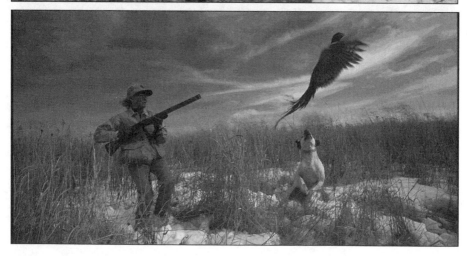

12

Stock Photo Agencies and Decor Photography

OUTLETS FOR TRACK A

Stock photo agencies can offer opportunities or headaches. There was a time when it was fairly easy to place photographs with stock agencies. Photographers placed their "grab shots" with agencies, and the agencies happily accepted most of what they could get. Gradually the agencies became more and more selective as volume increased and the demands for high-quality stock images became more frequent.

That trend continues today, making it harder to get into a top agency. The agencies are becoming even more selective as to the quantity of images, kinds of images, and number of new photographers they accept.

Stock agencies are going one of two ways: Either they become huge and broad (generic), or they become small and highly specialized (niche). Unless you're a recognized name in the industry, the smaller, more specialized agency is likely to be a better option for you rather than the huge agency where it's easy to become just a number amongst dozens of others.

It used to be that the vast majority of agencies were located in, or were very close to, New York City. Not so anymore. While it's still true that a great many stock agencies are in Manhattan, more and more smaller agencies—I call them micro agencies—are popping up all over the country. These micro agencies are most often very specialized and deal with only a handful of subject areas.

For the photobuyers, this great plethora of agencies is a good thing. If a photobuyer is looking for something *generic*, she looks to a big, generic agency. If she's looking for something highly specific, thanks to the Internet, she turns to a micro agency or to an individual photographer.

Photobuyers use agencies for all kinds of photo needs. The reason many photobuyers would rather deal with an agency than an independent photographer is that they think they will be sure to receive professional treatment. If you show these photobuyers that you can present them images of equal quality as the agency does, with equal reliability and professionalism, chances are the photobuyers will turn directly to you instead. Photobuyers who use stock agencies range from book and magazine publishers to ad agencies and public relations firms. These photobuyers have one thing in common: They can pay the high fee that stock agencies demand.

Everything New Under the Sun

If your goal is to supply generic pictures to a stock agency, take note of the kinds of pictures in current newsstand magazine ads. Two other indicators of what buyers are currently after are the Web sites of major stock agencies such as Corbis and Getty Images. Also check out the major catalogs, such as the Black Book, American Showcase, Klik, and Workbook, and the Web sites of 1StopStock, Comstock, ImageState, Corbis Stock Market, SuperStock, and Alamy.

Keep in mind that commercial stock photography is much like the fashion industry. What's popular today is "old hat" tomorrow. So your research on the style and content of the pictures you see online or in catalogs may be useful to you for only a short while. It's an ongoing,

ever-changing process. While the "standard current images" will always have a chance to sell, remember that buyers like to find innovative, creative photo suppliers, too.

Brian Yarvin *www.brianyarvin.com*, an experienced commercial stock photographer from Edison, New Jersey, says "Generic pictures are available as clip art [royalty free, or RF] these days, so few agencies would try licensing generic images as rights-protected. Today's successful agency stock photographer knows his market and shoots for that market with great creativity. Agencies are going more and more toward targeting the commercial stock photo market.

"Signing on with an agency is like signing any other business agreement. Do your research ahead of time, and make sure that you do business with the agency that's right for you. When you do your research you might find out that you need to sign up with several agencies to get what you want, and there's certainly nothing wrong with that," Yarvin says.

What should you submit to an agency? You should edit your work ruthlessly, and send only your best work, at least for the initial submission. The good news is that these days, basically any format goes.

"Agencies are much more open to reviewing different formats these days, and I'm not talking just different-size transparencies. Digital, prints, Polaroid transfers, virtually anything is possible," says Yarvin.

"You should check with your agency prior to submitting anything other than what they state they accept, but you might be surprised to learn how open most agencies are these days to submissions that are a bit out of the ordinary."

Prepare to Share Your Profit

Stock agencies do demand high fees. They can afford to, because they offer the photobuyers something they can't get anywhere else—a huge selection at their fingertips. It's this fact, so attractive to photobuyers, that is your disadvantage. If your picture of a windmill or frog or seagull is being considered for purchase among dozens and dozens of others

in the same agency—never mind competing agencies—your chance of scoring is minimal.

Even against this reality, however, the chances of that kind of Track A picture selling are greater at an agency than if you tried to market such shots yourself.

Does big money await you when you go with an agency? As Brian Yarvin says, it depends on how well you choose your agencies and how often you supply them with your targeted photos. Agencies will tally their sales for you on a monthly, quarterly, or semiannual basis and send you a check. Although this check is for only 40 to 50 percent of the agency's sales fee (the agency retains the remainder), it's always welcome. (From $40 to $150 is the current range of your share of an average transparency sale.) Most photographers, whether they are service or editorial stock photographers, count on agency sales only as a supplement to the rest of their photography business.

So how much money can you expect from the agency you have selected to work with? It used to be one dollar for every photograph you have in the agency, per year. This is no longer true. There are too many variables these days to give a general figure. However, if one of your images makes it into the agency's paper catalog, figure around one thousand dollars per that image per year. If an image makes it onto the Web site of an agency, figure around five hundred dollars per such image per year. These figures are based on what the larger, established agencies are making, and if the agency you have chosen is a modest size or isn't as well established, you can expect to make less than the above.

Agencies: A Plus With Limitations

As I mentioned, most experienced photographers expect agency sales to only be a supplement to the rest of their photography business. Many newcomers to photomarketing (and some not so new) sometimes think they can relax once their pictures are with an agency. They believe that now they can concentrate on the fun of shooting and printing and check

cashing, and let the agency handle the administrative hassles of marketing.

It just doesn't work that way. Most stock photographers still have to market images themselves, as well.

However, making money through the agencies is a bit like gambling. You can increase your chances of making regular sales through agencies if, as at the baccarat table, you study the game.

Agencies offer the pluses of good prices and lots of contacts, but they have limitations that affect the sale of *your* pictures. One is that monumental competition faced by any one picture. Another is that no agency is going to market *your* pictures as aggressively as you do yourself. The agency has something to gain from selling, yes, but it spreads its efforts over many photographers.

Another limitation, which you can turn into a plus once you're aware of it, is that different agencies become known among photobuyers as good suppliers in some categories of pictures but not in others. Like art galleries, agencies tend to be strong in certain types of pictures. Sometimes, however, an agency will accept photos in categories outside its known specialties. If you place your pictures in the *wrong* agency, your images won't move (sell) for you.

THE SPECIALIZATION FACTOR

When a photobuyer at a magazine or book publishing house needs a picture, he assigns the job of obtaining that picture to a photo researcher, a person (often a freelancer) who is adept at finding pictures quickly, for a fee. The researcher checks the Internet or makes a beeline for a local agency that she knows is strong in the category on the needs sheet.

If a book publisher, for example, is preparing a coffee-table book on songbirds, the researcher will know which agency to visit, and it might not be an agency you or I have ever heard of. It might not even be in New York.

Photo researchers know that agencies, like magazine and book publishers, have moved toward specialization. By going to an agency that she knows is

strong in songbirds, the researcher knows she'll have not a handful of pictures to choose from, but several hundred. Often the picture requirements will demand more than simply "a blackbird." It will specify the background, the type (Brewer's or red-winged), the time of the year (courtship, nesting, plumage changes), the action involved (in flight, perching, or a certain close-up position)—and the wide selection will be particularly necessary.

Researchers feel that they're doing their clients justice in choosing agencies they know will have a wide selection. If your pictures of birds or alligators are in a different, more generalized agency, they may never be seen.

The first order of business in regard to agencies, then, is to research the field and pick the right ones for your mix of categories. You can have your pictures in several agencies at once, as Brian Yarvin mentions. Choose them on the basis of geographical distribution (an agency in Denver, one in Chicago, and one in New York) and on the basis of picture-category specialization (scenics at one, African wildlife at another, horses at the third).

HOW TO FIND THE RIGHT AGENCY

If your photography is good, just about *any* agency will accept it, whether or not they're looked to by photobuyers as strong in your particular categories. That's where the danger lies. How, then, can you find the right agency—or agencies—for you?

It takes time, but here's one approach. Part of your task on the second weekend of your Four-Weekend Action Plan (see chapter four) is to separate your pictures into Track A categories on the one hand and your PS/A on the other. Take both your Track A and PS/A lists, and narrow them down to the areas where you have the largest number of pictures.

Let's invent an example. Say that in Track A (the "standard excellents") you isolate three areas in which you are very strong: squirrels, covered bridges, and underwater pictures. In your Track B PS/A, you isolate five strong areas: skiing, gardening, camping, aviation, and agriculture. Taking your Track A pictures first, do some research and find which agencies

in the country are strongest in each of your three categories, rather than placing all three Track A categories with one general agency.

You might find that your covered-bridge pictures land in a prestigious general agency in New York or Seattle that happens to have a strong covered-bridge library. You will supply that agency with a continuing fresh stock of covered bridges, and they will move your pictures aggressively. Your underwater pictures might land in a small agency in Colorado that is noted for its underwater collection. Again, your pictures should move, since photo researchers will know to look to this agency for underwater shots.

Your covered bridge pictures fall into Track A; you would probably have difficulty marketing them on your own. But how about your Track B pictures, like your camping or agriculture shots? Should you place them in an agency, too? Or will you be competing against yourself, since you will be aggressively marketing your Track B pictures to your own Market List?

Your answer will depend on your Track B pictures themselves, their particular categories, and your Market List. If your own marketing efforts are fruitful, you will do best to continue to market your Track B categories yourself. If certain of your Track B pictures move slowly for you, you might find it advantageous to put them in an agency. (If you do, place your slower-moving Track B categories in different agencies, with the same forethought you gave to your Track A categories.)

RESEARCHING THE AGENCIES

Determining the strengths of individual agencies will take some research on your part. The magazines, books, and Web sites that are already using pictures similar to yours will be your best aid. As an example, let's take your Track A squirrel pictures.

Being a squirrel photographer, you naturally gravitate to pictures of squirrels. If you see one in a newspaper, encyclopedia, Web site, or textbook, it attracts your eye. Make a note of the credit line (if there is one) on each squirrel photograph. It will be credited with a photographer's or an agency's name in about a third of the cases. (Picture credits are some-

times grouped together in the back or front of a magazine or book.) If, after six months of this kind of research, the same stock photo agency name keeps popping up, your detective work is paying off. (Sometimes, depending on your Track A category, two or three agency names will appear. This is a plus. It means you can be choosy about whom you eventually contact, basing your decision on how long each agency has been in business, its location, whether it has an impressive Web site, and so on.) Locate the photo agency's address in a directory such as *Photographer's Market* or through an Internet search engine. You can re-search the needs of a variety of stock photo agencies by consulting the latest edition of *Photographer's Market.* You'll also learn what formats the agency accepts as well as payment terms.

You also can check agencies out by contacting the Picture Agency Council of America (PACA). It has 150 members. Send fifteen dollars plus an SASE for a list showing members' specialties. (This list will help you locate agencies and the categories of pictures they carry, but you'll learn more about where photobuyers go, and for what, through your own research.) Contact PACA at P.O. Box 301, Chatham, New York 12037, (518) 392-3967, *www.pacaoffice.org.*

At PhotoSource International we produce a computerized printout of agency strength areas. Check out *www.photosourcefolio.com/catalog.htm* on our Web site for the report "Stock Photo Agency Strategies."

Signing up with an agency is just like signing any business agreement/contract. You have to do your research and make certain that the agency you're signing up with is solid, is honest, and will meet your expectations. The best, and possibly easiest, way to check out an agency is to ask them for some references of other photographers who have been with the agency for at least a couple of years. If the agency refuses to give you any references, forget them and move on.

Ask a lot of questions before signing up with an agency, but make sure you ask them in a letter or an e-mail. This gives the agency a chance to respond when they can, rather than trying to force a rapid response over the phone.

How to Contact a Stock Photo Agency

Agencies, like photobuyers, expect a high reliability factor from you. If you're certain that you have discovered an agency that is strong in one or more of your categories, contact the agency with a forceful letter.

Your first paragraph should make the agency director aware that you have been doing some professional research and that you aren't a fly-by-night who just happened to stumble onto the agency's address.

Let the agency know the size and format of the collection you are offering and whether it's black and white or color (a surprising number of agencies still require black and white in addition to color). If you place special emphasis on a certain category or if you live in or photograph in a unique environment, state this, also.

Impress upon the agency that your group of pictures is not static, that you continually add fresh images. (Some photographers hope to dump an outdated collection on an agency.)

Tell the director that you're considering placing this particular collection in a stock house. Give the impression that you're shopping, *not* that you're expecting or wishing to place your pictures with him.

If your research is accurate and your letter professional in tone and appearance, the photo agency will welcome your contribution to its library. More important, your pictures will be at an agency known for a specialty—which happens to be *your* specialty.

In some cases, you can make a personal visit to an agency instead of writing a letter. A few agencies in the large cities designate one day of the week as a day when photographers can come in to display their photos for consideration.

One photographer I know walked into a New York agency with ten notebooks of vinyl pages (about four thousand slides). The director said, "I can't look at that many slides. Weed them down to one book, and come back tomorrow." The photographer went back to his hotel room and spent until three in the morning narrowing down the selection to one book that represented his best. He returned the next day, and the director said, "This is nice stuff. Do you have any more of these 'people

having fun in winter sports'? We get a lot of calls for outdoor recreation."

The photographer went back to his hotel, went through the selection process again, and rushed back to the director with a book of outdoor-recreation pictures. The photographer has since sold outdoor-recreation scenes through the agency and continues to update his file there. Learn from this example. Categorize your pictures before you step into an agency. The director will want to see the best you have—on the subjects that interest him.

Once an agency says, "Okay, we'll carry your pictures," how many should you leave for their files? If it's a highly specialized agency, a minimum of forty black-and-white prints (if the agency wants black-and-white prints) or slides (two vinyl sheets) is acceptable. A general agency would expect ten to fifteen of your vinyl pages and/or two hundred to three hundred black and whites. You would be expected to update this selection with twenty to forty new photos at a time, every six months to a year.

The agency will specify how your pictures should be identified and keyworded. For example, on slides, most agencies want the agency's name at the top and the caption information at the bottom. Your identification code, name, address, and telephone number should appear on the sides. They'll want to know which pictures have a model release (MR) or a model release possible (MRP).

Agencies will send you their standard contract form in which they'll stipulate, among other things, that they will take 50 (sometimes 40, sometimes 60) percent of the revenue from picture sales. Expect them to require you to keep your pictures on file with them for a minimum of five years. (If after a period of time you want your pictures returned, an agency may take up to three years to get them back to you.)

The Timely Stock Agencies

A few editorial picture agencies deal in current photojournalism and sell for the service photographer who supplies fresh, news-oriented pictures. These agencies, again, are based in New York, and they send individuals or teams to trouble spots or disaster areas, much as a local or regional

TV camera crew covers news of immediate interest. Most of these agencies, with channels or sometimes headquarters in Europe, sell single photographs and provide feature assignments around the globe for their top-ranking photographers. If you happen to photograph a subject, situation, or celebrity that you think has timely national or international impact, contact one of the following agencies:

Black Star, 116 E. Twenty-seventh St., New York, NY 10016, (212) 679-3288, fax: (212) 447-9732, *www.blackstar.com.*

Contact Press Images, 341 W. Thirty-eighth St., New York, NY 10018, (212) 695-7750, fax: (212) 695-7768, *www.contactpress.com.*

Sygma/Corbis, 15395 SE Thirtieth Place, Suite 300, Bellevue, WA 98007, (425) 641-4505, fax: (425) 643-9740, *www.corbis.com.*

Gamma Liaison (Getty Images), 601 N. Thirty-fourth St., Seattle, WA 98103, (877) 438-8966, fax: (206) 925-5001, *www.gettyimages.com.*

Payment for your picture or picture story is based on several factors: (1) exclusivity (has the rest of the world seen it yet?); (2) impact (would a viewer find your picture(s) of interest?); (3) your name (if your name is Rick Smolan, add 200 percent to the bill); (4) timeliness (is it of immediate interest?). The following agencies will accept the kind of pictures and picture stories mentioned above, but they also will accept nondeadline human-interest pictures and stories:

The Associated Press (AP), 50 Rockefeller Plaza, New York, NY 10020, (212) 621-1500, *www.ap.org.*

International Herald Tribune, 850 Third Ave., Tenth, New York, NY 10022, (212) 752-3890, *www.iht.com.*

United Press International (UPI), 1510 H St. NW, Washington, DC 20005, (202) 898-8000, *www.upi.com.*

Stock Agency Catalogs

Many of the major stock agencies produce print catalogs. In most cases you'll have to pay, by the photograph, to be included. All things being

equal, the venture generally turns out profitable for the photographer. Some agencies also produce a catalog on CD-ROM. The jury is still out on whether these are cost-effective for both the agency and the photographer. As online galleries become more popular, CD-ROM catalogs may lose their effectiveness.

Possible Problems in Dealing With Stock Agencies

In dealing with a stock photo agency, remember: You are the creator, you are in control, and *you* own your picture.

Investigate as thoroughly as possible all agencies you're thinking of joining, before you sign anything.

CONTRACTS

Read any stock agency contract *very carefully*. Most photo agency contracts ask you to sign with them exclusively. Some stipulate that if you market any picture on your own, 50 percent of those revenues become theirs. Some agencies ask that you shoot stock pictures on a regular basis and send the results to them. If you fail to do so, they assess a maintenance charge to your account.

Treat contracts as agreements to be modified by both parties. Draw a line through any section in the contract that you disapprove of, and initial it. If your pictures aren't returned to you shortly thereafter, you'll know that the agency values the opportunity to market your pictures more than having you agree on the point or points you deleted from the contract. (Be prepared for possible negotiation and sharing of concessions with the agency.)

CONFLICTS

Some photo agencies may express wariness of a possible sale conflict—say, two competing greeting card companies buying the same picture—if the agency, plus you, plus one or two other agencies in the country are marketing your pictures. Explain to the agency that you have placed your pictures *by category* with agencies that are strong in these differing categories—and

that you have not placed the same picture (or a duplicate) in competing agencies, and don't intend to.

Could a problem still arise on a major account where significant dollars are involved? In such a case, the art director would thoroughly research the pictures with you for releases, history of the picture, previous uses of it, and so on, before it is used. Any inadvertent duplication or possible sales conflict would come to the fore at that time.

In any case, if you've signed up on a nonexclusive arrangement with a stock agency, you put the burden of follow-up on the history of sales of a particular picture on the stock agency that handles your photos, not on yourself.

DELAYS

You'll be more likely to run across a problem in the area of delays: By far the highest percentage of complaints that come into the PhotoSource International office are about the slowness of stock agencies to move pictures. ("I know they could sell my stuff, but they don't try. They don't actively keep my pictures moving for sales. They're selling other photographers' work, but not mine!")

I've followed up on every complaint and have found that in all cases the grief could have been avoided. The problem usually lies in the *eagerness* of both parties.

The eagerness of stock photo agencies to supplement their stock of pictures by accepting categories of photos outside their known strength areas can be likened to the well-run garage that keeps its well-paid mechanics busy. They accept any job, any make of vehicle, foreign or domestic. They pride themselves on their versatility. The fact is, no one is *that* versatile. Someone usually loses—more likely than not, that somebody is the customer. With a little research, the auto owner could have found the *right* garage for his car and his pocketbook.

By the same token, the eagerness of photographers to have their photos accepted into a prestigious stock photo agency for the sake of the name, rather than on the basis of research showing the agency as being strong

in their specific categories, gives rise to the complaint, "They don't aggressively move my material!"

If your pictures of Alaskan wildlife, for example, were placed in the ABC Agency—a well-known, prestigious agency—a photo researcher seeking wildlife pictures would bypass that agency if it were *not* known for a strong wildlife selection. Instead, the researcher would head for the smaller Accent Alaska Agency, for example, which is strong on wildlife. Do your research, and choose your agencies with care.

HONESTY

There are other complaints and problems. I often hear them in this form: "Are they honest? I'm not receiving checks for *all* the pictures of mine the agency is selling."

If it's any consolation, I have heard of only one documented case in which it turned out that a major stock photo agency purposely attempted to carry out this scenario. I know it happens, but I believe it rarely happens on purpose. Stock agencies trade on their own reliability factor, just as you do.

As a free-agent stock photographer, you place yourself at the mercy of the basic honesty of all the contacts you make in the world of business. That's one of the disadvantages of being a freelancer, and it's probably a good reason that there aren't too many of us. Before you place your pictures with a stock photo agency, find out as much as you can about the agency. If it's a good match, then take a leap of faith.

Do You Need a Personal Rep?

What stock photo agencies do for photographers on a collective basis, representatives do on an individualized basis. A rep earns a living by securing the best price for your single pictures and the best fee for your photographing services. There's an old saying in the business, "You'll know if you qualify for a rep because the rep will come to *you*—just when your photography has finally arrived and you don't need a rep anymore."

Can a rep be of benefit to you? Yes, especially by freeing you from the

confinements of administering your sales. You'll have more time to take pictures. However, reps can be expensive. Depending on the services they provide to you, they take from 20 to 50 percent of the fee. Most reps are in New York and Los Angeles, where so many *commercial* photobuyers are located.

Unless you live in a city with a population of over a million and your name is well established in the industry, you and a rep would not find each other mutually beneficial. For further information on reps, contact the Society of Photographers and Artists Representatives (SPAR), 60 East Forty-second Street, #1166, New York, New York 10165, (212) 779-7464, fax: (203) 866-3321.

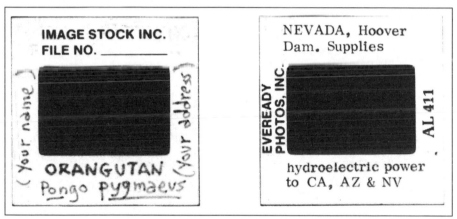

Figure 12-1. Ways to identity transparencies that you send to stock photo agencies: The example to the right is the correct way of identifying your slides.

Will Stock Photo Agencies Go Out of Style?

Photobuyers have the choice of dealing with a massive agency (Corbis or Getty Images, for example) or a small specialty agency. Depending on where you choose to place your pictures, the photobuyer will find your agency. If you choose to set up your own Web site and develop a highly specialized collection of photos, you may fare better than if you join a massive agency.

Figure 12.2. How *not* to caption a slide for a stock agency.

Start Your Own Mini-Agency

If a stock agency or a rep is not for you, but you want the photo agency system for marketing your pictures (i.e., you want someone other than yourself to handle the selling), and you want a more aggressive approach to the sale of your photographs than you get with a regular agency, then establish a mini-stock-photo-agency of your own to handle your pictures. You can do this on an individual basis, or get together with one or more other photographers to form a co-op agency. Both forms of mini-agencies (sometimes called "micro agencies") have advantages. Both can be set up as Web sites.

THE INDIVIDUAL AGENCY

Find a person (friend, neighbor, spouse, or relative) who has spare time, an aptitude for elementary business procedures, and a desire to make some money. An interest in photography is helpful but not necessary. More important, the person should have the temperament for record keeping and the ability to work solo.

Your job will be to supply the finished pictures. (You absorb all costs for film and processing.) Your cohort's job will be to search out markets, handle inquiries, send digital previews, send out photos, keep the records, and process e-mail and postal mail. From the gross sales each month,

subtract the expenses off the top and split the net fifty-fifty. (There won't be many expenses: postage, phone, mailing envelopes, stationery, invoice forms, and miscellaneous office supplies, such as rubber bands and paper clips.)

Before you start up your mini-agency, decide on a name and design a letterhead and invoice form. Open a business checking account. Work up a letter of agreement with your colleague that in effect will say the following.

1. You will split the proceeds fifty-fifty after business expenses. All pictures, transparencies, and the *name* of the agency will revert to you, the photographer, in case of termination of your business arrangement. Also, the back of your prints will show *your* personal copyright—not the agency's.

2. Bookkeeping records will be kept by your colleague, who will pay you from the business checkbook. Major purchases will be mutually agreed upon and the cost divided between the two of you. (Should you incorporate at this point? Probably not, but it depends on many variables that only you can answer. See the list of business information books in the bibliography.)

3. Your colleague also may collect other photographers' work to market. Reason? IRS rules state that if other photographers' work is also represented, then your colleague is not an employee of yours (which requires employment records), but rather an independent contractor, which requires no government paperwork on your part. Your colleague fills out his own tax forms. You fill out Form 1099 for him.

The success of your mini-agency will depend on the efficiency of your retrieval system—designed for the convenience of both the office help and the walk-ins (i.e., photo researchers looking for pictures). Pictures should be categorized and filed with attention to physical ease of retrieval. (Chapter thirteen will help you with this.)

For business reasons, as a mini-stock agency, you may want to explore joining the following three organizations. (Membership can add credibil-

ity on your business stationery, and all three provide newsletters with information from the picture-buying point of view, which can be valuable to your operation.)

Picture Agency Council of America (PACA), P.O. Box 301, Chatham, NY 12037, (518) 392-3967, *www.pacaoffice.org*.

American Society of Picture Professionals (ASPP), 409 S. Washington Street, Alexandria, VA 22134 (703) 299-0219, *www.aspp.com*.

Society of Photographers and Artists Representatives (SPAR), 60 E. 42nd St., #1166, New York, NY 10165, (212) 779-7464, fax: (203) 866-3321, *www.spar.org*.

If you've chosen a good, aggressive colleague, once your one-person agency is set up and rolling, you'll find that you'll be able to concentrate more on picture-taking and less on administration.

THE CO-OP AGENCY

Some photographers prefer to band together and form a cooperative agency, an establishment in which nonphotographer members handle the administration and photographers handle the picture-taking. The nonphotographers share office-sitting chores, and they are compensated on a total-hours-contributed basis.

I have watched the demise of many micro agencies, and the failure always can be traced to a concept problem: They attempted to be a general agency servicing local accounts. This seems logical enough, but a local account figures if it's going to pay national prices, it ought to get its pictures from a national source—and it does. Using the Internet or convenient express services, such as UPS and FedEx, it bypasses the local agency.

THE MICRO AGENCY

The solution for a small regional agency is to specialize and become a micro agency. For example, a small agency in Nebraska might specialize

Micro Agencies on the Rise

If recent editions of the popular annual directory *Photographer's Market* can be used as a benchmark, midsize to small stock agencies (micro agencies) are on the rise, not the decline.

Our guess would be that despite the introduction of royalty free (RF) and the influence of Corbis and Getty Images, micro stock agency entrepreneurs have seen a niche opening up for them. In other words, Budweiser, Miller, and Coors don't have the entire beer market wrapped up; the micro breweries found their niche, just as small stock agencies are doing.

Although these micro agencies are two- and three-person operations in many cases, and many as yet have not turned a profit, they are a sign that increasing numbers of photobuyers are seeking specialized images that more precisely match the scope and theme of their publishing enterprises.

It may be that part of your photo files might belong in agency *X*, another part in agency *Y*, and yet another in agency *Z*. You could market your remaining images (or digital duplicates) yourself, electronically, through such services as PhotoSourceInternational's *www.photosource.com/bank*, which photo researchers use to find highly specific images.

Year	Number of Stock Agencies in *Photographer's Market*
1996	181*
1997	202*
1998	174*
1999	200**
2000	230**
2001	235***
2002	240***

* majority were general agencies.

** transition: larger agencies are decreasing; smaller specialized agencies are increasing.

*** majority are small to midsized specialized agencies. Only a few general agencies.

Photographer's Market, F&W Publications, 4700 E. Galbraith Road, Cincinnati, OH 45236, (513) 531-2690.

in submarines, an agency in Vermont might specialize in things Mexican, and an agency in Florida might specialize in pro-football celebrities. In today's world, where distance has been annihilated by electronic delivery, express mail, and computers, there's little reason for a Montana agency to specialize in the obvious—cowboys. It's more important for an agency to be a mini-expert in one particular field, such as outdoor recreation, and if possible specialize in one of the subcategories of that field—snowboarding, for example. You'll then gather the pictures from all over the country, and the world, if need be.

The local clients might continue to ignore your micro agency, but not when they need your specialty. When they do need what you can provide, you'll find them standing in line with the rest of your national and international accounts.

How many pictures should you have on file to start your micro agency? At least five thousand when you specialize. How do you find qualified stock photographers? A few will come out of the woodwork locally. A good resource is the Web. At your favorite search engine, type in two words, your subject, and the word "photo." Depending on the specialization, potential photographers' names will come up. Other sources are directories (see Table 3-1 on page 62) such as *PhotoSourceBOOK, Literary Market Place*, and ASPP, APA, and ASMP membership directories. List your agency in *Photographer's Market*, and photographers who specialize in the subject you wish to cover will come to you.

Before you launch your micro agency, think like a marketer. Ask yourself, "Will my agency have customers?"

To find out the answer, use the power of the Web. Here's how. Let's say you're interested in antiquity, and your specialty will be archaeology. Using a search engine, type in "associations." For example, the "Directory of Associations in Canada" lists nineteen thousand Canadian and foreign associations. You'll find fourteen archaeological societies and organizations listed worldwide.

Next step is to contact them to find the conventions and conferences these associations hold.

You'll choose a conference to attend, and you'll set up a display booth for your stock agency's images. The experience will not only pay for the cost of your exhibit (don't forget it's a write-off on your taxes), but it also will provide you with long-term contacts that will result in "first-name basis" working relationships with many of your clients.

When you decide on a specialization, don't choose a broad topic, such as health care. Instead, choose nursing, fitness, disabilities, nutrition, and so on. You'll be rewarded with many sales because you have pinpointed your client's *specific* needs. They won't have to look further than your agency to find the photos they require.

Decor Photography: Another Outlet for Your Standards

As a stock photographer, you'll find that many of your Track A pictures lend themselves to decor photography (or *photo decor, decor art, wall decor,* or *fine art,* as it's sometimes called)—photographs that decorate the walls of homes, public places, and commercial buildings. In contrast to your work in stock photography, you will be selling *prints* (analog and or/ digital), not slides.

The two basic ways to sell photography for decoration are (1) *single sales* (yourself as the salesperson) and (2) *multiple sales* (an agent as the salesperson). In either case, you, or the person you appoint to select your prints for marketing, should have a feel for the art tastes of the everyday consumer. You're headed for disaster if you choose to market prints that appeal only to your sophisticated friends. You'll ring up good decor sales if you can match the kind of photos found on calendars, postcards, and greeting card racks.

I suggest that, as a beginner, you offer your photo decor *on consignment*. You can expect to receive a 50 percent commission from your retail outlets for your decor photography.

SINGLE SALES

Art shows, craft shows, and photo exhibits of all kinds are typical outlets for single sales of your decor photography. Aggressively contact home

designers, architects, remodelers, and interior decorators. They are in constant need of fresh decorating ideas. Your pictures can add a "local" touch. Gift shops, frame shops, and boutiques can be regular outlets.

Art fairs provide an opening into the decor-photography market. Offer your pictures at modest fees. (Most visitors come to an art fair expecting to spend no more than a total of sixty to seventy dollars. Let this be your guide.) You'll find that you can make important contacts at art fairs that will lead to future sales. Pass out your business cards vigorously.

There are two categories of decor photographers at major art fairs: those that net forty dollars for the weekend, and those that net four thousand dollars. The former group wears work jeans and relaxes at their booths in beach chairs. The latter group consists of equally excellent photographers who have studied the needs of consumers, present their work in a professional-looking booth, and are aggressive salespersons.

Miller Outcalt, writing in *PhotoLetter*, says that exhibitor entrance fees at art fairs range from $25 to $250, with the average being $90. Most fairs are held on weekends, usually from 10:00 A.M. to 5:00 P.M. Setup time is at 7:30 A.M.

RESOURCES

Photo galleries offer important exposure and sales opportunities for your decor photography. The Photographic Resource Center at Boston University, 602 Commonwealth Avenue, Boston, Massachusetts 02215, (617) 353-0700, produces aids for photographers, including *The Photographer's Guide to Getting and Having a Successful Exhibition*. Support organizations can be found at Art-Support.com *http://art-support.com/nonprofits.htm*. ArtNetwork, P.O. Box 1360, Nevada City, California 95959, *www.artmarketing.com*, features monthly information. Art Calendar, P.O. Box 2675, Salisbury, Maryland 21802, *www.artcalendar.com*, produces a monthly newsletter and marketing tips. Several books on the subject of art and decor marketing are available from North Light Books, an imprint of F&W Publications (4700 East Galbraith Road, Cincinnati, Ohio 45236, (513) 531-2222), *www.artistsnetwork.com/nlbooks/*. An excellent Web site is "Selling Art on the

Internet" 331 Howard Avenue, Vallejo, California 94589, (707) 642-2933, e-mail: marques@neteze.com, *www.marquesv.com*.

The single-print sales system that requires person-to-person contact can be time-consuming, cutting into your profits. However, if you enjoy the excitement and camaraderie of art fairs and public art exhibits, it can be rewarding. Probably the most lucrative market channel for single sales would be architects and interior designers. They are in a position to sell your pictures for you.

WHAT MAKES A MARKETABLE DECOR PHOTOGRAPH?

Answer: One that makes your viewers *wish they were there*. Choose a view or subject you would enjoy looking at 365 days a year. If *you* don't like the view or subject, chances are your customers won't either. Keep in mind that most buyers of decor photography enjoy pictures of *pleasant subjects* because they find in such pictures an escape from the hassle and routine of everyday living.

That's why, for this market, it's important to take your scenics without people in them. Your viewers would like to imagine *themselves* strolling through the meadow or along the beach. Figures that are recognizable as humans in your picture are an intrusion on the viewer's own quietude and privacy. In addition, people included in decor photography can date the pictures with their clothes, hairstyles, and so on.

Here are some excellent standards that sell over and over again for decor-photography purposes.

Nature close-ups. Zooming in on the details of the natural world at the correct f-stop always produces a sure seller. These subjects rarely become outdated: dandelion seeds, frost patterns, lichen designs, the eye of a peacock feather, the quills of a porcupine, or a crystal-studded geode. Decor-photography buyers tend to buy easily recognizable subjects. An antique windmill would consistently sell better than an antique wind generator (the kind with propeller blades); a still life of a daisy would sell better than a still life of potentilla.

Keep your photography salable by keeping your subject matter simple.

Feature only one thing at a time, or one playing off another, rather than a group of things.

Animals. Both wild animals and pets are perennially popular. Choose handsome and healthy subjects. Keep the background simple so it will enhance, rather than overpower, your subject.

Dramatic landscapes. Shoot landscapes in all seasons, especially with approaching storms, complete with lightning and rolling thunderclouds. If you lean toward PhotoShop digital enhancement, take care. Overly "enhanced" images often have an effect on viewers opposite from what you anticipated. The effects of ice storms are always popular, as are New England pathways in the fall, and rural snow scenes.

Nostalgia. A rustic pioneer's cabin or an antique front-porch swing; historical sites with patriotic significance, such as Paul Revere's home or Francis Scott Key's Fort McHenry; still lifes containing memorabilia such as Civil War weapons or whaling ship artifacts.

Abstracts. Your pictures can range from bold, urban shadow patterns to the delicate network of filaments in a spider's web. Abstracts, whether analog or digital, lend themselves well to waiting rooms, attorneys' offices, and professional buildings, as well as homes.

Sports. Capitalize on the nation's avid interest in sports and sports personalities. Close-ups sell best. Scenes of sporting events lend themselves to game rooms and family playrooms. Keep in mind that many sports teams aggressively guard their perceived right to market images of their teams and players exclusively.

Patriotism. These appeal to government (state, county, and federal) offices as well as to corporations.

Portraits. Model releases are necessary. Close-ups sell best. Exotic, interesting, quizzical, yet pleasant (Mona Lisa) faces sell to legal suites and corporation offices.

Erotic. Eroticism finds a market in private clubs. Subject matter can range from newsstand pornography to esoteric nude studies.

Industrial. Sell your best industrial scenes to engineers' offices. Pictures should be well composed, visually exciting but easy to look at, and

of high technical quality. Visually appealing abstract patterns, close-ups of computer chips, laborers in meaningful work, or factories at sunset after a fresh rainfall are appealing. De-emphasize the negative aspects of industry.

Underwater. The quietude and exotic nature of underwater scenes are appealing to consumers. For a how-to book on underwater photography, read *Jim Church's Essential Guide to Nikonos Systems,* by Jim Church or *The Underwater Photography Handbook,* by Annemarie Köhler and Danja Köhler.

WHAT TO CHARGE

Prices depend on whether you sell in volume or individually. In either case, the buying public will pay about fifty dollars for an eleven-by-fourteen and thirty dollars for an eight-by-ten, after markup. Before you decide on your own price, see what the local department stores are getting for similar decor photography. Also, check out fees online and in catalogs from sellers of fine art and decor photography.

Limited editions are another question: You can demand a higher fee. Of course, if you keep a couple prints for the grandchildren, they just might become heirs to *very* valuable prints. How do you limit the edition? As with other printmaking (silkscreen, digital, etching, or lithography), you usually destroy the original after making one hundred to five hundred prints. In decor photography, you destroy the negative.

What should you charge for limited editions? Keep in mind the professional artist who once said, "If you are going to price your watercolor at $15, you'll find a $15 buyer. If you price it at $75, you'll find a $75 buyer. And if you price it at $850, you'll find an $850 buyer. Just takes time." The going rate for a sixteen-by-twenty-inch color limited-edition photograph is between $100 and $175 with a basic frame.

BLACK AND WHITE OR COLOR?

Black-and-white prints often sell well as decor photography if they are sepia toned. However, color probably has the edge over black and white. As a stock photographer, you'll also want to market your color through

regular publishing channels, and they generally require transparencies. If you so wish, you can buy a film scanner, software, and a professional-grade printer, and print your own images. It's a lot of work, but it might save you a buck or two in the long run, and you will have greater control and more opportunities than if you farmed the printing out. The initial investment can be rather large, though.

DIGITAL CONSIDERATIONS

There's no denying that film-based decor art (analog) is fast becoming an artifact. As digital technology moves into the decor field, less and less analog (film) prints will be produced, making them a valuable commodity. However, in the short term, digital production will bring quicker monetary reward. It's both easier, quicker, and, produced with quality equipment, cheaper. Another advantage: Rather than have a decor print produced at great expense via lithography, an equally fine print can now be made through "on demand" short-run technology.

SIZE

If you sell your prints on a single-sales basis, you'll find that the larger 16″ × 20″ print (and higher fee) will result in more year-end profit than smaller (11″ × 14″ or 8″ × 10″) prints (and lower fees). On the other hand, if you go to *multiple sales* and smaller prints, and you aim for the volume market in high-traffic areas such as arts-and-crafts fairs or shopping malls, you can be equally successful.

Frames. Framing or matting your print definitely enhances its appearance and salability. You can improve some prints by using textured or silk-finish print surfaces. Dry-mounting materials, glass, and hinge mattes are available everywhere. Some processors offer protective *shrink wrap* (a thin, close-fitting, clear plastic covering). Check photography magazines for advertisements for do-it-yourself frames. How-to series often are featured in photo and hobby-and-craft magazines; search the Web or consult your library's *Reader's Guide to Periodical Literature* for back issues. If all else fails, team with a frame shop and split the profits.

Promotion. This is the key to your selling success. If you've sold a series of prints to one bank in town, let the other banks know about your decor photography. Work for ways and places to exhibit your pictures often. Sign your prints or mattes for added promotion and referrals. Offer your services as a guest speaker or local TV talk-show guest. Produce brochures, flyers, or catalogs of your work. Here are two helpful books: *The Executive's Guide to Handling a Press Interview,* by Dick Martin and *DIY PR: The Small Business Guide to "Free" Publicity,* by Penny Haywood *www.photosourcefolio.com/bookstore.* (For more hints on self-promotion, see chapter ten.)

Leasing. Start your own leasing gallery. Businesses know that leasing anything can be charged against expenses. By leasing decor photos to corporations, small businesses, or professionals, you'll get more mileage out of your photos.

Decor-photography and stock photo agencies both offer opportunities as outlets for your Track A pictures. The main message of this chapter has been to emphasize that success with these two secondary marketing channels takes research and time on your part. If you're willing to give it what it takes, you can realize rewards.

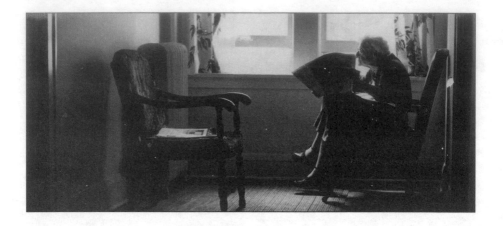

13

Keeping Records: Knowing Where Everything Is

THE LAZY PERSON'S WAY TO EXTRA SALES—KNOWING WHAT'S SELLING

I'm lazy at heart. I like to put the lawn rake back when I'm done with it, because I've learned if I don't, it's a lot *more* work next time to search for it, and possibly not even find it, when I need it.

This lazy kind of thinking got me into a very good habit after a while. By having (or finding) a place for everything here at the farm, I got into the habit of putting *everything* away.

I take the same approach to filing computer disks, slides, negatives, and color and black-and-white prints. If something's worth having, I figure, it's worth knowing where it is when you need it.

I was happily spurred along in this principle when I inherited several hundred used file folders from a businessman who was retiring. By using

a separate folder for each separate photo illustration, I could note right on the folder whenever a picture sold. For black and whites or color negatives, I put a matching contact print on each folder, thus giving myself an immediate visual reminder of what was selling.

After a few years, my record-keeping system was teaching me what pictures sold best and therefore which pictures I should take more of. By continually supplying my Market List's buyers with the kind of pictures they needed, I survived as a stock photographer.

File It! How to Avoid Excessive Record Keeping

This record-keeping system also extends to my everyday office activities.

One method I use to minimize record keeping is to put new projects into a mini-file rather than into the central files. I find that I usually complete mini-projects in about a year. Researching for and purchasing a new computer network was a mini-project; so was remodeling our office in the barn. Other mini-projects revolve around collecting material for future photo stories or photo essays.

Here's a simple technique for a mini-file. The essential ingredients: two sets of two indexes numbered 1 through 24 and lettered A to Z; a temporary portable open file cabinet (like a box), usually made of pressed cardboard or metal and available at stationery stores; and two sheets of 8½" × 11" paper, one numbered in two columns from 1 through 24 and the other set up in two columns from A through Z.

Let's say you're compiling some research on CD-ROM stock photography disc producers. Each entry is given a numerical designation, filed numerically and entered on the "number" sheet. The category also is cross-referenced by title and subject on the alphabetical sheet, with its numbered designation under the appropriate alphabet letter. The alphabetical listing also allows you to cross-reference the subject of the project or category. For example, if a Corel stock photo disc advertisement that you've torn from a magazine is filed under the number "34" (that's the numerical designation for Corel Corporation in your filing system) and it contains three categories (birds, reptiles, and horses), you would list

those three categories on the alphabetical list and designate "34" as the file folder you could find those categories in.

Since the file box is small and portable, you can carry it between home and office or store it in a regular file drawer. I often have six or seven projects going at one time, with information building in twelve to fifteen others, and the mini-file system aids me in being a lazy shopkeeper. I never have to work at finding anything. When the project is completed, the file either earns a spot on my central files or is tossed away.

Knowing How to Put Your Finger on It: Cataloging Your Black and Whites and Transparencies

No cataloging system is better than the keywords it utilizes for its search function. Make sure your keywords are accurate. In the long run, this will be well worth it. For example, in the future, stock photographers will make their keyword database available to certain photobuyers or search engines for highly specialized images. A sale or no sale might be the result of what kind of attention you give to proper keywording.

Many different software systems are available, and we'll touch on all of them, from the simplest to the more advanced. Picking a system is often a matter of personal preference, but it's crucial for you to keep in mind that changing systems down the road is a lot of work. Take time to pick the system that's right for you.

Software products change constantly. Thus, as you review the guides to software catalog systems in this chapter, think of them as rough guides only. Before you decide on any software for your cataloging needs, check with the manufacturer to make certain the current version is what you need.

Now then, do you need to be computerized to be able to catalog your images? Absolutely not. Even though cataloging software is a wonderful help—especially as your photo file grows—it's not a necessity.

The Basics

A cataloging system should make it easy for you to find a specific photograph. The system also should let you quickly and accurately search for

photographs in particular categories in your files. You want a system that's easily expandable, versatile, and able to handle a large amount of entries so that you can keep on using it as your files grow.

For a free report called "Make Your Own Catalog," on how you can make your own manual catalog system, go to our PhotoSource International Web site. You can find this report under the Reports tab in the Stock Photography 101 section, at *www.photosource.com/101*.

The Systems

The two main elements in any cataloging software are ease of data entry and ease of data retrieval (search). It should be easy for you to enter data about your photographs into the system and it should be easy for you to search the system to find the photographs you're looking for.

Choose a known, reliable software company to have the best chance for having support and upgrades available in the future. Over the years I have seen at least a dozen cataloging software companies go out of business—leaving their customers stranded.

The most basic of the computerized systems actually is not a software system in the true meaning of the word. This system will cost you little money, you will not need any special software, and you'll be able to start right away. I'm talking about the easiest, and simplest of them all: the "Do It Yourself" (DIY) system. Before I go into the various software systems made specifically for cataloging photographs, I'll explain how you can set up a simple DIY system that can get you started right away.

DIY SYSTEM

This system assumes that you have a computer, a printer, and some basic word-processing software like Microsoft Word, Corel WordPerfect, or something similar. You need to make sure that you can use your word-processing software to make labels. In Word, check under the "Tools" header, and in WordPerfect, check under "Format." Look for Avery Return Address Labels #8167 or #8667, ½″ × 1¾″ inches, the perfect size for use on slide mounts *www.avery.com/index.com*. Each package will cost

you approximately thirteen dollars (at this writing). There are twenty-five sheets in a package and eighty labels per sheet, making two thousand labels. Cost per label is $0.0065.

For ease of use and readability, use two labels per slide mount. One label should have a copyright symbol, your name, and your contact information. Here is where it's crucial that you plan ahead. Unless you know for sure that you will not move, change phone numbers, or change your e-mail address in the next ten years, limit the contact information you put on these labels. Instead of putting your home phone, consider getting an 800 number that can move with you. Most phone carriers offer inexpensive 800 residential number services.

The second label should carry the identification number and the caption for the individual photographs. This label will change from photograph to photograph.

The next step is to figure out how you want your identification number system to work. Say that you photograph pure breed dogs. One way you could organize the system is to give each breed its own number: German shepherd is #01, Belgian Malinois is #02, Bernese mountain dog is #03, and so on. Then, arrange all photographs of German shepherds and catalog them in whatever order you want starting with Photo #01-0001; the next one will be #01-0002, and so on. Your photos of Belgian Malinois would be #02-0001, #02-0002, #02-0003, and so on.

You can keep your cataloged slides in slide sleeves in metal or cardboard filing cabinets, hanging file folders, or three-ring binders. The most popular among stock photographers seem to be the larger binders with D-shaped rings, which will hold around one thousand slides per binder.

You can adapt this system to prints as well. Instead of two labels per slide, use one (bigger) label, one per print, on the back.

THE SOFTWARE SYSTEMS

If you don't feel like building your own system, or if you need something a little bit more advanced, a software cataloging/database product might be right for you.

Existing software products vary in price, from under seventy-five dollars for a basic system without many frills, to several hundred dollars or more for a high-end system that offers image tracking, delivery memos, invoicing capabilities, bar coding, and so on.

Again, software products come and go, and you should make sure to buy a reliable system that has promise to be around for a long time in case you need to expand and/or upgrade in the future.

Some products with solid reputations in the business that I feel comfortable recommending are: *Emblazon*—Distributed by PlanetTools Solutions Ltd., 4514 East Pinnacle Vista Trail, Cave Creek, Arizona 85331 *www.planettools.com* (previously known as The Cradoc Caption Writer); *Proslide II*—distributed by Ellenco *www.proslide.net*; *StockView* and *InView*—distributed by HindSight Ltd. *www.hindsightltd.com*; *PhotoLibrary*—distributed by PKZ Software *www.photolibrarysoftware. com*; *FileMaker Pro*—distributed by FileMaker Inc. *www.filemaker.com*.

Remember that you want a system that can grow with you and a system that you feel comfortable working with. Most of the software products mentioned here have free demo versions on their Web sites available for downloading. It's not a bad idea to "test-drive" the demo version of many different products before you decide what to purchase.

If you belong to a camera club, ask fellow members who are working stock photographers what product they would recommend. Best bets are those who have used their software for at least three years.

Counting the Beans

Knowing where the dollars are coming from and how many are staying at home is an important part of your operation. By not having an accounting system, you could be pouring dollars into the wrong area of marketing. Bad business decisions usually come from faulty information.

At an office supply store, you can buy an accounting ledger that you can tailor to your needs. If you're computerized, you can start with an accounting program such as Quicken, Eastern Region, (212) 621-0169, *www.quicken.com*. We did this originally and have since upgraded to the

networked version. Other good accounting software products are Intuit's QuickBooks and Quicken Deluxe *www.intuit.com*, and Peachtree Accounting *www.peachtree.com*.

Photographer William Hopkins uses a simple graphics program to chart progress. He tracks the number of submissions he makes and then charts the number of photos sold and dollars that come in. He puts these figures together in a pie chart (see Table 13-1).

Protecting Your Files

Humidity is the greatest enemy of your transparencies (and sometimes of your prints). For ten dollars you can buy a humidistat (from the hardware store) to place near your storage area; it should read between fifty-five and fifty-eight degrees. If the reading is lower, you'll need a humidifier; if it's higher, a dehumidifier. Moisture settles to the lower part of a room. Depending on the area of the country you live in, store your negatives and transparencies accordingly.

Cute animal shots are usually Track A pictures, but when people are involved with the animals in a meaningful way, the pictures become something more than "cute animal" pictures.

Damage from fire, smoke, or water can put you out of business. Locate your backup disks, negatives, and transparencies near an exit with easy access. If you live in a flood-prone area, store your film as high as possible.

Excessive temperatures also will damage your transparencies and negatives. Store them where the range of temperature is between sixty and eighty degrees.

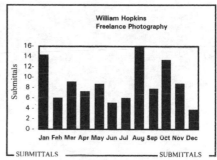

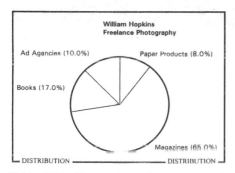

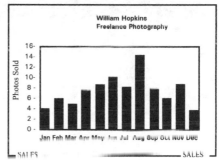

Table 13-1. Simple charts let you see where you're going, and where you've been.

Everything Has Its Place

We've all seen cartoons picturing busy editors, their desks piled high with paper. The caption usually quotes the editor defending her "filing" system.

You can't afford the luxury of an editor's haphazard filing system. As your stock photo library grows, so will your need to be able to locate everything, from addresses to contact sheets, negatives to notes.

Keep in control. If everything has its place, nothing should get lost. If you use an item, put it back when you're finished. In contrast, the editor's desk got that way because she didn't follow these two principles.

1. Make a place for it.

2. Put it back in its place when you're finished.

Is the editor lazy? To the contrary. It takes a lot more work to shuffle through that heap on her desk to locate something.

Time lost can mean lost sales for the stock photographer. Take the lazy person's approach—know where everything is.

14

Working Smart

THE SUCCESS HABIT: FOLLOWING THROUGH

Some might say that there's no big secret about how to succeed as a stock photographer. You simply take good pictures. They'll sell themselves.

Wrong.

For every picture that sells itself, there are about 100,000 waiting in files unsold, because the photographer believed the above. Good pictures are only half of what you need: The other half is *working smart*.

Photomarketing is a business. The principles that help businesspeople make a success of their efforts also will help you. Imagine your business as a locomotive. It rides on two rails. One rail is the quality of your photos; the other your business know-how. One parallels the other.

Knowledge is useless unless it's applied. That's the first thing novices learn when they venture into the business world. Photographers who succeed do so not because of their knowledge of photography or photomarketing, but because they apply what they know.

Sounds simple, but wisdom in business is not a one-time move; it's a continuing movement, a momentum, a follow-through, until it becomes

habit. If you take the principles in this chapter and make them habits of your photomarketing lifestyle and work style, you will be on the road to success.

Setting Goals

Where is your ship headed? Are you on a fishing expedition, heading out in the bay hoping to get a bite? Or do you have a definite destination, a well-researched spot where "they're bitin' "?

The Small Business Administration *www.sba.gov* tells us that most newcomers venture into a new business as if they were going fishing. They have a lot of anticipation and enthusiasm, and most of their emphasis is on externals instead of on precisely where they want to go and how to get results.

Your chances of getting your stock photos published and your photographic talent recognized will be excellent if you form the winning habit of setting goals for yourself *before* you make a move in your business development.

Getting Organized

Could you imagine entering a sailing race without checking for torn sails, sizing up your competition, charting the course, figuring what currents and marine traffic you'll have to buck, knowing when and where to tack, and being prepared to adjust to the vagaries of the weather, sandbars, or reefs? An organized and efficiency-conscious person will be through the race and back on the dock, enjoying wine and cheese, while the person who thinks he can enter the race without setting goals and making plans will still be out in the elements attempting to get to shore, paying the price for his lack of preparation.

As you build your photomarketing business, set your goals, and follow through, be prepared when opportunity beckons. These are the secrets of creative success.

Time Your Goals

Set short-term and long-term goals. Make them realistic.

For a short-term goal, aim to send a certain number of pictures by a

certain month. Aim to cut your processing and film costs by a certain percentage within the same month (by shopping for the best price and streamlining your buying procedures—e.g., order by mail, the Internet, or phone, rather than in person, and order in quantity).

For a long-term goal, aim to sell, within two years, three times the number of pictures you are currently selling.

Goals need not be rigid and inflexible. They can be changed—upward or downward—depending on many variables. Write them down, though. Spoken goals don't have the same impact.

Write down a few dream goals, also. They're free.

I'd advise you not to share your written goals with anyone, save your spouse or cherished friend. Few people will share your enthusiasm. Friends, colleagues, and relatives often are experts at giving advice, though their experience and personal life situations may not justify it. Keep your goals to yourself, and share them by accomplishing them.

Is It Easy? A Survival Secret

Probably the most frequent question put to me is, "How can I become successful at publishing my pictures?" The answer is simple, though it's not the answer most photographers expect. That may be one reason why the answer is so elusive to so many.

We might expect the answer to be, "Be born with talent," or "Work hard!" Having talent and working hard can help, of course. However, we all know photographers with a lot of talent who are going nowhere. We also know a lot of hard workers who are headed for the same place. To get to the point: If your desire to become a published photographer is so strong that your personal constitution will allow you to "put up with and do without," then success is just around the corner.

Whenever I follow up with photographers who in the past expressed dreams and aspirations of publishing their pictures, I find that the ones who have met with success are the ones who have persisted and endured.

First of all, they have "put up with" the unglamorous chores inherent in this business. As they faced each day, they didn't avoid the tedious

tasks. They had *true grit*. They knew that if they avoided an irksome job, it wouldn't go away but would grow into a larger problem the next day, and by the end of the month, it could be an insurmountable barrier.

What are these unpleasantries? As a stock photographer, you face them daily: rewriting a poorly composed letter to a prospective photo editor, rescanning a slide, making a phone call that will straighten out a disagreement, maintaining and updating your photo database, filing your transparencies, packaging photos, sending digital previews to prospective clients, licking stamps.

If you're new to the field of stock photography, you'll recognize a parallel in those drudgery jobs that it takes to run a smooth, comfortable household. Every uncleaned paintbrush or tool unreturned to its shelf, every unanswered letter in that pile of important letters, that unbalanced checkbook—all are examples of things we don't like to do, things that if we're not careful can pile up until it becomes a habit to *not* get them done. That habit, then, becomes our style, or *us*. Wishing away drudgery jobs never works. We cannot become a success at anything until we face the fact that a goal or a purpose must be worth *more* than the inconvenience of tackling the chores most people just don't like to do.

In my experience, I find that stock photographers who throw in the towel do so not for lack of talent, but because they are victims of their own failure to recognize this essential point: *They must put up with the drudgery.*

The second dictum: Do without the creature comforts. Hopefully, this will be necessary in only the initial stages of your career. How long you will do without depends on the goals you have set for yourself. Some goals are short range and easily attainable. Other goals are long range, worthwhile, and rewarding to the soul, but they're not necessarily immediately rewarding to the pocketbook.

To get established as an editorial stock photographer, one must frequently do without the conveniences that Madison Avenue continually reminds us we "must" possess: a VCR, a wide-screen color TV, the latest-model car, a DVD player, stacks of current music CDs, and an extensive

wardrobe. To meet film or postage costs, or to purchase a new computer, we often must change lifestyle or supermarket habits to economize. We must do without. Although it might be a bit overboard, an excellent Web site for economizing is *Frugal Living www.livingfrugal.com.*

If you begin today to economize and tackle each drudgery chore as it comes along, you'll be surprised to find that you'll get into the habit of successfully meeting challenges. A task that you once found annoying will become joyous for you, because you'll welcome and recognize it as another milepost on your journey to becoming a successful stock photographer. If you persist and develop the inner constitution to "put up with and do without," you will begin your success where others failed.

> "Victory belongs to the most persevering."
>
> —Napoleon

Think Small

In a few pages, I'll be asking you to think big, once you get your stock photo marketing operation rolling. However, Rome wasn't built in a day. Aim high in your photography aspirations, but aim low in your sales targets—initially. Make your first mistakes where large audiences and your later-market photobuyers won't see them.

I'm not proposing mediocrity; I'm simply advising you not to fall into the "glory" trap: You'll run up against the wall built by experienced competitors, only to become discouraged and end up taking that lucrative job offer at the local car wash. The result: You'll become another name in the Directory of Also-Rans. *Work smart = Think small* in the early stages. Give yourself production and fee goals that are immediately reachable, and then move along in steps on your way to thinking big.

DON'T MISDIRECT YOUR WORK

Working smart includes not working on projects or not working in directions that offer little promise. If you gauge in advance what to avoid, you can save yourself money and time.

As an editorial stock photographer breaking into the markets, assess beforehand the degree of difficulty you will face when approaching a particular magazine or publishing company. Is the market crowded? Is it a closed market for you, such as *Time*, *People*, or *National Geographic*? Or is it wide open? (Open markets include local magazine supplements for Sunday newspapers; denominational publishers [listed in *Photographer's Market* under Book Publishers], which publish dozens of magazines and periodicals; association and organization magazines like *The Rotarian* or *Kiwanis Magazine*.)

What is the supply/demand ratio involved for each type of market? Some photographers don't learn the answer until they have uselessly spent a fortune trying to market pictures to a virtually closed market. Read the clues: "No use for this type of photography." "We're over-stocked on those." "Bring more detail into your pictures if you want to sell to us." "We have a photographer who does those and don't need any more."

When you fill in your yearly assessment of your best markets, you'll know which markets to cross off your list. With each sale, you'll gravitate closer to your ideal markets.

Typically, closed markets (see Appendix A) are the calendar, greeting card, photo product, postcard, poster, and place mat areas. These markets are glutted with fine photographs and fine photographers, many of whom have worked for a particular company for decades. Why try to drive through a stone wall for infrequent sales, when lucrative avenues await you? Magazine and book publishers with ten-thousand-, twenty-thousand- and thirty-thousand-dollar-a-month budgets for photography await the editorial stock photographer who has discovered her own PS/A (Photographic Strength/Areas) and zeroed in on a specific Market List.

Your research and personal experience will determine which markets are closed to you. If the situation doesn't look promising in light of your current degree of expertise or depth in a certain photographic area, don't knock fruitlessly at a door that isn't ready to open to you yet. Put your energies and your dollars into tapping the lesser-known markets first.

You'll save money, gain experience, build your picture files, and sell photos—that's *working smart*.

Draw up a weekly report that tallies work activity scores, such as how many submissions you sent, how many pictures you sold, and so on. Analyze these on a continuing basis to see if your sales are growing and to find out what categories and which submissions have been most successful. Continue to revise your Market List priorities from these figures.

You Manage the Business—Not the Other Way Around

Being one step ahead of the competition, whether in a footrace or a pass pattern in football, makes all the difference between winning and losing. In business, it works the same way. If you get behind, you lose control and get "behinder and behinder." The business begins to manage *you*. You can be out front, even if it's by inches, if you adopt the winning habit of keeping your ship on course each day.

In stock photography, this applies especially to the routine you establish to get your submissions to photobuyers. Establish a written plan (this will help crystallize your thinking), and follow through with it.

If you're not a self-starter, here's a technique many people have used effectively: Hire a part-time assistant to come to your office certain days of the week to send out shipments of pictures. To keep your helper productive, you must always have new work ready to send out.

A Self-Evaluation Guide

How do you tell if you're making any progress? By measuring it. Too often, photographers and other creative people find one year running into the next without ever analyzing their efforts to see if they're really moving or just running in place. If you have a well-received exhibit or a local TV interview, it might create an illusion of success, but if the bottom line shows zero at the end of the year, it's time to reassess your efforts.

Your measuring system doesn't have to be elaborate, but it should

encompass at least a three-year span to be an effective, meaningful basis of comparison. (Quarterly or monthly assessments, based on your photo submissions *in/out* ledger, will be helpful until you reach the three-year mark.)

You will want to keep a running tally on four areas: pictures sent out; pictures bought; money received; and film, processing, mailing, telephone, and computer supplies costs. Chart these monthly, and at the end of three years, you will see your progress. (*Pictures bought* in one month may include many pictures actually sent during previous months.)

How to Measure Your Sales Strengths

Here's how to chart your sales strength areas your first year. A spreadsheet program on your computer will tally these figures for you. Otherwise, use a simple ledger sheet and a pencil.

Start with any month of the year.

1. Assign a code number to each of your sales areas.
2. Make a sales slip (use carbonless paper, a photocopy, or a computer form) that includes a blank space for:
 Date:
 Amount:
 Code Number:
3. Each time you receive a check for one of your pictures, record the previous information. If one check is for two or three different sales areas (code numbers), make two or three sales slips.
4. File your sales slips in a drawer until the end of the month.
5. At the end of the month, enter information from the sales slips onto a chart (ledger) similar to the example in Table 14-1.
6. Total the previous months and the current month for a year-to-date total.

Your sales totals are your best marketing teacher. Which code area(s) shows the highest income? By monitoring these statistics, you will be

able to accurately document which areas you should concentrate your sales efforts on.

Pictures Just Aren't Selling?

Working smart includes reevaluating your working procedures now and again, too. Start with your packaging presentation. A trick you can use to ensure that you're maintaining top quality is to ask the person closest to you to be your quality-assurance specialist. Every so often, when you prepare a package for a photo editor, don't let it out of the house until your quality-assurance specialist has given it the go-ahead. Let this person critique it, acting out the role of photobuyer. Painful as it might be, you'll form the habit of giving your best to every detail of your presentation.

THE FIVE REASONS FOR REJECTION

If you're not getting the sales you feel you ought to be getting, give the following points some serious thought. Often, success can be a process of elimination. By avoiding failure, you succeed. Get back to the basics, and watch your marketing sales spiral upward.

Photographs are rejected for five basic reasons. If you're guilty of any of them, you should reassess your marketing methods.

1. Poor presentation. Are you mailing in a crisp, white, thick cardboard envelope? Are you using a professional label or an imprinted logo? Did you include an SASE with your submission (if you're a new contributor to the publication)? Are your transparencies packaged in protective sleeves or sheets? Will the slides fall out if the page is inverted? Are your photos clearly identified? Have you verified the publication's address and the contact person's name? Is your cover letter a professional-looking printed form letter (which saves you and the editor time) rather than a rambling handwritten letter?

It may seem unfair that the outside appearance of your package is so important, but photo editors are busy and have found through experience that amateurish packaging usually reflects the contents. Often they relegate a sloppy package to the *return* bin—without opening it.

MONTH: _____			CODE NO.	TOTAL SALES PREVIOUS MONTH	TOTAL SALES THIS MONTH	TOTAL SALES YEAR TO DATE	TOTALS FOR 12 MONTHS BEGINNING: ENDING:___
PRIMARY MARKETS	MAGAZINES	SPECIAL INTEREST	100				
		TRADE	101				
		BUSINESS	102				
		DENOMINATIONAL	103				
		ASSOCIATIONS, ORGANIZATIONS	104				
		LOCAL MAGAZINES	105				
		STATE & REGIONAL MAGAZINES	106				
		NEWS SERVICES	107				
		OTHER	108				
	BOOKS	TEXTBOOKS	200				
		CHURCH RELATED BOOKS	201				
		ENCYCLOPEDIA	202				
		CONSUMER TRADE	203				
		OTHER	204				
SECONDARY MARKETS	STOCK PHOTO AGENCIES	AGENCY A	300				
		AGENCY B	301				
		AGENCY C	302				
		AGENCY D	303				
		OTHER	304				
		MAJOR NEWSSTAND MAGAZINES	400				
	DECOR PHOTOGRAPHY	MARKET A	500				
		MARKET B	501				
		MARKET C	502				
		MARKET D	503				
		OTHER	504				
THIRD CHOICE MARKETS	PAPER PRODUCTS	CALENDARS	600				
		GREETING CARDS	601				
		POSTERS	602				
		POSTCARDS	603				
		OTHER	604				
	COMMERCIAL ACCOUNTS	ADVERTISING AGENCIES	700				
		PUBLIC RELATIONS FIRMS	701				
		RECORD COMPANIES	702				
		AUDIO/VISUAL HOUSES	703				
		GRAPHIC DESIGN STUDIOS	704				
		OTHER	705				
	ART PHOTO SALES	MUSEUMS	800				
		PRIVATE INDIVIDUALS	801				
		OTHER					
	OTHER	GOVERNMENT AGENCIES	900				
		NEWSPAPERS	901				

Table 14-1. A simple ledger can help you assess your sales strengths. We use the computer program Q&A to pinpoint similar strength and weakness areas.

If you want first-class treatment from photobuyers, give them first-class treatment.

2. Off-target and unrelated submissions. Does the material you've submitted meet the buyer's request? Do your pictures hit the mark? Or has the buyer asked for pictures of waterfalls, and you've submitted pictures of brooks and streams just in case the buyer might want to see them?

Are your pictures *cohesive in style*? Do the pictures themselves have a consistent, professional appearance? That is, do they all look like they came from the same photographer? To test the professionalism and cohesiveness of your pictures, gather editorial stock photos from magazines and periodicals on your Market List. Lay about twenty of them on the living room floor, and then place *your* pictures beside them (or if you deal in slides, project them on a screen with the tearsheets taped to a nearby wall). Do your pictures fit in? If so, you're on target. If not, retake the same pictures, incorporating what you've learned from this exercise.

3. Poor quality. Look at your pictures again. Assuming you are using top-quality equipment, is your color vibrant and appropriate for the mood and scene? Have you properly filtered your indoor shots where fluorescents are involved? If you've used flash or lights where appropriate, have you avoided hot spots?

Published pictures must go through several steps before they reach the printed page. Your pictures must be appropriately in focus, with good film resolution (sharpness), no grain (unless appropriate), and no camera shake; these faults will be magnified in your published picture.

Are your prints technically good? Have you achieved the best possible gradation in your black-and-white prints (a stark white, with some details, and several gradations of grays, all the way down to a deep, rich black, also with some details)? If you've used burning and dodging techniques, they shouldn't be apparent to the photobuyer. Have you spotted your prints, especially the 35mms?

Are your black-and-white prints dog-eared, with rough edges, cracks, stains, folds, tears, or scratches?

If you're submitting digital images, have you cleaned up your scans?

Is there visible dirt or dust at a high (or normal) magnification? Are you using a high enough resolution? Have you submitted according to the procedure the photobuyer wants digital submissions to follow?

All of the previous elements provide a photobuyer with quick evidence of your craftsmanship and reliability. Whether you score high or low is up to you.

4. Outdated pictures. Outdated pictures can be another enemy to your sales. Photo editors expect a fresh batch of new pictures from you on each shipment. Some pictures are long-lived and timeless: Fifty years from now, your heirs could continue to benefit from their sales. The majority of pictures, however, are short-lived, because they reflect the *now*. In a matter of years (usually between five and ten), you will want to extract these pictures from your files because they are dated by clothing and hair styles, equipment, machinery, furnishings, and so on.

Some stock photographers have attempted to circumvent this problem by eliminating anything from their pictures that would date them. This generally means excluding people; however, the most essential element in a successful photo illustration *is* people. Exclude them, and sales diminish.

Putting your dated pictures out to pasture is not an enjoyable prospect. Be as objective as possible in your weeding-out process. If you find it difficult to eliminate pictures, ask a friend to look through a group of pictures and guess what year they were taken. Your friend's objective assessment will be similar to a photobuyer's.

We all tend to rationalize our pictures' usefulness and stretch their life spans beyond marketing reality. At the risk of sounding like dial-a-mortician, I'm asking you to be *realistic*. Photo editors are. Outdated pictures will outdate your business operation and will possibly eliminate you from the photobuyer's roster. Move these outdated images to your historical file. It's practical and sensible. You'll make occasional sales when requests *for how things used to be* come in, and these photos may find new life as digitally modified images.

5. Poor composition. Assess the *composition* of your pictures. Do your compositions adhere to the $P = B + P + S + I$ formula? (See chapter two.)

Do you zero in on your subject matter with the appropriate emphasis for each situation? When you work with people in your pictures, do you orchestrate the scene so that the results are natural and unposed? In other words, are you producing marketable editorial stock photos?

If this section on why pictures fail to get published is discouraging to you, it shouldn't be. Remember that editorial stock photographers successful at photomarketing are not those who occasionally produce a brilliant photograph but those who periodically assess and evaluate their progress. If they find deficiencies, they take the next step: They do something about it.

Please be cautioned that some photographers take my suggestions for avoiding failure to extremes. These folks are perfectionists. "Do it right or not at all." This admonition is certainly well founded, and many successful stock photographers can trace their success to adherence to such good rules. The paradox is that many unsuccessful stock photographers can trace their failures to them, also. Why? The procrastinator, under the guise of perfectionism, accomplishes nothing for fear of not doing it flawlessly.

Procrastinators spin their wheels reading about and studying cameras and equipment and how to take pictures. They keep telling themselves they don't know enough to start, that their pictures aren't good enough yet to send to an editor.

If you find yourself justifying procrastination, ask yourself to redefine *quality*. You can pride yourself on quality presentations without crippling yourself by equating quality with perfection.

A Potpourri of Additional Aids in Working Smart

When you get upset with a photobuyer, remember the Law of 125. Each person you deal with influences 125 other friends, neighbors, relatives, or business colleagues. It works this way: If you produce a good product for a person, that person will probably tell five people (5), who may each tell five people (25) who may tell five people (125).

$1 \times 5 = 5 \times 5 = 25 \times 5 = 125.$

If you turn a prospective customer away with an angry remark or letter, or a poor attitude, you may be turning away 125 prospects.

INSURANCE

Are you insurance-poor? That is, are you putting a disproportionate amount of your dollars into insurance instead of photo and computer supplies? Don't allow yourself to be talked into equipment-insurance plans that will put you in a bind. Talk with other photographers. Visit the PhotoSource International's Kracker Barrel on the Web at *www.pho tosource.com/board*. If you hear of many instances of stolen equipment, then a solid equipment or business protection plan might be in order for you. Reexamine your policy from time to time. Some of your equipment may have depreciated to the point where it isn't cost-effective to continue to insure it. If you're a member of ASMP (150 North Second Street, Philadelphia, Pennsylvania 19106, (215) 451-2767 *www.asmp.or g*), you are eligible for a comprehensive insurance package. The cost ranges from $650 to $850 if you're living in New York City. Rates will vary according to where you live.

Your camera equipment usually can be insured as part of your business insurance package, or a broker who handles your other insurance, such as your homeowner's policy, can negotiate it. An example of a broker who will handle photographer's insurance is The Hoffberger Insurance Group, 5700 Smith Avenue, Baltimore, Maryland 21209, (410) 542-3300, *www.hoffberger.com*.

Buying insurance is like gambling. You play the odds. However, some careful research on your part can establish how much insurance is enough for you. Shop around. If you're quoted disproportionately different rates, read the fine print and investigate the company through *Consumer Reports* or your local Better Business Bureau.

The best insurance is the daily habit of prevention. *That's* affordable.

1. Know the high-risk areas for thievery in your location and photographic destination.

2. Don't tempt thieves with flashy camera bags or unlocked car doors.

3. Invest in a monitored burglar-alarm system or a dog that likes to bark.

4. Inscribe your name on your equipment. Your local police department will help you with this.

5. Ask for references from the people you consider hiring.

6. Keep receipts and serial numbers for all your equipment.

LOW-COST EQUIPMENT

Camera equipment (new) can dent your budget. Several companies sell used camera equipment. Two that come highly recommended are B&H, *www.bhphotovideo.com*, in New York and KEH, *www.keh.com*, in Atlanta. Also, check out eBay on the Web.

If you're looking for office equipment, check with your state to see if they have auctions where surplus equipment is sold. You can normally save at least 50 percent compared to buying new.

TOLL-FREE NUMBERS

The telephone is an important resource for the stock photographer. For toll-free numbers available to you, call the toll-free information operator at (800) 555-1212 or your local phone company and ask if the company you're trying to reach has a toll-free number. You'll save on your phone bill, and you'll get your answers from the experts, fast. The major photography magazines often list toll-free numbers in the ads for camera equipment and film processing. A toll-free directory is available from AT&T, (800) 222-0400. Companies sometimes will change their toll-free numbers. If this happens, just call (800) 555-1212 and ask for the new numbers. Note: If the business has a toll-free number with an 888, 877, or other toll-free area code, you would still dial (800) 555-1212 to find it.

SEARCH THE WEB

Another resource available to use for searching for information is the World Wide Web (WWW). Using your computer, you can find the latest

gadget, research arcane subject matter, and find answers to highly specific questions.

Some excellent search engines are:

Google *www.google.com*
AltaVista *www.altavista.com*
Dogpile *www.dogpile.com*
Lycos *www.lycos.com*
Yahoo *www.yahoo.com*

These search engines are excellent tools for finding information, whether it be small business tips or research on an assignment location. Use the search engines also to locate addresses I've listed in this book if you find they might have changed recently.

GRANTS, LOANS, SCHOLARSHIPS, FELLOWSHIPS, AND AID ASSISTANCE

These are available to photographers at local, regional, and national levels. The funds come from state and federal agencies, as well as from private corporations and foundations. The monies usually are awarded for specialized photographic projects. If your idea is accepted, the grant can boost your supply of stock photos in one of your PS/As.

To apply, photographers propose a photographic project. If selected, they receive stipends ranging from five hundred to one thousand dollars a month for a period of several months.

Tweak Captions To Attract More Photobuyers

Use the synonym/thesaurus in your word processor to help you expand your captions in Webster's Compact Dictionary Synonyms ($6.50, *www.m-w.com/book/thesaur/comsyn.htm*)
Select number 5 on *www.photosourcebook.com* for more help.

You can learn more about how to write proposals for and receive such funds through the following books and organizations:

Foundation Grants to Individuals, The Foundation Center, 79 Fifth Ave., New York, NY 10003, *www.fdncenter.org*;

Free Money for Small Businesses and Entrepreneurs, by Laurie Blum, *www.amazon.com*; *Grants in Photography: How to Get Them*, by Lida Moser, *www.barnesandnoble.com*;

National Endowment for the Arts, 1100 Pennsylvania Ave. NW, Washington, DC 20506, *www.arts.endow.gov*

The ultimate in working smart, of course, is doing work that you don't consider work at all. If you've defined your PS/A well and tailored your Market List to markets that offer you the best potential, you'll find that you'll automatically be working smart.

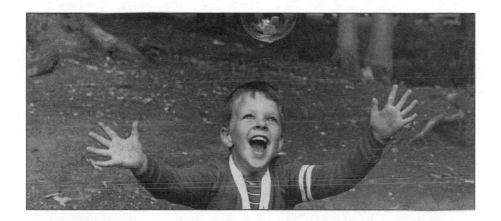

15

Rights and Regulations

COPYRIGHT

Who owns your picture? You do! The Copyright Law speaks loud and clear. Copyright law generally gives you, as the author of your photos, copyright for each picture from the moment you press the shutter. Ownership of the copyright enables you to determine or limit the use of every photo in whatever way you specify, to re-sell various rights in the work, and to have your rights in your work protected by a court of law in case of infringement.

The easiest way to assert your claim is to affix a copyright notice—© Your Name—to each photo. You also can formally register your picture with the U.S. Copyright Office for a fee (currently thirty dollars). You then receive a registration certificate, the prerequisite for taking an infringer (one who has used or reused your picture without authorization) to court. If you don't register your picture, it's still protected by copyright as your property, and you still have legal claim to it. However, formal registration helps cement your claim. If you register the image before or within three months of first publishing your work, you have a better

chance at receiving full financial recompense in the event of infringement.

The familiar *c* within a circle–©–is no longer necessary to preserve copyrights. Late in 1988, the United States ratified an international copyright treaty known as the *Berne Convention*. This put the final nail in the coffin of the former long-standing rule that a copyright in a published work could be lost if the work didn't carry a valid copyright notice. (The old rule still applies to photos published before March 1, 1989.) However, using the © will strengthen your copyright protection. It's still advisable to use it. By doing so you give notice to the public that you are claiming copyright, and you are alerting any potential user as to who the owner is and how to contact you. Print your copyright notice on your new slides and prints to eliminate any doubt as to who owns the copyright and to broadcast a warning that infringement will be prosecuted. However, for the record, the copyright in any photo you have published after the March 1, 1989, deadline will be automatically protected, whether or not you have printed the copyright notice on it.

Copyright Infringement

Let me say at the outset that I believe the spirit of the Copyright Law is to encourage the free flow of information in our society. The law is a basic protection for that exchange. It was written to protect not just photographers, but the users of photographs as well—the photobuyers. Copyright infringement in stock photography is rare (as opposed to service photography, where infringement does happen). In thirty years as a stock photographer, I have personally experienced only one instance of possible infringement, and in that case an art director, new on the job, made an honest mistake.

If you wish to be super safe, you can register your extra-special marketable pictures. When you do, you'll receive the benefit of the Copyright Office's documentation and recording, and you'll have copies of your work filed with the Library of Congress. However, in stock photography work, you generally won't find it necessary to register many pictures. The © symbol affixed to the back or front of your picture or next to your

credit line in a layout serves as a warning to would-be infringers. The right to use the © is yours; it costs you nothing. The law recognizes that you own your picture once you have it on film, even if the film has not yet been processed. The Copyright Act of 1976 is, in effect, a photographer's law rather than a publisher's law, as it was prior to 1978, when the 1976 law took effect.

Remember, a copyright protects only your picture, not the *idea* your picture expresses (Section 102[b]). If you improve someone else's idea with your picture, that's not necessarily copyright infringement, that's free enterprise. The test for infringement is "access plus *substantial* similarity." How similar is substantial similarity? That's anybody's guess, but bear in mind that the jury that decides the case is drawn from ordinary citizens. How do you think such persons would feel about a photo you've created that shows similarity to another? Keep in mind also that among the rights of the copyright owner is the right to prepare "derivative works." If your photo appears to be *derived* from someone else's photo to which you had access, you may be infringing. On the other hand, don't be intimidated or deterred from creating or re-creating a new photo on the remote chance it may infringe on an existing photo. After all, the engine of the world of art is fueled by creative improvements to old ideas.

Group Registration

Another option—and to the photographer, quite an advantage—is that under the revision, you can "group-register" photographs. There are different rules for group registration, depending on whether you're registering *published* or *unpublished* images. Currently you can register a maximum of five hundred previously published photographs at a time. The photographs need to have been published during the same year. So, if you have work regularly published in magazine A and newspaper B, you can have all the images registered at once by sending in one year's worth of copies of your published work, along with the fee and all forms. The fee is currently thirty dollars, but check with the Copyright Office to find out the latest details.

You can register an unlimited number of *unpublished* photos for a one time thirty-dollar fee. Unpublished works may be reregistered after publication. Registering unpublished works usually is unnecessary but can expedite getting into court in the event a work is infringed. Moreover, it entitles you to sue for punitive awards (if not registered, you're limited to damage awards only, which must be proved).

Again, omission of a © notice adjacent to your photo does not void your copyright. In addition, the picture will still be protected by the publisher's copyright notice, usually included in the masthead, which protects all editorial matter and photographs (except advertising) within the publication.

How to Contact the Copyright Office

For more details on specific points about copyright, phone the Copyright Public Information Office, (202) 707-5000, between 8:00 A.M. and 4:00 P.M. (Eastern time), or write: Register of Copyrights, Library of Congress, Washington, DC 20559. You can also visit them on the Web at *www.loc .gov/copyright*.

The Copyright Law is lengthy (the official law is 117 pages) and covers all aspects of creative endeavor, from book publishing to motion pictures. We'll be addressing here only the portions of the law that relate to stock photography.

Interpreting the Law

Writing and commenting on "the law"—any law—is like discussing philosophy or religion. A point of law might be stated one way, but it's open to different interpretations. Only time and court tests solidify the interpretation. Even then, there are exceptions to the rule. As each stock photographer's Market List and PS/A are different, so is the photographer's need to interpret the Copyright Law. I have made every effort to ensure the accuracy of the information contained in this chapter, checking it with copyright officials and attorneys, but I cannot guarantee the ab-

sence of error or hold myself liable for the use or misuse of this information.

To sum up the points of law covered so far:

- You own your picture (unless you have signed a "work-for-hire" agreement, discussed later in this chapter).
- You can register your pictures for added protection.
- You can group-register your photos for a reasonable fee.

Be Wary of Dates

Note that copyright of your pictures published in copyrighted publications prior to *January 1, 1978*, when a new, broader copyright law (which I'll address in a moment) went into effect, belongs to the public, in each case, unless you can show proof that you leased the pictures on a one-time basis or that the publisher reassigned all copyright privileges to you. It's doubtful that this situation will cause you any problems, unless the picture concerned is one with great market potential (such as a photo of a person who recently catapulted to fame). Nevertheless, pre-1978 pictures generally have copyright protection from infringement if they were published with the © symbol, and it may even be possible for you to assert your sole right to them at the time of renewal (more about this later).

Though your rights in pictures published before 1978 may be limited by the arrangements you originally made with the publisher, pictures taken before 1978 but not published until after 1978 will enjoy the benefits of the revised Copyright Law.

Now for the bad news. It's possible for you to lose the right to your pictures and for them to fall into public domain. Here's how it can happen: If your work was published without your copyright notice before 1978, or if it was published before March 1, 1989, and neither your copyright notice nor a general notice for the entire publication (such as in the masthead) were involved, *and* if you did not register that picture within a period of five years from the date your picture was published, then the Copyright Office will now refuse to register your picture. The Copyright Office takes the position that your copyright has expired and

that your picture belongs to "the people." It's in the public domain: Anyone can use it.

To register a work that has been published without notice (before March 1, 1989), it must have been within five years of publication (and that deadline has long since past). In addition, you will have to show the Copyright Office that either (1) the notice was omitted from only a relatively small number of copies distributed to the public, (2) a reasonable effort has been made to add notice to all copies distributed once the omission was discovered, or (3) the notice was omitted in violation of your express requirement, in writing, that your notice appear.

For current work (after March 1, 1989), the Berne Convention makes it unnecessary *legally* to have to include a © notice, but as I stated in the beginning of this chapter, for the public it's still a good safeguard to stamp (or write) your © notice on all photos you send out. In your cover letter, state that if the photos are published, your © notice must appear beside them. An official © notice consists of the word *copyright* or the abbreviation *copr.* or a © symbol and your name (© Your Name). The use of a "c" in parentheses "(c)" is *not* a valid copyright symbol.

Since the Berne Convention relieves you of the *necessity* of having a copyright notice on your photos published after March 1, 1989, it's no longer critical for you to insist that your © notice be published alongside your photo for the purpose of establishing that you hold the copyright. Again, though, it's still helpful to attach the © notice to your photos to give warning to would-be infringers.

The revised Copyright Law offers the machinery to protect your ownership of your pictures, but ultimately the burden of protecting your rights is on you.

The Copyright Office can offer you no protection if you have relinquished your rights through neglect, ignorance, or your own wishes. Moreover, the U.S. District Attorney can prosecute only if an infringement is willful and for commercial advantage.

Your © notice on your slide or print is your first order of protection.

Laying Claim to Your Picture

The Copyright Law doesn't specify what else you should have on your picture for identification, other than the notice. (Always copyright under your name, not the name of your business. Otherwise, if you sell your business, the copyright to all your pictures would go with it.) For your own identification purposes, however, always include your address and phone number. I also advise using labels with the memo shown in Figure 15-1 for your prints. (Use two labels—the other for your address and phone.)

Your slides will require an abbreviated form of the labels shown in Figure 15-1 because of the border-size limitation, but be sure to include all the information on your accompanying invoice.

<table>
<tr><td align="center">**Stamp 1**</td><td align="center">**Stamp 2**</td></tr>
<tr><td>© Your Name
This Picture is licensed for one-time inside-editorial use only.
Publication of © is requested</td><td>Your Name
Name of Business (optional)
Your Address
Your Phone Number</td></tr>
</table>

Figure 15-1. Stamps to protect your prints.

The following are sound reasons for going to the trouble of a memo label.

1. *Licensed* implies that this picture is not work for hire. (In work for hire, the copyright may not belong to you.) *Licensed* implies that you have not entered into any separate sales arrangement with your client, that you want any transparency returned to you, and, when practical, you'd like any black-and-white print returned to you.

2. *One-time* ensures that you're not assigning any rights other than rights to one-time use. If you wish, include this sentence in your invoice: "Additional rights available."

3. *Inside-editorial* use simply lets the client know that if he decides to use your picture on a cover, he must pay extra. (See Table 8-2 on page 132 for how to increase your fee when a picture is used for a cover, for

advertising, and so on.) This phrase also will protect you in the future if an art director happens to use your picture without authorization for commercial (trade) purposes or advertising. If a suit were to arise relating to trade and advertising use because of the people pictured in the photograph, you could show proof that the picture was leased only for editorial purposes (which usually require no model release).

4. *Include © credit.* This shows proof, in case of infringement, that you asked the publisher to name you as copyright owner.

Some Drawbacks of the Copyright Law

INFRINGER (Section 501[a]): Someone who violates any of the exclusive rights of a copyright owner.

Prosecuting an infringement may be costly, and you may never recover all the money you expend, but if you prevail, you may be able to seize and destroy the infringing articles, or enjoin the infringer from further production and distribution. This may be worth more than money to you.

Your greatest protection may be to place the copyright notice on *each* of your pictures. (Remember, the notice costs you nothing.) An infringer is not "innocent" if she pirates a picture that bears your copyright notice. It carries clout. Like the average citizen who never removes the mattress label "Do Not Remove Under Penalty of Law," the infringer is likely to shy away from anything that looks like a federal offense.

In a rare instance, you might discover an infringer within three months after you've published an unregistered picture. If you choose to press charges, you can register your picture at the Copyright Office (special speedy handling will cost you, at this writing, an extra five hundred dollars—by certified check!), and haul the infringer into any court having jurisdiction in a federal civil action. If it's past the three-month deadline, you can still register your picture, but damages you would receive if you won the case would be limited.

The process of registration is simple for authors who register an entire book for twenty dollars. For stock photographers, who produce thousands

of pictures, the administration and expense of registering each photo might be likened to separately registering each paragraph in a novel or textbook, unless you group-register huge batches. As stock photographers, then, we continue to be left to the mercy and basic honesty inherent in most people. God won't save us from "innocent infringers," but we can do a lot to eliminate their "innocent" status by putting notice on every photograph that leaves our hands.

A Remedy

If you discover a person or an organization has used your picture without your permission, send the person a bill. How much? The normal is three hundred to five hundred dollars. If the person has "deep pockets," go ahead and charge him fifteen hundred dollars, an acceptable fee for color transparencies in the commercial photo community.

Under copyright law (Section 113[c], 107, the "fair use" doctrine), libraries, schools, and noncommercial broadcasters (such as public television) can sometimes use your pictures without requesting your permission, provided their use is limited to educational and noncommercial activities and does not diminish the future marketing potential of your picture.

This latter ruling will need further interpretation because of the paradox involved when a picture receives wide exposure. Consider the broadcasting of pro-football: Leagues are still not sure whether broadcasting enhances or decreases gate sales. Hence the blackout provision. This provision of fair use by the nonprofit sector, which has yet to be fully tested in court, could greatly disadvantage the stock photographer. Fair use is, however, limited by many of the provisions detailed in Copyright Office Circular 21, which describes some of the limitations on fair use. If your work has been used extensively, the use may not be "fair" (reading Circular 21 may shed some light on this for you).

Q&A Forum on Copyright

In the following Q&A forum, I'll give detailed answers to some significant questions as they apply to you, the stock photographer. I'll first cite the

source in the Copyright Law of 1976 (Title 17 of the U.S. Code).

Is it necessary to place a © notice on all of my photos to preserve my copyright?
Sections 401, 402, and 405

No. As of March 1, 1989 (per the Berne Convention agreement), the familiar © is no longer necessary to establish proof that you own the copyright. The law recognizes you, as the photographer, as owner of copyrights of your photos. However, I recommend using the © notice to eliminate any doubt in viewers' minds (i.e., the public) as to who owns the copyright to your photo. The © notice broadcasts a warning that infringers will be prosecuted.

Can the © be placed on the back of my picture, or must it appear on the front?
Section 401(c) and House Report ML-182

Your copyright notice can be rubber-stamped, printed on a label, or handwritten on the back or on the front of your prints. In the case of a transparency, it can be placed on the border (back or front). Be sure the © is enclosed in a circle, not just parentheses. Thanks to the Berne Convention, the copyright notice doesn't even have to appear anywhere; nevertheless, place it on each of your photos to warn would-be infringers.

Who owns my picture?
Sections 201(a)(b)(c) and 203(a)(3)

You do, from the moment you click the shutter ("fix the image in a tangible form"). Before 1978, it was assumed the person you authorized to use your picture (publisher, ad agency, client) owned the copyright. The new law assumes that *you* own all the rights to your pictures, unless you have signed those rights away. Except in a case where you have entered into some kind of transfer-of-rights agreement in writing with a client or publisher, such as a work-for-hire agreement, no one else can exercise any ownership rights to your picture. Even if you do sell "all"

rights to your picture, in thirty-five years, if you or your heirs take appropriate action, you can take the copyright back.

How long do I own the copyright on my photograph?
Sections 302(a) and 304(a)(b)

The 1976 Copyright Law says copyright in your picture "subsists from its creation" (when you click the shutter), and you own copyright to it for as long as you live, plus fifty years. The old law, by the way, allowed you only twenty-eight years to own your picture, plus a renewal period of twenty-eight years—for a total of fifty-six years. If you register, that renewal has been extended to forty-seven years, for a total of seventy-five years. If you don't register your copyright in a pre-1976 work, you can't renew it, and at the end of twenty-eight years it will fall into public domain. To register pictures that hold special importance for you, the current fee is twenty dollars. Ask for Form VA. If you wish to register nonphotographic work, such as writing, ask the Copyright Office for Form TX.

How can my picture fall into the public domain?
Sections 405 and 406

Publication without notice before 1978 meant your picture was in the public domain—that is, anyone could use it and not be required to pay you for it. From 1978 to March 1989, publication without proper notice put your picture in the public domain unless you took steps to "cure" the omission or defect. Under present law, you needn't worry about your post-1989 photos falling into public domain until your copyright expires (your lifetime plus fifty years).

What is group registration, and how do I do it?
Section 408(c)(2)

This provision of the law says you can register any number of pictures published in one publication during one year for one price. Whether you're registering five pictures or fifty, as long as they're all in one maga-

zine, newspaper, or publication, the fee is currently only thirty dollars. (You can file group registrations of your published works for one filing fee if they are all created in the same year; if publication dates aren't listed, all must be first published within three months of filing.)

How to do it: For each photo you choose, obtain one copy of the entire periodical in which it appeared. To group-register, fill out Forms VA and GR/CP (available from the Copyright Office, Library of Congress, Washington, DC 20559, *www.loc.gov/copyright*). Send to the Copyright Office the forms, your thirty-dollar fee (in check or money order payable to the Register of Copyrights), and copies of the periodicals or news-papers in which your published pictures appeared. (The U.S. Copyright Office has been a part of the Library of Congress since 1870.)

For unpublished pictures: Submit several contact-size pictures on one eight-by-ten-inch sheet, or submit photocopies of transparencies or black-and-white prints (photographic prints, not photocopies) of the pic-tures you wish to register. Since unpublished works must be in the form of a collection, title this collection of pictures "Collection of Photographs by [Your Name]." Fill this title in at space number 1 on Form VA. A handy way to group-register a collection of slides is to put twenty images in a plastic sleeve, photograph them in color on your light stand and then blow them up to eleven by fourteen inches. You also can submit printouts and CD-ROMs with your images. (For more detailed information on digital formats, check out the Web site of the Copyright Office, *www.loc .gov/copyright*.) You can submit any number of multiple sets under one title, and the cost is thirty dollars (at this writing).

Note: Because the Copyright Law is an ever-changing document, be sure to check for updates and/or changes with the Copyright Office from time to time.

If I ask a publisher to include my © notice alongside my picture when she publishes it, but the © is omitted, does this invalidate my copyright protection?
Sections 401(a)(c), 405(a)(2)(3), 407(a)(2) and 408(a)

No. Since March 1, 1989, no notice is required to preserve a copyright. For earlier work first published between January 1, 1978, and March 1, 1989, your copyright protection exists if you can show proof that your picture (1) was rubber-stamped, labeled, printed, or handwritten with the copyright notice on the front or back before it was published, (2) was accompanied by a letter from you asking for publication of your notice with the photo in the publication, or (3) was published in a copyrighted publication. Since *all* of the pictures (except advertisements) in a publication are covered by the blanket copyright notice in the masthead, copyright protection for you was implied. However, make sure that the publication's copyright notice was correct (you'd be amazed at how many publications print partial—or erroneous—notices!).

Can I place the © notice on my slides and photographs and be protected even if I don't register my photos with the Copyright Office? *Sections 401(a)(c), 405(a)(2)(3), 407(a)(2) and 408(a)*

Yes. The © notice you put on your picture is "official," and is free. It lets the world know that you own the copyright to your picture, but you don't *need* the © notice for your picture to be protected. The revised Copyright Law recognizes you as copyright owner, with or without the © notice and with or without registering the photo. If a picture isn't registered with the Copyright Office, that doesn't mean it isn't copyrighted. However, like your automobile, if it's stolen, it's a lot easier to prove it's yours if it's registered with the Department of Motor Vehicles. You have more immediate clout than if you can produce only your title to your car but no registration. Of course, the important reason to register any photos is so you can get attorneys' fees and punitive awards (statutory damages in an infringement suit). In cases of your very special pictures, you may wish to have the extra clout that you would have against possible infringers if such pictures were registered.

If I don't register my pictures, but I publish them anyway with the

© notice, can I be ordered to send them in to the Copyright Office?
Sections 407(a)(d)(1)(2)(3) and 704 Title 44 (2901)

Yes. Under the 1978 system, a photographer will not be forced to register his pictures, but he can still be ordered to submit to the Library of Congress (the parent office of the Copyright Office) two copies of a published work in which a © notice appears. If, after being ordered to send them, the photographer does not do so *within three months*, he can be fined up to $250 (for each picture) for the first offense, plus the retail cost of acquiring the picture(s). If the photographer fails to or refuses to comply with the demand of the Copyright Office, an additional fine of $2,500 can be imposed. All deposited pictures become the property of the Library of Congress, but you retain the copyright, since copyright is distinct from ownership of any copy. Incidentally, if you register your work, the copies sent with the registration satisfy the deposit requirement—but the reverse is not true. Even if a work has been deposited, two additional copies must accompany any registration application.

What does "work for hire" mean?
Section 101(1)(2)

If you're employed by a company and take a picture for that company as *an employee*, generally speaking, that's work for hire. The company owns the picture. At some point, you may have signed a work-for-hire agreement with your employer. Even if you haven't, and your work was done within the scope of your employment, total ownership of your pictures belongs to your employer. If you're a freelancer and a picture is specifically commissioned or ordered by a company, and you have signed an agreement saying so, your photos may be works made for hire. However, if a magazine gives you an assignment and pays for the film and expenses, that is not working for hire unless you sign a document saying so. If you receive such an assignment, avoid signing a work-for-hire statement. Instead, agree to allow exclusive rights to the client for a limited time. If the client insists on all rights, increase your fee. A good test for work for hire is to ask, "If someone were to be sued regarding this,

who would be liable—the photographer or the entity commissioning the photographer?" For an in-depth discussion on work for hire as it applies to publishing and multimedia development, consult the bibliography for *Multimedia Law and Business Handbook*, by J. Dianne Brinson and Mark F. Radcliffe.

Are the pictures I submit to a photo editor who's listed in *Photographer's Market* or similar reference works considered works made for hire?
Sections 101(1)(2) and 201(b)

No, unless you have signed a work-for-hire letter, slip, form, or statement. Remember, if the pictures existed before you made contact with the photobuyer, they were not "specifically ordered and commissioned" and cannot be works made for hire.

What if a magazine publisher wants to reprint my picture a second time as a reprint of the original article, wants to use my picture to advertise his publication, or wants to use my picture a second time in an anthology? Does the publisher have the right?
Section 201(c)

As a stock photographer, you should license only one-time publishing rights to a photobuyer. Unless something different is stipulated in writing, the law assumes that you have licensed your picture to the photobuyer only for use in the magazine, any revision of that magazine, or any subsequent edition of that same magazine issue—which could mean more than one use, but not in another publication or for a different usage. In no other case may the photobuyer presume to use your pictures without your consent and/or compensation to you. If a photobuyer would like your picture for additional use, refer to the pricing guide for photo reuse in Table 8-3 on page 138. Note: In the stock photo industry, we use the term *photobuyer*. This means that the buyer is buying certain *rights* (usually one-time rights), not the copyright, and not the physical black-and-white print, slide, or digital image itself. These prints, slides, and CDs (or other

digital media) usually are returned after the transaction. (Slides should *always* be returned.)

What penalties does infringement (unauthorized use of a photo illustration) call for?
Sections 412(1)(2), 205(d), 411 and 504

The owner of a registered copyrighted picture on which infringement has been proved may receive, in addition to the actual damages she has suffered (lost sales, for example), the amount in cash of the profits received by the infringer. If the copyright owner can prove the infringement was willful, she can receive as much as $100,000 for each infringement if she wins. However, if the infringer proves that he infringed innocently, the award to the copyright owner could be as low as two hundred dollars or less—even zero. If the copyright is registered within three months of publication, the copyright owner can receive statutory damages instead of lost profits. Thus, even if the infringer earned only fifty dollars, the award could be between five hundred and twenty thousand dollars. Legal fees also may be reimbursed but only if the copyright was registered within three months after publication or before the infringement occurred. If you don't register your picture and it's used without permission, you must register before you can go to court—and you may lose the right to statutory damages and attorneys' fees by procrastinating in your registration.

However, other remedies, such as impoundment or injunction, are available and may be worth the cost of going to court for the satisfaction. In addition, the government occasionally will even prosecute an infringer. Criminal penalties include fines (of which you get no share; the government gets it all) and imprisonment.

What is the statute of limitations on infringement?
Section 507(a)(b)

If you don't discover infringement within three years, you have no recourse for damages.

Can I take a picture of a photograph or an object that is copyrighted?
Sections 113(c) and 107

Yes. Under the "fair use" doctrine, a photograph or other copyrighted work can be copied or photographed for uses such as criticism, comment, teaching, or research. The court is more likely to consider your use as "fair use" if you use it for a noncommercial purpose rather than a commercial purpose. For example, your one-time use of a copyrighted picture in a slide program for a nonprofit lecture series or camera club demonstration would likely be considered fair use. However, if you used the picture for self-promotion or advertising purposes, or if the picture was given such widespread distribution that it reduced the effective market value of the original copyrighted photograph or article, you would probably be guilty of infringement. As a stock photographer, if your pictures are used basically to educate and inform the public, taking a photograph of a copyrighted object or picture might not be infringement. However, one of the criteria for fair use is the amount of the work you reproduce. A photograph of someone else's entire photo or painting might well be infringement. Of course, keep in mind that your interpretation might be different from that of the court, and consider each case in its own context.

For a more thorough discussion of fair use, see Copyright Office Circular 21 *www.loc.gov/copyright/circs/circ21.pdf*, or consult chapter eleven in the *Multimedia Law and Business Handbook* listed in the bibliography.

How long can I wait to register a published picture?
Sections 101(a) 405, 406, 408(a) and 412(2)

Any length of time. Pictures registered *within three months* of first publication (or registered prior to publication) receive broader legal remedies than those registered later, and registration is the prerequisite for any suit. However, your copyright exists whether or not your picture is registered. If your pictures were published before March 1, 1989, and no copyright notice was applied to them, you had five years to register the pictures in order to correct the omission. If the copyright notice was erroneous (e.g., if your name or the date was incorrect), you may not be

protected against those who rely on the information in the notice until you have registered.

If my picture is included in a magazine or book that's copyrighted, does that mean the publication owns the copyright to my picture?
Section 201(c)

No, *you* own the copyright, unless you've made and *signed* some special arrangement with the publisher. If you've leased a picture on a one-time-rights basis, then it's assumed that the publisher has only leased your picture for temporary use in that publication.

If I don't have my picture registered and it's included in a copyrighted publication without my copyright notice on it, am I protected by the blanket copyright of all the (editorial) material in the publication?
Section 201(c)

You are protected, in most cases. (See *Morris v. Business Concepts, Inc.*)

Are pictures used in advertising also covered by the blanket copyright notice on a copyrighted publication?
Section 404(a)

No. The publisher can claim copyright only on that material over which it has editorial authority. If your picture is used for advertising purposes, request that the advertising agency include your notice. Although the notice isn't required, using it alongside your photo might result in additional sales.

What is the copyright status of all the pictures I published before the new law came into effect on January 1, 1978?
Section 408(c)(3)(c)

Under the old law, unless you *registered* and renewed those pictures, your pictures would have copyright protection limited to twenty-eight years. Renewal would have extended the protection to fifty-six years.

Since 1978, works that are or have been renewed have their copyrights extended for a total of seventy-five years.

Prior to 1978, unless you had an agreement limiting the rights you were granting, or unless the publication reverted the rights to you after publication, copyright for the first twenty-eight years belonged to the publication as work made for hire.

Note: As mentioned, the Copyright Law is an ever-changing instrument. Great effort has been made to make this section as up-to-date as possible. This section is not designed to be a legal reference, however, and I recommend checking with the Copyright Office for the latest information.

Work for Hire

Although the Q&A forum touches on work for hire, you should know more about this subject, especially if you'll be accepting an occasional service assignment that could fall into a work-for-hire situation.

Before 1978, the courts generally assumed that if a freelancer did a specific photographic job for a person or company, the photographer didn't own the resulting pictures—the company or client owned them. The 1978 Copyright Law reverses this, and the courts assume the photographer owns the pictures, not the client. This alone clearly indicates the growing awareness of the resale value of stock photos.

The law now says that except for employees acting within the scope of their employment, unless there's a written agreement signed by both parties stating the photographer's work is work for hire, claims to ownership of the resulting pictures must be based on the rights (ranging from "one-time" to "all") that you assign to the client.

A client *could* assume ownership of your pictures under the following circumstances:

1. Your client is actually your employer, and you have made no provision to transfer copyright ownership of your pictures to yourself while under his employ. (Note: It's possible to have the copyright of your pictures assigned to you after an agreed-upon time.) An employer owns the

copyright in works created by an employee within the scope of employment.

2. The client is not your employer but claims to be. In *Community for Creative Nonviolence v. Reid (1989)*, the U.S. Supreme Court ruled that the tests for *employment* found in agency law apply to work for hire. These would include who paid for the supplies and equipment, whether you could hire assistants, where the work took place, whether the employer could order you to do additional work, and whether you are in business.

3. If you don't fit these definitions of *employee*, a work for hire must meet three conditions: (1) It must be specially ordered and commissioned; (2) there must be an agreement in writing, signed by both parties, specifying that this is a work for hire; and (3) the work must fall into one of nine specific categories, such as contributions to a collective work or an atlas. For a more thorough discussion, see *the Multimedia Law and Business Handbook*.

At all costs, we as stock photographers should protect and defend our rights provided by the Copyright Law. We need to be ever vigilant. As an example, in 1985 the American Association of Advertising Agencies called for (but did not get) a return to the "traditional understanding" of the 1909 Copyright Law, which made the client, not the photographer, the presumed copyright owner. Work for hire in the present Copyright Law presumes that *you* own the copyright. Let's keep it that way.

4. A purchase order, assignment sheet, or similar form that you have signed could state (sometimes in an ambiguous or roundabout way) that you're assigning copyright of the work to the client. The statement might read, "All rights to photographs covered in this contract become the sole property of the client." If you give away all rights, you give away your copyright. A work-made-for-hire agreement is effective only for eight types of specially commissioned works:

a. Contributions to collective works

b. Part of a motion picture or other audiovisual work [Many multimedia works (including CD-ROMs) are audiovisual works.]

c. Translations

d. Supplementary works (works prepared as adjuncts to other work)

e. Compilations

f. Instructional texts

g. Tests or answer material for tests

h. Atlases

5. If you've endorsed a check that has printed on it a statement that says by endorsing the check you relinquish all claims to ownership of your pictures, you may be assigning all rights: "Endorsement below constitutes release of ownership of all rights to manuscripts, photographs, illustrations, or drawings covered by this payment." A statement after the fact that the work was made for hire might have the same effect. Your recourse here would depend on various circumstances. You might cross out the offending lines, initial, and endorse the check. You might send the check back, and ask the client to issue a new check minus the offending phrase. Each situation is different. If possible, consult with other photographers who have completed assignments for the same company, and compare notes on how arrangements with the client have been worked out.

In some cases, the client may be testing you. Handle with care. With diplomacy, you could get full copyright ownership, and remain in the client's good graces.

The work-for-hire provision of the Copyright Act of 1976 is a benefit to the stock photographer because it makes the assumption that the photographer owns the picture, not the client. If you find yourself in a game of politics in a service-photography situation and your client insists on "all rights" (that is, work for hire), ask the client this question: "If I were to be negligent and be sued, who would be liable—me or you?" The client might back off from insisting on all rights.

Electronic Rights

Treat electronic rights like you treat rights for printed media. Insist on having your name and the © symbol by all your images used electronically.

Do not allow publishers to use your images electronically without ne-

gotiating a separate usage with you. Many photographers, who have failed to read contracts before signing them, have discovered that some publishers now want print and electronic rights—often for the same fee that usually covered only print rights.

For more detailed information on this check my other book, *sellphotos.com* as well as the PhotoSource International Web site at *www.photosource.com*.

Which Usage Rights Do You Sell?

The title of this book is *Sell & Re-Sell Your Photos*. It should be *Sell & Re-Sell the Rights to Your Photos*. As a copyright owner, you have the exclusive right to reproduce, distribute, and modify your photos.

You don't want to sell all usage rights, as in a work-for-hire situation. You want to license your photos, granting people permission for specific usage rights. There are different sizes, shapes, and extents of rights, but primarily you want to base your sales on *one-time-use* rights. Any other rights of use should require separate negotiation and additional payment.

Read the Fine Print

The different designations of usage rights commonly accepted are as follows.

> **One-Time Rights.** The client or publication has permission to use the picture only once. *You license* the picture for that one use only.
>
> **First Rights.** These are the same as one-time rights, except the client or publication pays a little more for the opportunity to be the first to publish your picture(s).
>
> **Exclusive Rights.** The client or publication has exclusive rights to your photograph. This can be for a *specified amount of time*, such as one or two years. After that time, the rights return to you. Calendar companies often ask for exclusive rights. You also may limit this by territory or type of use (for example, North America, or calendar but not book use). Again, the client pays more for these rights.

Electronic Rights. You can arrange to lease your image on an exclusive-rights or an all-rights basis, for an appropriate fee just like for use in magazines, textbooks, and calendars.

Reserved Rights. A client or publication may wish to pay you extra to be the only purchaser to have the privilege of using your picture in a particular manner—such as on a poster or as a bookmark—in which case you would reserve that use specifically for them.

All Rights. This is the outright assignment (transfer) of copyright to a client. After thirty-five years, if you wish the rights to the photo to return to you or to your heirs, you or your heirs have the right to reclaim them. Some photobuyers think they need "all rights" when they really don't. Educating your clients is part of being in business.

As a stock photographer, you should avoid assigning all rights to a client or publication if the picture has marketing potential as a stock photograph. If the picture, however, is timely, it may be wiser to accept the substantial payment that an all-rights arrangement commands, and relinquish your rights to the picture. Examples of pictures that might soon become outdated, and therefore unsalable, are photos of sports events, festivals, and fairs.

World Rights. The client or publication is granted a license to use the photograph in international markets.

First-Edition Rights. You sell rights to only the first printing of a book, periodical, and so on. After that, you negotiate for other editions.

Related Rights. These rights allow the use of a photo for related purposes, such as advertising and promotional use.

Specific Rights. Certain individualized rights are outlined and granted.

Your standard cover letter (see Figure 9-1 on page 157) can serve as

an invoice to your photobuyer. In some cases, however, you will come to an agreement with a buyer regarding certain other rights and/or arrangements that are not covered by your standard letter. Spell out these terms in a separate letter to the buyer confirming the understandings. Also send an invoice with your shipment that reiterates all of the pertinent details of the transaction, such as rights being offered, number of pictures, and each picture's identification number, size, type (color or black and white), date, and so on. Invoices are available at stationery stores. Professional-looking invoices are available from your local printer and office supply stores like OfficeMax *www.officemax.com* and Staples *www.staples.com*. If you're computerized, you can prepare your own invoices. Just be sure to use quality stationery.

Forms to Protect Your Rights

Up to this point, we've been discussing the rights of photo usage that you sell. What about *your* rights with regard to damage, loss, or pictures being held for lengthy periods of time? Your photomarketing endeavor necessitates submitting valuable photographic materials to persons with whom you've never had personal contact. Is this taking a risk?

Is it a risk to travel down a road at 55 mph and face the oncoming traffic on the other side of the road? Any one of those cars could cross over into your lane. What makes you continually take this risk?

You take it because the benefits of driving your car outweigh the risks involved.

Likewise, you're going to have to put a lot of *faith* in the honesty of the photobuyers you're dealing with. You're continually going to have to risk damage or loss to reap the benefits of getting wide exposure for your pictures.

There are contract forms available—also called "Terms and Conditions" agreements—that a photographer can issue to a photobuyer to specify terms of compensation in the event of damage or loss of photos while in the hands of the photobuyer or his company, agents, and so on. However, newcomers (or sometimes anyone—veteran *or* neophyte) have

little chance of getting a photobuyer to sign a "Terms and Conditions" agreement. The disadvantages to the buyer outweigh the potential benefits. In fact, he might turn the tables and ask *you* to sign an indemnification statement that will free him of any liability as a consequence of using your pictures.

Keep in mind that others you depend on to handle your prints and transparencies—the U.S. Postal Service, FedEx, UPS, and your film processor—refuse to reimburse you more than "the actual cost of a similar amount of unexposed film" in the event of damage or loss. Also, the IRS, in assessing the depreciation of your slide inventory, sets the value not at intrinsic value, but only at actual cost.

My advice: If you're an entry-level editorial stock photographer, lay out your terms and conditions to a photobuyer in a friendly, easy-to-understand cover letter, as shown in Figure 9-1 on page 157. Once you attain stature in your stock photo operation, if you wish—or in special instances—you can test the waters by submitting a formal "Terms and Conditions" statement. This kind of statement, however, might intimidate, turn off, or actually anger a publisher, unless presented by a "name" photographer. Politics is involved, of course, and you'll have to judge how to handle each situation on an individual basis.

Even a "name" photographer will think twice before using these agreements, however. For example, such agreements usually include a provision that calls for reimbursement of fifteen hundred dollars for each transparency lost or damaged. This fee has indeed been collected, but subsequent communication between photobuyer and photographer is usually not quite the same, if it exists at all. If you find yourself in a similar situation, you will probably want to weigh your loss against your relationship with the photobuyer, and determine whether you wish to press such a payment from a good client for the result of an unusual accident or an honest mistake. The photobuyers who seem to make 90 percent of the mistakes in this industry are those who are new in the field. A good rule: Don't deal with a photobuyer or publisher unless she has a track record of three years, minimum.

If you wish to research these forms further, particularly as an aid in dealings with clients or companies you're not familiar with or whose proven track records are questionable, *ASMP Professional Business Practices in Photography* (includes tear-out sample forms), offers sound examples. It's listed in the bibliography and is available from the PhotoSource International bookstore at *www.photosourcefolio.com/bookstore*.

Legal Help

If you need legal help in dealing with a photobuyer, a publisher, or the IRS, the two organizations below might offer assistance. To consult with just *any* attorney on a legal problem concerning the arts and publication is like offering him a blank check to finance his education in the matter. Different attorneys are well versed in some areas, less informed in others. Before you contact an attorney, check with Volunteer Lawyers for the Arts (VLA). The organization includes more than eight hundred volunteer attorneys across the nation who handle a variety of arts-related situations. For more information and a directory of VLA offices nationwide, contact the New York office (1 East Fifty-third Street, Sixth Floor, New York, New York 10022-4201; (212) 319-2787, ext. 1; *www.vlany.org*). In some cases, the consultations are free. In other cases, there are predicted fees, but at least you'll know that the VLA attorneys have good track records in dealing in the area of intellectual properties.

A helpful organization for copyright help is Editorial Photographers (EP) *www.editorialphoto.com*.

You Will Rarely Need a Model Release for Editorial Use

There is perhaps no area of photography more fraught with controversy and misconception among equally competent experts than the issue of when model releases are required.

Photographers are confused and, as a result, often hesitate to take or use a picture because model releases will be too difficult to obtain. This uncertainty seriously limits the photographer, and in the end it limits you and me—the public.

The Constitution is brief and open to interpretation when, in the First Amendment, it affords us freedom of the press. Freedoms are sometimes abused, and court cases over the years have attempted to interpret and clarify our freedom to photograph. New York State courts have tried many cases over the years. As a consequence, many of the other forty-nine states tend to look toward New York statutes and precedents for guidance. The current spirit of the interpretation of the First Amendment is that we, the public, relinquish our right to be informed if we succumb to a requirement of blanket model releases for everything photographed. If a photograph is used to *inform* or to *educate*, a model release is not required.

What are other books saying about model-release requirements?

It has long been established that photographs reproduced in the editorial portions of a magazine, book, or newspaper do not require model releases for recognizable people. Under the First Amendment of the U.S. Constitution, photographs may be used without releases if they are not libelous, if they relate to the subject they illustrate, or if the captions are related properly to the pictures, and if they are used to inform or educate. These provisions are confined to photographs used for non-advertising and non-commercial purposes.

—from *Selling Photographs: Rates and Rights*,
by Lou Jacobs Jr. (Amphoto Books, page 174)

Can you include bystanders in the photographs of the parade when the article is published? Yes, you can, and you don't need a release. This is because the parade is newsworthy. When someone joins in a public event, he or she gives up some of the right of privacy.

—from *Selling Your Photography: The Complete Marketing, Business, and Legal Guide*, by Arie Kopelman and Tad Crawford
(St. Martin's Press, page 194)

Most of your publishing markets are well aware of the fact that they seldom need model releases. In my own case, I started out getting model releases whenever I shot, which hampered my photography in the process. Once I learned that publishers for the most part take their First Amendment rights seriously and do not require model releases (with the exception of specific instances, which I'll discuss in a moment), I stopped getting written releases and haven't gotten any for thirty-some years. (That's one of the advantages of being an editorial stock photographer and not a commercial photographer.) My model-release file gathers dust in a far corner of my office, and my deposit slips continue to travel to the bank with regularity.

In the course of my photomarketing career, I've come across publishers now and then (or photobuyers new to the job) who were unaware of their First Amendment rights or were unwittingly surrendering them. If they persist in requiring model releases when they're not necessary, I drop them from my Market List.

Model Releases—When Must You Get Them?

Your photo illustrations are used to inform and to educate. That's why your photobuyers will rarely require a model release. Just when *are* you likely to need one?

Some gray areas have developed over the years, and these instances are the exceptions to the rule. Pictures that might shock what's defined as the normal sensibilities of ordinary people may be categorized as outside the "inform or educate" interpretation. Some other sensitive areas include mental illness, crime, family or personal strife, chemical dependency, mental retardation, medicine, religion, teen pregnancy, and sex education. Each case has to be interpreted in its own context. For example, a court case involving sex education might be treated differently in Mississippi than it would in California. Take local and regional taboos into consideration when you publish your photos.

A model release might be required by the publisher of an industry-

sponsored magazine because of implied endorsement. If a picture of you, for example, were to appear on the cover of *World Traveler Magazine*, it might imply that you, indeed, agree that Northwest Airlines "knows how to fly."

As mentioned earlier, model releases usually *are* required in service photography. If a picture of you or your son or daughter is published in a commercial way and a trade benefit is implied, you or your son or daughter should have the right to give permission for such use, on one hand, and should receive compensation for such use, on the other.

Stock photo agencies sell pictures for both editorial and commercial use, and while they frequently do not require model releases when your pictures are submitted, they will want to know if releases are available. Being in a position to say to an agency, "MRA" (Model Release Available), will make your pictures more salable.

Oral Releases

Written model releases are required in New York State, but oral releases are valid in most other states. This means you can verbally ask permission for "release" from the person you photograph. This is to avoid later misunderstanding, even though the way your picture is used might not even require a model release. You can say, for example, "Is it okay if I include this picture in my photography files for possible use in magazines or books?" Keep in mind that, should it ever come to court, verbal agreements are *much* harder to prove.

However, if you're also a commercial stock photographer and there's a chance the picture may be used for commercial purposes, it's advisable to make your verbal request more encompassing: "If I send you a copy of this picture as payment, would you allow me to include this picture in my files for possible use in advertising and promotion?"

When you read about lawsuits involving the misuse of photographs by photographers, it's usually a commercial stock photographer who has used a photograph of a person in a manner different from what

the model expected. If you're a commercial stock photographer, *don't* rely on a verbal model release. Get a signed release. Spell out exactly how the picture will be used. If the person is under eighteen years of age, obtain a release from a parent or guardian. If the property you're photographing also capitalizes on its notoriety, and you plan to use the photo for commercial use, then get a "property" release. You'll find that in most such situations, the property owner will be happy to sign a property release; in effect, you're serving as a free public relations or publicity agent, who normally might cost the owner seventy-five dollars or more an hour.

How do you learn if oral model releases are acceptable in your state? Almost every county in the United States has a law library at the county courthouse. Consult the current volumes of state statutes for the laws on invasion of privacy. Ask the law librarian or the county attorney to assist you. For details on cases involving invasion of privacy, consult the volumes entitled "Case Index" or the equivalent. You'll be pleasantly surprised to learn that few cases are recorded.

If you're unable to visit the law library in person, try phoning. Let the librarian know if you're not familiar with the terms or descriptions. An expert will be more helpful and willing to refer you to additional sources of information if you let her control the conversation.

Many photographers shoot the pictures that they plan to send to an agency, or that might be used from their own files for commercial purposes, within a close geographical area. They can then easily go back later and obtain a written model release, when necessary. Another route is to work with one or several neighboring families and get a blanket model release for the entire family, then barter family portraits over the years in return for the privilege of photographing family members from time to time for your stock files.

Figure 15-2 shows an example of an acceptable model release. Figure 15-3 shows a release for parents and guardians to sign for models under eighteen years old (under twenty-one in some states). These two releases have each been designed to fit onto a pocket-size 3" × 5" pad.

RELEASE

In consideration for value received,[4] I do hereby authorize _____
_____ ("the photographer") and or parties designated by the photographer (including clients, purchasers, agencies and periodicals or other printed matter and their editors) to use my photograph in any medium the photographer or his designees see fit for purposes of adevertising, display, audiovisual, exhibition or editorial use.

I affirm that I am more than 18 (21) years of age.

 Signature _____

 Date _____

Figure 15-2 Model release.

RELEASE

I, _____, $\frac{parent}{guardian}$ of _____, a minor,
in consideration for value received,[4] assign to _____
its customers and representatives, the exclusive right to copy and reproduce for the purpose of illustration, advertising and publication in any manner whatsoever any photograph or said minor it its possession.

 Signed _____

 Address _____

Witness _____

 Date _____

Figure 15-3. Guardian's consent for model release.

[4] Value received translates in everyday terms to compensation. The compensation the model receives might be a dollar, a copy of the publication the picture appears in, etc.

Can We Save Them Both? The Right of Privacy and Our First Amendment Rights

The rights safeguarded by our Constitution include the right of privacy—our individual right to decide whether we want our peace interrupted. Occasionally a photographer violates normal courtesies, laws, and decency with her picture-taking. Such instances are, of course, exceptions, and all are answerable within the law.

However, we've seen instances in which individuals engaged in medical quackery and leaders of political groups, militia groups, or religious cults will commit their misdeeds against society and then attempt to take refuge in our right-of-privacy laws. Usually, prominent public figures must surrender such privacy and open themselves to public scrutiny. Such is the price of glory.

One state, Tennessee, has passed a law ("The Personal Rights Protection Act of 1984") that is a bureaucrat's and politician's dream. It states that publishers in Tennessee cannot use photos featuring people if the photographer has not obtained a model release. This means freelancers cannot photograph police brutality, school system wrongdoings, militia activities, highway accidents, city hall personalities, religious rites, and so on. Our First Amendment recognized that the curtailment of information to the public invites corruption.

What about the nonpublic figure, the person who is just going about his normal business? Invasion of privacy is not so much a question of whether or not you should take a picture or not, but whether or not the publisher should publish it, and in what context.

While our Constitution allows us freedom of the press, it also allows us freedom from intrusion on our privacy. Herein lies a conflict, and the courts are left to decide whether a photographer committed invasion of privacy in any individual instance.

Instances usually considered invasion of privacy would occur if you were to do the following.

1. Trespass on a person's property and photograph him or members of his family without valid reason (in connection with a newsworthy event

generally would be a valid reason).

2. Embarrass someone publicly by disclosing private facts about him through your published photographs.

3. Publish a person's picture (without permission) in a manner that implies something that is not true.

4. Use the person's picture or name (without permission) for commercial purposes.

There have been very few cases in U.S. court history involving a photographer with invasion of privacy. Except for number one above, invasion of privacy usually deals with how a picture is *used*, not the actual taking of the picture. When in doubt, rely on the Golden Rule.

1. Service photographers, take note. Since non-editorial photographs (ads) are not protected by the blanket copyright, insist that your copyright notice (unless you worked "for hire") be included with your picture.

2. If the purchase order or agreement—or even the check—you receive from your client requires you to sign anything that implies that you're offering more than one-time publishing rights, or states a work-for-hire arrangement, don't sign it. Cross out and initial that portion of the purchase agreement, place your rubber stamp on the margin, send it with the picture (also stamped), and let your client carry the ball from there.

3. Random published photographs, under this system, are arbitrarily requested for deposit by researchers at the Copyright Office. By the way, I haven't heard of any cases where someone was fined $250, or $2,500, for not submitting the requested pictures.

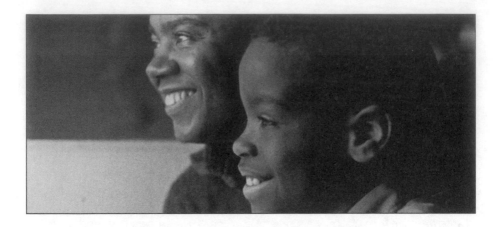

16

Your Stock Photo Business: A Mini Tax Shelter

THE GREAT REBATE

If, as you read this book, you discover you're missing out on a lot of selling opportunities, then I'm accomplishing my purpose. This chapter shows you another significant and far-reaching opportunity: If you work at a "regular" job, you have an annual tax rebate coming to you—when you begin calling your sideline stock photography work a *business*. Your rebate can amount to more than one thousand dollars a year, depending on your household income, the number of dependents you claim, your photography business deductions, and a few other considerations.

What I'm going to say will enable you to buy a new camera every year, new lenses, and new computer equipment or software. Listen carefully.

The Tax Return

I call it the "Tax Rebate System." It's legal, logical, and lovely. It's based on the fact that in our free enterprise system, the government tries to help small businesses get off the ground. Many a flourishing business existing today started as a transfigured hobby—and made it, thanks to the tax allowances offered by the Internal Revenue Service (IRS).

While it may be your legal obligation to pay taxes, it's never your duty to pay more than you owe. In fact, just the opposite is true: European and American courts alike have recognized both an individual's and a corporation's right to minimize taxes owed.

If you follow a few simple IRS-approved guidelines, you'll receive a tax rebate, you'll get your stock photography business off the ground, and the IRS will give you no heat. In fact, the IRS will be on your side; after all, your business will one day be in a position to pay taxes, too. Up to now you may have called your photography a *hobby*, but Uncle Sam will "pay" you as much as one thousand dollars a year or more to call your photography a business.

Declaring your photography as a business is easy. You simply say, "My photography is now a business." That's it. Then at income-tax time, in addition to the regular 1040 tax form, you also fill out a form called Schedule C (Profit or Loss From a Business or Profession).

Tax professionals suggest that you take at least the following steps to solidify "business status" for your photomarketing operation.

1. Give a name or title to your business, and open a separate business checking account and, possibly, a Web site in this name.
2. Have business stationery, business cards, and invoices printed.
3. Ask the IRS for an employer identification number (EIN) if you have employees. It costs you nothing, and it remains your number for as long as your stock photography business is in operation. Ask for Form SS-4, or download the form from *www.irs.gov/forms_pubs/pubs.html*.

These three actions show clear-cut intention for IRS purposes, if any question arises later. Naturally, the IRS doesn't act kindly toward the

Sales Tax

Q: Is there a federal sales tax on the images I sell through the Internet?

A: There is no federal sales tax. Forty-one states, however, have a state sales tax law. If you sell one of your images to someone who lives in your own state, and if your state has a sales tax law, then you'll be required to charge a sales tax to your client. If your customer does not live in your state, you are not required to charge them a sales tax, unless you happen to have an office (it's called "nexus," or "presence") in your customer's own state.

Q: If I'm just "licensing" photos to a client in my own state for publication, am I required to charge a sales tax?

A: Check with the department of taxation in the state where you live.

Q: I heard they are extending an Internet ban on nationwide Internet taxes. Will this affect my stock photo sales?

A: At present, there is no taxing structure for e-commerce sales per se. A 1992 Supreme Court decision blocks states from collecting taxes from catalog, telephone, or online sales unless the retailer has a physical presence in the state.

person who fabricates a business operation and then enjoys the benefits.

Bear in mind that we're not discussing tax evasion. That's against the law. We *are* talking about making legitimate, legal, justified tax deductions. That's your right. It's called *tax avoiding*.[1]

If you're still in doubt, call the toll-free IRS number for your local area. Tax information specialists are on hand to answer questions and send you literature. Most IRS operators are knowledgeable and cooperative, but if the information isn't clear to you, you can call back and get

[1] To avoid is legal, but to evade is illegal. U.S. Supreme Court (*Gregory v. Helvering*, 293 U.S. 465)

a different operator. You also can call and ask for the IRS's Tele-Tax information. It's a recorded information system of 140 topics. You can hear up to three topics on each call you make. The IRS will supply you with local and regional 800 numbers to call. Some of the topics: "Taxpayers Starting a Business" (#583); "Business Expenses" (#535); "Travel, Entertainment, and Gift Expenses" (#463). Finally, if your question doesn't have a simple answer, ask to speak to an advisor or a supervisor.

The World Wide Web can be an excellent resource for personal tax questions. For example, the tax columnist for our newsletter is represented on *www.keen.com* (search the site for Julian Block) and is available for phone and e-mail consultation [(914) 834-3227; julianblock@yahoo.com; *www.photosourcefolio.com/TaxReports.htm*].

You also can ask your personal accountant or tax consultant about these guidelines, but you will need to check the thoroughness of the response. Your questions might require some research—that is, extra work—on the consultant's part. Don't open your checkbook to a tax person who has had little experience in dealing with small businesses in the creative fields.

My own experience has been that many tax consultants concern themselves only with the routine elements of retail businesses, standard business situations, and individuals on a salary—not the individualized self-employment, intellectual property (creative fields) questions that may take extra research and study. With this in mind, ask around your area. Speak with successful freelancers, writers, and other creative persons. Ask them, "Which tax advisor do you use?" You'll eventually come across the name of a tax advisor who is knowledgeable in the area of intellectual properties.

By establishing your business status with the IRS, you're establishing intent to make a profit. In your first five years of operation, you should be able to show a profit for any three years out of five. (In other words, you could go as long as two years before you need to show a profit.) The second five-year period, the third, and so on, are treated in the same manner by the IRS. However, the law doesn't say that the profit must be large (or likewise that a loss from your business must be small). One

dollar of income over expenses is a profit. The five-year period is not a block of time (first five years, second five years), but instead it focuses on the current year plus the prior four years.

However, the record documents that the IRS doesn't come down hard on people who don't show a profit, as long as they show reasonable *intent* to make their business prosper. If you conduct your business in a business-like manner—with evidence of consistent submission of your photographs, self-promotion activity, Internet marketing activity, reasonable record keeping, and use of business letterhead—it's unlikely that you'll be challenged by the IRS, even if you go many years without showing a profit.[2]

A GOVERNMENT INCENTIVE TO START UP YOUR BUSINESS

Even though you might not make a profit your first several years (on paper), you may have more money available to you, in terms of actual cash flow, than if you never attempted to start up your stock photography business. Here's how it works: Say you're making forty thousand dollars a year at your regular job. Your weekly paycheck would be $769.24. However, after taxes and other deductions (about 28 percent), you could take home as little as $558.24—$211.00 less than your gross income. Since your employer has taken taxes out of your wages in advance (withholding tax), you in effect have placed on deposit with the IRS a sum of money (about thirty dollars a day), which, if not owed to the IRS, is returnable to you. (Maybe this is why they originally called it a tax *return*!)

Apart from your regular, salaried job, you are now also a small-business person just starting a new business, and you are going to have a lot of

[2] The IRS could claim that your business is actually a hobby, in which case you can claim deductions only to the amount of actual gross income from your "hobby." You qualify as a bona fide business if you claim business status and conduct your business with regularity, though as a sideline. If, after the first year, the IRS challenges your "intent" to make a profit, within sixty days after receiving an IRS notice to disallow your business deductions, you can file Form 5213, "Election to Postpone Determination," until the end of the five-year period. You can voluntarily file this form within three years after filing your first return as a business. Publication #334, available from the IRS, gives further details.

related expenses. This is where the Schedule C (profit or loss form) and Form 4562 (depreciation and amortization) come in when you make out your tax forms.

Let's say that after your first year, when you have deducted the legal tax deductions listed later in this chapter (film, chemicals, car expense, Internet expense, stationery, travel, home-office expenses, and so on) and enumerated them on your Schedule C form, you find you show a "loss" of four thousand dollars.[3] On your Form 1040, you will deduct this from your regular income of forty thousand dollars, which means your actual net for the year has been thirty-six thousand dollars. Since taxes were taken out on forty thousand dollars and not thirty-six thousand dollars, the government owes you a rebate. (Or if you are self-employed and haven't taken advantage of all of these deductions, it will mean a lower taxable income.) You could receive anywhere from ten to one thousand dollars or more from the U.S. Treasury Department. Nice going.

It might sound almost un-American to suggest that you come out with a loss in your business. Sometimes, however, it's more profitable not to make a profit. The popular newsstand magazine *Money*, which advises how to handle financial matters, was launched by Time Life in 1972: It didn't show a profit until 1981.

Carrybacks

Did your stock photo business have a bad year? Or did you start a new stock photo business in which expenses exceeded receipts?

Either way, a relief provision allows you to use a loss from the *active* operation of a business to recover or lower taxes paid in other years. The

[3] Remember, this is an "academic loss" in that you probably would have had similar photo, car, film, travel, heat, and light expenses (deductions) whether or not you called yourself a *business*. Your wife's (or husband's) expenses are now also deductible if you can show that your spouse's presence on a trip (or at a dinner, seminar, and so on) had a bona fide business purpose (e.g., assisting you in some manner). By establishing yourself as a business, you can now legally deduct these as business expenses from your total income, thus reducing your taxes. When large corporations talk about taking a "paper loss," this is what they're referring to.

key to this opportunity: Internal Revenue Code, Section 172 permits a business that suffers a NOL (net operating loss, which is tax jargon for when expenses exceed income) to carry that loss *back* to earlier years or *forward* to later years.

Even better, a 2002 law change temporarily liberalizes the carryback period for NOLs incurred during 2001 and 2002. The revision extends the carryback for 2001 and 2002 losses to *five* years from two years previously in most situations. The cap remains two years on the carryback for NOLs for 2000 and earlier years, and, as of this writing, for 2003 and later years.

BACKWARD OR FORWARD?

One option for an ailing business is to use the current year's NOL to first offset business profits or other kinds of income in the five previous years, thereby garnering a refund of taxes paid on income for those years. This strategy is particularly advantageous for any outfit with negative earnings that urgently needs cash.

What happens when the NOL is greater than five years' income? Then the "carryforward" rules come into play. Under those rules, you apply the *unused* part of any NOL not employed as in income offset, until used up, against profits or other kinds of income in the *following* twenty years.

A second option is to skip the entire carryback and simply carry forward this year's NOL—provided it's advantageous to do so. This tactic might be preferable when, for instance, your income was taxed at low rates for the previous five years and you expect to be in higher brackets in future years.

Example: Your expectation is that the current year's (2002) bottom line is not going to be black; 1997–2001 were low-income years. By electing to forego any carryback of 2002's NOL, you should come out ahead, assuming you can use up the NOL during the carryforward years that begin in 2003.

GOING THE CARRYBACK ROUTE

Generally (using 2002 as an example), there's a chronological sequence. You must first carry back and deduct 2002's NOL on your 1997 return

to obtain a refund of part or all of 1997's taxes. Only if the NOL *surpasses* 1997's income can the unused part then be carried to your 1998 return. Still have a part of 2002's NOL left? It can then be carried over to your 1999 return, and so forth. However, you'll have the option to use a two-year carryback, if that saves taxes.

Tip: Does it pay to build up 2002's loss and thereby increase the amount of the carryback? In that event, where possible, delay the receipt of income until 2003 and accelerate the payment of deductions from 2003 into 2002.

EXCEPTION TO THE GENERAL RULE

Previously, the carryback already was *three* years for, among others, individuals who suffer casualty losses, and small businesses and farmers with losses incurred in places designated by the president to be disaster areas eligible for federal assistance. Under the revised rules, their carryback becomes five years.

AUDIT ODDS

Before you decide to claim a NOL, check to see whether your returns for the prior years contain any items that might be challenged by the IRS. Filing for a carryback refund doesn't mean that your return for the loss year will be bounced automatically for an examination. Nevertheless, a refund claim might prompt the feds to question not only your return for the loss year, but also look at returns for earlier years.

HELP FROM IRS

For additional information on the complex carryback/carryforward regulations, consult IRS Publication 536, *Net Operating Losses*. To obtain a free copy, telephone (800) TAX-FORM or download it from the IRS Web site *www.irs.gov*.

Your Stock Photography Business Deductions

Now that you have your own business, you can, in addition to taking the normal personal deductions, allow yourself dozens of other deductions

related to your stock photo enterprise. Your film and processing expenses, magazine subscriptions, business-related seminars, office supplies, Internet fees, camera and computer equipment, and even the cost of this book are natural business deductions as long as they aid you in your business goals.

In its own unique fashion, the stock photography business also can require travel to distant places to get your inventory. It generally can't solely be "manufactured" locally. If you require amateur or professional models in your pictures, a percentage of their lodging, meals, and other expenses on trips is deductible if paid by you.

Incidentally, photographers are the only businesspeople who have a "backup" receipt: a photograph, which gives proof to the IRS that the photographer actually traveled to a certain location and *spent the money reported* as deductions (which is the main reason to collect receipts).

As an independent photographer, you're always on the lookout for stock photographs, whether you take them across town or across the country. You have probably called your trips *vacations*. Now that you have a business, portions of the costs of your trips are eligible as deductible business expenses. You will bring back dozens of pictures of interesting mining operations in Colorado, or agricultural observations in Wisconsin, to add to your stock photography collection. You will talk an editor into giving you an assignment in one of the villages or cities along your travel route.

The deductions don't occur just on your three-week summer trip but throughout the year. Your car now becomes your "business transportation." You will keep a daily log of your travel, plus gas, meals, and lodging receipts for IRS verification.[4]

It continues. Since you're a photographer, everyone is a potential customer. Whenever you entertain, at home or elsewhere, keep records of your

[4] Generally speaking, the IRS won't question expenses for meals and lodging if they're within the limits the government allows its own traveling employees. Receipts: No receipt is required by the IRS for expenditures less than seventy-five dollars. (Note: IRS rulings change from time to time. Call your local IRS toll-free number, (800) 424-1040, to validate figures in this chapter.)

guests and define a business relationship or a potential business relationship (as a buyer of your photos, possible model, or possible client). Then you can deduct those expenses, too. Be sure, though, that you *can* show a relationship between your guests and your work to the IRS. If you travel overseas, a log will prove vital in case of an IRS audit. Your *business* time must be 50 percent of your trip or greater, or deductions are severely limited. A good booklet on the subject is IRS Publication 463, "Travel, Entertainment, and Gift Expenses." It's free and available by phoning or writing your local IRS office. The IRS Web site is at *www.irs.gov.*

Let's look at your new business expenses in some detail.

OFFICE IN THE HOME

Because you may use part of your home as the headquarters for your stock photography business, the IRS allows you deductions for the portion of the house that you use to operate your business. However, you cannot use your office-in-the-home expenses to create a net operating loss. If the total of your other business expenses (*not* including home-office expenses) is greater than your income, giving you a loss, that *is* allowable. On the other hand, if your office-in-the-home expenses, when added to the total of your other business expenses, take you over the top to give you a loss, that's *not* allowable. Only that portion of your home-office expense that takes your total of expenses up to the amount of your gross business income can be deducted each year (there is a carry forward provision). If the total of your home-office expenses added to the total of your other business expenses comes to *less* than your gross income, the full amount of your home-office expenses *is* deductible.

Here's how that works. Let's say your stock photography business, operated out of your home, has a gross income (receipts before expenses) of $12,000. Your business incurs home-office expenses of $1,500 (utilities, percent of mortgage interest, roof repairs, and so on). Your other normal business expenses, such as office supplies, postage, travel, and film, total $11,500. Since your gross income was $12,000,

326 Sell & Re-Sell Your Photos

you can use only $500 of your $1,500 office-in-the-home expenses as a deduction. However, you may carry forward the disallowed $1,000 to subsequent tax years; these carried-forward home-office expenses, though, are subject to the same restriction each subsequent year—i.e., they are *not* allowable if the addition of their total creates a net loss from the business activity.

The room(s) in your home where you conduct your photomarketing business must be used exclusively and regularly for your photomarketing operations. The IRS won't approve the room as a deduction if it's also used as a sewing room or a part-time recreation room or if it's part of your living room. If you've made a room or large closet into a darkroom, consider that room also as tax-deductible. Measure the square footage of your home (don't include the garage unless it's heated or air conditioned), and then measure the square footage of your working space. Divide the latter by the former, and you'll determine what portion of your home is used for "profit-making activity." For example, if your working area is a fourteen-by-eleven-foot room (used exclusively and regularly for your photomarketing business), and the total square footage of your home is 1,232 square feet, you are using one-eighth of your home for business.

"Business Use of Your Home" is the title of IRS Publication 587. It's a clear explanation of what you can and cannot deduct. Also check out Booklet 529, "Miscellaneous Deductions." Write, log on, or phone the IRS for a free copy, (800) TAX-FORM.

Before you established your photography business, you were unable to use the expenditures in the following list as tax deductions. However, now that you're engaged in an intent-to-make-a-profit activity, you may deduct one-eighth (or 50 percent or 100 percent—whatever your particular setup may be) of these expenses. Get advice from your tax professional as to which of your home deductions would fall under "capital improvement," or normal repair and upkeep expenses. List these deductions on Schedule C when computing your taxable income (which includes the income from your full-time employment).

HOME

Home repairs; real estate insurance; carpentry; plumbing; masonry; electrical work; roofing; heat; fuel; depreciation; rent or mortgage payment; water; air-conditioning; maintenance; refuse collection; painting; decorating; lighting; fire losses; sprinkler system; burglar alarm system.

AUTO USE

The deductions don't end with home expenses. You will use your car to travel on assignments, research stock photo possibilities, deliver packages to the post office, and so on. If you have two cars, designate one your business car, and use it for that purpose. Note the mileage at the beginning of the year and on December 31. No matter how many cars you have, keep a perfect record of their use (keep a diary in the glove compartment), and record trips and expenditures related to transportation for your business and professional activities. You also can deduct a percentage of the maintenance and repair of your car equivalent to the percentage of time it's used for business. Some typical deductible expenses:

Insurance; registration; gas, oil, and fluids; lubrication; car washes; rental; waxing; cell phone; accessories; CB radio; tires; snow tires; garaging; tolls; parking fees; repairs; depreciation; vehicle license fees.

TRAVEL EXPENSES

To make your stock photographs, you may have to travel far and wide—in which case these expenditures are legal tax deductions:

Bus; train; boat; airplane; equipment; luggage; taxi; hotel; laptop; motel; meals; passport fee; business tickets.

ENTERTAINMENT[5]

You'll have all the usual business expenses, including taking clients out to lunch. If the meal is business related, 50 percent is deductible. Expenses include: meals; theater; tickets to miscellaneous events; nightclubs.

[5] Must be carefully documented.

ADVERTISING/PROMOTION

Getting yourself known is deductible: design work; graphics work; copywriting; typesetting; mailers; postcards; flyers; CD-ROMs; Web site development and maintenance fees; business gifts; seasonal cards (Christmas, Hanukkah, and so on); leaflets; brochures; booklets; catalogs; business cards; magazine ads; newspaper ads; telephone (yellow pages) ads; radio ads; TV ads; matchbooks; calendars; portfolio costs; trade shows; conventions; donations

PHOTO-RELATED ITEMS

Those expensive lenses and cameras are now deductible. Document the following carefully: camera(s); lenses; accessories; disks; film; printing; processing; lights; model fees; props; costumes; instruction manuals.

PRINTING

It's an important expenditure for you, and it's deductible (see Advertising/ Promotion). Be sure to deduct the following items: business stationery (envelopes, letterhead, cards, labels, and so on); mailers; books; sell sheets; ads; catalogs; announcements; tearsheet reproductions; office forms.

BUSINESS EDUCATION, SELF-IMPROVEMENT, AND MEMBERSHIPS

If they will help you make a business profit, the IRS says the following are deductible: subscriptions (business related); club memberships; market services; business development; dues to professional organizations; seminars; books and references; cassettes; directories; courses.

OFFICE EQUIPMENT AND SUPPLIES[6]

"Little" expenditures in this area add up. Be sure to keep track of the following: computer components (such as extra memory, cables, video accelerator card, and so on); CD-ROMs (blank and professionally pressed demos); insurance; freight charges; file cabinets; pencils, pens, ink; paper;

[6] Depreciate major purchases.

software; file folders; directories; cleaning service; printers; independent contractors; paper clips, staples, erasers, correction fluid; blotters, pads; mailing envelopes; rubber bands; return labels; loose-leaf notebooks; photocopier; fax machine; equipment lease; refunds to customers; computer supplies; diaries; postage stamps; International Reply Coupons; bookkeeping supplies; calendars; briefcase; delivery charges; backup tapes; uninterruptible power supply (UPS).

EXTRA DEDUCTIONS

A good test for any business deduction is to ask yourself, "If I weren't in business, would I have this expense?" Include the following: wages to employees; safe-deposit box; accounting fees; self-publishing expenses; legal fees; postage meter rental; permits, licenses, and business fees; maintenance agreements; mailing lists; business-related tools (craft knives, and so on); postage; telephone calls; telegrams; R&D (research and development); equipment repairs (furniture, computer, and so on); product displays; professional fees; bad debts/bounced checks; interest expense; commissions; consultants; contract labor fees.

Keep records of your expenses. (An excellent book on keeping personal tax records is the J.K. Lasser *Tax Series www.jklasser.com* published by Simon & Schuster, New York.) Gather your tax records together at tax time, and list these expenses on Schedule C. These legally deductible expenses are bound to reduce your income received from your regular occupation, as listed on your Form 1040. The result will be a rebate for you. Or, if you're self-employed, you'll have less taxable income or a loss.

DEPRECIATION

Depreciation allows businesses to replace their business equipment by offering them time-released write-offs over a period of years. For photography equipment, the time period is usually seven years. For your computer or car, it's five years. However, check with your tax advisor or the IRS, as these provisions change from time to time.

"Investment tax credit" is another incentive *sometimes* offered by our

tax laws to stimulate the economy. Depending on current IRS tax regulations, the government encourages spending by giving you a tax credit incentive on the purchase of major items for your business. Check with your tax advisor.

THE S CORPORATION

Most stock photographers set up their businesses as sole proprietorships. The numbers work out best for them. Some find advantage in setting up as an S corporation.

As an S corporation (formally called a Sub Chapter S Corporation), you do not operate as a *self-employed* sole proprietor or partner. Your business income is not subject to self-employment (Social Security) tax. By forming an S Corporation, you legally change the nature of your photomarketing income. By making the Small Business Corporation Election (on Form 2553), you eliminate corporate taxes on the corporate income. A newly formed S corporation never pays income tax. Instead, the net income of the corporation is reported on each stockholder's (or "owner's") individual tax return(s) (on a Schedule E). The owners pay the income tax on their corporate S income, but no Social Security tax. With the Social Security tax rate continually going up, this can represent a considerable tax savings. When you're an employee of the S corporation, your salary, of course, is subject to the usual employment taxes.

Almost all forms of business have some disadvantages, and the S corporation is not without its drawbacks. There are legal setup costs and annual costs to maintain your corporate status. Once you check with your tax advisor and gauge your financial situation in relation to the S corporation, you'll know if this business form can be advantageous to you.

ADDITIONAL TAX AVOIDANCES

Other tax breaks you will want to consider (depending on your circumstances) are Credit for Child Care Expenses (Form 2441), Moving Expense Adjustment (Form 3903) and the tax-sheltered retirement plans, such as a Roth IRA, Keogh Plan, or SEP (Simplified Employee Plan).

For a detailed discussion of tax-saving strategies, I recommend Julian Block's *Tax Avoidance Secrets*. This title is available directly from the author: 3 Washington Square, Larchmont, New York 10538-2032, (914) 834-3227, e-mail: julianblock@yahoo.com, *www.photosourcefolio.com/books tore.htm#0887231128, julianblock@yahoo.com*. Block is an attorney and a nationally syndicated columnist.

Also, two other provisions might result in the return of money to you.

1. *Earned Income Credit*. This credit is available to certain low-income families. Information on how to apply for this is in the filing instructions that accompany Form 1040.

2. On the *state level*, about half the states offer a *Homestead Tax Credit* (in Wisconsin, for example, use Schedule H, Homestead Claim). This is a rebate on your property tax if you're in a low-income tax bracket. Other states, such as California, have a "Home Owners Exemption" that will save on your property taxes, regardless of income bracket. If you rent, you also receive a proportionate refund.

As noted earlier, to be recognized as a bona fide pro in the eyes of the IRS, you have to, in good faith, be operating your business with regularity. As I mention elsewhere in this chapter, the IRS will provide you with some excellent free booklets on operating professionally: 583 and 552 deal with record keeping, 587 is on using your home for your business, 917 deals with business use of a car, and 334 deals with small-business taxes. Ask for "Your Business Tax Kit," written for anyone thinking about starting a business.

Here's some recommended reading: *Home Office Magazine; Volunteer Lawyers for the Arts Directory; Legal Handbook for Photographers*, by Bert P. Krages; *Legal Guide for the Visual Artist*, by Tad Crawford; *The Legal Guide for Starting And Running a Business, by Fred Steingold*. Most of these are available at Amazon.com.

Note: The information in this chapter can be helpful in getting your stock photography business off the ground. It will allow you to reinvest

money into your business by allowing you to keep more of the money you earn.

I assume you will take this information and apply it in an honest manner. To make sure you don't put yourself in a position to get heat from the IRS, always plan your deduction activities with the IRS in mind. In other words, cover your bases *before* you go on that trip, plan that business entertainment, or make that photo-related purchase. Ask yourself, "Can I satisfy IRS substantiation requirements?" "Does this proposed tax deduction meet current IRS guidelines?" When in doubt, give the IRS toll-free number a call: (800) 424-1040. For recorded tax information, call (800) 554-4477; for tax forms, call (800) 424-3676. Also check out their Web site at *www.irs.gov*. If you use this simple procedure, you'll have few problems with the IRS because you have followed the rules of the IRS game. You beat the system with your own system. The percentages are actually heavily against your photomarketing enterprise ever being audited.

Helpful IRS Publications

PUBLICATION NUMBER	TOPICS	IRS CODE
334	Home Office	162
463	Travel, Telephone, Entertainment	162 and 274
560	SEP and Keogh Plans	162 and 401
587	Home Office	280A

17

Stock Photography in the Electronic Age

"It'll save you a day a week!" proclaims the ad in the computer magazine. Hmm . . . Does that mean I can spend every Friday in the hammock? Are computers good or bad for the stock photographer? Well, they are good *and* bad. They can save you time and cost you time. They can save you money and cost you money. They can save you frustration and cause you frustration.

Time-savers they are, but like any efficient tools designed to save labor, they can end up increasing labor.

As you read this chapter, I hope it becomes apparent that I'm all for computers. I may sound like I'm challenging them, but I'm actually challenging *you* to exercise restraint and moderation when it comes to investing in them, utilizing them, and proselytizing about them.

If I had to do it over, yes, I would invest in a computer but my business isn't *your* business. You might need one or fifteen or none. Keep this in

mind when I, or any other person who talks about computers, start waxing gloriously about them.

In this chapter, I'll include comments from several stock photographers who have been kind enough to give me their input through correspondence, online chat sessions, seminars, phone calls, and surveys. I believe their thoughts and advice will help give you a better outlook on the computer as it affects you, the editorial stock photographer.

Which Computer to Buy?

Buying a computer is like driving into a new community and asking the first person you see to recommend a good restaurant. If that person likes Italian food, she'll probably say, "Olive Garden!" The next person you ask (preferring seafood) will say, "The Fish House!" and a third person might say, "McDonald's!" You are at the mercy of their tastes, not yours. Of course, if the person's brother-in-law owns a steak house, guess what he's going to recommend?

As photographers, most of us have learned that camera store salespeople frequently know little about the product they're selling. You'll find the same can be true in computer retailing. The last person on the list to talk to about a computer is the computer salesperson. That's not to say all computer salespersons lack sufficient knowledge of the topic, just that most (especially in the typical retail electronics store) seem to be.

Here are six popular tidbits of advice you should take with a grain of salt:

1. **Buy software first.** (Software is the stuff that tells your computer what to do.) If you're a neophyte, you're supposed to research the software, and then buy the computer that fits the software.

2. **Buy a name-brand computer.** Leaders in the field at this writing are Dell, IBM, Hewlett-Packard, and Gateway. Macintosh and Mac clones are popular with designers and graphic artists but are losing ground to IBM-compatible computers (otherwise known as "PCs") running the Windows operating system. In any case, you'll easily find a machine under nine hundred dollars with a 1.2GHz Intel

Pentium® processor or equivalent, 128MB or more of RAM (computer memory), a 20-40GB hard disk (storage space for your programs and data), a sound card, a CD-ROM/DVD, speakers, a 56K modem, and a sixteen- or seventeen-inch monitor. Price wars in the computer business are constant. You would do well to shop around at the computer superstores, including the online stores for Dell *www.dell.com* and Gateway *www.gateway.com.*

One final note: Used computers generally are not a good deal. By the time the current owner wants to replace it with a newer model, the old model is too old to properly run the current crop of software (unless you have a friend who's a computer techie and likes to mess around with older computers).

3. **Buy what your friends are using.** After all, if you're new at this, it would be nice to know that a friend could come to the rescue.

4. **Buy the power.** After you've done your homework, buy the most powerful machine your pockethook can afford.

5. **Buy for service.** If your computer breaks down, and it usually will at crucial times, where will you turn for repair?

6. **Buy nothing.** Wait till the prices come down. What was selling for two thousand two years ago is selling for half that price or less today.

Commenting on these six points:

1. It sounds good to say, "Buy software first," but throw this one out. Only computer-wise people buy software first, and if you were such a person, you wouldn't be buying your first computer, nor would you be reading this chapter. Which software to buy? Get the simple version. In many cases, all that you need to start productively using your new computer, such as word processing software and basic image-editing software, will be included with the computer. The manual will be small, if there is any (generally they're included on the CD-ROM), and the program will be inexpensive. By the way, if you buy expensive software (more than $250), you're probably taking on more than you can handle at this point. The learning curve will be steep. Avoid the temptation to "borrow" soft-

ware from your neighbor. Not only is that illegal (remember copyright?), but the money you pay for legitimate software helps develop new and improved versions. In addition, be *very* wary of downloading software from the Internet. A lot of good freeware (you never have to pay for it) and shareware (you pay for it if you like it) programs are out there, but a lot of bogus stuff is out there as well. There's also the ever-present threat of computer viruses.

2. The reason for buying a name brand of anything is to ensure that service and parts will be available to you. Today, though, the interiors of computers are so generic and interchangeable that most hardware problems can be solved quickly (not counting the time to *find* the problem!) with some basic computer knowledge, no matter what type of desktop computer you have. However, there's a lot to be said for name brands that include one-year on-site repair and two additional years of parts-only service (and often you can upgrade to three years on-site service for little additional cash). Additionally, these are frequently offered as "package deals" with color printers and/or rebates, which further increases the value and decreases your cost. Avoid purchasing any computer that comes with a big "discount" *if* you sign up for one year (or more) with a specific Internet service provider. You can get better deals on Internet access yourself, and if you later decide you don't like the packaged Internet service, you'll pay a steep penalty for early termination. (I've had many a photographer tell me about getting a great computer deal at their local computer shop, only to find out a year or so later that the shop has gone out of business, and their support along with it.) Should you buy a laptop? Yes, if you spend a lot of time away from headquarters. However, most editorial stock photographers spend a lot of time at base camp, where a desktop computer with a large monitor is more convenient and practical. Finally, there's also computer leasing, a practical option in some cases.

3. Should you let friends influence your buying? Yes, if they know something about software problems and (minor) computer repair. They'll show you how things work and save you hours of trying to figure out the manual. As my photographer friend Lou Jacobs Jr. says, "The manual writers are

experts, and they assume far too much regarding the ability of the novice user." Buy what your friends own so you can capitalize on their know-how. Put the law of probability on your side. For example, if ten people in your community have PCs and no one has a Mac, who will come to your rescue if your Mac breaks down or you can't figure something out? If you join the local ranks with a PC, you'll probably get answers, support, and condolences from your cohorts. A friend in need But, at the same time, proceed cautiously. Beware of "technolust," as photo columnist and Web site development consultant David Arnold (david@arnoldrutman) calls it. This is a disease that afflicts many computer owners. These loyalists believe that their particular hardware/software is the *one and only*. It may be—for them. If you're buying a computer, recognize that you won't get a balanced opinion from this breed.

4. Should you buy the biggest and the best? If you were a serious musician, you'd want to perform on the best musical instrument your pocketbook could afford. Look for the best that fits your budget. Rather than buying the one with the fastest processor, you'll get improved performance if you get a little slower processor and put that "extra" money toward more memory. Keep in mind that if you buy in the fast lane, you're preparing for the future and you'll be able to capitalize on new software that requires ever-faster processors and more memory (RAM). Your accountant will tell you that a state-of-the-art computer that you can amortize over five years is going to be cheaper (in the long run) than one that becomes obsolete in three years. Keep in mind, also, that many computer systems can easily be expanded later, as you grow in size, need, and wisdom. Buy smart. Don't buy a Boeing 747 if a Piper Cub will do (and the latter *will* do if you have less than five thousand pictures and intend to use it mostly for correspondence, cataloging your images, e-mailing, and surfing the Internet). However, if you intend to enter the world of digital photography, you'll need (or wish you had) that 747. The question is how serious you are about your photomarketing. Definitely *buy big* if you are *thinking big* about your photomarketing, but don't become computer-rich and penny-poor. You'll know where to draw the line.

5. Service to your machine is essential, yes. However, unless you buy something that you have to put together yourself, or you buy a second-hand computer that went out of production in 1999, service won't be a big problem. Most horror stories about computer breakdowns result from an act of God or from solvable human error like failing to regularly back up your data, contracting a computer virus because you thought fifty dollars for antivirus software was extravagant, or seeing no need to buy a surge protector. Unlike the age we've grown up in, in which machinery equals moving parts, computers are different animals. Except for the hard drives and cooling fans, there are few moving parts, hence less chance for mechanical breakdowns. Help hot lines are available for most major-brand computers (another reason for buying name-brand stuff), and you can often find peer-to-peer help on the Internet.

I am amazed that my original home-built IBM look-alikes (circa 1985) have kept up with their newer compatriots. We clean the innards with computer air spray and replace the boards ourselves. For major repairs, such as a zap to the boards from a lightning strike because someone left the modem attached to the phone line during an electrical storm, we truck an ailing computer over to Minneapolis (an hour and a half away), where it's hospitalized for three days. Knowledge of how a computer works is not necessary.

6. Finally, don't wait. Do your homework, yes. Read *Consumer Reports*, check out the vendors on the Internet or at computer shows, join a computer club, read the computer magazines, and for online help, visit the PhotoSource International Kracker Barrel *www.photosource.com/board*.

Don't forget the neighborhood teenagers. You'll be amazed at their computer knowledge. At some point, though, take the plunge. You may make some wrong decisions, yes, but as photographer/author Fredrik Bodin says, "The computerized photographers will leave you far behind if you don't make the leap." Waiting for the price to come down or the machinery to improve gets you "behinder and behinder." By getting your computer now, what you gain in doubling your efficiency far outstrips what you might have gained in discount dollars by waiting. If you jump

in now, you'll get a head start on learning the rudiments of imaging, desktop publishing, cataloging, retrieving, using the Internet, and e-mail. You'll make it easier for yourself to communicate with photobuyers (e-mail), and you'll be ready as online retrieval of photos becomes mainstream for the photobuyers you deal with. Lou Jacobs Jr., sums it up: "My computer is not a luxury, it's a necessity, even before I owned it." Your local library or bookstore will have many instructional computer books, some of which will include chapters on buying a computer. You can also check out Stock Photography 101 on the Internet *www.photosourc e.com/101*, and our online bookstore *www.photosourcefolio.com/bookstore*. Many local libraries provide free computer use to members, to search the Web or learn word processing. Your local community college or technical college will likely offer inexpensive classes.

Cataloging and Retrieving Your Pictures

You can store your photo information—descriptions, file numbers, sales history, and locations—on your computer in a *database*. You can buy "off-the-shelf" database programs and customize them for storing your photos, using the built-in wizards and templates. You also can buy custom software that's specifically designed for stock photographers.

Beware of software that files images sequentially, starting at 000001 and upward. You'll have to physically locate them in that order. Instead, choose software that will allow you to group your slides according to your PS/A. Then when a photobuyer calls, you'll have them in one location (except those that are cross-referenced).

If you buy a catalog/retrieval program and are satisfied, please e-mail me about it (info@photosource.com) if you've cataloged more than five thousand pictures. With fewer than five thousand photos, you don't need a computer system; the inexpensive device between your ears can handle that amount. Help is needed, though, for ten thousand to fifty thousand or more pictures.

If you are just starting out or starting over, you can use $3'' \times 5''$ file cards or a loose-leaf notebook system to locate and cross-reference a

picture (see chapter thirteen). There's no machine to turn on, no skills or training involved, and no manual to refer to.

If you do have a compulsion to record data regarding your slides on your computer, do it like most stock agencies do: Record basic information about each slide into a computer database, usually when the slide is initially sent on a sale (this justifies the cost of entering the information). If the agency wants a caption printed out to track where the slide is or to search for *very general* (the issue here) categories, most simple database programs will do. For a review of three popular programs for stock photographers that appeared in four issues of our newsletter, *PhotoStockNotes*, in 2002, send an SASE with three first-class stamps affixed to 1910 Thirty-fifth Road, Osceola, Wisconsin 54020. I'll send you those four issues.

Stock photographer Lewis Kemper, who uses the InView and Stock-View software *www.hindsightltd.com*, says, "Requests from photo editors are getting more and more specific nowadays. Recently an editor wanted a white-tailed deer doing something specific. I set the program to search through my images of deer. In the past, finding those transparencies would have consisted of viewing several dozen slide pages on the light table. These programs save on the eyesight."

Kemper likes the "clairvoyance" feature of StockView. "If I start my search, I only have to type in the first few characters of my search. As with a voice mail search for a person's extension number, the program will activate once it makes a match, even with only three of four initial characters. The program then merges the information into my invoice, letter, or other correspondence. It's great!"

CD-ROMs

Royalty-free (RF) images are what most often come to mind when people talk about photo CDs. You'll want to seriously research this area before deciding whether or not you want to be part of RF. RF through the major agencies can be profitable for the photographer in the short run.

Catalogs on CD are an entirely different matter, and one that works

well. Low-resolution images that are easy for a photobuyer to access can be a great marketing tool.

Should you produce your own custom CD-ROM? Maybe. Photobuyers continue to embrace new technology, however slowly, but most are not yet convinced that the CD-ROM medium can make their jobs easier. The problem is not just apprehension about the learning curve or the unpredictable quality of the images (from a photobuyer's viewpoint), but also the interoperability of the technology. Without workable standards, buyers often become frustrated trying to view images on their computers and office networks.

Many stock agencies, large and small, as well as individual stock photographers, have produced their own CD-ROMs. However, as one art director at a publishing house told me, "When we open the mail, we stand over a wastebasket. If a CD-ROM sampler comes in the mail, unless it's from a major stock photo supplier, the disc gets trashed."

Establish Your Own CD-ROM Service

Here's the situation: Photo editors periodically send out "want lists" of specific photos, traditionally through postal mail, fax, or e-mail, and sometimes (rarely) by phone.

Give photobuyers your Web address if you have one. It puts you a notch above the competition. With a Web site, you'll be perceived as an important player in the industry. Some photo editors are starting to send their want lists to photo suppliers' Web site addresses, and they're requesting that suppliers (usually, at this point in time, midsize to large photo agencies) send submissions in digitized form on a CD-ROM or via broadband (high-speed) Internet connections.

This system helps the photobuyer in four ways.

1. It eliminates the need for buyers to do their own searches; the supplier handles the search in the traditional way.
2. It eliminates the liability and labor involved in receiving and returning original images.

3. Buyers can conveniently load high-resolution images into their own databases for later retrieval.
4. Buyers can load pictures into a page layout for preview by a photo editor, client, or designer.

Although few photo editors presently use this system, this promises to be a practical application of the Internet that could prove useful to individual editorial stock photographers.

Can you just put your images in a searchable file on your Web site, and let the buyers do the initial search? No. Editorial photo editors prefer that you narrow the search for them, and send them a selection in a format that they can use immediately.

Stock photographer Bill Wittman has broken from the traditional method of dealing with photobuyers and switched to a method he believes has come of age. "For my approach, I always make prearrangements with the publishers before I send anything off. Then I send high-res [high-resolution] CD submissions and printouts of relevant photos in a CD booklet.

"The cost of shipping 125-150 high-res JPEG images on a CD is negligible vs. sending prints or dupe slides—not to mention avoiding the potential risk of lost or destroyed images.

"It is my experience that most of the publishers I work with now prefer to receive high-res digital submissions on CD with accompanying thumbnail printouts, which they can view first before opening the CD. A photographer may want to initially provide a low-res CD because it will give them a bit more control in knowing a picture's use. If a high-res picture is later requested, it will signal that the buyer likely intends to use the image.

"Most publications I have worked with are happy to use digital images provided they are at least 300 dpi in the requested size. Of course, for Web usage, a low-res image of 300K is suitable, but for print reproduction, the 18MB PhotoCD file is usually all that is ever necessary—even for a full page."

The question always comes up, "Should I let the photobuyer keep the images in-house in their central art library?"

Bill Wittman says, "Yes, I find that the publishers I work with are happy to have the prescanned images at hand. They act as an extension of my photo library. On the publisher's part, they are very pleased not to be at liability while evaluating or using the images. In addition they do not have the cost and time-consuming responsibilities of reassembling a large submission of originals for return. Another advantage for them is that they can speedily access my in-house file if they have a tight deadline coming up. They can use the images as comps and easily position a scanned image into their layout, helping them deal with decisions and tight deadlines.

"I believe digital/CD submission is much more than a future wave. With most of the current photobuyers I deal with, this is the current preferred process. Albeit, the last-century approach of sending original prints or slides is still acceptable—at least for a little while longer. I'm aiming my marketing efforts toward those buyers who understand the advantages of the digital approach to accepting images.

"Several buyers have told me that they have three tiers of suppliers. The first group is about five or six photographers. These have a proven track record of reliability and depth of relevant and fresh subjects. This group shares about 60 to 70 percent of the work. The second tier is about ten to twelve photographers. Some in this group do good work but are not consistent in regularly submitting relevant photos. A few in this group are unproven but appear to have the potential to eventually become first tier. They receive about 25 percent of the work. The last group, fifteen to twenty photographers, may very well be good photographers but most of their material is not relevant to the buyer's needs, or their pictures may be outdated. Consequently, their photos are accepted only occasionally.

"Buyers have told me it is their consistent experience that many photographers initially promise to be first-tier suppliers but fade away when they don't achieve immediate big sales. To win over a new photobuyer, I have learned that 'Rome wasn't built in a day.' You have to hang in

there and give prompt service to that photobuyer. It pays to be ever true . . . in good times and in bad.

"I have found a practical strategy for me is to set my initial expectations to aim for the second tier and build gradually to the first tier. If the client and I are 'right' for each other that usually happens within a year."

To set up your CD-ROM service (review chapter seven to refresh yourself on how to deal with photobuyers), here's what you need to do.

Library

☐ Start with a minimum base of ten thousand images.

Production

☐ Invest in a 4000 dpi scanner (Nikon, Canon, and Minolta scanners come highly recommended), and a CD writer. Scanners and CD-ROM drives have come down in price. If you don't feel you can produce professional-quality scans for your photobuyer, you can always farm out this task to a local service bureau.

Web Site

☐ Since hypertext communication has led the buyer to you, there's no need to develop an elaborate CD-ROM delivery site. Convincing text and miniature graphics on your home page are sufficient. Do it yourself—but unless you're an accomplished designer, get help.

Package Design

☐ First impressions count, and often we don't get second chances. Make your delivery materials top-notch. Don't skimp. Invest in quality labels, delivery memos, promotion sheets, business cards, and mailing cartons. Full-color digital printing, such as Indigo, can produce beautiful sell sheets and CD-ROM package designs comparable to conventional offset lithography, with one important advantage: Your production quantity can be as low as ten. (That's *ten*, not ten thousand.)

Eventually, many photo editors in the magazine and book publishing industry will be convinced that electronic searching is the optimum photo-acquisition method. Since their searches are so frequently for spe-

cific images, they will shun general-interest sites and target their searches to special-interest sites.

NARROW YOUR FOCUS Working backward, then, it's important that you establish a site that is highly specialized. Or join an already-established site, such as *www.photosource.com/bank*, and make your pages specialized. Remember, you're no longer working just locally, but worldwide. When you widen your customer base, you can narrow your product focus.

Electronic searching on the Internet will not be an overnight phenomenon. If you jump in now, you can expect some frustration, but you also can expect an education in the right direction.

Of course you can accomplish this whole scenario with conventional communication: phone, fax and FedEx. However, by reaching photo editors through your Web site, you're sure to collect an important number of computer-literate photo editors. When the stock photo industry reaches electronic maturity, your preparation will have you set to fly.

Several programs are now available that can be put to use by the photographer with a computer. Keep in mind that most of these programs have limited track records (there are some exceptions).

The following periodicals have featured compilations of computer software and have assessed their potential worth to the photographer: *Photo District News www.pdnonline.com*, *Outdoor Photographer* (various issues) *www.outdoorphotographer.com*, *PhotoAIM www.photoaim.com*.

The Three Fs: Fone, Fax, and FedEx

News of President Abraham Lincoln's initial election success took six weeks by horseback to reach the hinterlands. A century later, news can reach citizens anywhere in the world in under five seconds—via computer. A modem attached to your computer enables you to receive information and pictures via the Internet. You can then print the information, or you can store it to disk for later viewing.

This speed is important to the editorial stock photographer. The former postal *information float*, the lapsed time between when a photo editor

sent a photo request list by mail and when it reached the photographer's mailbox, amounted to five or six days. A generation ago, this meant that stock photographers who were in the same city as a photo editor had an advantage. The photographer was on the scene to respond to a phone request, with same-day service.

Today, a combination of the Internet, fax, and express delivery services enables outlying editorial stock photographers to be just as valuable a resource to photobuyers as the stock photographer down the street. If you have a computer and a modem or high-speed access (DSL, cable, satellite, and so on), you're no longer at the mercy of the postal information float.

In addition, assignment and travel information, as well as time-sensitive business tips, are available to you on a variety of Web sites, on an instant-summons basis. This gives you a substantial business edge.

Internet: The Electronic Post Office

Mini-electronic post offices sprung up in the early seventies—Compu-Serve, The Source, GEnie, Prodigy, America Online (AOL), Microsoft Network (MSN), WorldNet, NewsNet, and MCI Mail, to name a few. Some have folded (NewsNet, Prodigy), others have merged (Compu-Serve and AOL), and some have been reincarnated for other purposes (GEnie). They mostly were proprietary, for-fee systems that offered discussion groups (forums) and e-mailing capability. Today, all that they offered—and much more—is available on the Internet.

Typically, you'll pay a flat rate of about twenty-one dollars per month to an Internet service provider (ISP) for unlimited dial-up modem access. Higher speeds, such as DSL and cable modems, will cost more. Some service providers have cheaper rates for restricted-time access plans. Some services are free *www.juno.com*, although you'll end up paying for them by all the go-along-with-the-deal advertisements cluttering your screen and interrupting your work.

The Internet started in the 1960s as a text-based information exchange for governments, universities, and research facilities. In the early 1990s,

a new graphic medium called the World Wide Web (WWW) evolved. The Web makes pictures and drawings available to users worldwide. The Web allows you to receive and deliver images and to establish a "home page" and link with other like-minded individuals. You'll find more about this later.

And, yes, all is not free even on the Internet. For example, many major publications such as *The Wall Street Journal, Los Angeles Times,* and *Photo District News* have electronic editions requiring subscriptions if you want to read all their news.

While online, you can access millions of corporate and other Web sites for information (Nikon, Pentax, Microtek, Dell, Hewlett Packard, and so on), seek out photobuyers via their company Web sites, and participate in *newsgroups* available in your interest areas. Newsgroups are like party lines using e-mail. They're generally unmoderated, meaning no one is really watching to help keep the discussions sane and on-topic.

One *moderated* newsgroup that can be counted on to stay on track is Joel Day's STOCKPHOTO forum (he communicates from Australia). Subjects ranging from camera techniques to computer graphics are discussed. It's the oldest Web stock photo discussion group I know of, and it garners broad participation, perhaps because Joel keeps the reins tight and guards visitors from going beyond the scope of stock photography. You can sign up at his Web site, *www.stockphoto.net.* For a list of photo-related discussion groups on the Internet (they range from Leica cameras, obsolete silver processes, and photojournalism, to underwater photography, image databases, and Pentax cameras), try any search engine or contact your ISP to find out how to access the newsgroups they offer.

Our own PhotoSource International market letters (*PhotoDaily* and *PhotoLetter*) and newsletters (*PhotoStockNotes* and *PhotoStockNotes/Plus*) are examples of the kinds of information available online. Other online services similar to our market letters are Visual Support/Photonet *www.vsii.com* and AG Editions *www.agpix.com.*

You also can sign up for free e-mail accounts with services such as MSN Hotmail *www.hotmail.com,* Yahoo *www.yahoo.com,* MailandNews

www.mailandnews.com, Juno *www.juno.com*, and many more. These services are especially useful if you're traveling and need to go on online.

Online Delivery

Commercial agencies, starting with PNI (Picture Network International) and IPX (The Photo Exchange—no longer in business), and later with Corbis, Getty Communications, and Infosafe's Design Palette, have pioneered the concept of online delivery of stock photos. It works like this. The database at the online agency contains several thousand images, which have been supplied by stock agencies and individual photographers. Photobuyers, looking for commercial stock photos, search the database using their modems and computers. When they find the pictures they need, negotiations are made and the selected images are delivered, usually on CD-ROM by FedEx next day, or, in some cases, are downloaded to the buyer's computer.

This concept is gaining ground rapidly, but there are still some hurdles.

Buyers. The average editorial stock photography buyer is not convinced that online delivery of quality digital scans is a significant improvement over the way photos are presently acquired.

Hardware. The equipment and training cost to get operational to retrieve pictures online has not convinced management that the ROI (Return on Investment) is there. One exception: daily newspapers and their photographers. Says Jack Stokes of the Associated Press, "We now have our whole operation using digital cameras on a day-to-day basis."

Quality. Unless you have the luxury of having top-of-the-line equipment, the quality necessary for reproduction isn't there with digital. Scanned film continues to be the medium of choice for most photobuyers.

Storage. Great strides have been made in digital storage, from improved compression algorithms, supercapacity hard disks, and DVD jukeboxes. Still, images are space-hungry beasts. Since we talk with ten to twenty photobuyers a day at PhotoSource Inter-

national, we will be the first to know when online retrieval and delivery of pictures becomes the workable system of choice for editorial stock photographers. In the meantime, the Internet remains an excellent highway for *communicating* (with words) and advertising, within our industry.

One word of caution: Information overload is a hazard on the Internet, just as it is in the Sunday newspaper, on cable TV, and in your mailbox. If you don't need the information, the delivery method is unimportant, whether it be over the Internet or via homing pigeons.

No longer is it necessary to live within shouting range of the large media centers. As long as the Internet is available (via telephone line, satellite, cable, or other means), a stock photographer will be in touch whether she lives in a high mountain cabin in Wyoming or a high-rise in Atlanta.

The Fax

The facsimile machine has become an indispensable office machine for photographers and photobuyers. This device is a good tool for transmitting text and work-print copies of photos over the telephone lines with ease. No programming, no tie-ups, and no need to become "fax literate"—you already are.

You can buy a quality plain-vanilla fax for less than one hundred dollars at your local department store or discount warehouse. Once you get it operating, you'll wonder how you ever managed without one. There's no need to get a dedicated phone line. A "box" can be plugged between your phone and your fax machine to direct the incoming call to one of four areas: your fax, your computer, your answering machine, or your voice line. (The "box" recognizes the different signals produced by an incoming fax vs. a modem call.) The fancier fax machines often have this feature built-in. If you keep your computer on at all times, you could install a fax/modem board in it at half the cost of a stand-alone fax. The only disadvantage is you'd need to buy a scanner to transmit anything that wasn't created on your computer or saved as a graphic or word-processing file.

We deliver our *PhotoDaily* market letter both by fax and online. Almost all photobuyers have fax numbers, though like their e-mail addresses, they don't always give them out freely. Do request their numbers when you contact them. You can show the impact of your photo(s) by sending a fax of it. Black-and-white prints are easy to fax. To copy a slide yourself, you'll need something similar to the Vivitar Polaroid Slide Printer (out of production, but you can probably bid on one at an online auction site like *www.ebay.com*, but *caveat emptor!*). Or you'll need a scanner attached to your computer that's capable of scanning your slides (some flatbed scanners include a slide/negative copy attachment). Keep in mind, though, that most photobuyers are moving toward wanting to receive scanned previews by e-mail rather than by fax.

Printers to the Rescue

Laser and color ink-jet printers are commonplace in offices. What might become routine in the future is high-quality color printers in the stock photographer's office.

Color ink-jet prints are the answer to the request from a photo editor for a file copy of recent images. Many printer manufacturers (Canon, Epson, Hewlett-Packard) offer a line of printers that can produce text and color images that are close in quality to the real thing. The typical desktop ink-jet color printer costs between one hundred and five hundred dollars, but it can be more. Photobuyers can download photos from your Web site or from your e-mailed previews and either use them as layout examples (comps) or, if used tiny, for actual reproduction. As I mentioned earlier, remember that most photobuyers are too busy to do the research (i.e., troll around your Web site) themselves; they prefer that you do the research for them. Secondly, you'll be able to send mini-*sell sheets* for file use once you return from your trip or self-assignment. If you don't own a scanner, you can have a company like PhotoWorks *www.photoworks.com* (previously known as Seattle FilmWorks) or dotPhoto *www.dotphoto.com* develop your roll film and scan the images for you. They'll place your scanned images on their Web site. You can download the images to your computer, ready to print

on your ink-jet printer, or you can send them to a photobuyer as preview images. Many local photofinishers also can put your images on CD-ROM at the same time they process your film, or later.

You also could incorporate the use of a digital camera into this methodology, providing you deal primarily in low-resolution pictures for the Web or preview images for your photobuyers. For print reproduction in books and magazines, photo editors will require a much higher resolution than the average-priced digital camera can deliver. In our 2002 Photobuyer Survey *www.photosource.com/101/survey.html*, 86 percent of photobuyers responding state that they accept digital submissions for preview. However, most are unsatisfied in general with the quality of the digital scans they receive from photographers.

Captions

Here's where the computer shines. What could be more tedious and boring than typing or writing the same caption, in neat, tiny, legible words and numerals, on twenty boxes of slides? This doesn't include the times that the twenty captions need to be repeated because the slides are basically the same location or subject. It's enough to wither a blossoming stock photo career. A computer can take over your captioning tasks.

Just as professional-looking stationery gets the attention of a photobuyer, so do neatly captioned slides. If you project the image of an efficiently run stock photo operation, a photobuyer will want to consider you as part of the team.

It's to your advantage to dress up your slides with computer-assisted captions. Here are options for using your computer in captioning.

Database-generated is the most popular approach. If you own a computer and database software, you assign a code number to each new slide. As long as that slide is part of your stock file, you can keep a record on it: who has bought it, how many times, where it is today, and so on. When you enter the slide into your system, you also can generate a caption on a small ($\frac{1}{2}'' \times 1\frac{3}{4}''$) slide-size label that you affix to the slide mount itself.

Figure 17-1. The Cradoc Caption-Writer software can turn your computer and printer into a slide captioning tool. It features a ½"×3½" label that wraps around both sides of a 35mm slide.

Figure 17-2. Computer-generated slide captions add a professional touch to your stock-photo operation. In this illustration, the PhotoTrack software produces three-line labels using a 22 cpi printer. The software allows you to use your existing numbering system.

Figure 17-3. A bar code labeling system provides both a caption and a bar code. Depending on the software, they are printed separately or together.

Figure 17-4. When a group of slides require the same repetitive information, the computer can generate duplicate caption labels.

If you don't want to spend time testing and designing a system, you can purchase specialized software for captioning your slides, such as Emblazon (formerly known as The Cradoc CaptionWriter, Proslide II, and FotoAgent.

Bar-coding is omnipresent in today's world. Why not get on the band-

wagon? By "swiping" a reader across the code, the photographer can enter data about the slide into a file and then generate a report, including such information as the slide's whereabouts and productivity, at any time. If your stock file numbers twenty thousand images or more, and you want to accurately trace the immediate whereabouts of your images, bar-coding is an answer.

Mark Antman of The Image Works says, "We think bar-coding is an excellent system. It's efficient. It simplifies the entry of delivery memos. It's accurate. Now we can track the whereabouts of any of our images at any given time." He uses Label Master.

Jim Pickerell of Rockville, Maryland, disagrees. "I have concluded that bar-coding a large file is a waste of time unless you have a huge number of images going in and out on a daily basis. Many of the things I did ten years ago to manage a file turned out to be not cost-effective. Photographers need to be careful not to spend more money in managing a file than the file will generate in income."

Jeff Cook of Stock Broker is cautious about bar codes. "What if a photobuyer returns the right mount, but the wrong piece of film is in it? You need to look at the film itself."

Sharon Cohen-Powers of The Wildlife Collection says, "Bar-coding may be useful for large-format photographs and where your selection of images is limited, but for thousands of 35mms, it may be counterproductive."

A supplier of bar code labels is Watson Barcode Products, 3684 Forest Park Boulevard, St. Louis, Missouri 63108, (314) 493-9300. The bar-coding hardware, which plugs into a computer keyboard, costs about $650. A supplier of label programs is Teklynx International, P.O. Box 1786, Milwaukee, Wisconsin 53201-1786, (800) 552-2331, fax: (414) 577-3901, *www.teklynx.com*. Their Bar Code Library sells for around $300, and their popular Label Matrix for around $495.

Turnkey software such as Emblazon *www.perfectniche.com*; Planet-Tools Solutions Ltd., 4514 East Pinnacle Vista Trail, Cave Creek, Arizona 85331, *www.planettools.com*,) is designed solely for captioning slides. It's one of the first captioning software products (originally

known as The Cradoc CaptionWriter) and continues to get good grades. The software is available in both Mac and PC versions, and you can download a trial version from their Web site. The cost is sixty dollars (less if you're upgrading). Assignment and stock photographers often use Emblazon with a laptop computer to accomplish their captioning right at the light table, in a motel room, or in the office. Captions can be affixed immediately or printed at a later time. Three slide management programs seem to stand out, in both popularity and quality: FotoBiz (Mac and Windows, $199.95, *www.fotobiz.net*), Stockview (Mac and Windows, $495, *www.hindsightltd.com*), and NSCS Pro2 (Windows only, $189, *www.nscspro.com*).

Direct printing eliminates the need to affix labels to your slides. Dia-Mind, Elden Enterprises, P.O. Box 3201, Charleston, West Virginia 25332, is a unit that will print up to sixty characters of caption information—twenty characters per line—onto the wide edge of a mount, or two lines on either narrow edge. It costs just under $1,300.

Another system that will print your captions directly onto your 35m cardboard slide mounts is the A10 Slidetyper from TRAC Industries, 26 Old Limekiln Road, Doylestown, Pennsylvania 18901, (215) 345-9311. The price is $4,500 for the PC version, and you can print up to ten lines on one side of the mount. Several other models are available, depending on your needs. Because there is no ink from ribbons (it uses ink-jet printing), there is little chance of ink smearing across the slides.

Of course, if none of the previous systems are in your future, you can always use the time-tested manual method of typing or neatly hand printing on the label or slide.

If someone were to invent a riding vacuum cleaner, we can agree that it wouldn't save time, because most folks would discover *more* places to clean. Automated slide captioning offers the same enticing trap. We'd caption everything in sight. A word of advice from software producer Mark Iocolano: "Put the photographs into the system as they are used, and convert gradually. When new photographs are taken or added to the file, put them into the computer that day. If you try to start from scratch, you'll never catch up."

Word Processing

Word processing, the ability to produce professional business or form letters using electronic means, is probably the computer's greatest advantage to the stock photographer. It's a real time-saver. You not only can store all your letters, graphics, or other documents, but you also can store and merge address lists and integrate them into your documents and correspondence.

Word processing becomes a necessity for your promotional efforts. You will build lists of current buyers and potential buyers, along with specific information about each of them, such as when they first/most recently bought one of your pictures, who they replaced at the magazine or publishing house, and what the most convenient time to contact them is. When you're ready to announce an upcoming trip or the appearance of one of your pictures on the cover of *National Wildlife*, word processing gives you an efficient way to get a personalized notice out to people on your list, by either letter or postcard.

Word processing also provides a bypass around one of the major roadblocks of writing: "I just don't like to do second and third drafts of my letters or manuscripts." No convoluted insertions or retyping are necessary with word processing. Corrections, changes, and additions are simple to incorporate. You'll find that writing becomes far less of a chore. A word processor may not be a surefire route to a Pulitzer Prize, but there's no doubt it gives you an edge over the competition who happen to be still tussling with the now-antiquated typewriter. Having the right equipment can give you confidence as you develop and refine your expertise.

Spreadsheets

Before computers came along, accountants would use the stub of a pencil and large sheets of graph paper to combine available figures about a business in order to produce a forecast or current picture. Spreadsheets (such as Microsoft Excel) and accounting software (such as Quicken) do the same thing, only better and faster.

The charts on page 265 are good examples of what can be entered into a spreadsheet and then printed out in pie charts or bar graphs. Since information on your photobuyers and sales is already included in your computer's database, you'll be able to engage in "what if" projects. Spreadsheets supply you with facts to hang on to, and they can show you what's in store for you if you want to take the challenge.

For example, if you wanted to increase your stock photo sales next year from ten thousand to twelve thousand dollars, a 20 percent increase, a spreadsheet program could let you know the percent of increase in sales you'd have to engineer with each of your photobuyer clients. It also would indicate how many new photobuyers you'd have to add to your roster. Of course, you could crank that figure up to a 30 percent or even a 50 percent increase. The results can tell you the work you have to perform to accomplish your goal.

Computerizing gives other benefits, too: Jackson, Wyoming photographer Bob Culver lauds the ability of a computer "to give my business a professional look when I submit a computerized invoice." Software (such as Intuit's Quicken Deluxe and QuickBooks) also is available for standard business needs such as accounts receivable, accounts payable, payroll, and general ledger. As Minnesota photographer Lori Sampson says, "If nothing else, the computer gives me the feeling that I'm getting organized."

Graphics

The advent of digital photography has brought new vision, new meaning, and increased opportunity to the field of editorial stock photography. In the past, we were confined to the limitations of film-based pictures. Digital pictures provide a broad new dimension for us.

As photography has evolved over its 170 years of existence, it has brought along the notion that whatever you photograph should not be manipulated or changed. You were supposed to *take* a photo, not *make* a photo. When the school of photojournalism came along, it reinforced this principle. The public—rightly so—did not want alteration or misrepresentation of a reported news situation.

However, what of non-news photos that rely more on the photographer's interpretation and insight? Do you add a dewdrop to a leaf to make it more effective, or do you photograph it as you found it?

The debate ended in the mid-1980s when it became evident that digital photography gave new license to image-makers. Like the French Impressionists of the nineteenth century, digital image-makers began experimenting with this new medium. Young photo editors and photographers who were not bound by the accepted confinements of the past began producing a new entity called the *digital image*, with computer-engendered enhancements, additions, deletions, color alterations, and so on.

Although all of the technology is in place for editorial stock photographers to take advantage of this new medium, we have only to look at history to see that it takes about thirty years for the public to accept a major innovation. Familiar perspectives and requirements die hard, and usually new ways of looking at things and doing things have to wait for a new generation to gradually take hold.

It's important, then, not to take too seriously the hype from computer and software vendors that our traditional ways of doing things are going to change this afternoon, or at least by tomorrow. For editorial stock photographers it's pretty much "business as usual," although stock photographers are gradually becoming more successful at marketing their digital imagery to savvy photobuyers. Little by little, more and more, publishers and photo editors are climbing aboard the electronic bandwagon. The transfer is in full swing—but the wagon is moving at a slow pace. If you can keep informed, you'll know when it's right for you to jump aboard. In the meantime, experiment with some of the current innovations I've mentioned in this chapter and that you'll find at our Web site. Don't worry if you're taking it slow; you're not missing the boat.

Picture Enhancement

Do-it-yourself manipulation software is available for the editorial stock photographer who chooses to get involved in photo enhancement. A scanned photo can be broken down into millions of dots ("pixels," or

picture elements). The dots can be rearranged or deleted, or new ones can be added for different effect. If this sounds like good old retouching, it is, only with computers. You are now known as a *pixelographer*.

Few editorial stock photographers are willing or able to invest the time and big dollars in the equipment and training required for high-level computer graphics. When high-resolution results, intricate manipulation, or enhancement are required by a photobuyer, you can always turn to a local service bureau to do the job for you.

Popular software packages (always being updated) include Adobe Photoshop and PhotoDeluxe, Corel DRAW and Corel Photo-Paint, and less expensive software such as Ulead PhotoImpact, Jasc Paint Shop Pro, and the GIMP.

Storage

Optical discs (CD-ROM, DVD) and cataloging software for the computer are within the reach of most photobuyers and stock photographers. Indeed, many new computers (at affordable prices) come with a CD-RW drive (where you can both read and make CD-ROMs) and operating software already installed. In addition, DVD writers are dropping in price. These optical discs can store ten thousand to fifty thousand full-color pictures and more, depending on the image resolution, compression ratio, and disc technology. In essence, the application is simple: You are able to digitize your stock photo file of original transparencies and black-and-white prints, and send them over the Internet or mail a disc copy to a photo editor, along with pertinent details about yourself and each picture.

When the system operator needs a specific picture, he enters a description into the computer, which locates a dozen or two dozen choices. The pictures can be viewed on screen and printed in hard copy or transmitted via terrestrial or satellite connections anywhere they're needed, such as to the magazine's printing plant. Some stock agencies, such as Index Stock Photography, The Stock Solution, Alamy.com, and others, have

Should You *Watermark* Your Internet Images?

The popular *Digimarc* and other similar security systems out-
lined in my book *sellphotos.com* have been reasonably effective
in implying a "No Trespassing Without Permission" zone on a photogra-
pher's images. However, there are problems. Firewalls that some sites put
up won't allow Digimarc and other similar programs to enter. (Digimarc
is the leader in the field).

"These programs can't hurt," says photographer/writer, Bob Shell.
"But so far as I know, neither Digimarc nor anyone else has solved the
firewall problem. I think most images stolen on the Internet are used on
sites behind firewalls, so I give Digimarc very low marks for being useful
to prevent Internet piracy."

Some hacker software allows thieves to remove watermarks through
digital manipulation. What's more, a watermark, if it's visible, can disfigure
the photographer's work. Then there's the cost. Digimarc, for example,
will cost you, on average, about twenty dollars a year per image. Finally,
there's the "mistrust" factor. "No Trespassing" signs splattered all over a
photographer's Web page sends a negative message to potential photobuy-
ers: "You look suspicious. We're going to keep a close eye on you."

For the average editorial stock photographer, heavy-duty protection for
images usually is not called for. Thievery is an infrequent occurrence, and
in any case, to follow up an alleged theft and seek out the perpetrator is
not cost-effective. So we let it be.

However, we *are* concerned about the willy-nilly "borrowing" of our
images by unscrupulous graphic artists and video/graphic entrepreneurs.
It's a moral issue. They benefit from our creativity. We receive neither
compensation nor credit line when this happens.

One program on the market (as of this writing) is CopyNo, the "Multi-
Level Copyright Protection Warning/System and Application for Visual
Artists and Image Creators." It's a simple program that says, "Appeal to
their conscience."

It works like this. The would-be borrower attempts to use the universal

"mouse-click" download method for taking an image from a Web page. A notice pops up where the picture would normally appear that states copying the picture is illegal without prior permission. The infringer now has the moral choice of deliberately taking the image using a hacker method to steal it in bad faith or of getting permission from the copyright owner. CopyNo does not prevent actual theft nor is it foolproof. However, it's a good warning mechanism to would-be infringers of editorial stock photography up on the Web.

Let's hope CopyNo flourishes for us here at the editorial level of stock photography. Check it out at *www.copyno.com*.

pioneered this area. Large corporations and the military have been utilizing these capabilities effectively for years.

Where To From Here?

As you know, both you and the photo editor have been limited to the pigeon-hole-retrieval method of locating pictures. You file them away in a slot and pull them out to view them. It's the same system our U.S. Postal Service has used for generations to sort and find letters. The system was invented by our first postmaster, Benjamin Franklin.

Today, the U.S. Postal Service has been automating its system successfully over the past decade. The stock photography community also is embracing digital archives and the Internet. Stock photo agencies are digitizing their vast inventory of historical and current images and making them available online for photobuyers, and many independent photographers are putting selections of photos online.

Computers offer stock photographers an excellent springboard to the automated business office. Will the noncomputerized stock photography operation soon be a relic of the past?

The *good ol' days* for the stock photographer of the past generally translate to hand-printed captions on slides, carbon-paper copies of transmittal letters, typewritten correspondence, party-line telephone

calls, Rolodex, and $3'' \times 5''$ file cards, all handled by the U.S. Postal Service. If you made mistakes in the good ol' days, you couldn't blame them on a computer. However, this doesn't mean that your office nowadays has to look like something out of George Lucas's *Star Wars* in order to compete.

"Whether you're using a postal meter or licking and sticking postage stamps, the package still has to contain good stock photography," says Alan Carey of The Image Works.

Changing technology will have a great impact on not only stock photography but also the other areas that affect the field—publishing, printing, research, package delivery, communications, and travel. In the area of marketing, for example, a stock photographer can get the full benefit of the *total net worth* principle (see page 72) by using a computer with appropriate software. Without it, you can still employ the *total net worth* concept, but a computer lets you assess more information more efficiently, pointing you toward good business decisions faster.

Specialized closed-circuit networks for the electronic marketing of photography—via both computers and faxes—are around the corner. Another innovation: high-definition TV. In the future (a few are doing it now), stock photographers will keep their originals safely at home and market their wares electronically via satellite.

Keep In Touch

E-mail allows you to keep your business rolling while you're not at your home office. Whether you're traveling in your home country or on a foreign shore, you'll find several options for connecting to the Internet. Hotels often have private room connections or a place in the lobby with a coin slot and a pay-as-you-go service. Outside, Internet cafes invite you to sign up for a computer connection. The charges are added to your meal tab. Local public and college libraries often are available for free or a low fee.

We're all going to take a ride on a massive technological wave that will have some of us riding the crest, others swept into the roiling undercurrents, and some washed ashore. However, in the end, good management, good photo illustrations, and wise business decisions, as usual, will be the key to moving forward in your stock photography business.

Bibliography

You can order all books in this bibliography at the PhotoSource International Online Bookstore, *www.photosourcefolio.com/BookStore-SRS.htm*.

2001 Gold Book of Photography Prices, Thomas I. Perrett

All-In-One Directory 2002 (Gebbie Press All-In-One Directory, 2002), Amalia Gebbie (editor)

ASMP Directory www.asmp.org

ASMP Professional Business Practices in Photography, American Society of Media Photographers

ASMP Stock Photography Handbook, Michal Heron (editor)

Beginner's Guide to Digital Imaging for Photographers and Other Creative Types, Rob Sheppard

Bulletproof News Releases: Help At Last for the Publicity Deficient, Kay Borden

The Complete Tightwad Gazette: Promoting Thrift As a Viable Alternative Lifestyle, Amy Dacyczyn

Creative Black Book www.blackbook.com

The Digital Photographer's Pocket Encyclopedia, Peter Cope

DIY PR: The Small Business Guide to "Free" Publicity, Penny Haywood

The Executive's Guide to Handling a Press Interview, Dick Martin

Foundation Grants to Individuals, 12th Edition, Phyllis Edelson (editor)

Free Money for Small Businesses and Entrepreneurs, Laurie Blum

Graphic Artists Guild Handbook: Pricing and Ethical Guidelines, 10th Edition, Graphic Artists Guild

A Guide to Travel Writing and Photography, Ann Purcell, Carl Purcell (contributor)

How to Shoot Stock Photos That Sell, Michal Heron

How to Survive and Prosper as an Artist, Caroll Michels

Jim Church's Essential Guide to Nikonos Systems, by Jim Church

Julian Block's Tax Avoidance Secrets, Julian Block

The Law (in plain English) for Photographers, Leonard D. DuBoff

Legal Guide for Starting and Running a Small Business, Fred S. Steingold

Legal Guide for the Visual Artist, 5th Edition, Tad Crawford

Legal Handbook for Photographers: The Rights and Liabilities of Making Images, Bert P. Krages

Literary Market Place www.literarymarketplace.com

Metro California Media

Metro California Media Multimedia Law and Business Handbook, J. Dianne Brinson and Mark F. Radcliffe

Negotiating Stock Photo Prices, 5th edition, Jim Pickerell and Cheryl Pickerell DiFrank

New York Publicity Outlets?

The Permanence and Care of Color Photographs: Traditional and Digital Color Prints, Color Negatives, Slides, and Motion Pictures, Henry Wilhelm, Carol Brower (contributor)

The Photographer's Business and Legal Handbook, by Leonard D. DuBoff

The Photographer's Guide to Getting and Having a Successful Exhibition, Robert S. Persky

The Photographer's Guide to Marketing and Self-Promotion by Maria Piscopo

Photographer's Market: 2,000 Places to Sell Your Photographs, Donna Poehner (editor)

The Photographic Art Market: Auction Prices 2001, Robert S. Persky (editor)

Photography: What's the Law? by Robert Cavallo and Stuart Kahan

Photoshop Users Encyclopedia, Peter Cope

PhotoSourceBOOK, PhotoSource International www.photosourcebook.com

Pricing Photography: The Complete Guide to Assignment and Stock Prices, 3rd Edition, Michal Heron, David MacTavish (contributor)

Professional Digital Photography, Dave Montizambert

The Public Domain: How to Find and Use Copyright-Free Writings, Music, Art and More, Stephen Fishman

Publishing Your Art As Cards, Posters, and Calendars, Harold Davis

sellphotos.com, Rohn Engh

The Successful Promoter: 100 Surefire Ideas for Selling Yourself, Your Product, Your Organization, Ted Schwarz

Techniques of Natural Light Photography, Jim Zuckerman

Top Tax Saving Ideas for Today's Small Business, Thomas J. Stemmy, Camille Akin (editor)

Ulrich's Periodicals Directory 2002, 40th Edition

The Underwater Photography Handbook, Annemarie Köhler and Danja Köhler

Winning Photo Contests, Jeanne Stallman

Working Press of the Nation 2002: Magazines and International Publications, Vol. 2

Working Press of the Nation 2002: Newspapers, Vol. 1

Working Press of the Nation 2002: TV and Radio, Vol. 3

Appendix

Third-Choice Markets

PAPER PRODUCT COMPANIES

For want of a better name, I've grouped calendars, greeting cards, posters, postcards, and the like under the heading "paper products." This segment of the marketplace produces millions of products but usually pays very little. And why not? There are millions of *standard excellent* pictures available to these markets from thousands of photographers—all scrambling to sell their silhouettes of a seagull against the setting sun.

The midsize and smaller calendar and card markets do rely on freelance submissions, but they also rely on your vanity to fill their photographic needs cheaply. Not only are their rates low, but they also attempt to acquire three- to five-year exclusive rights and sometimes all rights to your photograph (see chapter fifteen to define the difference). They may even ask you to transfer copyright of your picture over to them. Such terms, which take a photo out of circulation, are contrary to your working methods and diminish the resale and income potential of your stock photographs.

The one redeeming feature of greeting cards, posters, and calendars is that they can offer a showcase for newcomers to the field. If you feel this exposure would be advantageous to you, deal with the well-established companies. Check a prior edition (three to five years' prior would be good) of *Photographer's Market* against a current edition to see if a firm is still listed and the address is the same.

The following are the markets for paper products.

POSTCARDS. You can sell and re-sell your travel pictures more often at higher fees elsewhere, so why bother with the low-paying picture postcard companies? If you want to pursue this field nevertheless, look on the back of current postcards in gift shops and stationery

stores in the state or country you're visiting to find addresses of the companies that produce the cards.

CALENDARS. Calendar markets usually prefer medium or large format, but more and more are looking at 35mm. They buy exclusive rights. They use staff or established service photographers who often shoot in four-by-fives or eight-by-tens. Sometimes they will use free-lancers, especially the smaller companies.

Calendar companies usually accept the standard scenic clichés; however, some houses have become innovative in their photographic tastes. Every now and then a calendar company will produce a line of calendars featuring abstracts or art photography. However, the experienced (and financially successful) calendar houses have learned to stick with the standards that appeal to the common denominator of the general public.

GREETING CARDS. Trends change more quickly here; visit a stationery store to see what's selling now. Greeting card companies buy exclusive rights (see chapter fifteen); the pay is low and competition is high.

POSTERS. These are usually produced by calendar and greeting card houses; however, some are produced by independents. Nevertheless, the constraints mentioned for greeting card and calendar companies hold true for the poster markets. They rely on freelancers, but they also usually require exclusive rights. An excellent book in this field is *Publishing Your Art as Cards, Posters, and Calendars*, by Harold Davis, The Consultant Press, Ltd.

Do you plan to produce your own posters or art prints? Check out labs such as Calypso or West Coast Imaging (WCi), *www.westcoastimaging.com*, and ask about their drum scan and large-format digital printing service.

PUZZLES, PLACE MATS, AND GIFT WRAPS. Again, you can sell your pictures at higher rates to other markets. Unless you're doing a favor for an in-law, stay clear of these markets. Your time and talent are worth more than they can offer.

If you wish to try your luck at calendar, greeting card, poster, or place mat sales, you'll find the market reference guides listed in Table 3-1 on page xx and in the bibliography to be of some help.

Commercial Accounts

If breaking into the commercial side of stock photography is a challenge you just can't turn down, here are three books that will be helpful: *How to Shoot Stock Photos That Sell*, by Michal Heron, Allworth Press; *Publishing Your Art as Cards, Posters, and Calendars*, by Harold Davis, The Consultant Press, Ltd.; and *Stock Photography, The Complete Guide*, Ann and Carl Purcell, Writer's Digest Books.

Here are your commercial targets.

AD AGENCIES. Ad agencies rely heavily on photography for their visuals. The smaller the agency, the more apt they are to take time to look at you and your photography. The reality: Ad pictures usually are created and shot to order by an established service photographer. If ad agencies want stock photos, they historically go to a stock agency or to the established local professionals first.

GRAPHIC DESIGN STUDIOS. The smaller studios do buy from free-lancers. The pay is fair, and if you love knocking on doors, wearing out shoe leather, and showing off a portfolio, these folks will entice you with a carrot on a string. They may like you, but you'll find that they still like dealing with large stock agencies.

CD COVERS. If you know the packaging industry backward and forward, you might score here with stock photography, but it's rare. CD cover markets prefer dealing with local service photographers or massive stock agencies.

AUDIO VISUAL (AV): These multimedia markets turn to stock photo agencies or have staff photographers shoot their needs. The prospective multimedia photographer must be prepared to adapt to rapid change. Time spent cultivating this market usually is fruitless, because the field lends itself best to the service photographer, who routinely visits clients.

BUSINESS AND INDUSTRY. Since businesses of any substantial size

(and these are the only ones who have volume photo needs) often have staff photographers and on-tap independent service photographers, your pictures won't carry much weight with them, even if your photos are outstanding. When these people need a stock picture, they consult a stock agency.

FASHION. Don't confuse fashion with *glamour*, which sells well to the publishing industry. The fashion industry sometimes has use for stock shots for backgrounds, but they consistently go to stock agencies for the selections.

PRODUCT PHOTOGRAPHY. Forget it. They don't buy stock pictures—it's all "to order."

An authoritative book used constantly by service photographers to price their work is *Gold Book of Photography Prices*, 21237 South Moneta Avenue, Suite 17, Carson, California 90745, (310) 328-9272. Author Thomas I. Perrett publishes the "going rates" in service photography across the nation. Each year, he surveys the industry and produces his new findings. Pricing software such as FotoBiz also is a useful resource for this field of photography. (See Table 8-2 on page 132 for prices to charge for multimedia, CD-ROM covers, and other commercial-market sales.)

Other Third-Choice Markets

The following are included in third-choice markets because they rate an "A" in exposure value, and a "C-minus" in pay and resale potential.

NEWSPAPERS. Sunday newspaper feature supplements sometimes buy editorial stock photography (see chapter one). Daily and weekly papers (a good starting place for the beginner) occasionally will buy a single photograph. The pay is low, but the exposure is helpful. It's like free advertising. Contact the photo editor of your nearest metropolitan newspaper for guidelines and payment information for picture stories, photo essays, and single-picture sales.

GOVERNMENT AGENCIES. Although the government is this country's largest publisher, it is also its smallest, since each unit deals on

its own local, specialized level. Government photobuyers come with a variety of titles: art director, editor, promotion manager, and so on. They buy pictures for their publications in a variety of fields: agriculture, transportation, commerce, health, education, and so on.

I know photographers who have persisted and found a market in the government for their photo illustrations, but they live in cities where there is a large federal center, such as Washington, DC, Kansas City, or Atlanta.

ART PHOTOGRAPHY. A definition of art photography is elusive. Generally speaking, when photographers refer to it, they have in mind the photographs seen in magazines such as *American Photo*, *Popular Photography*, and *Print*, and in salons and exhibitions. Art (or artful) photography is salable. Collectors will purchase it in much the same way as paintings, and for the same reason: The investment value is ultimately dependent on the renown of the painter or photographer.

Except for a few specialized, low-paying magazines, art photography is not marketable in the publishing world.

Index